**Sell
&
Re-Sell
Your
Photos**

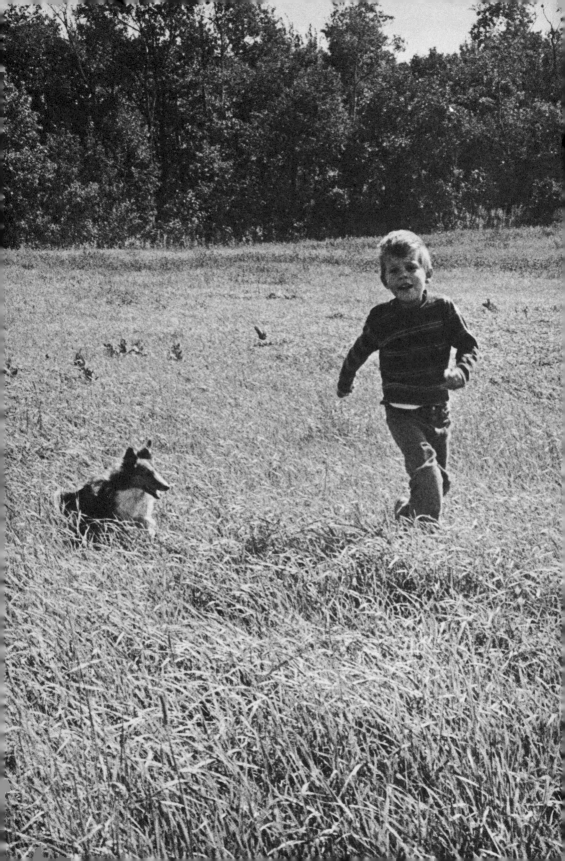

SELL
& RE-SELL
YOUR
PHOTOS

ROHN ENGH

Writer's Digest Books

Cincinnati, Ohio

Second printing 1982
Third printing 1983
Unless otherwise credited, all photographs in this book are by the author, copyright 1981 by Rohn Engh.

Library of Congress Cataloging in Publication Data

Engh, Rohn.
 Sell and re-sell your photos.
 Bibliography: p. 309
 Includes index.
 1. Photographs—Marketing. I. Title.
TR690.E53 770'.68'8 81-1872
ISBN 0-89879-046-8 AACR2

Book design by Barron Krody.

I'd like to dedicate this book to my parents, Mr. and Mrs. Lynn A. Engh ("Muzzie and Coolie"). My dad inspired me to believe that anything is possible in life if you "Keep in a good frame of mind." My mother showed me how to enjoy my blessings twofold by sharing them with others.

. . . To my two boys, Danny and Jim (both are pictured in this book; that's Danny on the cover), for constantly reminding me that most problems can be solved if you meet them with childlike freshness and clarity of vision.

. . . And to my wife, Gerry, for the common sense, good humor, and love that keep our family on a straight course.

I'd like also to acknowledge Gerry's wonderful help on this book. We spent many hours these past eleven months, watching the seasons change as we toiled over the manuscript. Not only did she bring her professional writing expertise to the project, she is my severest critic and my best friend.

My deepest gratitude goes also to these folks: Eileen Hacken, our office manager here at PhotoSearch International, devoted many weekend and evening hours to typing and proofreading the manuscript. Joseph Moriarity, editor of the Photoletter, together with Eileen valiantly kept the ship afloat while Gerry and I put full time into producing this book. Sincere thanks also go to Robert Cavallo and Lou Jacobs, Jr., for their knowledgeable aid with the copyright section, and to David Strickler, for his help on the model-release section.

There are many others whose influence or example through the years have helped make this book possible. The best way I can express my appreciation is to pass what I have learned on to you.

Finally, thanks to the acumen and professional guidance of Carol Cartaino and her staff at Writer's Digest Books, with whom it has been invigorating and a real pleasure to produce this book for you.

Rohn Engh
Pine Lake Farm
Star Prairie, Wisconsin
May 1981

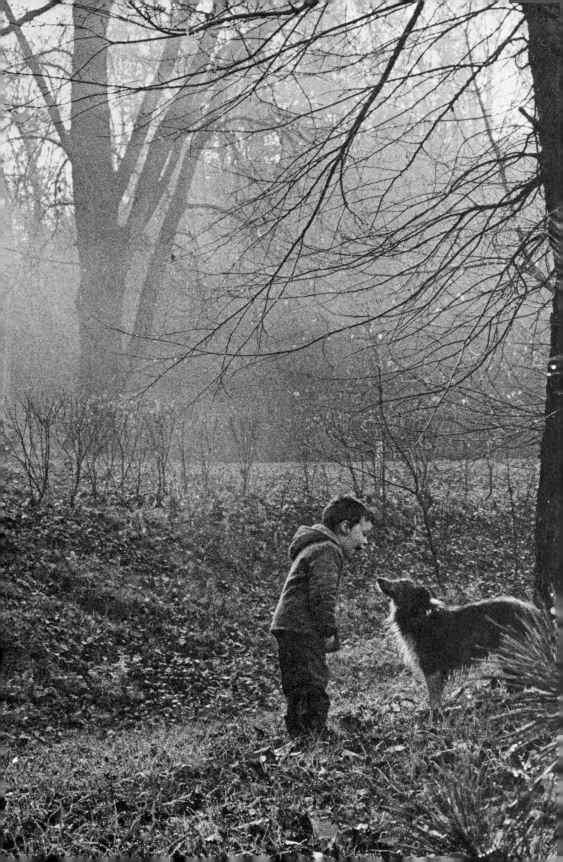

TABLE
OF
CONTENTS

1. The Wide World of Possibilities 5

The buyers are waiting. Trends in the marketplace. 20,000 photographs a day. A wide-open door. Find the market, then create. You, the photo illustrator. The target markets. Prime markets: books and magazines. Secondary markets. Third-choice markets. You supply the pictures—they'll supply the checks.

2. What Pictures Sell and Resell? 19

The difference between a good picture and a good *marketable* picture. Good marketable pictures. The Rohn Engh formula for producing a marketable picture every time. Using the formula. The missing link: 4 illustrations that show why the $P + B + S + I$ formula works. On target and off target: 10 photo illustrations that miss the mark, and why. You are an important resource to editors. A gallery of photo illustrations.

3. Finding Your Corner of the Market 49

First, find yourself. Photographically . . . who am I? Your PMS (personal photographic marketing strengths). Track A. Track B. One photographer's track list. The majors and minors. How to use the reference guides and directories. Using your local interlibrary loan service. Chart your course . . . build a personalized Market List. Market directories. Setting up your list. The specialization strategy. Keeping on top with newsletters. Track A: The boulevard of broken dreams. How to find your PMS. How to narrow down your Market List. Publisher's buying power guide.

submissions. Writing the cover letter. Deadlines: a necessary evil. Unsolicited submissions. The magic query letter. Seasonal trends in photo buying. How long do editors hold your pictures? Using postcards to relieve the agony. A holding fee—should you charge one? How to inquire about pictures being held too long. When can you expect payment? How safe are your pictures in the hands of an editor? Lost, stolen, or strayed? Your recourse for lost pictures. How much compensation should you expect? Liability notices. A twenty-four-point checklist to success.

10. If You Don't Sell Yourself—Who Will?

Promoting your photography: how to blow your own horn. Look like a pro even if you don't feel like one yet. Your personal trademark. Your letterhead. Envelopes. Business cards. Build a mailing list. Mailers—they pay for themselves. Brochures. Catalogs. The phone. A photographer's catalog. Credit lines and tearsheets—part of the sale. Speaking engagements. Radio and TV interviews. Press releases. Promotional news features. Advertising. Reassess your promotional effectiveness. Postscript: a word about portfolios. Exhibitions. Salons. Contests. Decor photography. Greeting cards, calendars, and posters. Some final self-promotion suggestions.

11. Assignments

An extra dimension for the photo illustrator. Negotiating your fee. Expenses. Extra mileage from assignments. A sample expense form. The stringer. Self-assignments—where do you start? Speculation. Take a free vacation. Who buys travel pictures? What does the travel photo buyer really need? Making the contact. A typical assignment query letter. Sample shotgun (after the trip) query letter. A sampling of hot sellers.

12. Stock Photo Agencies and Decor Photography

Outlets for Track A. Prepare to share your profit. Agencies: a plus with limitations. How to find the right agency. How to contact a stock photo agency. The PhotoDataBank and Compu/Pix/Rental. The timely stock agencies. Possible problems in dealing with stock agencies. Do you need a personal rep? Start your own mini-agency. The individual agency. The co-op agency. Decor photography: another outlet for your standards. Single sales. Multiple sales. What makes a marketable decor photograph? What to charge. Black-and-white or color? Size. How to make your decor photography more salable. Promotion. Where to find more information on decor photography.

graphic design studios, record covers. AV: filmstrips, motion pictures, video discs. Business and industry. Fashion. Product photography. Newspapers. Government agencies. Art photography.

Introduction

**Exciting
Opportunities
at Your
Doorstep**

Will a Rolls-Royce be sitting in your driveway if you follow the principles set forth in this book? Maybe not. But then again, maybe two of them will. Or maybe a moped will. In other words, you'll reach whatever goals you set for yourself. That's the exciting part about all this: Whatever your goals, you have complete control over whether they come to fruition. Success or failure in publishing your pictures is not determined by the wave of some mysterious wand out there in the marketplace. If you've got the know-how, you determine how far and how fast you go. This book will give you that know-how.

In over twenty years of selling photographs, I've refined a marketing system that works for me today better than ever, and is working for scores of other photographers who have learned the system in my seminars and through my market letter, the *Photoletter*. Hundreds of letters in my files attest to the efficacy of the system, testimony from photographers who are publishing their pictures (and depositing checks) with regularity.

The components of the system are simple—but the process isn't easy. It takes effort, energy—perhaps some un-learning of initial misconceptions—but that's all that's required, and there are compensations:

Live anywhere. No need to live in the canyons of Manhattan or downtown Chicago "to be close to the markets." They're as close as your mailbox. You can work entirely by mail, entirely at home, and still score

in the wide world of markets open to you. Whether your headquarters is a mountaintop cabin in Wyoming or a high-rise in Hartford, the markets will actually come to you through this system.

Pick your hours. You can arrange your own schedule and enjoy the flexibility of being independent. You can work at your photography full-time or part-time.

Be your own boss. Photo buyers don't care whether you're an amateur or a pro, a housewife or a parachutist. They're concerned about the quality of your picture and whether it meets their current needs.

Take paid vacations. You can pay for your trips through assignments you initiate or by judicious picture-taking and picture-placing, all described in my system. If you enjoy travel, you'll find your situation can become one of having to pick and choose among all the trip opportunities open to you.

Earn more money. You will sell the same photo over and over again. You'll choose from hundreds of good-paying markets you never knew existed, and you'll enjoy working with them because they're in your interest areas.

See your pictures in print. You'll be publishing your pictures, sharing insights and your views of life in all its beauty, humor, discord, poignancy, delight, tragedy, and fascination. Sometimes your picture will make a tangible social contribution, sometimes it'll be business-as-usual. But it will all be deeply satisfying, with the gratification that comes from starting with a clear piece of film and creating something entirely your own.

There are six elements in my marketing system that I'll explore with you in detail in the course of this book:

1. I touched on this one above: You market your photos by mail. No need to pound the pavements with a portfolio.

2. You distinguish between *service* photography and *stock* photography (photo illustration). The service photographer markets his *services*—on schedules that meet the time requirements of ad agencies, businesses, wedding parties, portrait clients. The stock photographer takes and markets his *pictures*—on his own timetable, selling primarily to books, magazines, publishing companies of all kinds, all over the country. My marketing system addresses the stock photographer.

3. You distinguish between *good* pictures and good *marketable* pictures. The former are the excellent scenics, wildflowers, sunsets, silhouettes of birds in flight, mood shots of the lake, pet pictures. These are A-1 pictures, but in spite of the fact we see them everywhere in the marketplace (on greeting cards, record covers, posters, travel brochures,

magazine ads), they're terribly difficult (they can cost you money) to market yourself. I'll tell you why later in the book. You learn how to place these pictures in the right stock photo agencies, who *can* market them for you, for now-and-then supplementary income. For regular income you sell good *marketable* pictures: photo illustrations. You continue to take pictures in your interest areas, but you learn how to turn a picture into a highly marketable shot. Photo illustrations are the pictures in great demand; they are published by the thousands every day by book and magazine publishers who spend hundreds of thousands of dollars each month buying them.

4. You find your **PMS**—your **personal photographic marketing strengths**—and specialize. Knowing how to do this will give you invaluable insight and irresistible momentum. To my knowledge, it is treated nowhere else in the photographic literature.

5. You determine your **Market List,** coordinated with your PMS. You don't sell your pictures before you understand how to market them. Selling is what happens naturally, after you do your marketing homework.

6. You look like a pro with your photo-identification methods, your stationery, labels, packaging, your cover and query letters.

You may find this book quite different from what you initially expected. Many books on photography glamorize market possibilities for the serious amateur or new professional; I have tried to present an honest overview. I am a working photographer, and as publisher of a photo-marketing newsletter, I deal daily with the realities of the photography marketplace.

My goal in this book is to give you the tools to become a consistent seller—to markets you enjoy working with.

The new markets you discover will surprise you with their photography budgets of $10,000, $20,000, and $30,000 a month (a month, not a year). "Are these markets in New York and L.A.?" you might ask. No. Times have changed. New York, Chicago, and L.A. markets are still the top markets for service photographers, but publishing markets for the stock photographer abound all over the country.

This book will help you tap these markets, and you'll discover the real excitement, the genuine exhilaration, of the venturesome process of producing your pictures and sharing them through publication.

The sky *is* the limit. Where you go with your photography is up to you.

Onward. With today's dramatic increase in the use of photography, as well as in the number of new markets and special-interest magazines and books, the challenges and satisfactions in the field of photo illustration have never been greater. You can be part of them.

1.
The
Wide World
of
Possibilities

The Buyers
Are Waiting

You've probably turned to a photograph in a book or magazine and said, "I can take a better picture than that."

You are probably right . . . and not only from the point of view of quality or subject matter. Often a photo you see published in a magazine or book doesn't really belong there. When the deadline arrived, it was used by the photo editor because it was *there,* not because it was the perfect photograph.

Editors would gladly use *your* photographs, if they knew you existed, and if you'd supply them with the pictures they *need,* when they need them. The buyers are literally waiting for you, and there are thousands of them. This book is going to show you how to locate the markets that are, this moment, looking to buy pictures from someone like you, with your special know-how and your camera talent. This book is also going to show you how to determine what pictures editors need, and how to avoid wasting shoe leather, postage, and energy with markets that don't offer any future for your kind of photography. You'll earn the price of this book in one week through the postage or phone bills it will save you.

If you're a newcomer to the field of photo marketing, you'll be surprised to learn you can start at the top. I know many who have done so, and I did, myself. I sold my first picture to the *Saturday Evening Post.* Many of my pictures have sold to *Reader's Digest, Parents, U.S. News & World Report, People, Redbook,* and others. But let me interrupt here to say I soon discovered that if I wanted to sell *consistently* to the top magazines, I would have to travel continually and make my headquarters in a population center a good deal larger than Star Prairie, Wisconsin.

There are at least 10,000 picture markets today. I figured that if I subtracted the top-paying magazines, numbering about 100, that left 9,900 for me to explore. I learned that most of these markets were as close as my mailbox, and that many of them were actually eager for my photographs. Most important, I could sell to these markets on my own timetable and live wherever I wanted to.

Trends in the Marketplace

Back in 1960 when I began marketing my pictures, there were very few "photo editors." The art director or an editor at a publishing house doubled as the person who selected pictures—and the process often was hurried, at the last moment, whenever the book or magazine text was finalized. Pictures in those days frequently served simply to "fill white space" or to support a subject with documentation.

During the past twenty years our society has become increasingly visually oriented, to the point of a veritable explosion in the use of visuals. People today are more prone to be viewers than readers. Reading material is more and more capsulized (witness the proliferation of condensed books, specialized newsletters). People rely less on the printed word and more on pictorial images for entertainment and instruction. Textbooks have more pictures and larger type. Illustrated seminars and instructional slide programs are the preferred tools for education throughout industry, and of course TV is conditioning all of us to visuals every day.

Words and printed messages aren't going out of style, but a look in any direction today shows us that photography is one of the most prominent means of interpreting and disseminating information.

If you've grown up in the TV era, the switch to increased picture use is probably not apparent to you. The publishing industry, however, is greatly aware of it. New positions have been created in publishing houses—photo editors, photo researchers, photo acquisition directors— positions that never existed in the past. Revolutionary machinery has been developed to handle and reproduce pictures. Publishers produce millions of dollars worth of books, periodicals, and audiovisual materials every year. The photographs used in these products often make the difference between a successful venture and a failure. An editor isn't kidding when he says, "I *need* your picture."

The breadth of the marketplace this book will introduce you to may come as a surprise. For example, some publishing houses spend as much as $10,000 to $30,000 a month on photography. Some of those thousands could regularly be yours, if you learn sound methods for marketing your pictures.

As I mentioned earlier, you can start at the top. It's not impossible. But making a full-time activity of selling to the top markets requires a spe-

cific lifestyle and work style. You need to examine your total goal plan and make some major decisions before you launch out after the biggies. Only a handful break into that small group of "top pros" who enjoy regular assignments from the top markets. And most of those top pros pay their dues for years before they get to where their phone rings regularly.

Too often, the newcomer to any field believes the top is the only place it's at. The actor or the musician rushes to Hollywood to make it big. We all know how the story ends. Out of thousands, only a few are chosen. We also know they are *not* chosen on the basis of talent alone. Being at the right place at the right time is usually the key. The parallel holds true for photography. Good photographers are everywhere—just check the Yellow Pages. As with actors and musicians (or artists, dancers, writers), talent is only one of the prerequisites.

But if you are serious about your photography and are willing to look beyond the "top," you'll discover a wide, wide world of possibilities out there for you. There are markets and markets—and yet more markets. You *will* get your pictures published, consistently, with excellent monetary return, and with the inner satisfaction that comes from putting your pictures out where others can enjoy them. You can accomplish this if you apply the principles I outline in this book. Your pictures will be at the right place at the right time, and your name will be on the checks, sent out regularly by the picture buyers you identify as *your* target markets.

20,000 Photographs a Day

As you read this page, at least 20,000 photographs are being bought for publication in this country at fees of $20, $35, $50, $75, $100 for black-and-white and often twice as much for color. I'm not talking about ad agencies or general newsstand-circulation magazines. They're the closed markets—tied up by staff photographers or established pros.

I'm referring to the little-known wide-open markets that produce books, magazines, and related printed products. Such publishing houses have proliferated all over the country in the last two decades. Opportunities for selling photographs to the expanding publishing industry have never been greater. Some publishing companies are located in small towns, but that's no indicator of their photography budgets, which can range, as I've said, from $10,000 to $30,000 per *month*.

A Wide-Open Door

These publishers are in constant need of photographs. Many publishing companies produce up to three dozen different magazines or periodicals, plus related publications such as bulletins, books, curriculum materials, brochures, filmstrips, reports. Staffs of the larger publishing

houses have scores of projects in the fire at one time, all of them needing photographs. As soon as a company, large or small, completes a publishing project or current issue, it is searching for photographs for the next project on the layout board.

Educational publishers are in fierce competition with each other to nail down contracts with colleges and universities, technical institutes, school boards, and associations, to produce photo-illustrated educational materials.

Regional and special-interest magazines number in the thousands. While general-interest weekly magazines such as *Life* and *Look* (closed markets working primarily with the top pros) were meeting their demise, regional and special-interest magazines (open markets for the photo illustrator) were on the rise, and new ones continue to appear on the publishing scene. With the enormous amount of information available in any field or on any subject in today's world, our culture has become one of specialization. Increasingly, magazines and books reflect this emphasis, focusing on self-education and specific areas of interest, whether business, the professions, recreation, or leisure. This translates into still more markets for the photo illustrator.

Another major marketplace is the hundreds of denominational publishing houses that produce scores of magazines, books, periodicals, curriculum materials, filmstrips, posters, and bulletins. Some of these companies employ twenty or more editors who are voraciously eager for photos for all their publishing projects. Very few of these are what you might think of as "religious." Their photography budgets are high because their sales volume is high.

As I mentioned earlier, there are nearly 10,000 markets open to the photo illustrator today. (That's apart from the about 100 top magazines such as *National Geographic* or *Sports Illustrated.*) These are 10,000 open markets, accessible to both the part-timer and full-timer. Photo buyers in these markets are constantly revising, updating, putting together new layouts, new issues, new editions, new publication projects.

If you compare the per-picture rate paid by these markets against that paid by the 100 top magazines, or against the $500 per picture that an advertising photographer receives for commercial use of his picture, there's a big difference. But that's misleading. Unless you number yourself among the relative handful of well-known veteran service photographers who sell to the top magazines (many have staff photographers in any case), this is sweepstakes marketing—a sometime thing. The same goes for top commercial assignments. When you score, it's for a healthy dollar, but how frequently can you count on it? Commercial accounts and the top magazines often require all rights to your photos, as well.

In contrast, as a stock photographer selling ("renting") your photos for editorial use, you can circulate hundreds of pictures to publishing

houses for consideration, each picture making from $20 to $200 at every sale. You don't have to worry about the beck-and-call mobility and time-deadline requirements of top magazine assignments, or the frazzle of commercial assignments, and you can sell the same pictures over and over again.

You can do this from your own home, wherever you live. For the past fifteen years I've operated successfully out of a 100-acre farm in rural Wisconsin and can attest that more and more photographers are doing the same thing from such diverse headquarters as a quiet side street in Kansas City, an A-frame in Boulder, an apartment in Albany.

When you master the photo-marketing system outlined in this book, you'll know how to select *your* markets from the vast numbers of possibilities, and then tap them for consistent, dependable sales. If you're like most of us, you'll find that your range of markets includes some that are good starting points (easy to break into but pay modestly); some that are good showcases for you (prestigious publications in your special-interest areas that may pay little but offer a good name to include in your list of credits, or good visibility to other photo buyers); many that will be regular customers for modest but steady return; and many that will be regular well-paying customers.

Find the Market, Then Create

Many photographers who are successful today say their careers surged forward when they realized that they were conducting the business side of their endeavors exactly backwards. They had been creating first—and then trying to find markets for the photos they produced. This system can work to a certain extent (and everyone gets lucky now and then), but it doesn't make for consistent, predictable sales. It's another form of sweepstakes marketing. Here's the secret to guaranteed sales: Find the market first.

This isn't to say that you pick just any market and create for it. I mean search out markets that appeal to you as a person and a photographer—markets you would love to deal with and create for.

Finding your corner of the marketplace is going to be like prospecting. It's going to take some digging, but the nuggets you discover are going to be worth the effort.

You, the Photo Illustrator

After you become familiar with the photo-marketing system described in this book, you'll find that you can wear two hats in photography.

One hat is that of the photo illustrator, the other the service photographer. What's the difference?

The *service photographer* markets his *services* on schedules that meet the time requirements of his clients: ad agencies, businesses, wedding

parties, portrait clients, and PR, publicity, and audiovisual accounts. The service photographer usually finds he needs several different kinds of cameras, a myriad of lenses and accessories, and frequently a well-equipped studio.

The *photo illustrator* markets *stock photographs (photo illustrations)*, which he takes and sells on his own timetable, selling almost exclusively to publishers of books, magazines, and related publications. The photo illustrator can operate with only one camera and three lenses, though he's better off with two cameras (see Appendix B). The extensive equipment and studio of the service photographer aren't necessary.

A photographer can be either a service photographer or a photo illustrator, or both. The marketing system in this book, however, *addresses the photo illustrator*. The demand for photo illustrations in the publishing world has increased dramatically in the last decade. So have the photography budgets of publishing houses. And so has the need for photo illustrators—the photographers who can supply on-target pictures to the highly specialized magazine and book publishing industries.

The Target Markets

The primary markets for photo illustration are the publishing companies located in every corner of the country, and the magazines and books they produce. I've already touched on some major categories—educational, regional, special interest, and denominational. Now we'll take a look at each market in detail.

Remember that publishing houses tend to specialize. If in your research you come across a magazine that's new to you in one of your fields of interest, you'll often discover the magazine's publishing house produces several additional magazines, usually related or on the same theme. If your photo-marketing strengths include a focus on that theme, you've discovered one of *your* top markets.

Prime Markets

1. Magazines
2. Books

Secondary Markets

1. Stock photo agencies
2. Decor photography outlets

Third-Choice Markets

1. Paper product companies (calendars, greeting cards, posters, postcards, etc.)

2. Commercial accounts (ad agencies, PR firms, record companies, audiovisual houses, graphic design studios, etc.)

3. Newspapers, government agencies, and art photography sales

You'll find a full discussion of third-choice and secondary markets later in this book, so I'll say just a word about them here.

The third-choice markets range in marketing potential from "possible" to "not possible" for the photo illustrator. In Appendix A, I outline what to expect at these markets and what the requisites are to make sales in them.

The secondary markets, stock photo agencies and decor photography, are discussed in detail in Chapter 12. Stock agencies aren't "markets" in the usual sense; they're middlemen who can market your pictures for you. Decor photography (sometimes called photo decor, or wall decor) involves selling large photos (16x20-inch to wall size) that can be used as wall art in homes, businesses, and public buildings.

Both the agency and decor areas offer sales opportunities to the photo illustrator and can be important to your operation, but just how important may be different from what you initially assume. Agency sales can be successful when you place the right categories of pictures in the right agencies (not necessarily the most prestigious), and this takes some homework. Likewise, the decor route has its assets and its liabilities. Chapter 12 gives you the know-how to approach agencies and decor photography with a chance for elation rather than frustration.

Now to the prime markets for the photo illustrator, magazines and books (see Tables 1-1 and 1-2).

Magazines

You can determine the photo budget range of a magazine by asking yourself this question: "Whose dollars support the magazine?" If the magazine runs on advertising support, the photography budget is usually high. In the case of an industry magazine, if a company underwrites it, the photography budget is also usually high. The photo budget is in the middle range if an organization or association supports the magazine, or if subscriptions alone support it. Many magazines operate with a combination of advertising and subscription revenue, making for healthy photo budgets. Magazines with no advertising, subscription, or industry/association support can be expected to have low photography budgets. In Chapter 3, I'll show you how to be selective in choosing your magazine markets.

Budget, of course, should not be the sole factor you use in determining what markets to work with. Often it's actually easier to sell ten pictures at $75 each to a medium-budget publication than one picture at $750 to one of the top-paying magazines. You can use the budget question to

Magazine Markets			
Category	**Description**	**How they use photographs**	**Examples**
Special interest (avocation)	Focus on a specific subject area, aimed at a specific target audience such as travelers or amateur athletes who are either activists or armchair enthusiasts. Sold at newsstands, by subscription, or free. Advertising-supported. Good markets when they match your PMS. Pay is excellent.	To illustrate articles, how-to features, photo essays, covers; to establish a mood.	*Organic Gardening* *Happy Wanderer* *Ski Canada Magazine* *Official Karate* *Hot Rod Magazine* *Elementary Electronics* *Horse and Horseman* *Diver Magazine* *Popular Photography* *Writer's Digest*
Trade (vocation)	Address a specific professional audience, such as farmers, electricians, computer programmers, pilots, wholesalers. Not sold at newsstands. Advertising-supported. If your PMS includes technical knowledge, this will be a rewarding market. Pay is excellent.	To illustrate technical articles, how-to features, covers, photo essays, and industry news.	*Industrial Photography* *Magazine Age* *The Ohio Farmer* *Wings* *Solar Age Magazine* *Weeds, Trees, and Turf*
Business	Industry-produced (internal and external) as a medium to reach both employees and the general public. Not sold at newsstands. Usually free. Editors expect a solid knowledge of their field of interest. Pay is excellent.	To illustrate articles, covers, photo essays, industry trends; to establish a mood.	*Ford Times* (Ford Motor Co.) *Aramco World* (Middle East oil industry) *Friends* (Chevrolet) *Inland* (Inland Steel Co.)
Denominational	Numerous denominational magazines, newspapers, bulletins, and curriculum	To illustrate articles, photo essays, news	*Lutheran Standard* *U.S. Catholic*

Table 1-1. *Magazine markets.*

	materials on a wide variety of topics. Distributed by subscription or given away free to membership. Pay is medium to low but volume purchasing is high.	items, photo stories, covers; to establish a mood.	*Marriage and Family Living* *Living With Children* *Youth Magazine*
Associations, organizations	Published for members of organizations and clubs. News and events, plus general-interest articles. Not sold at newsstands. By subscription. Supported sometimes by dues and by advertising. Audience is usually specialized. Pay is mediocre.	To illustrate articles, covers, news items, photo essays; to establish a mood.	*Elks Magazine* *Kiwanis Magazine* *National 4-H News* *Scouting Magazine* *The Rotarian*
Local	Audience is usually a local metropolitan area. Feature stories, articles, and pix of local interest. Advertising-supported. Subscription, newsstand. Pay is low, but exposure is valuable.	To illustrate articles, covers, news items, photo stories; to establish a mood.	*Chicago* *Charlotte Magazine* *Phoenix Living* *Westchester Magazine* *Los Angeles Magazine* Sunday newspaper magazine sections
State and regional	Audience is statewide or encompasses several states. Feature stories, articles, and pictures of regional interest. Sold at newsstands and by subscription. Pay is usually low, but volume makes up for it.	To illustrate articles, covers, news items, photo stories and essays; to establish a mood.	*Rhode Islander Magazine* *South Carolina Magazine* *Northwest Magazine* *Arizona Highways* *Sunset Magazines* *Minnesota Sportsman*

Table 1-1. *(cont.)*

News services	Timely features and news pictures produced by staff, stringers, and freelancers. They can use pictures of your area. Pay is low.	To illustrate articles, news items, covers; to establish a mood.	Enterprise Science Service Black Press Service King Features Syndicate	
General newsstand	General, national interest, and large circulation (see Appendix A). These magazines are supported by advertising and subscription and appeal to a broad segment of the population (e.g. women, sports enthusiasts, etc.). These are third-choice markets for the photo illustrator because they assign most of their photo needs to staff photographers, well-known veteran service photographers, or stock agencies.		*Redbook* *Good Housekeeping* *Geo* *People* *National Geographic* *Sports Illustrated*	

Book Markets				Rating in terms of numbers of photo illustrations purchased
Category	**Description**	**How they use photographs**	**Examples**	
Encyclopedias and dictionaries	Multivolume and single volume. Some contain a broad range of information, others cover specific topics such as medicine, woodworking. Foreign-language editions. Children's versions.	To illustrate articles, section heads, updates, revisions, supplements.	*Britannica* *Compton's World Book* *Handyman's Van Nostrand's Scientific* *The Illustrated Computer Dictionary* *Science Dictionary of the Plant World*	C

Table 1-1 (cont.); and *Table 1-2. Book Markets.*

Textbooks	Textbooks range from brief paperbacks to multivolume hardcover series. Used in schools, associations, churches, business. All subjects (e.g. biology, math, history, special ed). Foreign-language editions.	To illustrate chapter heads, covers, technical articles, revisions, supplements; to establish moods.	Ginn Scott, Foresman Follett Silver Burdett	A
Church curriculum	Sunday school course books, Bible study materials, adult education, confirmation texts, family living and inspirational books.	To illustrate articles, chapter heads, updates, photo essays; to establish moods.	United Methodist Church American Baptist Church American Lutheran Church	B
Consumer trade	Sold in bookstores, supermarkets, by mail order, and through book clubs. Range from coffee table books to bestsellers to vest-pocket references. General and specialized hardcover and paperback. Specialized subject areas range from photographic to popular science to poetry.	To illustrate chapters, jackets, covers; chapter heads, section heads; "how-to" photo essays, updates.	*The American Wilderness* *The Entrepreneurial Woman* *How to Buy a Condominium* *Great Trails of the West* *American Wild-Flowers* *Photography and the Art of Seeing*	D

Table 1-2. (cont.)

good advantage, though, in determining how healthy a magazine is, and thus how stable a market it might be for you. Chapter 8 will show you how to determine the photo budget and the price you should ask for your photos.

Books

Approximately 40,000 books are published in this country every year. Books are produced by publishers who orchestrate the complete package: assigning manuscripts, editing, graphics, printing, promotion, and distribution. When you deal with a book publisher, ask these questions: "How well known is the publishing company?" "How long have they been in business?" "How wide is the market appeal of the book in question?" The photography budget is usually high if the book has a broad potential audience and the publishing company is well established. Fledgling book publishers, small presses, and limited-audience publishers rarely pay high fees. Again, however, this is primarily to orient yourself—I am not suggesting your targets should be only the high-paying markets. Selling a small publisher one hundred pictures at a bulk rate of $25 each makes good sense. In Chapter 3 I'll show you how to find your target book markets; Chapters 7 and 11 will tell you more about sales to book publishers.

You Supply the Pictures—They'll Supply the Checks

The prime markets pay photo illustrators millions of dollars a year to get the pictures they need. Sounds promising for the photographer, and it is, but wait—the key word above is *need*.

Whether you plan on grossing $50 or $50,000 in sales each year with your photography, don't ever forget that photo buyers purchase only pictures they *need*, not pictures they like. If you supply the *right* pictures to them, they'll buy. I've heard hundreds of photographers over the years complain that their pictures weren't selling. When I examined their selling techniques, it was easy to see why: They were putting excellent photographs in front of the wrong buyers. A photo buyer may think your pictures are beautiful, but he won't purchase them unless they fit his specific requirements. A photo editor is like any other consumer: If he thinks he *needs* it, he'll buy it. Chapters 2 and 3 will show you how to determine what his needs are and how to fill them.

Will your models cooperate with you? The boys in the picture above were happy to drive their bikes in a figure 8 between two telephone poles I designated.

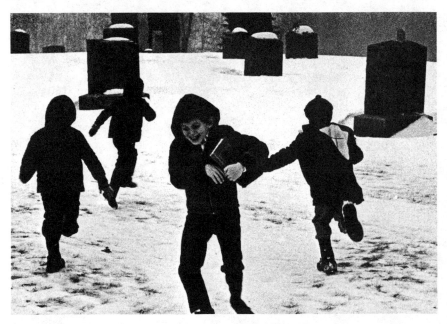

The Family of Children featured this picture. I started with two scenes: children playing a game, and a cemetery in winter. Put the two together and you have a new picture.

2.
What Pictures Sell and Resell?

The Difference between a Good Picture and a Good Marketable Picture

What kind of picture can you be sure will sell for you—consistently? And what kind of picture will disappoint you—consistently?

You may be surprised at the answers to these two questions. The heart of the matter is that one type is a "good picture," and the other is a "good *marketable* picture." The surprising part is that "good pictures" seem like they ought to be marketable—because we see them everywhere, looking at us from billboards, magazine covers, brochures, advertisements, greeting cards. These "good pictures" are the lovely scenics, the beautiful flower close-ups, the sunsets and dramatic silhouettes—those excellent Kodak-ad shots and contest winners. These photos could also be called "standard excellent pictures."

"But why do they consistently ring up 'no sale' when I try to market them?" you ask. Because the ad agencies, graphic design studios, and top magazines who use these standard excellent shots don't *need* them; 99 percent of the time these photo buyers have hundreds, indeed thousands, of these beauties at their fingertips—in inventory, at their favorite stock photo agencies, or available from their list of service photographers they've long worked with and know are reliable. Ninety-nine percent of the pictures you see published in national magazines or on calendars, brochures, posters, are obtained from one of those two sources: stock photo agencies or top established pros.

The established pro usually has a better supply of standard excellent

pictures than the average photographer or serious amateur, even though the latter may have been photographing for years. Pros have work schedules and assignments that afford them hundreds of opportunities to supplement their stock files. Out-of-the-way locations, locations that are timely or exotic, which would cost you a great deal in travel and operations expense, the pros can shoot more easily and less expensively because an assignment already has them in a promising location, and they can piggyback such photos on their original assignment.

And buyers of these photos don't turn to a photographer who's unknown to them and has no track record when they want a "good picture."

The best place for your standard excellent photos, then, is in a stock agency. This too is a form of sweepstakes marketing. But chances are that, even amid the tough competition in the agencies, you'll realize a sale now and then as a nice tributary to the main river of your sales.

Have I discouraged you? If you have an unquenchable desire to make this category of stock photography your career, by all means persevere and aim to join the small group of top pros. But if you feel you've been spinning your wheels and getting frustrated in your photo-marketing efforts, this chapter is going to be worth the price of this book to you many times over, because it will blueprint for you the kinds of pictures you *can* start selling—today.

Good Marketable Pictures

What, then, are the good *marketable* pictures that will be the mainstay of your photo-marketing success? These pictures are the consistent marketing bets—the photos you can count on to be dependable sellers. These photos have buyers with ample purchasing budgets eager to purchase them, right away and over and over.

These good *marketable* pictures are the ones photo buyers *need*. Let the pictures in the magazines and informational books in your local library be your guide. These editorial (nonadvertising, or noncommercial) pictures show ordinary people laughing, thinking, enjoying, crying, helping each other, working, building things or tearing them down, playing, sharing. The world moves on and on, and our books and magazines are our chronicle. Around 20,000 such photo illustrations are published every day; more than 140,000 every week. They are pictures of all the things people do, at all ages and in all stations of life. These pictures are often in black-and-white, and they're what editors need constantly. These are good *marketable* photo illustrations—your "bestsellers."

To clarify the difference in your chances of selling these good *marketable* pictures compared with standard excellent pictures, consider the Boston Marathon. Out of hundreds and hundreds of dedicated runners, there's only one winner. The trophy goes to the pro who practices day in

and day out, who makes running a full-time occupation. Anyone can get lucky, so I can't deny that you might win the Boston Marathon—that is, you might score with one of your standard excellent pictures in a national magazine. But the odds weigh heavily against you.

The first step, then, toward consistent success in marketing your photographs is to get out of the Marathon and start running your own race. The Marathon is crowded with fine photographers, all of them shooting pictures that everyone else is shooting. Newcomers usually enter the photo-marketing Marathon because of an erroneous concept of what photo buyers want (need), thus an erroneous concept of what they, as photographers, should supply them with.

I once asked a photo buyer, "Why do newcomers always submit 'standard excellent pictures,' instead of on-target, marketable pictures?" His answer: "I think the photography industry itself is partly at fault. Their multimillion-dollar instructional materials, their ads, their slide programs are always aimed at how to take the good picture. Photographers believe they have reached professional status if they can duplicate that kind of picture."

Well-meaning advice from professional photographers themselves sometimes adds to this misconception. In their books, seminars, or conversations, successful photographers tend to forget how many years of dues-paying they went through before they could sell good pictures consistently. Successful people in any field—medicine, theater, professional sports, photography—often hand out advice based on the opportunities open to them at their current status. They fail to put themselves in the shoes of the newcomer who has yet to establish a track record.

In running your own race, you'll be up against competition, too, but it's manageable competition. As you'll discover in Chapter 3, you'll be targeting your pictures to specific markets and taking good marketable pictures built around your particular mix of interests, access, and expertise.

The Rohn Engh Formula
for Producing a Marketable Picture Every Time

The secret to producing good marketable photo illustrations can be discovered in the markets themselves—the books, magazines, periodicals, brochures, and other materials that are produced every day by the publishing industry.

Use this test: Tear pages of photographs from magazines, periodicals, booklets, etc., and spread them out on your living room floor. Now place copies of your own black-and-whites or color prints* on the floor, or

*Note: Transparencies (slides) are generally used for publication. Only 10 percent of the publishing industry accepts color prints for publication.

project your color slides. Do you see a disparity in content and appearance between the published photos and your own? If so, how could you improve your pictures? Do a self-critique. If your pictures blend in, matching the quality of the published photos, you'll be leaps ahead of the competition.

Next, give yourself a quick course in how to take marketable illustrations: Select any of the published photo illustrations, and then go out and take photographs as similar to them as you can set up, using a Polaroid camera to give yourself fast, on-the-spot checks on how you can improve your picture quality.

Am I suggesting that you copy someone else's work? Yes, and if they will admit it, pros will tell you that's how *they* originally learned many of the nuances of good photography. But the word *copy* is a no-no in the creative world. Purists place undue derogatory emphasis on the word *copy*, which is their loss. If, because of conditioning, the word *copy* doesn't go down well for you, try *duplicate*.

When you check the content and style of published photo illustrations, you'll find they consistently feature a reasonably close-up view and a bold, posterlike design.

Photo illustrations *illustrate*. A medium or close-up view works best. The viewer wants to see what's going on, which requires a close look. The viewer shouldn't have to study the picture to perceive what it's trying to say. Bring the main subject or person in close. Most newcomers to photo illustration improve their pictures 100 percent when they move in to their subject for a tighter composition.

Magazine covers are good examples of photo illustrations. Like the background, the composition of your pictures should be simple and uncluttered. Strive for a clean and posterlike design, a picture that conveys its reason for being at one glance.

The Formula

This four-step formula is guaranteed to produce marketable photo illustrations every time.

$$P = B + P + S + I$$

PICTURE equals BACKGROUND plus PERSON(S) plus SYMBOL plus INVOLVEMENT.

Most of the successful photo illustrations you come across in your research will contain these elements. There are always exceptions to the rule, and we'll go into some of those after we explore the formula in detail.

Step 1: Background. Choose it wisely. Too often a photographer doesn't fully notice the background until he sees his developed pictures.

The background you choose can often make the difference between a sale and no sale. For example, if you are picturing a pilot, don't just snap a picture by a corner of the hangar that could be any building. Search the airport area for a background that says *aviation*. An office shot could include a desk or typewriter to set the scene. Or a stock brokerage could show a board flashing prices in the background.

These background clues should be noticeable, but not obtrusive, and the picture should not be cluttered with other objects. The background is crucial to how successfully your picture makes a single statement. Your illustration is more dramatic and more marketable if it expresses a single idea—and does it with economy. As you plan your illustration, ask yourself, "What can I eliminate in this composition—and still retain my central theme?"

Your central theme doesn't always have to be describable in words; it can be a mood you wish to convey—a feeling that, if expressed with simplicity, actually lends itself to a variety of interpretations by different viewers. By eliminating unnecessary distractions, you guide the viewer to a strong response to your photograph. A clean, simple background is usually available to you. Remember, you have 360 degrees to work with. Maneuver your camera position until the background is uncluttered.

Employ your knowledge of design, color, composition, and chiaroscuro (the play of darks against lights and vice versa). If the pilot is wearing a light uniform, shift your camera angle to include a dark mass behind him for contrast. If he is wearing a dark uniform, choose a light background. This technique will give your photo illustrations a three-dimensional quality.

Think "cover." Leave space near the top of your composition for a logo. Editors complain to us here at the *Photoletter* that most pictures are submitted in a horizontal format. A vertical format lends itself best to book and magazine covers, and many page layouts.

Step 2. Person(s). Now that you have a suitable background, maneuver yourself or your models* (in some cases, *you'll* have to do the maneuvering because the models won't or can't move for you) so that background and models are in the most effective juxtaposition. The models themselves must be interesting-looking and/or appealing. Choose them, when possible, with an eye to their photogenics.

If your picture will be used for commercial purposes—such as advertising, promotion, endorsement—you will want a model release (signed consent to be photographed) from your models. For pictures that will be used for editorial purposes—such as in textbooks, magazines, ency-

*Model = any person in your picture. Neighbors, relatives, politicians, celebrities, school-teachers, lifeguards, policewomen, groups of children at a playground, groups of adults at a town meeting—all are defined in our terms as models. I'm not talking about professional models.

clopedias, newspapers—a model release in most cases is *not* necessary. (See Chapters 6 and 15 for more on models and model releases.)

Your photos are illustrations, not posed portraits, so the people in them must be engrossed in doing or observing something. We are all people watchers, and photo illustrations are always more interesting when the people in them are genuinely involved in some activity.

Remember: You are *making* a picture, not *taking* one. The only thing you should take is your time.

Step 3. Symbol. In photo illustration anything that brings a certain idea to mind is a symbol. Symbols are everywhere in our visually oriented world. Symbols are used effectively as logos or trademarks in business. In a photo illustration they can be anything from a fishing pole to a tractor to a stethoscope. In the case of the pilot, his uniform, his cap, an airplane, a propeller, a wind sock, are all symbols. Including an appropriate symbol will make your illustration more effective. Use your object symbols as you would a road sign—to tell your viewers where you are. However, be careful that your symbol is not so large or obvious that it overpowers the rest of your photo. Symbols are most effective when they are used subtly. Avoid the temptation to use such mundane symbols as a pitchfork for a farmer, a sombrero for a Mexican musician, or a net for an Italian fisherman. The goal is to clue in your viewer to what is going on, but not knock him over the head with it. Let him experience some discovery as he looks at your picture. Next time you are perusing pictures in a magazine or book, watch for the "road signs" and note how and how often symbols are used in photo illustrations.

Step 4. Involvement. The people in your picture should be the *subject* of the picture (showing enjoyment, unhappiness, fear, etc.); or they should be interacting, helping each other, working with something, playing with something, etc.; or they should be absorbed in watching or contemplating some object, scene, or activity. Marketable photo illustrations have an involvement, a dynamism, about them that's distinct from the portrait or scenic quality of "standard excellent pictures."

Using the Formula

The formula, like a recipe, gives you the necessary ingredients. As with all recipes, that's just a starter. There can be variations, and final results are in the hands of the chef.

Illustrations 2-1 through 2-8 show the formula at work. In this first picture (Illustration 2-1), the formula is used to suggest a story. When I took this photograph I was driving a back road in West Virginia. The dilapidated shed, the lighting on the Appalachian foothills, the shadows, the lonely road—all seemed to say "rural poverty." I asked my traveling companion to walk along the road and hang his head down. For the symbol I gave him a suitcase. It introduces an element of in-

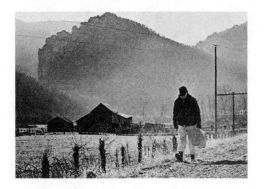

Illustration 2-1.

volvement and spurs the viewer to think—to feel that the man is leaving home or is returning. Either interpretation gives rise to feelings about the photograph and its subject, with resultant interest. This picture was taken in the '60s, and is no longer in my contemporary file. Yet I have sold it twice in the last year from my historical file.

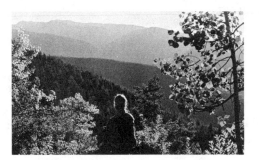

Illustration 2-2.

The formula *can* work when some of the elements are missing. In this mountain scene (Illustration 2-2), symbol and involvement, per se, are lacking. Yet the picture is still successful because, in this case, the background doubles as the symbol. The background is a panorama the person is obviously involved in, enraptured by, as she sits quietly as part of the stillness of the scene. Without the person, the photo would have failed as a marketable picture. The photo moves from the "standard excellent scenic" category to the "good marketable" category because of the predominant position and emphasis (with backlighting) given to the person. The picture says *involvement* or *contemplation,* in contrast to pictures that say *pretty scene,* with a person placed in the photo as a minor element for orientation.

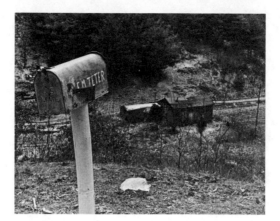

Illustration 2-3.

Again, a variation on the formula that nevertheless works as a marketable photo illustration. In this case the person is missing. In most cases photo illustrations need people, but as in this instance, not always. The symbol here is the mailbox; involvement is with the modest cabin in the background, achieved by the juxtaposition of the two. The picture gives the desired feeling of poverty and isolation, heightened by the fact of the arduous climb to reach the mailbox, the link to the rest of society. As long as a picture without people *implies* people, as this one does, you come out with a marketable photo illustration (Illustration 2-3).

In Illustration 2-4, I wanted to use the light poles disappearing into the foggy morning to create a mood, and I knew my picture would be more salable if it had people in it. But people can *detract* from the feeling of a

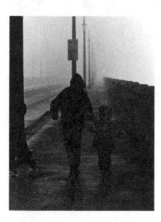

Illustration 2-4.

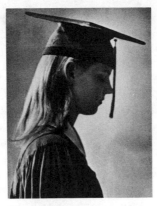

Illustration 2-5.

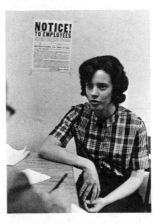

Illustration 2-6.

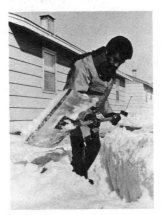

Illustration 2-7.

picture if they're just stuck into the composition. Having the older boy take the younger by the hand as they headed down their path along the lampposts added the right touch of naturalness and involvement. This picture has sold seventeen times so far.

Rather than overstate, let simplicity transmit the mood you wish to convey. In Illustration 2-5, the contemplation of the soon-to-be graduate is captured in profile, almost in cameo, against the smooth expanse of the wall in a school hallway. In this case, the background was purposely clean to focus attention on the symbol—the graduation cap and tassel. The person is "involved" with the symbol by its effect on her demeanor, causing her to be in deep reflection.

Symbols can help you underscore what your photograph is attempting to portray. On location where you are photographing, you will often find such symbols as flags, plaques, maps, and posters. Once you position your model for lighting, nondistracting background, etc., you can add dimension to your photograph by placing appropriate symbols into the background. Without the visual aid of the sign in Illustration 2-6, this photograph would be explained only by a caption. The sign on the wall authentically orients the viewer to the girl's job interview.

Involvement in your photo illustrations sometimes means actual work for your models. Why is Illustration 2-7 successful?

B = Background is uncluttered and lends itself to story line.

P = Person is included in composition.

S = Symbol (shovel) in background serves to emphasize activity.

I = Involvement is real.

Photo illustration moods can be manufactured by coming in the back door. While doing a story at a university, I was struck by the starkness of an examination room. The folding chairs, lined up in sterile rows, symbolized the loneliness and isolation that students can experience at a large university. I asked a young man who was accompanying me to sit in one of the chairs in the middle of my composition and to lean forward and look at his shoes. The picture (page 92) gets the idea across, and he was spared the self-consciousness or awkwardness of having to come up with a facial expression for the mood I wanted to portray.

The Missing Link

Meaningful pictures happen when you take an active hand in your composition. A snowy birdhouse hanging from a frosty limb on a December morning is picturesque. But when you add a young mother and her little boy (the people), a new dimension is created. The birdhouse (the symbol) becomes the object of their focus. For this photograph (Illustration 2-8) you may have supposed the photographer snapped a picture of a young mother and son who happened upon a snow-covered birdhouse. The process was actually in reverse. I happened upon the birdhouse, and then sought out my models as an interesting contrast to

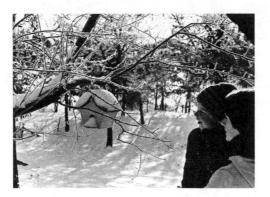

Illustration 2-8.

1. Background distracting or inappropriate (Illustration 2-9).
2. People missing (Illustration 2-10).
3. Symbol missing (Illustration 2-11).
4. No involvement with symbol (Illustration 2-12).

Illustration 2-9.

Illustration 2-10.

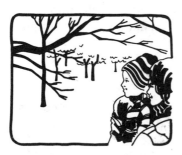

Illustration 2-11.

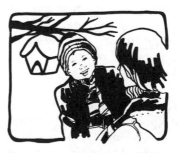

Illustration 2-12.

the stark frozen beauty. Try to think of your photography in these terms—in reverse. Find your background first, then the other elements: people, symbol, involvement. The result will be more marketable photo illustrations.

Illustrations 2-9 through 2-12 show how, with the elements in slightly different alignment, or with one or another formula element missing, Illustration 2-8 wouldn't make it as a good marketable picture.

On Target and Off Target

Illustrations 2-13 through 2-22 were taken by photography students. They are close to being good marketable pictures, and some are better than others, but they all need alterations to make the grade.

You Are an Important Resource to Editors

This, then, is what photo illustration is all about. These are the kind of good marketable pictures that allow you to run your own race.

To restate the problem with standard excellent shots: While you might hit a calendar or cover with one of these now and then, to depend on this type of shot for consistent sales is a mistake. Every buyer has hundreds of this kind of shot in inventory. Or he gets buried in them if he puts out a request for them.

For every one of those "good pictures" that finally hits, you'll sell hundreds of good *marketable* pictures. One sunset at the beach *might* finally sell for a nice $500, but you won't sell it again for three years or five years. Meanwhile, one picture of a boy chasing a bubble will sell scores of times—and bring more return in the long run. The latter is a good marketable photo illustration. And you'll have twenty, thirty, forty more of these, selling at the same pace, for every sunset in your supply.

Don't rely on wishful thinking. A few stock photographers do get lucky. But by and large, those who are on top, and who stay there, are those who have recognized the overwhelming odds in the Marathon route and have switched over to what I call "Track B" in the next chapter. There's competition in that race, too, but it's manageable enough to keep you healthily striving for excellence.

Whether you sell and resell your pictures is not up to the photo buyers, but to you, the photographer. You control whether you sell or don't sell—by controlling the content of your pictures.

When you are out on your next photographing excursion, keep two guidelines in mind:

1. Shoot discriminately. Treat each piece of film you expose as a finished product that will one day be on an editor's desk.

2. As you prepare to take a shot, ask yourself, "Is it marketable?" (One photographer I know taped this question to the back of his camera.) I am

not suggesting that you get involved in areas of photography that don't appeal to you. As I explain in the next chapter, you have assets, photographically, that are individual to you. In the course of this book I'll show you how to match your photographic interests with editors who are on the lookout for the kind of pictures you can easily supply. For example, if you live in New Mexico, there's a lot of picture-taking and selling to be done that a person in Michigan can't do. And your geographic advantage over other photographers is only one advantage. You may be into sailing, or raising hunting dogs. You may be an armchair geologist. Your hobbies and interests, and your knowledge of your career field, are assets. Which is why I say to persons new in the field of photo marketing, "You *can* position yourself where the competition is manageable." With your own PMS (personal photographic marketing strengths), which we'll learn to identify in the next chapter, you can be an important resource to editors who are, right now, waiting for your pictures.

Your aim is to sell the greatest number of pictures with the least amount of lost motion (i.e., unsuccessful submissions). Photo marketing is a business. Once you know the difference between a good picture and a good marketable picture, your sales will start to soar.

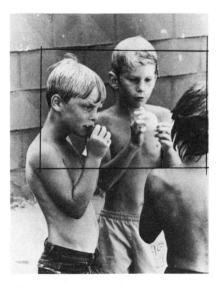

Illustration 2-13. *Move in close. Your audience needs to see what's going on. The photographer wasted half his frame in this case. This picture improves when we eliminate everything but the essentials.*

Illustration 2-14. *The background is clean and uncluttered, the involvement factor is high—but the camera angle is off. We want to see more of the fountain, more facial expression.*

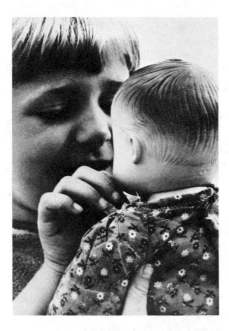 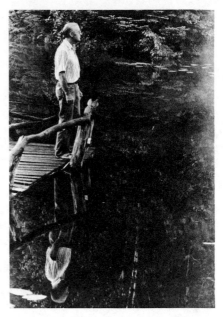

Illustration 2-15. *Again, this picture needs that "right" expression. The idea here is good—but the photographer lost a chance for a good marketable picture by not shooting enough film (shoot ten to one) to have a selection that includes the best expression from the best angle. The lighting on the little girl's face is not flattering, but remember, photo illustration is not portraiture. Your primary aim is to capture expression.*

Illustration 2-16. *This photo illustration expresses a mood or an emotion. It has the potential to be highly marketable because it lends itself to the many themes treated in books and magazines. Expression and position of the model could be improved. The man's nervous hands are incongruous with his contemplative face. On these shots you need to shoot ten or twelve to capture that "just right" expression. Ask the model to continue to move slightly after each exposure. Then choose the "right picture" when you examine your contact sheet.*

 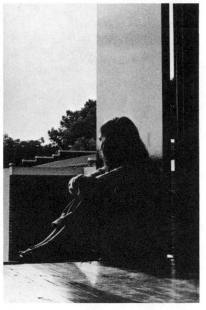

Illustration 2-17. *Photo illustrations that are successful follow the $P = B + P + S + I$ formula. The photographer should have moved to the left or right so as to include a meaningful background. The cup could serve as a symbol, but involvement with the cup (such as pouring coffee into it or drinking from it) would have made the picture more marketable. This picture is a portrait, or a documentary picture, but it is not a good photo illustration.*

Illustration 2-18. *Photo illustrations can leave much to the imagination. This picture is successful because the person's face is not in full view. Thus, it is not a portrait; it conveys a mood. This picture could be used many ways: articles on loneliness, meditation, boy-girl relationships, education. You'll be surprised at the uses photo buyers find for your pictures. The background is relatively uncluttered and nondistracting, which helps to emphasize the center of interest. This photo gets eight points out of ten as a good marketable picture.*

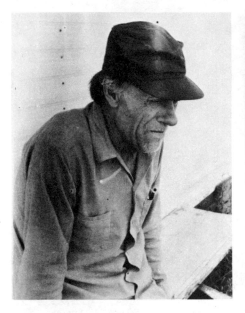 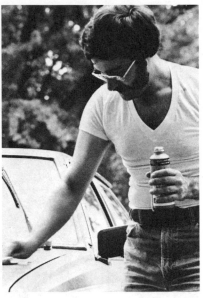

Illustration 2-19. This is a typical standard excellent picture, "The Character Study." (We all have at least ten of these in our files.) This type of photograph is very difficult to market—there are millions of them available to photo buyers because everybody takes these pictures. It's a portrait, with no involvement, no symbol, no dynamism, no action in the photograph. Include any of these, and it becomes a marketable picture.

Illustration 2-20. A slice of life is what photo buyers like to see in your photo illustrations. This could be a good nuts-and-bolts picture, with good marketing potential. But the photographer failed to answer several questions for us: Does the fellow like what he's doing? Does he hate it? Is this task easy? Is it difficult? The picture, because of poor body position, is too static. Again, if the photographer had shot ten to one, she would have gotten at least one frame where the model's expression revealed his feelings about what he's doing.

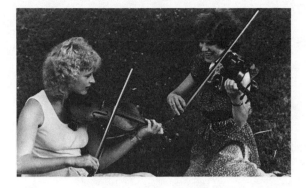

Illustration 2-21. *Use your knowledge of optics and composition to get the best photo illustration out of every situation. Making a three-quarter view out of this one and using a telephoto lens would improve it 100 percent. You are not making a portrait of the two young women, so it is excusable to feature one face more than the other in your composition.*

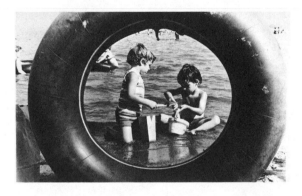

Illustration 2-22. *This picture is marketable, but it borders on being too clever. It's also old hat. Clichés are a fact of life in the photo illustration business—but handle them with care and use them sparingly. On the other hand, don't go to the other extreme and be obscure.*

A GALLERY OF PHOTO ILLUSTRATIONS

Photo illustrations and photo illustrators come from all walks of life. Here is a selection of pictures that have had repeat sales and a glimpse at the people who produced them.

I asked fellow photo illustrators to send me samples of photo illustrations that produce continual revenue for them. All of these photographers have zeroed in on their own PMS and supply their own corner of the market.

"I've been involved with photography for the past fifteen years, mostly as a photojournalist working on assignment for national magazines. My strongest images are of people—a subject I never tire of. I find I'm able to sell and resell these photos to book publishers and magazines through my own mini stock photo agency. This photo is especially popular, as it combines the beautiful facial expression of the little girl with a large open area for publishers to use for type."

Rick Smolan
New York, NY

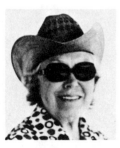

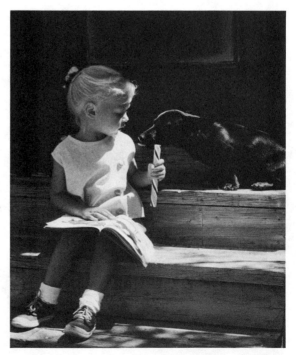

"After several years of freelance writing, I took up photography to illustrate my articles and soon found myself specializing in photos of children, which I market myself, and animals, which I place with an agency. Freelancers don't have to worry about retirement. Now a senior citizen, I am as busy as ever, with most of my time devoted to photo illustration. My pictures have appeared as illustrations and covers for books and magazines, and in newspaper Sunday supplements."

Helen Ellsberg
Alpine, CA

"I've been photographing a dozen years but have only recently moved to the United States. My studies were originally aimed at medicine, but I've decided I want to become a professional photographer. Recently, I've learned how to sell the kind of pictures I love to take. My pictures appear on the covers of youth magazines, and illustrate articles on young people."

Jasper Johal
Berkeley, CA

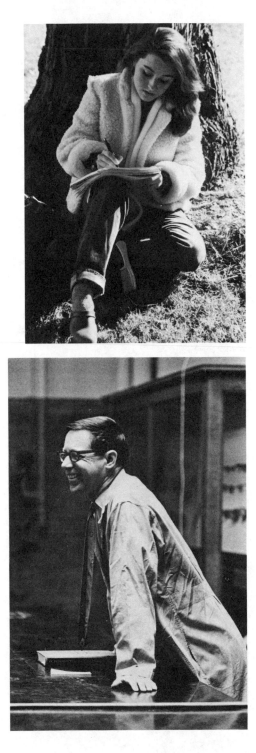

"The high school newspaper and yearbook started me photographing for pay, and during college I added freelance writing. I've been a professional communicator—writer, photographer, audiovisual producer—for fifteen years. I work full-time as an advertising copywriter and moonlight photos and articles, mostly to photography magazines, but ranging from encyclopedias to *Rock* magazine. It's a kick to use photos of my kids, friends, neighbors, and favorite landscapes to illustrate my articles."

Jerome P. O'Neill, Jr.
Rochester, NY

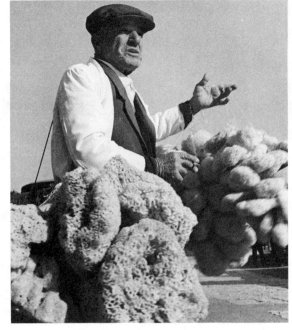

"I got started as a photo illustrator with a sale to a local evening paper while still a schoolboy back in 1948. Most of my photography career has been as a service photographer, but speculative submissions of pictures and photo/text packages are an increasingly important part of my income. I see concentration on writing and stock photography as the next stage of my career. I find that pictures of the people in the countries I visit are my best stock photo sellers, such as this sponge vendor in Athens."

Dennis Mansell
Braintree Essex
England

"I have been a writer for nearly fifteen years—and a photographer for five. The two go well together. I freelance for a local paper that has no full-time photographer. I and my camera are into children, animals, dolls, dollhouses, miniatures, baseball, basketball, and other scenes where I find people interrelating."

JoAnne Kash
Holly Hill, FL

"After twenty years as a service photographer/reporter for a newspaper, I became a full-time freelance photo illustrator nine years ago. I enjoy the freedom from assignments. I offer thousands of good stock photos to magazine and book publishers; my specialty is the human-interest people picture, in basic contexts of home, school, and church."

David S. Strickler
Newville, PA

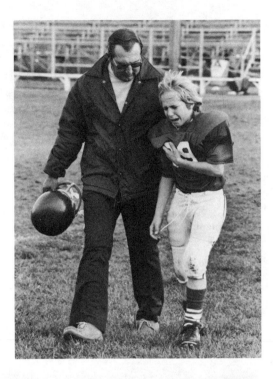

"I'm a synchronized-swimming coach at Ohio State University. My photos have been selling for the past two years to such publications as *Amsport* magazine, Charles Merrill textbooks, and *American Hunter* magazine. I develop my own black-and-white prints and use a photo lab for my transparencies. My photos usually center on the areas of sports and education."

Nancy Hines
Columbus, OH

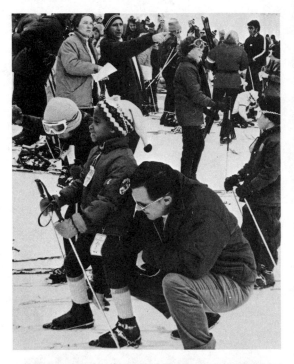

"Although I'm primarily a writer I have also taken pictures for the past twenty years. My work as a part-time photo agent resulted in interviewing many well-known photographers for the book (Freelance Writing: Advice from the Pros), published by Macmillan. Some of my subjects are the outdoors—skiing, mountaineering, and winter sports. I always advise students to learn how to use a camera. Photo illustrations make an article more salable."

Curtis W. Casewit
Denver, CO

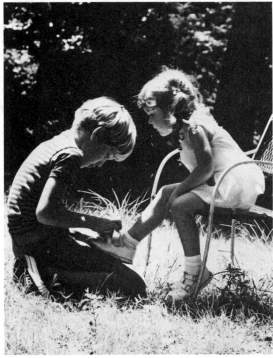

"A freelance photographer for thirty years, my most sold picture is a family of four singing at an upright piano, mother playing. Naturalness and spontaneity seem to be the requisites. Posed pictures are out. This picture has been a very good seller. Today most of my work appears in magazines and textbooks."

Vivienne della Grotta
Carpinteria, CA

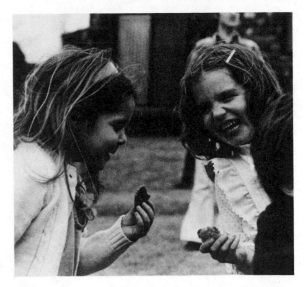

"I've been a service photographer for seventeen years. A couple of years ago I discovered that a lot of material I had shot with 35mm on assignment could be sold as single stock pictures. I had a veritable silver (if not gold) mine in my files. Now I spend my less busy time making the rounds of publishers through the mails. I have found a good market for my pictures of people and kids in all kinds of activities. It doesn't take long to get on a publisher's good side if you keep sending him the kind of pictures he needs."

Jack Hamilton
Milwaukee, WI

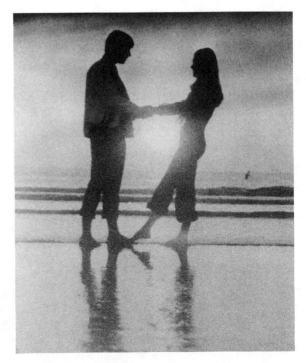

"Although my main income is derived from assignment photography in the field of recreation and leisure-time activities for national advertising accounts, 'stock photography' has always been a very important part of my total income. The most successful photos are those of people doing things. Several of my color photos have enjoyed remarkable sales records. This photo has been sold, by both my agents and myself, over thirty-two times in the last six years."

Burton McNeely
Land O' Lakes, FL

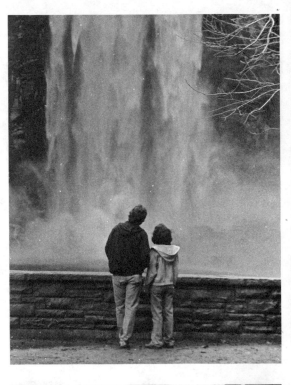

"I have been photographing for fifteen years, and started selling two years ago. Full time, I am a biological research scientist. I started in photo illustration for the extra income, but soon found that I really enjoy it. I specialize in black-and-whites of people interacting. This photo is a good example. I've been marketing it for less than a year, and it has already had multiple sales. I'm also a nature photographer with emphasis on biological subject matter and have placed most of those with an agency."

Peter G. Aitken
Ithaca, NY

"I am a full-time photo illustrator, in my twenty-fifth year of happy work. My pictures are used in magazines, books, posters, greeting cards, and advertising. I often illustrate articles on religion, education, and family relations. I have a writer-friend who often works with me. I have built up a large clientele and am able to sell my inspirational scenics as well as a variety of subjects."

Jini Dellaccio
Gig Harbor, WA

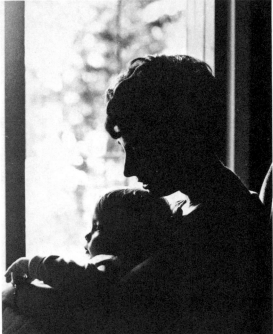

"Besides photography, I also dabble in carpentry, farm work, and other odd jobs, especially if they include travel. Thus my photography covers the gamut of human-interest subjects. Although my favorite area is black-and-white, I enjoy adding to my collection of color transparencies. Over one hundred publishers have used my photos in their magazines and books. This one has sold about twenty times to illustrate themes such as loneliness and adventure."

Robert Maust
Harrisonburg, VA

"In the 1950s my magazine assignments yielded few resalable pictures, but when I began writing and illustrating children's books and books and articles about photography, building a personal stock file became important. This London street, shot in 1973, has sold to numerous publications to illustrate various photographic techniques. Now I shoot for my own use as I travel, as well as for sale through the Heilman File. I'm always thinking of residual possibilities as I take pictures."

Lou Jacobs, Jr.
Studio City, CA 91604

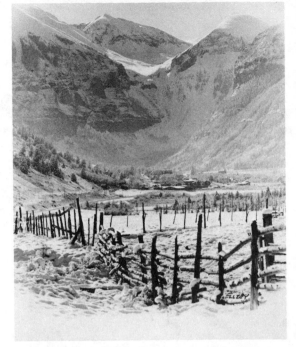

"I frequently work with freelance writers on picture stories. The material can often be rewritten and reslanted for extra mileage. I've been freelancing full-time since 1973. I wear two hats. My work has ranged from portraiture and service photography to editorial, illustrative, and decor photography. This picture is an example of decor photography. I have made a concerted effort to establish myself in this area. My archival black-and-white decor prints have been selling well lately."

Bill Ellzey
Telluride, CO

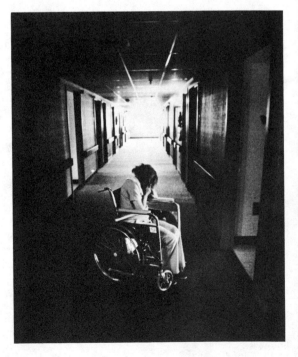

"Many publications have used my photos—mainly of people in all situations—since I began freelancing fifteen years ago. Today I'm the photo-journalism professor at CBN University in Virginia Beach. After hours, while others find excitement watching TV football games, I find mine in making moving graphic images that will sell and resell and in filling the request lists that keep coming in. The rewards are much more than financial."

Bob Combs
Virginia Beach, VA

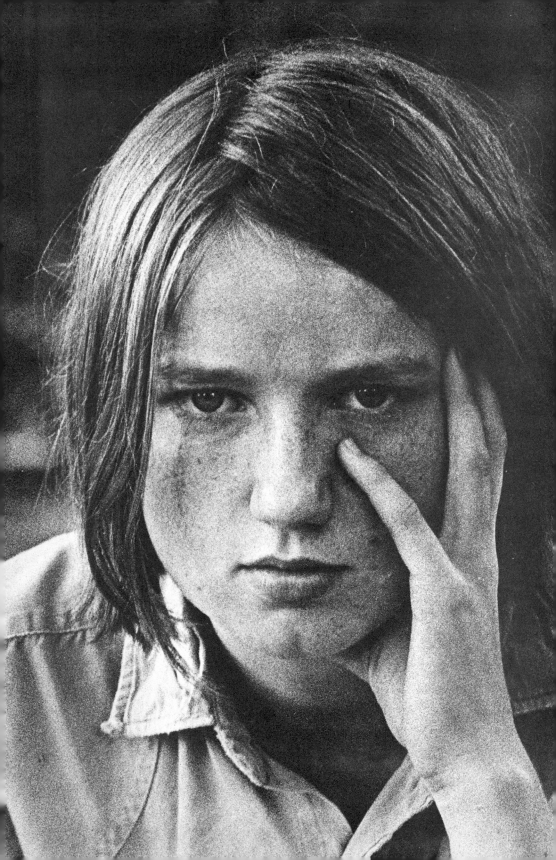

3.
Finding Your Corner of the Market

First, Find Yourself

Who are you? Photographers who are successful in selling their pictures have learned this marketing secret: *Know thyself.* That is, know your photographic strengths and weaknesses before you begin marketing your pictures.

You want to find your corner of the market. But first, you must find out who *you* are, photographically. You can do that by completing the following simple exercise.

Photographically . . . Who Am I?

Save a Sunday afternoon to fill out this section—it will be invaluable in terms of the wheel spinning you'll encounter if you jump into photo marketing without having the information in this chapter.

Take a piece of paper and make two columns like the ones in Figure 3-1. Head the column on the left *Track A,* the column on the right *Track B.* The columns can extend the length of the page or pages, if necessary.

Next, fill in the Track B column with one-line answers (in no special order) to these questions:

1. What is the general subject matter of each of the periodicals you subscribe to, or would like to subscribe to (or receive free)? (For example, if you subscribe to *Today's Pilot* you would write: aviation.) Write something down for each magazine. Do you welcome catalogs in the mail? What's the subject matter? Write it down.

2. What is your occupation? (If you've had several, list each one.) Also include careers you'd like to pursue, or are studying for or working toward.

3. When you are on a photo-taking excursion, what subject matter do you enjoy taking the most? (E.g., rustic buildings, football, celebrities, sunrises, roses, waterfalls, butterflies, fall foliage, children, puppies,

Track A	Track B
scenics	gardening
flowers	electronics
fountains	antique automobiles
insects	grocer
sunsets	teacher
historic sites	scenics
	flowers
	fountains
	insects
	sunsets
	historic sites
	antique automobiles
	snowmobiling
	old barns
	old movies
	Minneapolis
	Wisconsin
	Mississippi River
	St. Croix River
	Interstate Park
	TV cameraman
	dentist

Figure 3-1. *John's track list.*

Siamese cats, hawks, social statements, girls.) Use as many blanks as you wish. The order is unimportant.

4. List your hobbies and pastimes.

5. If you were to examine all of your slides and contact sheets, would you find threads of continuity running through the images? (For example, you might discover that you often photograph horses, train stations, rock formations, physical fitness buffs, minority groups.)

6. What are your favorite armchair interests? For example, if a passing interest is solar energy, astronomy, or ancient warfare, write it down.

7. What is the name of the nearest city over 500,000 population?

8. What state do you live in?

9. List any nearby (within a half-day's drive) geographical features (ocean, mountains, rivers) and human-made interests (iron or coal mine, hot-air-balloon factory, dog-training school).

10. What specialized subject areas do you have ready access to? (For example, if your neighbor is a bridge builder or a ballerina, or a relative is a skydiver, or your friend is an oil rig man, list them.)

If the list in Track B includes the following, *draw a line through them:* landscapes, birds, scenics, insects, plants, wildflowers, major pro sports, silhouettes, experimental photography, artistic subjects (such as the "art" photography in photography magazines), abstracts (such as those seen in photo-art magazines and salons), popular travel spots, monuments, landmarks, historic sites, cute animal pictures. Transfer all of the subjects that you just drew a line through over to Track A.

You'll find your best picture *sales* possibilities in Track B. Track A pictures have weak marketability for you. Most photographers have spent a great deal of their time photographing in the Track A area. Are you surprised to find you have the most pictures in the weak marketing areas, and have few pictures in the strong marketing areas? Most photographers who want to market their pictures never learn their marketing strengths and weaknesses until they have failed at selling their photography. At that point they believe they have failed at photography. There is a difference.

When you get off Track A and onto Track B you'll stop wasting time, film, postage, and materials. You'll get published, you'll receive recognition for your photography, and you'll deposit checks. Let's examine the Track B and Track A of a hypothetical photographer, John, in Figure 3-1.

1. John subscribes to magazines dealing with gardening, electronics, and antique automobiles. Not only do these reflect John's interests, but the combined total for photographs purchased each month for magazines and books in these three areas can exceed $150,000 per month. Yet

most of John's picture-taking energy and dollars have been put into Track A pictures with limited marketing potential.

2. John's occupation is grocer. The trade magazines in this area spend about $20,000 per month for photography. John could easily cover his expenses to the national conventions each year, plus add an extra vacation week at the convention site, with income generated by his camera.

John is a former teacher, and retains his interest in education. His experience gives him the insight and know-how to capture natural photographs of classroom situations. Such photos are big sellers to the education field, denominational press, and textbook industry. Let's make a conservative estimate of the dollars expended each month for education-oriented pictures: $500,000.

3. In his picture-taking excursions John usually concentrates on scenics, flowers, fountains, insects, sunsets, and historic sites. These all have limited marketability for the independent freelancer without a track record with the big agencies and top magazines. However, John could place some of these Track A pictures in stock agencies for periodic supplementary sales. A stock agency that specializes in insects, for example, will be interested in seeing the quality of John's insect pictures. Some of John's other Track A pictures belong in different stock agencies. Chapter 12 tells how to research which agencies are "right" for which pictures on your Track A list.

4. John's favorite hobby is antique cars. He can easily pay for trips to meetings and conventions through judicious study of the market needs for photography in antique cars.

John also lists snowmobiling as a hobby. More than $50,000 a month is expended on photography in publications dealing with winter fun sports in season.

5. John finds that he photographs picturesque old barns every chance he gets. Market is limited (Track A). One day he may produce a book or exhibit of barn pictures, but it will be a labor of love.

6. His armchair interest is old movies. No marketing potential unless placed in a specialized photo agency.

7, 8. Nearest city: Minneapolis. Chapter 11 will explain how to capitalize on your "travel" pictures.

9. The Mississippi and St. Croix rivers are nearby, plus a state park; see Chapter 11.

10. John's neighbor is a TV cameraman. He could get specialized access to television operations and be an important source to editors who need location pictures dealing with the TV industry. John's brother is a dentist, which gives him access to the world of dentistry. Publications in each of these areas spend easily a combined $15,000 per month for pictures.

Your PMS (Personal Photographic Marketing Strengths)

Let's take a closer look at Tracks A and B:

Track A

These are the areas of formidable competition. Track A pictures are used in the marketplace all right, but it's a closed market. Photo editors have tons of these photographs in inventory, or they locate them easily from their favorite top pros, or they contact a stock agency that has thousands upon thousands to select from. If you want to concentrate your efforts in the Track A area of photography, I suggest you stop reading right here, because you'll need to put every minute of your time into making a go of it. Only a handful of freelancers in this country—most of them full-time pros—are successful at making regular sales of Track A photographs, and the majority must still supplement their incomes with writing, consulting, speaking, or teaching.

If you're not planning to concentrate on Track A pictures, but you still want to take them, one solution is to put your Track A shots into a stock photo agency and then not worry about how often they sell for you. Every once in a while you may get a nice surprise check. Chapter 12 shows you how to determine which agencies are for you. A second solution is to turn to producing decor photography (again, see Chapter 12). Keep in mind, though, that you can't expect either of these solutions to result in *regular* sales for you. Decor photography is a labor of love, and stock agency sales are a sometime thing. Practically speaking, your forte and solid opportunity for immediate and consistent sales—in other words, your strong marketability areas—lie on Track B.

Track B

Take time to do a complete job of filling out Track B, and you'll find that you've sketched a picture of who you are photographically. This list is your PMS, your personal photographic marketing strengths. You have vital advantages in these areas. You offer a valuable resource to editors in these specialized subjects. You have access and an informed approach to pictures in these areas that many photographers do not have. Your competition in marketing Track B pictures is manageable. Throughout this book, I'll constantly refer to your PMS, your Track B list. You are already something of an expert in many of these Track B areas, and the subject matter appeals to you. Not all of your interests, of course, lend themselves 100 percent to photography. But you will be surprised how many do. For example, *chess* has spawned few periodicals that require pictures. But pictures of people playing chess have varied applications: *concentration, thinking, competition*—good textbook illustration possibilities—or for educational, sociological, or human-interest magazines.

Photo editors for the Track B markets will encourage you to submit pictures by purchasing more and more of your shots. Gradually you'll receive higher fees—and eventually assignments. Your efforts and sales in the nuts-and-bolts areas of Track B can also justify the time you still may wish to give to Track A photos, which actually *cost* you money to try to market.

Throughout this book when I refer to *you*, the photographer, I mean for you to adapt what I'm saying to *your* particular photographic strengths and approaches. Refer again to the photographic picture of yourself you've outlined on Track B. When I say *you*, I won't mean *me*, or any other reader of this book. Another photographer would fill out this chart differently. He would also be an important resource to an editor or editors, but rarely would the two of you be in competition for the attention of the same editors. Your task will be to find your own mix of markets, based on the areas you like and know best, and then hit those markets with pictures they *need*.

This approach eliminates the drudgery associated with the admonition we often read in books and hear at lectures: "Study the markets."

When I first began marketing my photographs, I also heard "Study the markets!" I've always associated the word *study* with tedium. I found it unnecessary to study the markets. The only studying I needed was to study *myself*—and then develop my personal photographic marketing strengths. If I listed the market in my PMS, I was already a mini-expert on the subject. If it wasn't in my PMS, I had no business either studying it or photographing it.

The Majors and the Minors

Do you know any successful photographers? *Success* eludes concrete definition. We all know that it is irrelevant to judge people's success by their net worth, or where they live, or the fame they have attained. When I refer to *success* in this book, interpret it not in terms of some stereotyped level of achievement, but in terms of the goals that are meaningful to *you*.

The major markets for your photography may not necessarily be the major markets for the photographer next door. Your neighbor's major markets may be your minor markets.

Will you have to change your lifestyle or your photography to apply the marketing principles in this book? Not at all. And breaking in won't put a dent in your pocketbook. Your major markets need not be in New York. They might be in your backyard.

The length of your Track B list will give you a good idea of the breadth of the market potential for your photography. Some photographers thrive in a very limited marketplace. Others find it necessary, because of the nature of their photographic interests, to seek out many markets. In my own case, I have six file drawers filled with correspondence with 635

publishing houses or photo-buying contacts developed over a period of twenty years. The files, like the publishing world, stay in a state of flux. Markets change focus, they fold, new markets appear, and personnel turnovers occur. (At the same time, many markets stay stable and dependable through the years.) I deal with about a third of the total number in my files on a regular basis. Yet I know of photographers who confine their photo-marketing contacts to only a couple dozen.

How to Use the Reference Guides and Directories

Once you know your photographic strengths, you'll find your corner of the market more easily. Several excellent market guides exist that will point you in the right direction. Keep in mind that directories, even a telephone directory, because of publishing lead time, are up to one year older than the date on the cover. Use your directories to give you a general idea of potential markets for your photographic strengths. For specific names, titles, and updated addresses and phone numbers, keep your directories current yourself by penciling in personnel changes whenever you learn them through your correspondence, phone calls, or newsletter reading.

Treat your directories like tools, not fragile glassware. Keep them handy, scribble in them, paste in them, add pages, or tear others out. Your directories are a critical resource for moving forward in your photo marketing.

Table 3-1 tells you the names and addresses of published directories. Most of these you'll find at any large metropolitan library, and many of them are stocked by your local community or branch library.

Which directories are best for you? You'll find out by matching the subject categories in your Track B list with the market categories covered by the different directories.

Using Your Local Interlibrary Loan Service

Some directories may be too expensive for you. They may also be too expensive for your community or branch library. Ask the librarian to borrow the directory through the interlibrary loan service (or its equivalent in your area). If the book is not available at a regional library, the service will locate it at the state level. It generally takes two weeks to locate a book. Since the books you order will be reference manuals, your library will probably ask that you use them in the library. However, you can photocopy the pages you'll need, thanks to the *fair use* doctrine of the U.S. Copyright Law.

Chart Your Course . . . Build a Personalized Market List

Now that you have defined your photographic strengths and focused in on your accessible subject areas, you are ready to chart your market course.

Advertising Art Buyers of America
G.P.O. Box 1491
New York, NY 10001

American Book Trade Directory
R. R. Bowker
1180 Avenue of the Americas
New York, NY 10036

American Hospital Association Directory
840 N. Lake Shore Dr.
Chicago, IL 60611

American Society of Journalists and Authors
Directory of Professional Writers
1501 Broadway, Suite 1907
New York, NY 10036

American Society of Picture Professionals Directory
Box 5283 Grand Central Station
New York, NY 10017

American Universities and Colleges
American Council on Education
1 Dupont Circle
Washington, D.C. 20036

Association for Educational Communication and Technology Directory
1126 Sixteenth St., N.W.
Washington, D.C. 20036

Audiovisual Market Place
R. R. Bowker
1180 Avenue of the Americas
New York, NY 10036

Ayer Directory of Publications
Ayer Press
1 Bala Ave.
Bala Cynwyd, PA 19004

The Bowker Annual of Library and Book Trade/Information
R. R. Bowker
1180 Avenue of the Americas
New York, NY 10036

Business Publication Rates and Data
Standard Rate & Data Service
5201 Old Orchard Rd.
Skokie, IL 60077

Canadian Almanac and Directory
Richard De Boo Ltd.
70 Richmond St.
East Toronto, Ontario M5G 2M8

Consumer Magazine and Farm Publication Rates and Data
Standard Rate & Data Service
5201 Old Orchard Rd.
Skokie, IL 60077

Contact Book for the Entertainment Industry
Celebrity Service, Inc.
171 W. Fifth-seventh St.
New York, NY 10019

The Creative Directory of the Sun Belt
Ampersand Incorporated
1103 S. Shepard Dr.
Houston, TX 77019

Decor Sources Annual
Commerce Publishing Co.
408 Olive Ave.
St. Louis, MO 63102

Directory of Small Magazine Press Editors and Publishers
Dustbooks
Box 1056
Paradise, CA 95969

Directory of West Coast Book Publishers
Creative Options
Box 601
Edmonds, WA 98020

Educational Marketer Yellow Pages
Knowledge Industry Publications
2 Corporate Park Dr.
White Plains, NY 10604

Education Directory: Colleges and Universities
(Stock No. 017-080-02011-4)
National Center for Education Statistics
United States Department of Education
Superintendent of Documents
U.S. Government Printing Office
Publications Department
Washington, DC 20402

Encyclopedia of Associations
Gale Research Co.
Book Tower
Detroit, MI 48226

Gebbie Press All-In-One Directory
Box 1000
New Paltz, NY 12561

Gift and Decorative Accessory Buyer's Directory
Geyer McAllister Publications
51 Madison Ave.
New York, NY 10036

Harfax Directory of Industry Data Sources
Ballinger Publishing Co.
Box 281, 54 Church St.
Cambridge, MA 02138

How to Reach Anyone Who's Anyone
Price, Stern, Sloan
410 N. La Cienega Blvd.
Los Angeles, CA 90048

Interior Design Buyer's Guide
Interior Design Publications
805 Third Ave.
New York, NY 10022

The International Buyer's Guide of the Music-Tape Industry
Billboard Publications
1515 Broadway
New York, NY 10036

Table 3-1. Directories.

The Journal of the Society for Photographic Education Directory Exposure Magazine 111 Stratford Rd. Des Plaines, IL 60016	**Reader's Digest Almanac and Yearbook** Pleasantville, NY 10570	**Working Press of the Nation, Volume V** Internal Publications Directory National Research Bureau 424 N. Third St. Burlington, IA 52601
Literary Market Place R. R. Bowker 1180 Avenue of the Americas New York, NY 10036	**Register of the Public Relations Society of America** 845 Third Ave. New York, NY 10022	**The World Almanac** Newspaper Enterprise Association 200 Park Ave. New York, NY 10017
Madison Avenue Handbook 17 E. Forty-eighth St. New York, NY 10017	**Society of American Travel Writers Directory** 1120 Connecticut Ave. Washington, D.C. 20036	**World Travel Directory** Ziff-Davis Publishing Co. 1 Park Ave., Room 1011 New York, NY 10016
Magazine Industry Market Place R. R. Bowker 1180 Avenue of the Americas New York, NY 10036	**Standard Directory of Advertisers** National Register Publishing Co. 5201 Old Orchard Rd. Skokie, IL 60077	**Writer's and Photographer's Guide** Clarence House Publishers 2115 Van Ness Ave. San Francisco, CA 94109
Magazines For Libraries University of Louisville Press Louisville, KY 40208	**Standard Directory of Advertising Agencies** National Register Publishing Co. 5201 Old Orchard Rd. Skokie, IL 60077	**Writer's and Photographer's Guide to Newspaper Markets** Helm Publishing Box 10512 Evansville, IN 47734
The Mail Order Business Directory Catalog Division B. Klein Publications Box 8503 Coral Springs, FL 33065	**Standard Periodical Directory** Oxbridge Communications 183 Madison Ave., Suite 1108 New York, NY 10016	**A Writer's Guide to Chicago-Area Publishers** Writer's Guide Publications Gabriel House, Inc. 9329 Crawford Ave. Evanston, IL 60203
New York Publicity Outlets Public Relations Plus, Inc. Box 327 Washington Depot, CT 06794	**Stock Photo and Assignment Source Book** R. R. Bowker 1180 Avenue of the Americas New York, NY 10036	**Writer's Guide to West Coast Publishing** Hwong Publishing 10353 Los Alamitos Blvd. Los Alamitos, CA 90720
O'Dwyer's Directory of Corporate Communications J. R. O'Dwyer Co. 271 Madison Ave. New York, NY 10016	**Television Contacts** Larimi Communication, Ltd. 151 Fiftieth St. New York, NY 10022	**Writer's Market** 9933 Alliance Rd. Cincinnati, OH 45242
Patterson's American Education Box 199 Mount Prospect, IL 60056	**Ulrich's International Periodicals Directory** R. R. Bowker 1180 Avenue of the Americas New York, NY 10036	**The Yearbook of American and Canadian Churches** Abingdon Press 201 Eighth Ave., S. Nashville, TN 37202
Photographer's Market 9933 Alliance Rd. Cincinnati, OH 45242	**Where and How to Sell Your Pictures** Amphoto (American Photographic Book Publishing Co.) 1515 Broadway New York, NY 10036	
Photography Market Place R. R. Bowker 1180 Avenue of the Americas New York, NY 10036		

Table 3-1. *(cont.)*

Consult all of the directories available to you and build a list of potential markets for your material by combing through the categories that match your photographic strengths. This might take several evenings of effort, but the investment of time is worth it.

Here at the *Photoletter* we provide a computerized printout of names and addresses of contact persons or photo buyers in every imaginable area. Your homework will result in several similar lists (the number of lists depends on the length of your Track B column).

For example, the list below was taken from a single market directory, *Magazine Industry Market Place*. Although your areas of interest may not include things automotive, take time to read through the list to get a sense of the variety. The same variety of markets is waiting for you in your fields of special interest.

American Motorcyclist
Antique Automobile
Antique Motor News
Auto Merchandising News
Auto Racing Digest
Automobile International
Automobile Quarterly
Automotive Aftermath News
Automotive Age
Automotive Body Repair News
Automotive Design & Development
Automotive Fleet
Automotive Industries
Automotive Messenger
Automotive News
Brake & Front End
Car and Driver
Car Craft
Cars & Parts
Cars Magazine
Choppers/Big Bike
Commercial Car Journal
Consumer Guide
Custom Bike
Cycle Guide

Cycle News
Cycle World
Defense Transportation Journal
Diesel & Gas Turbine Progress
Dirt Bike
4x4's & Off Road Vehicles
Four Wheeler
Heavy Duty Trucking
Hemmings Motor
Hot Rod Magazine
Jobber Topics
Magic Circle
Mechanix Illustrated
Midwest Motorist
Modern Cycle
Montgomery Ward Auto Club News
Motocross Action Magazine
Motor
Off-Road
Old Cars
1001 Truck & Van Ideas
Owner Operator
Parking
Pickup, Van & 4WD

Popular Hot Rodding Magazine
Popular Mechanics
Popular Science
Q-Vo Magazine
Racing Pictorial
Rider
Road & Track
Snow Goer
Special Interest Autos
Stock Car Racing Magazine
Street Chopper
Street Machine
Street Rodder
Sun Magazine
Super Chevy
Super Service Station
Super Stock & Drag Illustrated
Today's Transportation International
Touring Bike
Traveler
Travelin' Vans, Mini Trucks & Pickups
Truckin'
Ward's Auto World

Setting Up Your List

Type the address of each market included in your Market List on a separate 3x5 file card or in an expandable personal directory. On your cards you will want to include information about the photo buyers you deal with at each market—title, nickname, former position or title, fee range, plus a note or two about their photo-buying procedures, preferences, dislikes, and assignment possibilities. Leave room for code desig-

nations of your promotional mailings to them (see Chapter 10), and of course, space for changes of address, title, or personnel.

This system will allow you flexibility to delete, repair (e.g., make changes of address or spelling corrections), or add names easily.

You get the start for your personal Market List from the directories, but you can discover additional markets for your pictures at newsstands, doctor's offices, business counters, and reception rooms.

Your list is now tailored to your exact areas of interest. If you have several areas of interest, should you make several lists? My advice would be to keep one master list. Color-code the categories, or type them on different color file cards. Then, when you repair or replace a listing, you need do it only once. (For more on recordkeeping, see Chapter 13.)

The Specialization Strategy

Now that you have charted your course to sail straight for your corner of the market, you are bypassing the hordes of photographers on Track A to move along Track B where you can manage the competition.

As you work with this system, you will discover that you can define your target markets even more specifically—and improve the marketability of your pictures 1000 percent—through a strategy used by all photographers who are successful at marketing their pictures, the strategy of *specialization*.

We live in an age of specialization. Once we leave school, whether it be high school or medical school, we are destined to become a specialist in something. In today's world, with the immense breadth of knowledge, technology, and diversification, it's impossible for one person to be expert even in all aspects of a single chosen field. And in our culture, buyers of a person's services prefer dealing with someone who knows a lot about a specific area, rather than with someone who spreads himself thin.

The same holds true for photo editors. They know the discerning readers of their specialty magazines expect pictures that reflect a solid knowledge of the subject areas. Understandably, then, photo editors seek out photographers who not only take excellent pictures, but who exhibit familiarity with and understanding of the subject matter of their publications.

Technical knowledge alone is not sufficient to operate successfully in today's highly specialized milieu. Marketing has evolved beyond the "I buy a product because I like the product" stage. Marketing people have found that consumers often buy an "image" rather than a product. Their success at image-creating to sell cars, cigarettes, and beer attests to the power of images to move the buying public. Since most magazines (and, to a lesser extent, books) are extensions of the advertisers or supporting organizations, photo editors, directed by the publisher's editorial board,

are constantly seeking out photographs and photographers who can capture the publication's image in pictures. The image projected in a yachting magazine will be subtly different than that of a tennis magazine. The image projected by a magazine called *Organic Fruit Growing* will be radically different from that of one called *Chemical Fertilizers Today.*

These nuances are important for you to be aware of. In Chapter 9, I'll discuss these nuances further and show you an effective query letter for reaching editors. Go over the list of markets you've compiled for yourself. You need to familiarize yourself with the publications (write for copies or find them at the library) to educate yourself on their individual themes. Often, the book or magazine publisher will supply you with photo guidelines. If you can't get a handle on the image of some of the markets, put them at the bottom of your list. Keep the areas you're more sure of at the top. You have now fine-tuned your list; you can be more selective in your choices. The top of your list has your target markets, the ones that best reflect who *you* are *photographically,* the ones that fall within your personal photo marketing strengths. Editors have specific photo needs, and the sooner you match *your* subjects and interest areas with editors who *need* them, the sooner you'll receive checks.

You'll also be building a reputation among the photo buyers who need your specialized photography. Editors pass the word.

Keeping On Top with Newsletters

Another way to discover additional markets for your list, or to keep abreast of current market trends, is to read the newsletters in the field. Again, you can usually find these in the library, or you can send for sample copies (include $1 and SASE), to gauge whether your particular photographic approach would be served by subscribing. For names and addresses of a dozen of the best in the field, see the Bibliography.

Track A: The Boulevard of Broken Dreams

Your Track A and Track B lists have probably proved revealing to you. They may have surprised you also. You've discovered that the kind of pictures you have spent a good deal of time producing, those on Track A, don't have much marketing potential. They sell, yes, but as we've discussed, they're not good *marketable* pictures. Not at this stage of your career. You are in a game of chance with 50,000 other players. There's always a winner, but the odds aren't in your favor. That's why I call it "sweepstakes marketing."

If you follow the system outlined in this chapter, you can say goodbye to thinking that you have to depend on a stock photo agency to sell your work. You used to think that was the route to follow because a stock agency can be in touch with buyers for your pictures on a national scale.

But now you can move your own work more actively and consistently than a stock agency. You have now tapped national, regional, and local markets who will buy your specialized photography, and they'll give you all the business you need, provided you continue to supply them with what they need.

If you enjoy taking Track A pictures, continue to take them—but take them on Sunday along with your art pictures. Relegate those Sunday pictures to a photo agency for a sometime sale, or to your "famous" file. Then, like the poet or songwriter whose earlier work is unearthed, you too, when you become famous, can let the world discover your Track A pictures in exhibitions, anthologies, and art print sales.

In the meantime, direct your energies to producing marketable pictures.

IS IT A TRACK "A" PICTURE? *If you can imagine seeing it on a greeting card, consider it a Track A picture.*

There's a Target Market for every photographer. Take the time to fill out the lists on the next few pages. They are designed to fine-tune your photo marketing. What follows is a tested timesaving system for finding an exclusive Market List tailored to your personal photographic marketing strengths.

1. Using the columns below, break down your photo-marketing potential into two areas — Track A and Track B, according to the instructions on pages 49-54.

(Weak Marketing Potential)
TRACK A

(Strong Marketing Potential)
TRACK B

Before turning the page, draw a big
X over your Track A list.

Figure 3-2. *How to find your PMS:*

2. Which entries on your Track B list don't appeal to you photographically? In other words, you wouldn't enjoy photographing in this area.

 List here:

Eliminate that list from your PMS. Write in your *new* PMS here:

Figure 3-2. (cont.)

3. Be realistic. Which areas on your PMS list would it be impractical for you to photograph? For example, if you listed as an "access" a relative in Alaska who is a shrimp fisherman, it might be difficult to photograph this area (unless you are reading this in Alaska).

 Another consideration: Would concentration on any of the markets you listed require a heavy investment in new photographic equipment that you would prefer not to make at this time?

 List here:

Eliminate the preceding list from your PMS. Write in your new PMS here:

Figure 3-2. (cont.)

4. Which areas of your PMS don't lend themselves widely to publishing? Few areas don't, but one or two of them might be on your list.

For example, there may be a very limited audience for pictures of antique clock repair. Or there may be too few picture possibilities for an armchair interest in unidentified flying objects.

List here:

Rewrite your list below, leaving out the unlikely-to-apply-widely-to-publishing subjects. You have now further refined your PMS.

Figure 3-2. *(cont.)*

5. Decision! It's time to narrow your PMS down to *four* major areas. If you aim your marketing strategy at a minimum of four strength areas, you'll be able to develop them to their fullest potential.

Here are seven factors that will aid you in your decision. (Make an educated guess on some of them, since you probably don't have access to current circulation and payment figures in all of these fields.)

High Medium Low

☐ ☐ ☐ • Your knowledge or expertise in this field?

☐ ☐ ☐ • Your personal interest in this field?

☐ ☐ ☐ • Your existing supply of pictures?

☐ ☐ ☐ • The payment range for pictures in this field?

☐ ☐ ☐ • The competition factor — is it high, medium, or low?

☐ ☐ ☐ • Your access to the field or information about it?

☐ ☐ ☐ • The audience (number of readers)?

Using any other criteria you can think of, narrow your PMS down to four. Then decide which one of the four offers the best marketing potential for *you*. Then list the second best, and so on. Note your four strongest areas below.

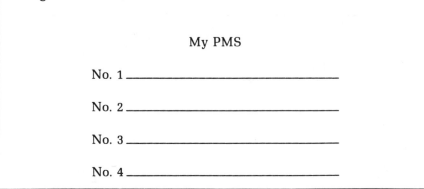

My PMS

No. 1 _____

No. 2 _____

No. 3 _____

No. 4 _____

Figure 3-2. *(cont.)*

1. Now that you have found your top personal photographic marketing strengths (PMS) you are ready to find the *markets* that are looking for pictures in your PMS areas. Your library, depending on its size, can provide you with many of the directories and reference guides listed in Table 3-1. Your Market List is your gold mine. You will want to refine it in the same manner as your PMS. In the two columns below, list magazines and publishing houses that are potential markets for your PMS No. 1. Do your research thoroughly.

My initial market list for PMS No. 1.

_____	_____
_____	_____
_____	_____
_____	_____
_____	_____
_____	_____
_____	_____
_____	_____
_____	_____
_____	_____
_____	_____
_____	_____

Figure 3-3. *Narrowing down your market list.*

2. To tailor your list, ask these questions of each potential market on your list (you're going to do some shuffling):

A. **What is the supply/demand factor?** (Remember that *supply* in this case means the photo buyer's supply, not your supply.)

High supply, no demand = move to lower third of list.

High supply, high demand = move to upper half of list.

No supply, high demand = move to top of list.

No supply, no demand = move to lower third of list.

B. **What is the competition factor?**

No competition = move to top of list.

Moderate competition = move to upper half of list.

Fierce competition = move to lower third of list.

C. **Miscellaneous considerations.**

The magazine or house demands model releases = move to lower half of list.

The magazine or house has no track record (brand new) = move to lower half of list.

Slow or no payment reported = move to lower half or remove entirely.

Poor reliability factor reported (e.g., photo buyers reported as uncooperative, disrespectful, poor administrators, or inefficient in handling photographers' pictures) = move to lower half or remove entirely.

D. **What is the publisher's purchasing power?**

Rather than trying to determine a single magazine's circulation, research the entire publishing house's purchasing power. Some publishing houses have as many as twenty to thirty editors. Most publishers concentrate on a specialized subject or theme. Often if your pictures don't score with one editor, they are circulated among other editors within the house. The best way to determine the buying power of a publishing house is to tally the number of periodicals and/or books published annually. If that figure is not available, you can get an idea of the house's purchasing power by looking at their circulation figures, number of pictures purchased per year, or

Figure 3-3. *(cont.).*

number of editors employed. Use Table 3-3, to rate your markets, in order of purchasing priority.

Publisher's Buying Power Guide

(Note: in this chart "Publishing house" means book or magazine publisher.)

	Place at top of list	Place in upper half of list	Place in lower half of list
Number of editors at publishing house.	20 to 50	6 to 19	1 to 5
Number of periodicals at publishing house.	15 to 35	4 to 14	1 to 3
Number of books or magazines published per year by this publisher.	50 to 100	11 to 49	1 to 10
Number of photos purchased annually by publishing house.	400 to 3,000	49 to 399	1 to 50
Circulation figure (for single magazine publishers)*.	250,000 to 500,000	75,000 to 250,000	20,000 to 75,000

Note: Magazines above 500,000 circulation are a closed market to most part-time photo illustrators. Large-circulation magazines acquire their photos from (1) their staff, (2) stock photo agencies, or (3) longtime established local (or sometimes national) service photographers.

Figure 3-3. (cont.): **Table 3-3.** Publisher's buying power guide.

3. What is the probability factor?

In the final analysis, you will determine your probability of scoring with a given magazine. Pictures in magazines can be broken down into two categories: advertising and editorial. As a photo illustrator, your concern is the *editorial market*.

These pictures are supplied by staff photographers, assignment freelancers, service photographers, stock photo agencies, and photo illustrators such as yourself on the magazine's available-photographers list.

Using the magazines on your Market List, analyze their use of both advertising and editorial photographs. The amount of advertising in the magazine will give an indication of the magazine's picture budget. While you're at it, analyze the use of Track A pictures; this should convince you of the futility of trying to market Track A pictures yourself. (See Chapter 12 for methods to sell these.)

Rate the magazines:

30 to 150 editorial pictures = place on top of list.

10 to 29 editorial pictures = place on top half of list.

1 to 9 editorial pictures = place on bottom half of list.

_____ _____

_____ _____

_____ _____

_____ _____

_____ _____

_____ _____

Figure 3-3. *(cont.).*

_____ _____

_____ _____

_____ _____

_____ _____

_____ _____

_____ _____

_____ _____

_____ _____

_____ _____

_____ _____

4. You have shuffled and refined your Market List for PMS No. 1, and your strongest markets have come out on top. Go through the same process for your three other Market Lists.

 Transfer your four Market Lists to 3x5 file cards or a three-ring (expanding file) notebook (see Chapter 13). Make additions, deletions, and address changes to your Market List as soon as they occur.

 Some Market Lists are long because of the general nature of the subject. Others are short.

 Work closely with the top half of your list. But, because publishers' budgets change, continue to keep in contact with the lower half of your list as well.

 If in the future you acquire new knowledge or interest in another field, consider replacing one of your lists with this new field.

Figure 3-3. (cont.).

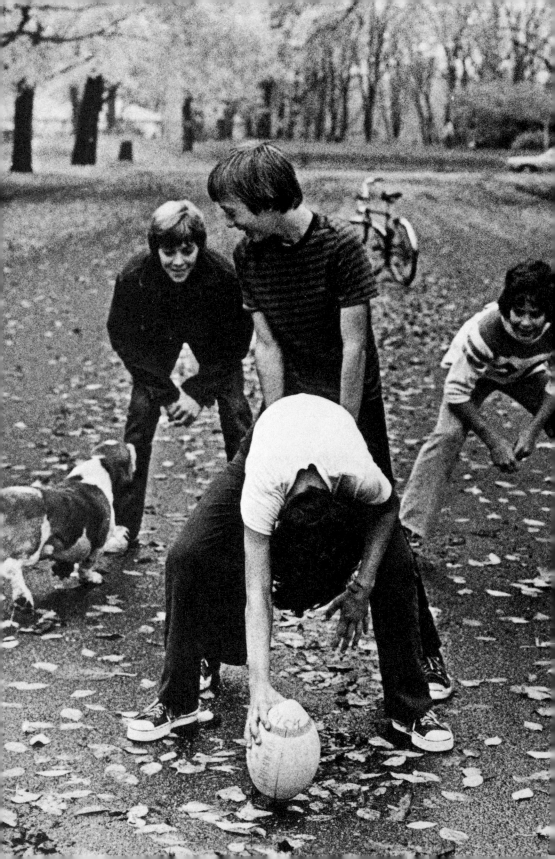

4.
Getting
Started

Seize
the Day

Throughout this book, I emphasize the importance of analyzing your photographic marketing strengths and then determining which markets need your kind of pictures. These invaluable assessments alone are an insurance policy against failure when you get started in your photo-marketing operation. Taking the time to pinpoint your PMS and research a sound Market List is fundamental to the success of your operation. If you skip this process, or give it only short shrift, your photo-marketing prospects will be shaky.

Should you *start today?* My answer is *yes,* if you start by mapping out your PMS and Market List—*then* set aside four weekends to physically set up your operation.

That's right—in just four weekends you can put yourself in business. We'll explore how to move step-by-step through those weekends in the "Four-Weekend Action Plan," but first let's take a look at a dozen road-blocks that may be standing in the way of getting started.

I've listed in Table 4-1 the twelve most common reasons people give as to why they haven't plunged into their photo-marketing operations. To the right are references to where each point is discussed and either solved or dissolved as a problem.

If you've found any of the reasons mentioned in Table 4-1 to be roadblocks along your own route, now's the time to break through them, and launch *your starting strategy.*

The Four-Weekend Action Plan

Most people have an aversion to starting things. Did you ever *not* start fixing a recipe because you weren't sure if you had all the ingredients? Did you ever *not* start work on a project because you weren't sure you'd

Breaking through the Roadblocks.	
"A dozen reasons why I can't!"	WHERE YOU'LL FIND THE REASONS WHY YOU CAN
Roadblock 1 "I don't have the time."	Chapters 4 and 13
Roadblock 2 "I have no experience."	Chapter 14
Roadblock 3 "There's too much competition."	Chapters 1, 2, 3, 6, and 14
Roadblock 4 "I only have one camera."	Appendix B
Roadblock 5 "I don't have a darkroom."	Appendix D
Roadblock 6 "Editors don't know me."	Chapters 7, 9, and 10
Roadblock 7 "It's too expensive."	Chapters 9, 14, and 16
Roadblock 8 "I live in a small town."	Intro. and Chapter 1
Roadblock 9 "I can't give it *full* time."	Chapter 14
Roadblock 10 "I don't know how much my pictures are worth."	Chapter 8
Roadblock 11 "I don't know *who* to sell to."	Chapters 1, 3, 7, and 12
Roadblock 12 "I don't know *what* pictures to sell."	Chapters 2 and 12

Table 4-1. *"A dozen reasons why I can't!"*

be able to find one of the necessary tools when you were halfway through it? Or you weren't sure *what* you'd need? Most of us procrastinate.

Well, you're lucky. You don't have to wait any longer to fire up your photo-marketing enterprise. Why not? Because the Four-Weekend Action Plan contains all the ingredients, all the tools, all the know-how you need to propel yourself into the field of photo marketing.

Your resolve will require some understanding on the part of your family and friends. Announce to your family that you are going to take the next four weekends to establish yourself in the business of marketing your photographs.

Now here's a paradox: As soon as you make your announcement, your loved ones will find every imaginable reason to distract you for the next four weekends. ("Johnny has a choir concert." "We're scheduled to play cards at the Howards'." "Ella Fitzgerald is at Orchestra Hall.") After all, they like you so much, they don't want to see you invest yourself in something that "might not work out" and secondly they don't want to see you engrossed in something they are not part of. At this point, you are most vulnerable to being talked out of your Four-Weekend Action Plan. Visualize your goals and hold firm. If you can, turn your loved ones' reservations into an advantage by recruiting their help in some of the routine tasks needed to set up your office and recordkeeping systems. Remember, though, that *you* are running the show.

Your blueprint is in Table 4-2.

The photo-marketing enterprise you are about to embark on is going to take endurance. You are going to experience setbacks. You will no doubt encounter some trying times of reassessment. If your desire is strong, none of this will faze you. Welcome to a magnificent obsession with this profession!

Table 4-2. The Four-Weekend Action Plan to launch your photo-marketing enterprise is on the following two pages.

WEEKEND ONE: Set Up Shop.

Take action. Announce your plan to family, relatives, colleagues, and friends. Enlist their help, but fly solo if they attempt to dissuade you from your plan.

Clear out a room, or partition off part of one, and set up a desk, chair, lamp, typewriter, and filing cabinet. (Consult the Yellow Pages for used-furniture bargains.)
Tack a sign above your desk, "_____Photography."

Order your supplies:

> Personalized stationery
> Mailing envelopes
> Plastic sleeves
> Labels
> Slide view files
> Rubber stamps
> Business checks
> Simplified bookkeeping system
> Recordkeeping system
> Subscriptions to business periodicals

WEEKEND TWO: Zero in on Your PMS.

Determine your areas of strong marketing potential and the areas of poor marketing potential. Photo marketing is a *business*. Success comes when you eliminate the barriers and pitfalls that prevent you from succeeding (failure avoidance). Discover your personal photo-marketing strengths (who you are photographically).

Catalog your slides (transparencies).
Catalog your black-and-whites.

Reread "First, Find Yourself" at the beginning of Chapter 3.

Reread Chapter 2, "The Difference between a Good Picture and a Good Marketable Picture."

WEEKEND THREE: Capture Your Corner of the Market.

Why compete with an army of photographers in the general arena when you possess channels of knowledge and access to select areas that specific photo editors are already looking for? Spend the weekend in your local library and compile *your* own Market List, a list of markets tailored to *your* photographic strengths. Request photo guidelines from each of your markets.

Reread all of Chapter 3, "Finding Your Corner of the Market."

WEEKEND FOUR: Roll the Presses!

All of your supplies are in. Set up a simple recordkeeping system (nothing elaborate) to note what you send out, to whom, and what sells. Validate your Market List. Confirm spellings. Make address corrections. Verify current contact's name. Mail out your first shipments.

Read Chapter 14, "Working Smart."

Read Chapter 16, "Your Stock Photo Business: A Mini Tax Shelter."

From here on out make it a *habit* to work in your new home office on a routine daily basis, for one hour or ten hours, whatever fits your work style, lifestyle, and income projections.

Read your business and marketing periodicals, and expand your knowledge a little each day. Learn what others are doing; attend specialized workshops and seminars. Listen to business and marketing cassette tapes in your downtime (driving to and from work, in the darkroom, etc.). Incorporate elements of such information as they apply to you.

You are now on your way. By the time you're ready to celebrate your first anniversary, you'll have many published pictures (and deposited checks) to your credit.

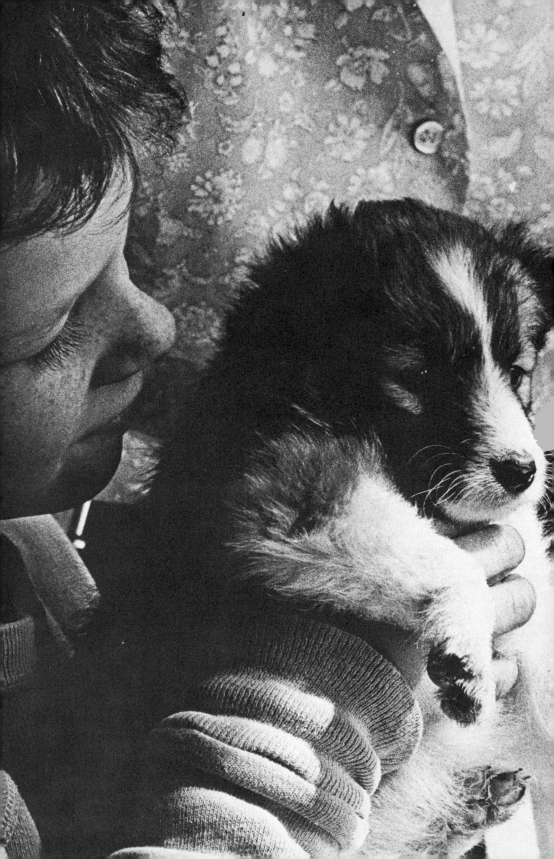

5.
Producing a Marketable Product

Some Basic Questions Answered

Color or black-and-white: Which should I shoot? Whether you shoot in black-and-white, color, or both, will be determined by your PMS (personal photographic marketing strengths) and your Market List. Most markets in the publishing industry lean heavily toward black-and-white. However, some periodicals deal exclusively in color. Make this test: Select a magazine from your Market List to which you plan to send your photo illustrations. Tear out any ads and put them aside. What's left are the editorial photo illustrations. What percent of them are black-and-white? Color? Checking each of your markets or prospective markets in this manner will give you a realistic appraisal of the black-and-white versus color needs of publishers you deal with.

Many photographers prefer to shoot exclusively in color. (Service photography market areas—ad agencies, graphic design studios, corporations, commercial assignments, and stock photo agencies—often require a heavy concentration on color.) In the near future, perhaps technology will provide a less costly way for publishers of books and magazines to employ color. Right now, in fact, trends in the magazine and book industry indicate a move toward more color. This may be because each new year brings the birth of new specialized magazines and book publishers, which increases the total amount of color (and black-and-white) used each year. The textbook industry, however, shows a marked increase in the use of color over black-and-white in the last two decades.

Is it cheaper to shoot in black-and-white or color transparencies? At first glance, black-and-white would appear to be less expensive. But if you take into consideration your developing/printing time and costs,

plus the cost of maintaining a black-and-white darkroom (see Appendix D), color is actually less expensive.

Again, remember, photo editors buy pictures because they *need* them, not because they like them. If you enjoy shooting color, shoot color; but if your markets require black-and-white, shoot black-and-white, too.

What Film Should I Use?

Black-and-White

For indoor shots, the faster films are best, of course. Tri-X has proved popular with many photographers. I personally shoot it at 800 ASA; other photographers shoot it as high as 3200 ASA. Other equivalents are Ansco/GAF 500 Super Hypan and Ilford HP5 (400 ASA).

If you're shooting outdoors, you might want to investigate a slower film, Kodak's Plus-X, or its equivalent in other brands, Ansco/GAF 125 and Ilford FP4 (125 ASA). When outdoors, I often shoot Plus-X at 320 ASA. I also shoot Tri-X in *outdoor* situations, and I find the results very satisfying. Generally speaking, no outdoor situation is too difficult for the faster Tri-X film, even shooting it at ASA 800 with a shutter speed of 1,000.

Unless you enjoy and can afford working with several cameras, it's handy to explore the versatility of a single film. It's convenient to work with one film—no problems arise when you need to dash from inside a schoolroom to an outside playground in mid-roll, and you can develop a fine-tuned familiarity with the qualities of "your" film and what you can produce with it.

Color

First, plan on marketing color transparencies, not prints (see page 85). Both fast and slow color film will be valuable to you. For outdoor work, I use Kodachrome (ASA 25) and Kodak Ektachrome X (ASA 64). Other equivalents are Agfachrome CT-18 (ASA 50), Agfachrome 64, and Fujichrome 100 (ASA 100). The lower the ASA (or ISO), the better photo editors like the results; the lower ASAs produce a tighter-grained transparency, which means the editor can blow it up larger and still get good definition. (Frequently, a photo buyer will use only a portion of a picture and enlarge it for the format.) Kodachrome 25, for example, is reported to have a resolution of 125 lines per millimeter, and Kodachrome 64 a resolution of 115 lines per millimeter.

Color films for indoor use include Kodachrome 40 Type A, or Ektachrome 160 Type B. These films are appropriate to use when you're inside under artificial light. If you're inside but able to shoot with available light from windows and doors, outdoor color film such as Ektachrome 200 and 400 and Agfachrome 100 works just as well as

indoor film. Again, when you can manage it, it's handy to be able to use just one film both for outside and inside.

We've talked about the 8x10 preferred size for black-and-white prints—for color, it's not so cut and dried. Both 35mm and 2¼ are welcomed by photo buyers. In some cases, especially if you are a service photographer, 4x5 and even 8x10 will be useful and often required.

Your best bet is really the 2¼ format for the most consistent marketing of color photo illustrations. This is mainly because when editors confront two transparencies of equally fine caliber, one a 35mm and the other a 120, they usually choose the *larger* picture.

Why? Big is beautiful to the art director, and also to the business manager who is often called in when decisions about big expenses are involved. If a photo buyer is going to spend $750 for the use of a color transparency, and an equal amount for color separations, it seems logical to get the "most for the money."

Later in this chapter we will discuss the marketing advantages of duplicating and enlarging your best 35mm pictures to the larger 4x5 format.

Black-and-White: What Makes a Marketable Print?

We are gazing at a black-and-white photograph at a salon. Texture and detail in the shadows of the photograph come through superbly. The dark areas are black and rich; highlights sparkle with crisp whites. Between these poles flows a broad range of values that give the print an almost three-dimensional quality. We are looking at the classic "good print."

In photo illustration, not every print needs to have this full range of tonal gradation in order to be marketable. Your pictures have to be technically good to sell, but they don't have to be technically perfect. Buyers of photo illustrations are primarily concerned with content, *communication.* A photo illustration taken in the fog, for instance, can have no highlights, yet still be effective. Or a picture of students in animated discussion around a seminar table, which exhibits only middle tones, will nevertheless make a successful photo illustration.

To add to the ambiguity, the same print can be treated different ways, with equal success as a photo illustration. I once showed three variations of one print to a group of seven photo editors. One version was contrasty, one dark and moody, one a classic good print. The editors could not agree on which was the "best" print. The "rightness" of each printing approach depended on how the print would be used.

Print quality, then, is relative. David Vestal, photographer, lecturer, and critic, adds this:

Most good prints are craftsmanlike. They tend to give maximum

information and show all the tones that the photographer chooses to show, clearly, richly, and in an appropriate degree of contrast (dictated by feeling).

Most good enlargements are in focus all over the paper, and are visually balanced, without unwanted inconsistencies. In poor prints, some areas usually "stick out" inappropriately, or fail to be clear, or both; usually because the photographer has not paid enough attention to his picture, or hasn't done the necessary work.

In any mode, a good print is one where the photographer has seen accurately what the picture needs and has successfully used his craft to provide it. The technique can be simple, as with Edward Weston, or complicated, as with Jerry Uelsmann or Gene Smith. Either way, a good print normally reflects thorough craftsmanship, from shooting through fixing and washing.

How Extensive Should Tonal Gradation Be?

No experts will commit themselves to a firm definition of a good print. But even taking into consideration the leeway involved, good prints do consistently exhibit the photographer's concern for tonal gradation. You will create a good print if you are able to extract the appropriate range of gradation values inherent in your negative and select and match these with the mood and atmosphere you wish to convey in your photo illustration.

In order to consciously eliminate some tones from a print to create the desired feeling in your picture, you must be aware of the range of gradation available to you in that print. To say some prints come off well with portions of their full gradation missing does not invite you to settle for substandard or hurried printing results. Photo buyers will recognize poor quality immediately. Only by taking time to become familiar with the precise potential offered in the tonal range of any particular print is it possible to develop creative control over tonal results. Educate yourself on different degrees of tonal completeness for technical excellence, yet remember that in photo illustration you can depart from textbook definitions of good print quality if the content of the picture says what you want it to say.

Black-and-White: What Size Should I Print and What Paper Should I Use?

The standard black-and-white print size in the publishing industry is 8x10. This size fits conventional file drawers and is easy to handle. Here are some paper pointers, whether you do your own printing or farm it out and want to know what instructions to give the lab. As to paper, photo buyers nowadays rarely ask for glossy prints, primarily because semigloss gives them a closer idea of how the photograph will look

when reproduced in their publication. Editors formerly asked for prints with high shine ("Gimme a glossy!") because in the old days printers required a glossy surface for best reproduction. This is not the case today.

Semigloss paper, such as Kodak's J-surface paper, is a good choice because it has a solid, professional look, and it takes "spotting" easily (see Appendix C). You can also get a semigloss finish by using glossy paper (e.g., Kodak's F-surface paper) but air-drying the prints in blotters rather than ferrotype-drying them. Because of their convenient air-drying feature, resin-coated (RC) papers are especially suitable for the photo illustrator who has neither the space nor the time for mass-producing pictures. Another timesaver in developing is the stabilization process, which bypasses the conventional "wet" darkroom procedures. Since editors are rarely interested in archival quality in your pictures, a stabilizer can be a convenient tool.

Should I Rely on Color to Black-and-White Conversion?

If you're strictly a color photographer, you'll find you have to deal with the fact that, despite the profusion of color used in the publishing industry, black-and-white still is the medium of choice. Depending on your Market List and your PMS, when you analyze your markets as suggested in Chapter 3, you'll probably find black-and-white usage leads color by a two-to-one or even three-to-one margin.

"How about conversion?" you may ask. Many publishers refuse to incur the cost of converting color to black-and-white (usually around $10 to $15 a picture). "If we do decide to convert to black-and-white," says one editor, "we'll charge off the conversion costs to the photographer." Other photo buyers don't like to convert to black-and-white because it isn't reliable. "You never know what you're going to get. Black-and-white conversions are usually lacking in technical quality." The time factor is also important. Editors, working against a deadline, don't like to be at the mercy of a lab. The editor will choose the next best picture, in black-and-white.

One answer is to shoot both color and black-and-white on the scene, with two cameras. Another is to use Eastman 5247 film. This is a negative 35mm movie camera film from which both slides and black-and-white prints can be made, but it has limitations, which I'll discuss later. Another answer is to convert color to black-and-white yourself. The results aren't guaranteed, but if your original picture exhibits reasonable definition, the results are often acceptable.

Here are two processes: Make a large-format internegative, then enlarge it to come up with the final print. This process can be markedly speeded up by the use of Polaroid positive/negative film. The Polaroid film holder (Model 405 or 545) is placed on the enlarger baseboard, and

the slide is projected directly onto the film. Exposure tests, of course, are necessary. The 405 holder uses type 665 pack film and gives a 3¼x4¼-inch negative; the 545 holder uses type 55 film and gives a 4x5-inch negative.

A second, even easier method involves the use of Kodak Direct Positive Paper. The paper is exposed to the slide in an enlarger like regular printing paper. Special processing produces a positive image in just one step—that is, no internegative. Print quality depends on both the quality of your original color transparency and your processing talents.

How Do I Make Sure My Color Will Sell?

I've pointed out, and you have probably confirmed by analyzing your markets, that black-and-white use leads color by two to one or even three to one or more. But what if your PMS points toward color and some of the buyers on your Market List require color? Can you make sure it's *your color* that hits often enough to make it economically viable for you? The answer is yes, you can put yourself strides ahead of the competition, *if* you put together a well-planned marketing strategy for your color pictures (transparencies).

More than black-and-white, color requires extra technology, equipment, and know-how to produce the right marketable picture. Three-fourths of all the technical questions I receive as publisher of the *Photoletter* have to do with *color* and how to avoid excessive expense in producing and marketing color photography. One of the first ways you can save is to ask yourself on your next photographic outing, before every shot: "Is this marketable?" With each frame you expose, ask yourself, "Will this one be on a photo buyer's desk next week for consideration, and will it have a good chance because I've researched my photo buyers and their specific needs?" If you find yourself shoulder to shoulder with dozens of other photographers on the bridge at Ellis Island, waiting for the right light at sundown on the Statue of Liberty, you can be reasonably sure you will get an excellent picture. You can also be reasonably sure the marketing potential of it will be zero. A dozen photographers waited on that bridge yesterday, and a dozen more will be there tomorrow.

Get in the habit of asking yourself, "Is it *marketable?*"

The Most Commonly Asked Questions about Color

In figuring your color marketing strategy you'll need the answers to the following questions:

What color film is most popular among photo buyers? When talking about film, technical quality looms as a more important consideration

with color than with black-and-white. Photo buyers draw up their technical requirements for color on the basis of recommendations set by their printers; printers are at the mercy of their particular printing equipment. If the equipment is sophisticated, they can sometimes excuse minor imperfections in a picture. If the equipment is mediocre, printers (and thus photo buyers) depend heavily on a technically fine picture from you.

Basically, an outdoor picture should be taken on a low-ASA-rated film such as Agfachrome CT-18 or Kodachrome 25. An indoor shot is acceptable when shot on the higher-rated ASA films such as Agfachrome 100, Fujichrome 100, Ektachrome 200, Ektachrome 400, Eastman 5247, and Ektachrome 160 Type B. There are exceptions to all rules, of course. Having said that, I'll say that editors seem to prefer K-25 for outdoor and Ektachrome 64 or Agfachrome 100 for indoor shots. These three films are very reliable and predictable.

And why the low-ASA K-25? As I mentioned earlier, an editor may wish to use only a part of your picture or use all of it for a cover or a poster that would require magnification. If a higher ASA film is used, grain clumping might preclude using the picture. To get around the grain-clumping problem, a 5x7 internegative could be made, but often photo buyers don't want to go to the extra time and expense. Preparing color photography for publication already requires longer production time than black-and-white.

Should I indicate which film I used? Some photo illustrators indicate on their slide mounts the film and film speed that were used. Although this might be helpful in your learning process, it could be detrimental to sales if your color, for example, is in the higher ASAs. Erase the information, or place your name and address label over it if it's in ink.

Should I shoot vertical or horizontal format? Editors continually lament that they do not have enough vertical shots to augment their layouts. "Printed matter is usually a vertical format," one editor told me. "Yet photographers persist in sending me horizontal pictures. I could use many more verticals than what I get."

One photographer friend told me that when she was starting out she pasted a label on her camera that read, "Is it a vertical?"

Do editors accept color prints? I've touched on this elsewhere, but let's examine this question in more detail.

Very few photo buyers, possibly 10 percent or less, accept color prints. Usually it's the *low*-paying markets that will accept color prints. When they do, they expect a *quality* 8x10 rather than the smaller "drugstore" prints. Incidentally, do not send your color negatives. Keep them home, safe, and on file.

The industry as a whole would certainly fare better if color prints could be accepted across the board, rather than color transparencies.

However, the industry has invested millions in color-positive (transparency) processing and printing machinery, and they are not ready to make the switch. Until they are, photographers are faced with the reality that the industry is geared for transparencies, not color prints.

I can liken the situation to taking $50 in foreign currency to a department store and trying to make a purchase. Yes, the manager will believe the money is worth something, but it's too much hassle to convert the currency to *his needs.*

So for now, although color negatives are more logical, convenient, and have a greater exposure latitude than transparencies, you're stuck with shooting transparencies. You must put up with the hazard of constant handling of your originals (your slides) by yourself and by photo buyers.

How can I get around the color print barrier? If you have a lifelong history of working only with color negatives, however, and are not willing to work with transparencies, read on. Some photo illustrators have attempted to circumvent the color neg-versus-transparency situation via these four methods:

1. Make your shots in color negative and enlarge to 8x10 color prints. Send the prints, or color photocopies of the prints, to several potential buyers on your Market List. Put a label or rubber stamp on the back explaining a color *transparency* is available on request. If a photo buyer does request the transparency, send a rush order to your custom processing lab and have the lab make a 4x5 transparency which you—or the lab, depending on the deadline—can forward to the photo buyer.

Incidentally, this type of duplicate (dupe) is actually an improved version of your original. The 4x5 transparency will prove to be of great advantage to you. The large 4x5 size is impressive and sells more readily than the smaller 120 or 35mm. Even if your picture doesn't make the photo buyer's "final cut," your 4x5 transparency has especially good potential for scoring with other photo buyers. You know it's a marketable picture because one photo buyer has already considered using it.

Make full use of this marketing maxim: If one photo buyer wants a picture, other photo buyers will want it *too.* Have duplicate or triplicate copies of your transparency made while it's at the lab. In multiples, the single cost is much less. Aggressively market your copies.

2. Make your photographs in color negative, select the most marketable, and have transparencies made from the selected negs. This approach could be costly unless you are confident in your ability to choose marketable pictures.

Kodacolor II, Fujicolor FII, and Kodak VPS film provide high resolution and fine grain. Also, Fujicolor II-400 and Kodacolor 400 provide excellent-quality images for indoor situations. Eastman will convert

negs into display transparencies for about $1 each, but the reproduction quality cannot be recommended in most cases. A custom lab will charge between $8 and $15 per transparency.

3. Eastman 5247 film is designed for use in the movie industry. It is a negative film which lends itself to 35mm camera use. Some photo illustrators may find it their film of choice. (See page 90 for details on it.)

4. One other means: Do it yourself. Kodak provides two printing processes for making transparency enlargements from color negatives. They're called Ektacolor Print Film No. 4109, and Vericolor Slide Film 5072. However, making your own transparencies requires darkroom precision, patience, and time. The end product must be acceptable for reproduction.

I don't want the above four suggestions to give you the impression that the color-neg system is the answer. In most cases it is not, for this reason: Photo buyers want a picture *now*. Any extra steps, such as waiting for a transparency to be made, will often make the difference between a sale and no sale.

Should you make duplicates of your slides? Newcomers to the field of photo marketing have a well-founded hesitation to send their original transparencies to some unknown entity. A seemingly popular answer is to make duplicates (dupes) of your originals. Before I launch into the pros and cons, here is the most convenient way to make dupes: *Make them as you are shooting your subject matter during the original shooting.*

Since you know what pictures will sell to your Market List, you aren't gambling away film dollars by making several extra exposures of an especially marketable scene or situation.

Of course, depending on the scene or situation, your "originals" won't be exactly the same. Some you might even want to discard. Those that remain will share equally strong marketing potential. With several "originals," you'll have no worries about losing, misplacing, or damaging the original.

But what if you have only *one* original? I wish that I could say an inexpensive, quick, and high-quality method of duplication is available to you. There is none—not for reproduction purposes.

Let me explain.

The photo buyer is midway between you and the printer (the pressman, platemaker, etcher, etc.), who demands the best-quality image in order to satisfy the publishers', advertisers', and subscribers' tastes, not to mention his own. The printer has a bag of tricks that can perform some limited miracles, but in the end, there is no substitute for a good original image.

This then rules out everything you've heard about making your own

dupes or having them made professionally by a filmstrip company at fifty cents apiece. These products are duplicates, yes, but usually not dupes a quality printer can accept for reproduction.

But all is not lost. Reproduction dupes can be made, and the cost is usually comparable to a dinner at a first-class restaurant. (I use this comparison lest inflation or deflation catch me with a strange quote by the time you're reading this.)

Here's how the pros make their dupes. Select an original that has enjoyed wide sales or has such sales potential. Contact a reputable color lab and have your original made into a 4x5-inch transparency. In many cases, your original can actually be improved by adjusting the color balance in the dupe. Slides that are too dark, but with adequate shadow and highlight detail, may be lightened either for a more pleasing effect or to bring their density into line with other slides in your presentation.

Overexposed slides may be darkened. Composition can be corrected or emphasis can be given to just a portion of the slide by cropping and copying a certain area. Color rendition can be changed by means of filters either for corrective or creative deviation from the normal. A "sandwich" can also be made at this time. This is the process used when you want to place two slides together, such as a seagull and a setting sun, and print them as one. If you want to have a sandwich made, tape your two originals together in the composition you choose. The lab will shoot them as a single slide.

The price quoted above is for a reproduction-grade dupe. At about half this fee, you can get a lesser-quality "display-grade" dupe.

Incidentally, many stock photo agencies (see Chapter 12) will make 4x5-inch reproduction-grade dupes of your 35mm. The reason? The improvement in color balance, plus the added size, improves sales. These agencies often have sales reps here and abroad who carry these dupes with them in their display cases. They sell the dupes directly from the case as originals, which they now are.

One quality color lab is *Creative Color*, 4911 W. Grace St., Tampa, FL 33607, owned by Burton McNeely. In addition to producing reproduction-quality 4x5 transparencies from your 120 or 35mm originals, his firm also offers a full-line lab service, as do the following:

Benjamin Film Laboratories
247 Richmond St. E.
Toronto, Ontario, Canada

Berkey K & L Custom Services
222 E. Forty-Fourth St.
New York, NY 10017

Custom Color Laboratory
947 Industrial Ave.
Palo Alto, CA 94303

Dale Color
Box 2460
Bloomington, IL 61701

Hollywood Film Enterprises
6060 Sunset Blvd.
Hollywood, CA 90028

K & K Color Lab
8302 S.E. Thirteenth Ave.
Portland, OR 97202

Meisel Photochrome Corporation
Box 6067
Dallas, TX 75281

Northwest Color Lab
10247 Ninety-Fifth St.
Edmonton, Alberta, Canada

Pro Color
909 Hennepin Ave.
Minneapolis, MN 55415

A few stock photo agencies and a few publishers will invite you to send 35mm dupes to be held on file as display. When they require the original, they contact you for it. Such display dupes are inexpensive, usually under a dollar. The following filmstrip companies produce quality display dupes:

Atkinson/Stedko
7610 Melrose Ave.
Los Angeles, CA 90046

Color Film Corporation
East Coast Lab: 777 Washington Blvd.
Stamford, CT 06901

Color Film Corporation
West Coast Lab: 3212 Nebraska Ave.
Santa Monica, CA 90404

World in Color
Box 392
Elmira, NY 14902

A final option, of course, is to make dupes on your own—not only duplicates but restorations of existing slides, color changes, sandwiches, and experimental pictures. Type 5071 Ektachrome slide-duplicating film is the usual choice, along with a duplicator such as the Bowens Illumitran Model 3-C, which includes a special contrast control unit. The final results usually fall into Track A—pictures which are interesting but difficult to market.

Unusual duplication techniques will come and go, but the duplication technique of choice will probably remain: Make on-the-spot duplicates by shooting extra pictures as backups.

Can you submit display prints of your transparencies? Yes. The Cibachrome method of making prints directly from slides has become a popular way to show photo buyers your photography without having to send your original slides. The usual procedure is to enlarge six vertical or six horizontal 35mm slides to 2¾x3¼-inch on an 8x10-inch sheet of Type A Cibachrome print material. Include your name and other details on the back of each sheet.

Robert A. Walsh at the Stock Photo Darkroom (158 Wyoming Ave., Audubon, NJ 08106) provides Cibachrome service.

A second way to reproduce your color transparencies for display purposes is the "positive-stat" method. No internegatives are required

since the system is a direct reversal, positive process. Stats are made in standard sizes of 5x7, 8x10 and 11x14 inches. For stat services, consult the Yellow Pages under Graphic Art Services or Graphic Designers.

A third method, mentioned earlier, is to make color photocopies of your slides. Twenty 35mm or twelve 120-size can fit on a standard 8½x11-inch sheet. The image quality is passable. Instant-print shops, banks, and libraries often feature this service.

A final method, and probably the costliest, is to gang-print a group of ninety-one slides (or black-and-whites) onto a 4x6-inch microfiche card. If the editor has access to a microfiche projector he can order slides from your card. Sid Bugelholl, 13854 Kinbrook St., Sylmar, CA 91342 produces microfiches for photographers.

The advantages of submitting color display prints or dupes of your slides to a photo buyer are as follows:

1. You can circulate more copies of your slides to more photo buyers simultaneously.

2. Your originals remain safe in your file until a photo buyer makes an order.

3. You can try untested markets without fear of losing valuable originals.

4. You save on the extra postal costs of shipping original transparencies.

5. You can, in effect, establish a catalog of your pictures with certain buyers on your Market List.

6. The enlargements of your slides (the Cibachromes or stats) give the photo buyer a good idea of what your picture looks like when it's reproduced.

7. Your reliability factor (see Chapter 7) goes up a few notches because you look more professional.

Of course, all these fine advantages go flying out the window when the photo buyer says, "I can't hold up production. I thought we had the *original* here. We'll have to use this other picture instead, because we have it right here."

Is 5247 Film Useful for the Photo Illustrator?

Eastman's 5247 is Kodak's standard movie film. It's an improved version of the earlier 5254 film, which didn't have the fine grain or wider latitude of the new film. Photographers have discovered that the 5247 film (it's a negative, rather than a positive) can offer slides, color prints, and black-and-white prints—all from the same negatives.

Here are some advantages for the photo illustrator:

1. The film can be shot indoors or outdoors at ASA 100. The corrections are made in the processing lab.

2. The film can be pushed to ASA 400 easily.

3. The color quality is comparable to Ektachrome. (As a movie film, it must be projected to movie screen size.)

4. Several "originals" can be made and circulated simultaneously to photo buyers. The photographer never loses an original slide, unless the original negative is damaged.

5. You can use it to shoot black-and-white and color in the same shooting situation and use only one camera. (No need to convert a color shot to black-and-white.) This film could prove to be very useful to the photo illustrator who shoots mostly indoors and where a 100 to 400 ASA range is practical.

6. You can make color contact prints of your available slides for the photo buyer's file.

7. Processing labs for this film are plentiful and the processing system is safe, since it's basically designed to service the 35mm film industry which can't afford processing mishaps in valuable film sequences.

The disadvantages of 5247 film are few, but major:

1. Because it does not have the tightness of grain of the lower rated ASA films, such as K-25, photo buyers will not accept its use in situations where K-25 could have been employed.

2. It is not standard. Photo buyers tend to be suspicious of any films that are not "standard." So do photographers.

3. It is confining. For an outdoor photo illustrator, the ASA is too high (100). For an indoor photo illustrator, in classrooms, offices, or similar available light situations, the ASA is too low.

Here is a brief list of labs that can process Eastman 5247 film:

American Passage
708 Warren Ave. N.
Seattle, WA 98109

Dale Laboratories
2960 Simms St.
Box 900
Hollywood, FL 33020

Multiplecolor System, Inc.
Box 30730
Jamaica, NY 11430

Multiplecolor System, Inc.
Box 2736
Portland, OR 97208

Red Tag Photo
2214 Pico Blvd.
Santa Monica, CA 90405

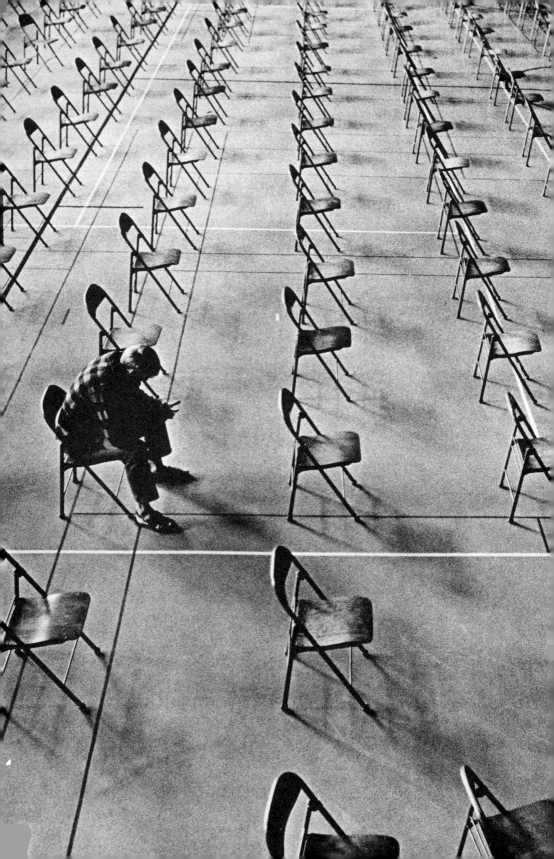

6.
Taking
and Making
Photo
Illustrations

Do You Take
or Make Them?

No book has been written on the subject of photo illustration, yet over the past half century a history of the photo illustration has been recorded in our magazines and books. The photo illustration as we know it today has evolved from a documentary snapshot to a subtle and sophisticated art form. This development can be traced in magazines that have existed for the past fifty years, such as *National Geographic.* Following the progression in bound volumes at the library can be entertaining as well as informative.

As we learn in zoology class, ontogeny recapitulates phylogeny (that is, the stages in the development of the individual mirror those of the species). A photographer entering the field undergoes the same sort of progression. He begins by taking simplistic photographs, similar to the early photo illustrations, and gradually grasps new ideas and technical knowledge and begins producing better and more interesting pictures, until, if he survives, he eventually turns out fine photo illustrations. This evolution is a valuable learning experience for the photographer, but it *can* be accelerated. Here's how.

Many photographers are conditioned to *take* photographs—to reflect the world somewhat as a mirror does. A documentary photographer *takes* a picture. He records things the way they were.

But to limit photography to mirrorlike documentation is to circumscribe knowledge and understanding.

Photo illustration, on the other hand, opens up a vast new field of interpretive endeavor. The fact that photo illustrations are in large measure workaday pictures doesn't preclude innovative and creative treatment of them. Photo illustration allows a photographer to *make* photo-

graphs. The photo illustrator creates a situation as it could be, or as it should be. As we all know, painters rarely paint their landscapes "true to nature." To limit their illustrations to exact duplications of nature would be to confine their creativity and their viewers' enjoyment. They rearrange the elements in their paintings to achieve a composition of wholeness and meaning that earlier did not exist. Jazz musicians improvise on the melody and rhythm of a familiar tune not because they wish to seem clever or self-consciously "different," but because they wish to discover, for themselves and their listeners, new meaning in the music. Photographs, like other expressive media, can offer fresh insights and deep understanding. A photograph can become a telescope/microscope for the viewer to see into and beyond what is being photographed.

All of this, of course, does not apply to photojournalism or documentary photography. It would be dishonest to alter or shape a news photograph that could lead to misrepresentation of a scene or subject.

The line between photo illustration and photojournalism, however, can sometimes be thin. W. Eugene Smith, one of the all-time greats, was once criticized for moving the bed away from the wall for better camera angle in some of his photographs of a midwife for a *Life* magazine story.

Photo illustrators often confront ethical questions when it comes to such improvisation. For example, if you photograph a teenager whose blemishes are here today but gone tomorrow, do you leave them in the picture or retouch them out? Which is the truer interpretation? Are the blemishes inappropriate if you are illustrating the winners in a student government activity or a science fair? Should they remain if you are illustrating nutritional deficiencies, or youth gangs? Or should the blemishes remain, no matter what the context?

The answers are ultimately left to you, the photo illustrator. It might appear to photography purists that allowing free rein to interpretive photography could lead to a lack of respect for the truth. However, before the arrival of the photograph and the photographer, pictorial illustrations came in the form of etchings, cartoons, drawings, and paintings. We accepted the artist's interpretations and managed to survive.

In photo illustration work, then, you are frequently and legitimately *making* a picture, not *taking* it. For example, you see something happen, you feel it was significant, and you would like to photograph it. You have two alternatives:

1. You can hope it happens again in your lifetime, or
2. While you are still on the scene, you can attempt to re-create it, "improving" on it (stripping it of distracting elements) as you do so with your $P = B + P + S + I$ formula.

In photo illustration you can also create scenes that never did happen,

but *could* happen. On an assignment to photograph a child's visit to a toy factory, for example, I realized my little model wasn't at all intrigued with the assembly line production. The bits and pieces didn't look like toys yet; the pounding and banging of the machinery were hurting his ears; the paint smell was disagreeable. Yet I needed to illustrate a small boy's excitement at seeing toys being manufactured. In desperation I wadded a piece of bubble gum (when working with kids, always have a supply of goodies handy) and stuck it on one of the toy trucks as it moved toward the next assembly stage. I stood on a ladder above the moving belt and asked my model to point out the bubble gum as it came into view. He did so with enthusiasm, and I snapped a picture of a delighted youngster pointing at a toy truck on an assembly line. In illustrations, it is true, you may bring elements together that never happened. You are, in effect, contriving. But you can keep your illustrations authentic by selecting situations that *could* happen, and then reenacting them in a way that appears unposed.

Danger Ahead: Trite Pictures

There's a trap waiting for the photographer who is new to photo illustration. Although I continually remind you in this book that workaday pictures are the most marketable, workaday subject matter can easily fall into the trite category—if you let it. Corny pictures are easy to produce. Beware of the temptation to take pictures that are trite, old hat, cute, clichéd.

"There's nothing new. . . !" you're probably saying.

Stop. Think about the pictures in your portfolio, print notebook, or recent slide show. If you were to eliminate (1) the dramatic silhouettes, (2) the sunset scenes, (3) the postcard scenes of mountains and clouds, (4) the portraits of the old men, (5) the father lovingly holding his daughter, (6) experimental abstract shots, (7) etc., etc.—how many pictures would you have left?

I don't want to imply that the above subjects are always trite. We have all seen these subjects treated with compassion, depth, and a sense of beauty. Many of them can qualify as "standard excellent pictures." However, the more photographs we see of these familiar subjects, the less charity we have available for them in our appreciation bank.

The tendency to take trite pictures is almost a disease among photographers—even veterans. Because we see trite pictures every day in local, regional, and national publications, we become conditioned to the status quo. Photographers find an easy way to take a school portrait, a commercial or architectural shot, and gradually lock themselves into an effortless routine that stifles creativity.

Photography, especially photo illustration, has become a vibrant communication vehicle in our daily lives. The public expects not only to be entertained but to be informed by photos. It doesn't take well to

photographs which, like old news, or old jokes, are mere repeats. It wants new insights, angles, and interpretations of everyday subjects.

As an example, let's say a publisher has assigned you to produce a photo essay on "The Circus." Take a scratch pad and jot down ten picture situations that come to mind. Don't read further until you've jotted down at least ten. . . .

That was easy, wasn't it?

Well, if it was, I'll bet you've listed ten trite pictures. Producing un-trite pictures takes a lot of thought.

Before you rush out and snap away five rolls of 35mm film on a subject that every man, woman, and child is familiar with, take at least a half hour to sketch out some picture possibilities. This brief exercise will save you hours of location and darkroom time spent on pictures that would probably be rejected by a publisher. It will also eliminate those blinders we often inadvertently wear when we arrive at a picture-taking locale and become immersed in the scope and immediacy of the situation. Objectivity is easier to retain if you have a preplanned sketch of what you want to photograph before you get there. By the same token, don't go overboard and lock yourself into a plan that has no room for spontaneity and innovation sparked by on-the-scene elements. Try to always be ready for new picture possibilities.

Let's take our circus example:

These shots are not new to us: the clown in his dressing room; the elephant's trunk appearing through the window of the circus moving van; the tightrope walker silhouetted by spotlight against the tent's ceiling; the roustabouts taking a well-earned coffee break; the trainer at work with his chimpanzees; the cleanup crew the day after. We've all seen these pictures—over and over again. Maybe the documentary photographer can be satisfied with such pictures, but not the photo illustrator, nor the photo editor who strives to provide fresh insights, even on such familiar subjects as the circus.

What *do* we want to see in your essay on the circus? The answer will take thought, timing, and preparation on your part. Imagination, luck, and persistence will be important too. You've got to zig when other photographers are zagging. You've got to anticipate. But most important, you've got to show us the circus like we never imagined it could be. (Caution: Please don't interpret this as a license to go out and shoot obscure, experimental, weird-angle pictures in an effort to be different. That would be equally trite.)

What non-trite pictures then will you shoot at the circus? For starters, let's see an extreme close-up of one of those curvaceous acrobats doing pushups in her dressing room. How about a mother with infant in arms happily holding a cotton candy cone up to a clown? Or an overweight father lifting his three-year-old up to touch the bar of the trapeze? How about a backstage shot of a roustabout pumping air into the tire of the

goofymobile while the chimpanzee driver waits nearby. As a photo illustrator you must remember that readers of publications are people, and that people love to watch and learn about other people. You will record how people at the circus relate and react: to the performers (with admiration?), to the animals (with fear or pity?), to the atmosphere generated by the circus (with awe?), to each other (with friendship?). When possible you will include symbols of the circus in your pictures—a trapeze, a cage, a tent—but these will serve only as incidental elements to establish the circus atmosphere.

In most cases you will want to apply the principle of *making* a picture rather than *taking* one. You can reenact or improve picture possibilities by asking the cooperation of spectators or performers. To a clown: "Would you mind taking a bite of that cotton candy again?" To a teenager: "Could I ask you to do that again—over here by the zebras?"

Photography is visual, and you can escape the plague of triteness by constantly *visualizing* picture-taking possibilities. Most successful photographers use this secret, so why not try it out yourself? In free moments, even days before you actually perform your assignment (circus, annual report, political convention, etc.), visualize the thousands of picture-taking possibilities that will probably come up. Eliminate the trite, the corny, and the cute. Concentrate on innovative possibilities that are practical and realistic. (This process will save you on-the-scene time, too.) If you visualize, you'll arrive at your assignment well prepared. Most important: you will have worked all of the tempting-trite pictures out of your system and you'll be able to concentrate on a fresh approach to your subject matter.

Are trite pictures salable? They are. So are trite paintings, songs, and handicrafts. There are also books devoted to making trite photographs. But not this one. If after reading this admonition against trite pictures, you find some culprits in your stock photo file, do this: Send them off to a stock photo agency (see Chapter 12). Professionals are familiar with stock agencies' need to provide "standard trites" to their clientele. One photographer friend says, "I market my best pictures myself, and I dump my clichés on my agency, which can use all I can send."

How Do I Manage the Models?

Marketable photo illustrations are very often pictures of people doing things. How well the people in your picture "perform" can determine the success of your illustrations. The service photographer often has the convenience of working with professional models. In photo illustration, most of your models will be regular folks rather than professionals, and it's up to you to make them feel comfortable and cooperative.

You will encounter many of your models spontaneously in the course of your routine shooting. For the most part children, teenagers, and

adults will willingly cooperate with you for the fun or novelty of being photographed or being involved in the action. People are often intrigued that their picture might be published.

Before you begin photographing your on-the-spot models, let them know who you are and why you want to photograph them. And take the time to make them feel at ease.

Often their first question will be, "What's this photograph going to be used for?" Give your models a direct answer: "For a book. If this photo is selected for publication, you'll appear in a school textbook." Or, "For a magazine [name]."

Or, "For my photograph files. I'm a stock photographer and have a library of my pictures, which I sell to magazines and books." Give some examples of where the picture might be used.

Control the Conversation

If it seems appropriate, explain the mood you are trying to capture in your pictures. Control the conversation throughout the whole picture-taking session to trigger naturally the kind of expressions you're aiming for. Don't let the conversation slip into a subject that is contrary to the mood you are trying to create. For example, if your picture calls for a happy, gay mood, steer the conversation away from war, taxes, the storm or fire that took so many lives last week, or the twenty-car pileup on the freeway this morning. However, if your picture calls for somberness, guide the conversation in that direction.

Relax Your Models

Sometimes, to elicit the right kind of expressions from a nonprofessional model, you'll need to go a few steps further and become an actor—occasionally to the point of an award-winning performance as a clown, demagogue, or saint!

After a while, you'll find in working with people for your pictures that you develop a technique of gentle persuasion. You become adept at moving the conversation along the lines you want it to go.

Be as selective as the situation allows in your choice of models. You'll make your task easier if you choose a model beforehand whose natural style or demeanor comes close to the expression you're aiming for—a serious thinker for sadness or weary expressions, a clear-eyed, optimistic individual for happy shots, and so on.

Here are some tips on how this works in practice:

Happiness. Don't ask for a smile. Instead, maneuver the conversation to some magic questions that always get smiles from—
SENIORS: "Do you have any grandchildren?"
ADULTS: "How's your (golf, bowling, tennis) game?" Or, "Been on a vacation lately?"
TEENAGERS: Teenagers won't usually allow themselves to be catego-

rized. I've found it best to learn the teenager's interests first (sports, music, movies, etc.), and then ask questions in those areas.

PRE-TEENS: "Who's your (boy) (girl) friend?"

SMALL CHILDREN: "What's your (dog's) (cat's) (horse's) name?"

BABIES: If you make strange noises, you'll usually be rewarded with a smile (from everyone!).

Sorrow. Some people look sad naturally (Abraham Lincoln, for example). You can induce a sad-looking expression by asking a model to look tired. Another method is to catch him between expressions. The resulting expression is often pensive and sad-looking.

Intimacy. Shoot from a three-quarter view with a long lens. This will bring two people closer. Ask your models to look at each other's eyebrows. Unless they are pros, models who do not know each other will feel self-conscious, and your resulting pictures will look stilted. For your intimate pictures, choose models who know each other.

Illustration 6-1.

Overcoming shyness. Use a long lens when your model is shy about being photographed. The young Indian girl in Illustration 6-1 refused out of custom (on the Northern Cheyenne reservation in Lame Deer, Montana) to be photographed alone. I asked her brother to appear in the picture with her. The telephoto lens captured her alone on all of the vertical shots. The long lens also brought the teepee (symbol—see Chapter 2) closer. "Don't take my picture!" shy people will often say. To accomplish your mission, try taking a picture of what they are doing, as in Illustration 6-2.

Children are good models and can be diverted in ways that will enhance picture content. They tend to participate more fully than teenagers or adults. A good technique is to get your kid models involved in

Illustration 6-2.

guessing games with you (the type of games we offer our children on long, boring car rides). Kids become animated when they like what they are doing.

Pictures of people sell. Photo buyers know that we're human, that nothing touches us more than a picture of someone feeling something we identify with—be it anger, humor, pensiveness, bewilderment, delight. Thus, when you aim your camera at your models with photo illustration in mind, you've got to adjust your thinking from the cosmetic approach usually employed when taking pictures of people. Your customer is not the portrait client or the bride or Aunt Harriet, but a photo buyer. Editors are not interested in how pretty or handsome you have made your subject look—but what emotion, what spontaneity, what insight into the human condition you have captured.

Should You Pay Your Models?

If you are shooting on speculation for inventory for your stock photo file, many models are satisfied with a copy of the published picture (tearsheet) if and when it is published. Other nonprofessional models are willing to cooperate just for fun or for the experience, especially if you are a beginner yourself. Others are happy to have copies of the photographs. Give *them* your card, and have them write to you. If you do promise photographs, and they contact you for them, follow through.

Monetary payment would be in order for on-the-spot, nonprofessional models when shooting a commercial assignment as a service photographer. A good rule of thumb is to budget a minimum of 5 and a maximum of 10 percent of the fee you are receiving for the picture to pay your model(s). Seal your transaction by obtaining a signed model release.

Other Model Sources

A good source of models is your local community theater. Amateur actors always need portraits for their portfolios. You can trade them some portrait shots in return for their posing (in natural settings, of course) for your people-picture needs (e.g., people talking, interacting, or expressing fear, sadness, loneliness, joy, and so on).

Check also with local families and neighbors in need of family portraits. I often sketch out photo illustration ideas (using my formula $P = B + P + S + I$—see Chapter 2) and have the members of the family act out the photo-illustration situations. In return for their modeling services (about an hour), I supply them with a family portrait.

And What about Model Releases?

Are model releases required for all pictures you take, whether as a service photographer or as a photo illustrator? This question has several answers, depending on the situation.

If you anticipate that any of your pictures might be used for commercial purposes, build a model release file. Print up a 3x5 model release pad, then file the releases alphabetically in a 3x5 file-card box. The model release form shown in Figure 15-2 can be reduced easily to 3x5 size. Make one pad for adults and one pad for minors. An organization such as Associated Photographers International sells model release forms and similar photographer aids. Write them at 21822 Sherman Way, Suite PL, Canoga Park, CA 91303.

Generally speaking, photo illustrations that are not used for advertising, endorsement, or similar commercial purposes do not need a model release. However, if the situation permits, obtain the release. Then, if any of your pictures are used for commercial purposes later on, you will have the release available and not miss a sale.

A general rule many stock photographers (and sometimes service photographers) follow is to use neighbors, friends, and relatives as models. Then they can be fairly sure of finding their models to get a release if they need to in the future.

Occasionally I get a model release request for a picture I took a decade ago. I consult my model release file-card box and usually find I received a blanket model release for an entire family when I originally took the picture. To obtain a blanket release, I had both parents fill out and sign the release, and asked them to list their (minor) children. And what if I don't have a release? Because the model was usually a neighbor, friend, or relative, I can often track them down for the release.

In the early stages of my photo-illustration career, I obtained model releases on every occasion. I have since turned this completely around and almost never get one, because experience has shown me that this

administrative disruption of the mood or atmosphere of my picture-taking session wasn't necessary. Model releases are not required when a picture is used for educational or informational purposes. Unless a picture has definite commercial possibilities, I save getting a model release until it's requested by the photo buyer. Since my personal Market List consists of magazine and book publishers, I rarely get a release request from an editor. However, since your PMS and Market List are different from mine, you will know how extensive you want your model release system to be. (See Chapter 15 for a full discussion of model releases.)

Dealing with Officials

The scene: An important high school football game, and you've arrived to get pictures of the kickoff for your stock file and an assignment. You'll leave as soon as you get the kickoff pictures, so you see no reason to pay admission. You enter by a side gate and are met by an attendant with an officious "Where do you think you're going?" expression.

You're not going to let this fellow steal your precious minutes, so you try to ignore him. You walk right past him. "Wait a minute!" he says, insulted that you have not recognized his importance. He has the right to detain you, and he does—long enough that you miss the kickoff shots.

Sound familiar? It will, unless you keep in mind this photo illustrator's motto: "Officials: Handle With Care."

As photo illustrators, we frequently can't get our pictures without first having to get permission from someone. Security is getting tighter in many sectors, and it's understandable because past abuses—or the sheer numbers of people—have made it necessary to screen *who* takes pictures of *what*. You'll encounter officials in many forms: gatekeepers, receptionists, police, bureaucrats, teachers, secretaries, security guards. You'll even encounter unofficial officials: janitors, ticket-takers, relatives of officials. But no matter who presents himself as an "official" (barrier) to your picture-taking, handle the person with care, allowing for the amount of time you sense will satisfy his need to detain you.

One of the easiest official-eliminators is the "I need your help" routine. In the case of the football gate attendant, you say, "I need your help. I'd like to get a dramatic picture of the kickoff [look at your watch]—could you tell me the quickest way to the fifty-yard line?"

If an official wants to know something about you—why you're here, what the pictures will be used for—here's the answer: "I represent the John Doe Stock Photo Agency, and I'm John Doe. These pictures go into my files of over 5,000 stock photos. They're used in magazines, textbooks, calendars, anything that would *be in the public interest*—you name it! [Smile.]"

Try to cultivate officials who could have access to information helpful to your picture-taking assignment, such as "When will he be back?"

"How many players are on this team?" "What time does the gate close?"

When you encounter an official who isn't cooperative, try offering a copy of the picture you're going to take. But don't take his name on a piece of paper. Such papers either get lost or add to your office work. Instead, offer him *your* card and say, "Here's my address. Write me in about two weeks. The picture will be processed by then." (Experience predicts you have a one in a thousand chance of hearing from him.)

Should you carry a press card? For large, important events, written permission from headquarters is your best introduction to on-site officials (headquarters usually issues its own press cards, stickers, passes). But for the 999 other events you'll attend, officials don't ask for a press card. If you're carrying two or more cameras around your neck (even if they're borrowed from a friend), that's official enough for them.

If you've found "officials" to be a constant thorn in your side, try the handle-with-care approach. However, there's an exception: if you stand to lose too much time by acquiescing to an official's demands ("Wait over there"; "Fill out this form"; "Stand in line"; "I'll put you on 'hold' "; "I have to check with my boss first"), then take a different tack; try a *different* official. In the case of the football gate attendant, if he is uncooperative, walk away and find another gate. In the case of an uncooperative receptionist, wait until she goes on coffee break or to lunch. The replacement might be more agreeable (or you might think of a better approach).

In cases where no officials appear, don't go out of your way to find someone to ask permission from. That someone may have no authority (a waiter in a restaurant, an attendant at a conference); he'll only pass the buck, detain you, and cause delays. Rather than take no pictures (because you didn't have permission), "jump in and start clickin'." An official will usually come forward. Before he gives you *his* routine, give him *your* "I need your help" routine.

You owe it to yourself and the rest of us in the field to carry out your assignments in a professional way and in a manner that will earn the respect of the public.

Special Effects

Some photo illustrations can be converted into interesting new illustrations through the use of posterization, special effects, and line conversion.

Photo editors welcome special-effect photography, providing the pictures follow basic photo-illustration criteria and conform to the magazine's or book's needs.

Special-effect aids are often advertised in photography magazines. Mine came from Edmund Scientific Co. (101 E. Gloucester Pike, Barrington, NJ 08007).

Special effects are often described in photography magazines. For example:

Petersen's PhotoGraphic, September 1977, page 12, "Mirror Images."
Popular Photography, May 1978, page 124, "Color by Laser."
Petersen's PhotoGraphic, October 1977, page 12, "Double Vision."
Popular Photography, October 1979, page 120, "Black Light for Halloween Magic."
Popular Photography, October 1979, page 112, "Through the Mylar Looking Glass."

Illustration 6-3. *A portrait can be converted to line art by using a special-effects screen.*

Illustration 6-4. *For special effect, the highlights were dropped out and the dark grays became solid black to create a high-contrast print.*

Illustration 6-5. *A photocopying machine will often produce interesting effects.*

Illustration 6-6. *Special-effect aids are often advertised in photography magazines. In this case, I placed an 8x10 special-effect "bullseye" negative and glass over the print paper.*

Two magazines are devoted to the darkroom and often include articles on special effects:

Darkroom Photography
609 Mission St.
San Francisco, CA 94105

Darkroom Techniques
Preston Publications
6366 Grosse Pointe Rd.
Niles, IL 60648

The Dramatic-Lighting Formula

As a photo illustrator gearing your pictures to the good marketable shots we've been describing, you may from time to time wish to treat a subject with unusual emphasis. The following comes in handy when you want to employ dramatic lighting with a subject, and will enable you to produce top professional results every time. I call it the "Dramatic-Lighting Formula." To check out the formula yourself, take a *spot meter* to Illustrations 6-7, 6-8, and 6-9. Measure these three areas in each one:

1. The main light falling on the face (M)
2. The shadow side of the face (S)
3. The background (B)

You achieve the most dramatic effect when the shadow side of the face is 2¾ stops lower than the lighted side of the face, and the background is ¾ of a stop lower than the lighted side of the face. You see that in the actual photographs these gradations of light show marked contrast. On the scene, however, at the time you take the picture, there is not a corresponding marked contrast visible to the naked eye. What appears to the eye as very slight gradations of contrast will be definite contrasts in your print. With the aid of a spot meter, you can train yourself to perceive "real life" light differences that are very subtle, but produce high-contrast results in your photographs. To achieve gradations in the face of your subject, use more or less fill light. To get the proper background ratio, move your background closer or further away from your subject, or use a darker or lighter background area.

Here, then, is the formula:

$$P = M + S + B \quad \text{when} \quad S = M\text{-}2\text{¾}$$
$$B = M\text{-}\text{¾}$$

$$P = \text{Portrait}$$
$$M = \text{Main light area of face}$$
$$S = \text{Shadow side of face}$$
$$B = \text{Background}$$

Illustration 6-7. *The formula is most effective when you position your model so that the eye in the shadow side will pick up a glimmer of light. If it does, the light falling on the high areas on the shadow side, such as the cheek, will give your photograph a dramatic dimension.*

Illustration 6-8. *The dramatic lighting formula can be used easily in a "window light" situation. In this case a window blind behind my model served as a plain background.*

Illustration 6-9. *The dramatic lighting formula is effective for portraits. The lighting may not always be flattering to your model, but it will be impressive to photo buyers, who are always interested in photo illustrations that catch readers' attention.*

Measure the light ratios in portraits you've taken in which you were aiming for a highly dramatic effect. Chances are you'll find the light ratio of M to B and S is much higher than in the above formula, resulting in an overdose of contrast, loss of detail, and an actual weakening of dramatic effect. Once again, you don't need to create lighting that gives high-contrast effects to the naked eye, in order to get the kind of dramatic lighting you see in these illustrations. Quite subtle light gradations will give you dramatic contrast on your print, without losing the detail that gives life and breath to your picture.

Some Notes on the Taking and Making of Photo Illustrations in This Book

As I said earlier in this chapter, the photo illustrator not only records things as they are, he often creates situations that could be or should be. You not only will be developing an eye for seeing potential illustrations in your viewfinder, you will often be taking an active hand in the *making* of good marketable pictures.

The pictures I've chosen to head the chapters in this book are examples of photo illustrations with high resale value. Each of them has been published many times by many publishers; each follows the $P = B + P + S + I$ formula. The following are some insights into their taking and making.

Introduction. Photo editors look for "naturalness" in your pictures. Because I used available (window) light and the dramatic lighting formula, the children felt at home, and not self-conscious. Studio lights or flash usually result in a "posed" look with nonprofessional models.

Chapter 1. Photo illustrations are more successful when they *suggest* rather than explain a mood. In this case, I used a telephoto lens and backlighting for effect. I shot ten to one and selected the most successful picture.

Chapter 2. How do you illustrate the isolation of a nursing home? A hundred ways. The somberness of the silhouette in this picture makes a statement. So does the woman's interest in reaching the outside world through her newspaper. Notice the use of the $P = B + P + S + I$ formula.

Chapter 3. Choose your models carefully for their ability to project certain expressions or feelings.

Chapter 4. As a photo illustrator, you *make* pictures. (The documentary photographer *takes* pictures.) Do the bike and dog add to the picture? I thought so, and so did the 18 editors who have bought this picture so far. When a police officer rounded the corner and asked, "Who parked that bike in the middle of the street?" the boys pointed to me and said, "He did!"

Chapter 5. Showing a relationship between elements in a picture is important. This picture might not be a successful portrait, but it is a successful photo illustration.

Chapter 6. Photo illustrations with interesting graphic designs are always welcome with photo buyers. See page 28 for a further discussion of this picture.

Chapter 7. The right moment, and only that moment, is crucial for the photo illustrator. At a ceremony at a Montana reservation, I stood behind these Indian mothers and snapped the picture just as the flag came into my vertical composition.

Chapter 8. Good ideas make good photo illustrations. One day I saw this happen but didn't have my camera along. I made a note in my idea file, and a year later when I found the right situation, made the picture again.

Chapter 9. When a blizzard hit western Minnesota one year, we were staying overnight at a friend's farm. When my friend's wife said, "There'll be no mail delivery today!" I said, "Let's pretend there is." I used the "shoot 10 to 1" rule and this picture best told the story.

Chapter 10. Photo illustration "portraits" are not always flattering, or glamorous. Photo buyers look first for an *illustrative* quality in your pictures. A special-effects technique was used in this picture to give it an engraved look.

Chapter 11. Interesting faces, especially close up, lend themselves well to photo illustration. I took this picture with my 130mm lens on a crowded street in Istanbul. I printed it on number 5 paper to give it extreme contrast.

Chapter 12. What attracted your eye first in this picture? Probably the highlight on the ocean. A successful photo illustration leaves an element of discovery for the viewer—in this case, the bird.

Chapter 13. In Turkey, it is the custom not to allow dogs inside a home. But that isn't necessarily a measure of a boy's affection for his dog and vice versa. I wanted to show this in my photo story and coaxed the dog to the door stoop with some meat while the boy caught his attention.

Chapter 14. Joy, surprise, delight—these are a few of the messages photo buyers are continually seeking for their layouts. Notice how people express emotions (other than through facial expressions), and try capturing them with your camera.

Chapter 15. Seasonal pictures are always in demand. We all know the standard ways of photographing "Winter"—we see them continually at the greeting card stands in the form of Track A pictures. How do you photograph a Track B winter scene? By anticipating, re-creating, or inventing a situation within the context of a winter background. In this case, I knew the bus would be arriving and asked the boys to start walking toward the road when the bus neared their driveway.

Chapter 16. In the formula P = B + P + S + I, sometimes the background can also serve as the symbol. The flag lent itself to a photo story on youth activists. I found the best lighting in the room first, moved the chair to it, and then hung the flag.

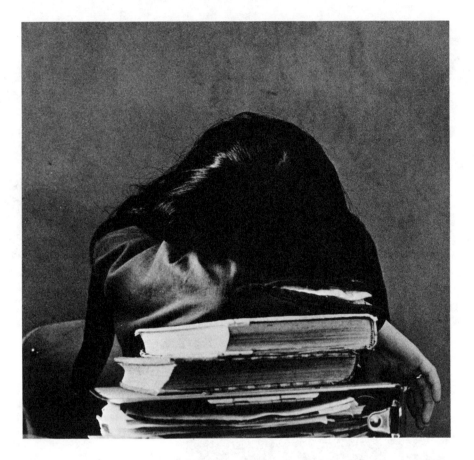

Photo illustrations are successful when they capture a mood that lends itself to magazine article or book themes and topics. This picture has served many books and articles.

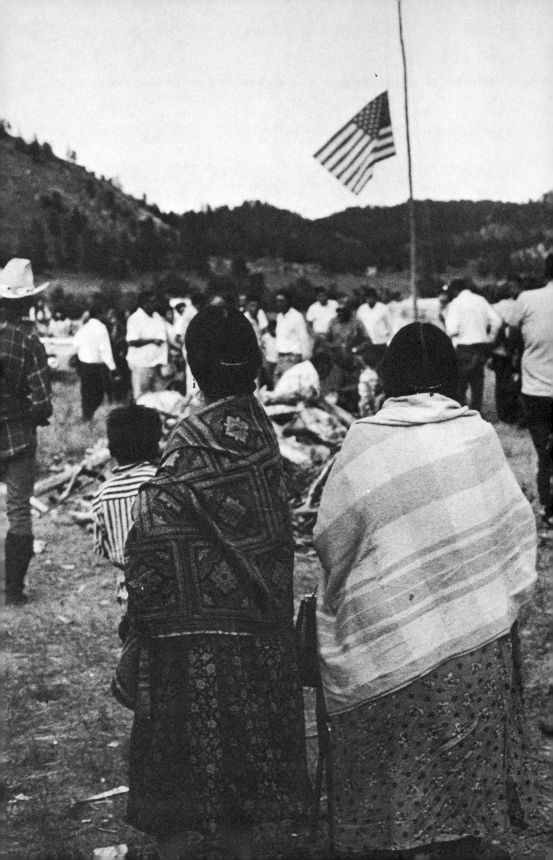

7.

The Fine Art of Dealing with Photo Buyers

Getting to Know Them

Thousands of photo buyers exist in market areas ranging from the commercial, such as advertising and public relations firms, to the editorial (books, magazines, publishing houses). In this book, when I refer to *photo buyers,* I will be referring almost exclusively to those (mainly editorial) who deal with the photo illustrator and not those photo buyers (mainly commercial) who deal with the service photographer.

Art director, picture editor, designer, photo acquisition director—are just a few of the titles bestowed on photo buyers at publishing houses and magazines. Photo buyers usually work out of an office, are usually between twenty-five and forty-five years old, and approve between $1,000 and $10,000 a month in photo purchases; probably half are female, and all are busy people.

Photo buyers tend to mellow with age. Younger photo buyers, new to the job, sometimes exercise their newfound decision-making power by exhibiting impatience or intolerance. Handle with care.

Veteran photo buyers have usually survived the rigors of the publishing world with enough aplomb to be able to take the time to admire a photograph now and then. They've also honed their viewing skills to the point where they can speedily select *the* picture out of a large pile as if by magic. Which brings to mind: Always send a picture buyer more pictures than you believe to be adequate, provided the pictures are appropriate. You'll often be surprised at the pictures the editor chooses. Don't edit your selection (except to delete off-target pictures). Let the editor do the editing.

A visit to an editor's office will bring home to you my adage about picture editors buying pictures that they *need,* not that they like. The

walls of an editor's office are plastered with lovely Track A pictures: prints clipped from calendars or signed originals from friends. Track B pictures, the kind the editor authorizes a check to you for, are rarely on the wall. What editors *need* and what they *like* are different. *Marketing* is understanding that difference.

The Reliability Factor

One paradox in the story of creativity in the commercial world is that those who succeed are not necessarily the most talented. In all creative fields—theater, music, art, dance—talented people abound. But the world of commerce is a machine, and a machine operates well only if all parts are moving smoothly together.

The people who sign the checks will readily admit that *talent* does not head the list when it comes to selecting a new person for a part, an assignment, or a position. History has taught them that "the show must go on," that reliable people make commercial productions a reality. Since talent is plentiful, they can be selective.

Thus, an unwritten law in the world of commercial creativity is the **reliability factor.** How well would you stack up if a photo buyer were to ask, "Are you available when I want to contact you? Are you honest? Prompt? Fair? Dependable? Neat? Accurate? Courteous? Experienced? Talented?"

I placed *talented* at the bottom of the list because that's where most photo buyers will place it. They *assume* you are talented. Their basic question is: "Can you *deliver* the goods—and when I need them?"

Because you are talented in photography, you purchased this book. You knew you could easily compete with the pictures you've seen published. But talent will not be your key to success in marketing pictures. You will succeed in direct proportion to the attention you pay to developing and nurturing your reliability factor.

There are exceptions to everything, of course. Even with a low reliability factor, some creative people succeed. (Witness the temperamental screen idol or the eccentric painter.) But usually they are coasting on previously established fame, or exhibit a unique ability. As a newcomer to the field of photo marketing, your greatest asset will be your ability to establish a solid reliability factor with the markets you begin to deal with.

The Photo-Buyer Connection

You will connect with photo buyers in person, by phone, and in writing, relying primarily on the latter. As a photo illustrator who conducts business via the mailbox, it's important to express yourself well in your communications with photo buyers.

From my overview of photographer/photo buyer relations at the *Photoletter*, I have noted that if a breakdown occurs, it's usually because the photographer didn't express himself clearly, whether in writing, in person, or by phone.

Many photo buyers reached their picture-editor post after serving in an editorial capacity—or continue to do both. They're often journalism or English majors initially attracted to editing and writing because of their communication skills. They have an advantage over the photographer, who frequently enters the field through the nonverbal avenues of art, design, or photographic technique.

In your dealings with photo buyers, if you experience a misunderstanding or mix-up in regard to purchase, payment, assignment, or whatever, here's how to handle it:

1. Give the editor the benefit of the doubt. Despite the harangues we hear from some of our fellow photographers, rarely will you encounter an intentional hustle on the part of a photo buyer. If you are in dispute with a photo editor and you are positive the fault is his, rest assured it was probably an honest mistake. We're all allowed some of those.

2. Be firm, but not offensive. Consider the buyer's self-esteem, too.

3. If you are emotionally upset over a transaction between you and a photo buyer, wait a day (twenty-four hours) before you react.

Remember this: The photo buyer is probably dealing with you because he considers your work valuable, even essential. Don't let a harsh word or irresponsible statement slip out and get in the way of future opportunities to publish your work.

The newcomer to the field of photo marketing is often amazed and sometimes insulted by the casual approach many photo buyers take in their handling of photographers and the photographer's work. To a photographer a photograph can be like a child, an extension of the soul, a piece of poetry or music. Photo editors don't have the same reverence for your work that you do. They can't. You may consider your photograph a work of art; to them it's another piece of work to process. This is not to say they don't admire talent or good photography. They do—most of them. But to survive in their field, they have learned to separate their emotional appreciation from their career demands.

If you take the same approach with your photo illustration—that is, separate and compartmentalize your photography into marketable pictures that will feed your family and not-so-marketable pictures that feed your soul—you will be able to suffer the jolts and inconveniences of photo buyers without feeling they are callous or insensitive.

They usually aren't. They're just doing a job, and usually doing it well.

Should You Visit a Photo Buyer?

If you tailor your marketing plan correctly, your specialized markets will be scattered throughout the nation. Unlike the service photographer who can work effectively with agencies within the confines of a single city, the photo illustrator deals with far-flung editors—mostly through the mail (see Chapter 9).

I myself have dealt with some editors for a decade and have never met them. My reliability factor continues to score high with them. A personal visit would serve only to satisfy our mutual curiosity. Yet while personal visits are not always necessary, they can be a real plus.

Personal visits always help seal a relationship. If my itinerary and schedule permit, I drop in on photo editors when I can to say a personal hello. People do respond more actively to a face than to a letterhead. If you are trying to develop a new market, a personal visit to a key editor could be your turning point. Or a personal visit might help solidify your relationship with a market you've already been dealing with successfully. But you will not necessarily find photo editors eager to set up an appointment with you. Especially if they don't know you. Talent is plentiful. Besides, they have a deadline coming up tomorrow. If they need a photographer, they'll consult their photographer file. They know that personal visits take time—and aren't often immediately fruitful. Their needs are too specific for a general, introductory visit to solve.

Don't make an appointment unless (1) you have sold a picture to the photo buyer in the past, or (2) you have something of value to give the editor, such as information or photos targeted to what you have learned is a current need for him. Photo buyers are understaffed and underpaid. They'll have little reason to welcome an "I'm me and I have photos" visit from you. You'll end up creating a reaction opposite to what you're after and get put on that buyer's blacklist. If you can make your visit worthwhile to the photo buyer, however, you'll be greeted warmly and your time will be well spent.

Realistically, a visit to an editor can be extremely costly for you. In effect you are making a sales call, and in the corporate world a salesman's call will cost out to just about the price of the suit he is wearing. As of this writing, the average cost of a sales visit is $137. If you live close to some markets, those visits need not cost that much. But for your far-flung markets, of course, the cost could be much more.

By working smart, you can cut such costs by diverting funds that might be spent for personal visits toward contacting buyers by mail. Since photo editors buy pictures not because they like them but because they need them, your tailored selection of twenty-five to a hundred prints *mailed* to a buyer will serve the same purpose as a personal visit with your portfolio. Also, your selection will receive more attention from the photo buyer. Dealing with you as a photo illustrator, your

separate photo buyers will not require you to be versatile—therefore, a portfolio that demonstrates your wide range of photographic abilities will not be necessary.

Should You Write?

By far the most effective way to contact and deal with photo buyers is by mail. Chapter 9 shows you how to write the standard cover letter (Figure 9-1) and how to graduate to the "magic" query letter (Figure 9-2) that captures a photo buyer's interest every time. You'll also learn that looking like a pro is a key to the success of any correspondence you have with a photo buyer.

Letter writing is probably the least expensive method of contacting photo buyers. The corporate world tells us, nevertheless, that letter writing is not cheap: each business letter costs about the price of a breakfast at a fast-food restaurant. As of this writing that cost is $4.36. The photo illustrator's letter can be much less expensive, as I'll show in Chapter 9. Because you have narrowed your list to a select group of markets, you'll find you'll need only about a dozen basic letters.

By using the mails for your photo-buyer contacting, you'll also have the opportunity to include self-promotional literature that will serve as an effective reminder to your clients that you exist and can produce what they need.

Your letter, with its unique self-promotion piece, photo example or two, and cordial hello, can provide a pleasant interlude for the photo buyer with a succinctness that a personal visit cannot match. A few such letters over the period of a year will create and sustain a good working rapport between you and the photo buyer.

Is dealing through the mails effective? Take a look at Sears Roebuck and Montgomery Ward—and thousands of other mail-order houses. Granted, we call 90 percent of the solicitations that arrive in the mail "junk mail." But the other 10 percent hits our interest areas—a sale on Tri-X film at a camera supply house, an antique camera catalog— captures our attention, and makes us want to buy.

Editorial photo buyers purchase nearly 100 percent of their pictures through the mail. They expect mailed solicitations. Part of your mail-marketing operation will be to establish a regular, daily letter-writing routine. Depending on the size of your Market List, you will want to write one or more letters a day to editors on your list. Your letter should remind them of your continuing knowledge and interest (expertise!) in their readership area, update them on your trip plans or assignments pertinent to their subject needs, and include a photocopy of a recently published picture of yours. If your Market List is lengthy, a few months will pass before you come around again full circle to the first name on your list. When you do, redesign your letter and your enclosures and

begin again. This might seem like an endless routine to you, like the continual repainting of the Brooklyn Bridge, but this system will reward you over and over. If you have built an effective Market List, your mail program will be effective.

Should You Telephone?

The telephone has evolved from a luxury to an important marketing tool, a tool that must be used skillfully to be effective. The key to successful phoning is understanding the principle of *give and take*. Most photographers, when they call, make the mistake of *taking* only. They take advantage of the photo buyer's courtesy by asking endless questions that could be answered through basic library research. (See the reference and directory list in Table 3-1 and the Bibliography.) They also take the editor's valuable time. They come away with answers to their own questions and leave the photo buyer with nothing.

Multiply such a call by ten times a day, five days a week, and you'll understand why a photo buyer is not interested in talking to photographers. Persistence is a virtue. But it has a reverse effect for photo illustrators who persist in phoning editors indiscriminately.

Here's the secret. Before you make your call, study the editor's needs backwards and forwards, then make up a "give" list. Decide what you will *give* the photo buyer.

How do his needs match your PMS, your personal photographic marketing strengths? You won't be wasting his time when you can say:

—"I'm a bass fisherman and have some excellent pictures of Florida, which I understand you'll be covering in your magazine next August." (Newsletters in the field will carry this kind of advance information.)

—"I regularly vacation in Maine and I'd be available for assignment when you need to update your files of New England pictures."

—"I notice you have a continuing need for classroom pictures. My neighbor is a teacher. With a few guidelines from you I could get the kind of pictures you want."

Once you establish rapport with some photo buyers by showing that you can offer *them* something, they won't mind giving *you* the information that you'd like. They'll also welcome your calls in the future, because they'll know your calls will save them time. Because you have narrowed your photographic interests to your Track B strong areas, you can approach any of the photo buyers on your list with confidence.

Telephoning can be inexpensive when you prepare beforehand by doing your marketing homework to zero in on the editor's needs. Often you can limit your conversation to five minutes. The editor will appreciate this. So will your bank balance.

Because you will be dealing with photo buyers who are in time zones

different from your own, phone them before 8:00 a.m. or after 5:00 p.m. your time, when possible, for savings.

Not every photographer has mastered the art of telephoning. Some are afflicted with "phonephobia." Practice your telephone techniques with a friend or a tape recorder. Professional telephone marketing people tell us to write out our proposed message (script it!), then refine it with rehearsals. Make your first call to a phone buyer for whom you have a strong give list. The conversation will go easily if you are doing all the giving.

As you become more adept at telephoning, contact more photo editors on your list. Your give list might not be equally strong for each editor, but as long as you figure out something to offer, what you pick up in your conversation might lead to picture ideas or subject matter that you can turn into a strong give the next time you call that same editor. As you progress in your telephone-marketing program, make a record of your calls and measure their efficacy. Eliminate those photo buyers from your telephone list who aren't productive for you. As you become more experienced in telephoning, you'll learn how to pick up leads in your conversations that will direct you to future picture-selling opportunities. You'll find it easier and easier to give to your photo buyers as you become more and more familiar with their exact needs.

Get on the Available-Photographers List

Your Track B list probably features several strong areas of special interest ranging from gardening to sailing. You have contacted a number of potential photo buyers in each of these areas, all of whom would like to know more about you because your photographic interests match their needs. They each maintain an available-photographers list in their office. If your reliability factor looks high, you could be on several dozen photo buyers' lists. Here's how you get on a list.

Make a "categories" form letter similar to the one in Figure 7-1, and send it off to photo buyers in your target market areas. Don't give in to the tendency to print only a few categories that match your Track B chart. List them all, but check off only the ones that apply to your PMS and the editor's needs. Photo editors will gravitate to their own immediate spheres of interest and when they find those specific areas checked off, they'll take notice of you. Since you checked few of the other areas, they'll know you aren't dissipating your photographic talents over territory that is of little concern to them, and concomitantly that you must have a lot of material in the areas you concentrate on, i.e., what they specialize in. This is one of the reasons why I suggest you curb your picture-taking in Track A areas and accelerate your Track B areas (Chapter 3). This form letter is another way of showing photo buyers, "I'm the person for the job"

YOUR LETTERHEAD

Dear Photo Editor:

Kindly include my name and work on your photographers list. I have checked off several areas below in which I feel I could be of photographic service to you.

FORMAT AVAILABLE:
- ☐ 8x10 black-and-white
- ☐ 35mm color
- ☐ 2-1/4 color
- ☐ 4x5 color
- ☐ Other: _____

Reproduction fee for one-time North American rights:
B&W's:_____
Color:_____

Holding fee past 2 weeks:
- ☐ I charge none
- ☐ My fee is: Color _____
 B&W_____

SOCIAL
- ☐ Health
- ☐ Welfare
- ☐ Drug abuse
- ☐ Alcoholism
- ☐ Sex education
- ☐ Rights movements
- ☐ Role reversals
- ☐ Juvenile delinquency
- ☐ Other _____

PEOPLE
- ☐ Preschool
- ☐ Elementary
- ☐ Junior high
- ☐ Senior high
- ☐ College
- ☐ Adult
- ☐ Families
- ☐ Senior citizens
- ☐ Multiracial groups
- ☐ Blacks
- ☐ Native Americans
- ☐ Chicanos
- ☐ Orientals
- ☐ Middle Easterners
- ☐ European-American
- ☐ Other ethnic groups_____

- ☐ Customs
- ☐ Holidays
- ☐ _____

SPORTS
- ☐ Basketball
- ☐ Football
- ☐ Baseball
- ☐ Track
- ☐ Other:_____

NATURE
- ☐ Animals
- ☐ Scenic
- ☐ Seasons
- ☐ _____

RELIGIOUS
- ☐ Congregational worship
- ☐ Communion, Baptism,
 Bar Mitzvah
- ☐ Adult education
- ☐ Church school,
 age levels: _____
- ☐ Family worship
- ☐ Religious holidays
- ☐ _____

INDUSTRIAL/TECHNICAL
- ☐ Food
- ☐ Agriculture
- ☐ Industry
- ☐ Government
- ☐ Labor
- ☐ Manufacturing
- ☐ Mining
- ☐ Transportation
- ☐ Communications
- ☐ Fisheries
- ☐ Tourism
- ☐ Entertainment
- ☐ Medical
- ☐ _____

EDUCATION
- ☐ Adult education
- ☐ Primary
- ☐ Elementary
- ☐ High school
- ☐ College
- ☐ Vocational
- ☐ Other:_____

OTHER
- ☐ City life
- ☐ Rural life
- ☐ Environment/ecology
- ☐ Occupations
- ☐ _____

TRAVEL
I have current pictures (within the last five years) of the following COUNTRIES:

I have current pictures (within the last five years) of the following STATES:

(Your Name)

Figure 7-1. A sample marketing "categories" form letter.

The March 1, 1978, issue of the *Photoletter* published an 8½x11 full-page sample of this categories form letter, complete with cover letter, both of which you can photocopy or instant-print, using your own letterhead. For a copy of that issue, send a self-addressed label and $1 to cover handling to *Photoletter,* Dept. 3, Osceola, WI 54020.

The categories letter is appealing to photo buyers because it doesn't call for any action on their part. They can just have it filed for future needs. And it is concise and to the point.

Photo buyers will do one of four things when they receive your letter:

1. Throw it away.
2. File it to have on hand for reference.
3. Phone you because of an immediate need.
4. Put you on their available-photographers list.

The available-photographers list in the photo buyer's office can take many forms—3x5 file cards, a three-ring notebook, separate files, or a computer file. Photo buyers will add notes to your file, such as what they perceive to be your strong areas within their categories of interest. They may also add notes concerning conversations with you, assignments, or a running list of your pictures they have used to date.

Once you are on the photo buyer's available-photographers list, you will periodically be sent a "needs sheet," which delineates the current photo needs of that publishing house or magazine. You'll send your pictures in for consideration at that time. Since the needs sheet describes the exact photos needed, you'll find yourself saving postage and making points by not sending inappropriate pictures for consideration. The photo buyer will welcome your pictures—because they are tailored to the publication's needs.

Since the publishing industry is forever in a state of change, mail your categories form letter to each entry on your Market List once a year. Why? Because some things might change: (1) your priorities; (2) the photo buyer's priorities; (3) your address; (4) the photo buyer's address; (5) the photo buyer.

Whether or not any changes have occurred, this letter is a good reminder about you for the photo buyer. New competition appears on the scene every day. Your letter will keep you and your work in the forefront of the photo buyer's mind.

Selling the Same Picture Over and Over Again

Multiple submission is the phrase often used when photographers submit the same photographs to different publishers at the same time. Unethical? Not at all. The reason? Your Track B pictures will be submitted to specialized markets targeted to different segments of the reading

(viewing) public. There is no cross-readership conflict, especially if your markets are regional or local. In other words, the readers of magazine X never read magazine Y or Z. Feed those statistics into the 10,000 photo-buying markets that exist, and you can see why a photo editor is not too concerned if your photo has already appeared, or will appear, in magazine X.

What's the appeal of multiple submissions to photo buyers? Savings. Most editors don't have the budget to demand more than one-time rights. They know they can get a picture much cheaper if they "rent" the picture from a photographer on a one-time basis.

And the multiple-sales system is healthy for you, the photo illustrator. It will encourage you to research more picture-taking possibilities as well as produce more photographs.

Multiple submission, of course, does not always apply to exclusive national publications such as *People* or *Ladies' Home Journal* who would prefer that you sell them "first rights" to your picture. Nor does it apply to commercial accounts where you have signed a "work for hire" agreement in which you transfer all your picture rights to your client. (This is a procedure I do not recommend to the photo illustrator. More about this subject in Chapter 15.)

But you'll find you can use the multiple-submission system with 95 percent of the photo buyers you deal with. The exceptions will be large-circulation magazines, and most calendar and greeting card companies, ad agencies, PR agencies (service photographer areas), and other commercial firms which require, because of their nature, an exclusive right to or sometimes ownership of your photograph. (But unless a photo buyer offers you a fee you can't refuse, don't sell anything but one-time rights.)

Photocopying Your Photographs

A great boon to photo illustrators has been the practice on the part of photo buyers of photocopying certain of your pictures (black-and-white or transparencies) when you send them in for consideration.

The advantages to you are many:

1. Although editors may not be able to immediately use a picture you have submitted, they might anticipate its future use. A photocopy in their file will serve as your calling card. When the need arises for your picture, the photo buyer contacts you for the original.

2. Some editors might hold photocopies of twenty to thirty of your photos in their central art libraries (see next section). Often as many as ten to forty other editors at the publishing house can have the opportunity to view the pictures.

3. Since your *original* is returned to you, it can be sent elsewhere. Conceivably, photocopies of the same picture can be working for you in

a couple dozen central art libraries at the same time.

4. You incur no costs.

And the disadvantages? Unauthorized use of your photocopies for rough layouts might occur. But that's a small price to pay for the marketing potential your pictures enjoy while on file.

Copyright infringement? There is none. The photo buyers are using your picture for the purpose of research (Sections 113(c) and 107 of the Copyright Law). They are required neither to ask your permission nor compensate you for its use.

A potential disadvantage might occur in the future when the electroopticals of photocopying are refined to the point where it would be difficult to tell the difference between your original picture and the photocopy. But that's in the future, and then again such a technological advancement just might turn out to be a *plus* for the photo illustrator.

Color copiers now exist (at libraries, banks, and instant-print shops) which will make reasonable *color* copies of your slides (twenty 35mm to a sheet). These, or Cibachrome copies, serve as excellent samples to leave on file with your photo buyers. (For information on file prints, see Chapter 5.) For your own purposes, photocopy your slides in color and cross-reference the results in a three-ring notebook as a handy office reference guide to your available color photos. You can also make documentary copies of your negatives if you have access to a black-and-white copier and not a contact printer.

Finally, photocopying has come into its own as an art. Recent exhibitions have featured visuals produced by the photocopying duplication process. Photo illustrators have also produced interesting copies of their own photographs and then rephotographed them, for illustrative impact.

To increase sales, whenever you contact photo buyers—by letter, phone, or in person—encourage them to photocopy your pictures.

The Central Art File

Publishing houses usually start from a modest venture, which then expands, sometimes over several generations. The main thrust of the publisher usually remains the same. For example, automotive publishers expand with things automotive, and so on.

As you research your market possibilities, geared to your photographic strengths, you'll plug into some large publishing houses, many of which employ twenty to fifty or more editors for as many periodicals and/or book specialties! In marketing your pictures to such houses, you of course save yourself time and expense. You need send only one shipment of one set of prints or slides, rather than thirty sets to thirty separate photo buyers.

Large houses have large photography budgets—$10,000 to $30,000 per

month is not uncommon for a large publishing house. If you have done your research well, part of that budget can be yours, because you can supply pictures that fill their needs.

In most magazine or book publishing houses, you'll find a *central art library* (sometimes called the *photo library* or the *photo file*). Incoming pictures are logged by a librarian and then distributed to the appropriate photo editors (or art editors or designers) for viewing. If your picture(s) is selected, the art librarian puts a purchase order into motion and within a month you receive a check.

Color is returned to you, but once your black-and-white is used it is tagged and placed in the central library's filing system, usually by subject, age bracket, or activity. Some libraries will make photocopies and cross-reference them in other related files for possible future use.

"But isn't a used picture less salable?" you might ask. On the contrary. The fact that your picture sold once puts a stamp of approval on it. The next photo editor who comes along and sees your picture in the file, its previous use noted, will be *more* likely to use it since it has received prior approval from a colleague.

You'll receive, generally, 75 percent of your original fee when your picture is used again (and again!). If the repeat sale is for a purpose other than inside editorial use, you should receive a higher fee (see Tables 8-2 and 8-3).

About once a year the art librarian will conduct a spring cleaning of the central art file and return outdated photos to photographers.

The Permanent-File System

Large publishing houses, especially the denominational houses that employ fifty or more editors, are always in need of up-to-date photographs that reflect society. Their need is so great (they produce several dozen periodicals and as many book titles each year) that editors keep a permanent file of black-and-white photographs in their art libraries. These photographs are chosen because of the broad appeal to the particular readership reached by that publishing house. The editors welcome additions to this file to keep on hand for immediate use when needed.

Photo buyers are fond of saying, "Send me pictures that I can always find a place for in my layouts." Of course, it would take a mind reader to score every time, but if you have been successful in selling to a certain market several times, in all probability you have a keen understanding of the photographic needs of that publishing house. Ask all your contacts if they have a permanent file. If they do, submit your pictures for consideration. They can be included in the file, and each time a picture is used you will receive a check.

Can you depend on publishing houses to be conscientious in their dealings in this kind of arrangement? The risk factor of a mix-up in use

and payments is low—when you consider an honest mistake every now and then compared with all those checks you would not have received if you never placed your pictures with the permanent file. Your greatest risk will be investing in multiple prints of your black-and-whites and then relying on your judgment as to which publishing houses would be likely to use them most frequently.

From time to time you'll want to update your supply on file with a fresh batch of photos. From time to time, too, the art librarian will return pictures to you to make room for more recent submissions.

The Pirates

Some newcomers to the field of photo marketing bring with them misconceptions about the ethics of photo buyers. From my conversations and correspondence with beginners, I'm always amazed at how many have visions of picture-buyer pirates lurking in their office coves, ready to seize some unsuspecting photographer's pictures and sell them on the black market.

Such infringers might exist in the field of service photography, where the stakes for a single picture are known to reach impressive heights, but in twenty-one years I have never run across a deliberate case of piracy in the field of photo illustration. An occasional inexperienced photo editor may make an error of omission or commission. Photographers have been known to do likewise. The lesson here is to be cautious when working with new publications that don't have a substantial track record, or publishing houses that have a history of hiring greenhorns.

All in all, you'll find photo buyers in the world of photo illustration reliable and interested in you as a person and a photographer. If you operate with the same attributes, you'll find dealing with photo buyers an easy task.

8.
Pricing
Your
Pictures

Master Your Marketing System First

As I cautioned earlier, it is foolhardy to jump right into trying to sell your pictures before you understand how to market them. *Selling* is what happens naturally, after you do your *marketing* homework. In Chapter 2 I explained the difference between a good picture and a good *marketable* picture, and why (unless you break into that small elite of top professionals) it is next to impossible to sell with regularity to the big money markets.

Rather than rely on luck, selling your pictures in scattershot fashion, use the system in Chapter 3 to tap dozens of markets that will consistently *rent* your pictures from you on a one-time-use basis. Some of these markets have monthly photography budgets of $10,000 to $30,000. Yet they are markets that the "pros" rarely have the time to discover or to research.

Chapters 2 and 3 show you how to set yourself apart from the hordes of photographers all trying to sell the "standard excellent picture"— Track A—to photo buyers who already have hundreds or even thousands of such pictures in inventory or on tap. Chapter 3 explains how to analyze your personal photographic marketing strengths (PMS), and in so doing, immediately become a valuable resource to specific editors.

Be sure, then, to get Chapters 2 and 3 under your belt before moving to this chapter on pricing. In other words, set up your *marketing* strategy first—before you attempt to sell. It will save you time and money spent on postage and packaging that bring only "nice work, but . . ." letters from photo buyers, if they write at all.

Trusting you've done your marketing homework, then, on to pricing your pictures.

Figuring prices need not be a mystery. The system I outline will aid you in keeping your prices professional and acceptable to photo buyers.

It's important to remember that you will be dealing with photo buyers as a photo illustrator (stock photographer), not as a service photographer. Therefore you can enter this field in high gear, provided your pictures are good and your reliability factor is high (i.e., you present yourself and your pictures in a professional way and on time).

Sell and Resell

There is a myth I will ask you to unlearn at this point: "Selling a picture" means selling it once—you can't sell it again.

This myth is perpetuated because it can be true in the field of service photography. It doesn't apply to photo illustration (stock photography).

You can sell your pictures over and over again, because in selling a photo illustration, a stock photograph, you are selling *one-time use* of the picture, not the picture itself. Naturally you must exercise common good judgment, and not submit a picture to three sailing magazines simultaneously, where there could be cross-readership. But you *can* submit the same picture to a sailing magazine, an elementary school textbook publisher, and a denominational publishing house simultaneously. Photo buyers "rent" a photo for one-time use, whether for cover or inside editorial use, to obtain quality pictures at fees lower than they would have to pay to purchase the picture outright. They do not attempt to exercise any controls over where else you might market the same picture—it is understood that you observe the ethics of the business in not sending the same pictures at the same time to publications that are competitors.

Photo buyers recognize that the risk of the same picture appearing simultaneously in another publication is minimal. It rarely happens. In the twenty years I have been submitting pictures on a multiple basis, only one photo editor has been hesitant, and that was back in 1963 when the field was young and editors weren't always familiar with the benefits of "renting" pictures.

The Price Range

Should you set a fee for your pictures and stick with it? If you are a service photographer, perhaps, yes. But if you are selling stock photographs, you'll learn that the different photo buyers on your Market List have different budgets. If you have three hundred potential markets on your list, you are going to find a wide range of fees paid for your photos.

A low-circulation magazine will not have the budget of one with a high circulation. A high-circulation publication sponsored by a non-

profit organization might not have the budget of a low-circulation magazine sponsored by an oil company. Another consideration is advertising. Some trade magazines are heavily supported by advertising. Other magazines with the same circulation figures have little or no advertising and are supported by subscriptions. You'll find the latter category on the lower end of the payment range. You, of course, have the option to choose what markets and what price ranges you want to deal with.

Base Camp: Inside Editorial Use

As a photo illustrator, you deal basically with photo editors, designers, and art buyers at publishing houses. Your pictures are usually bought (rented) to illustrate the editorial content of periodicals or books. You'll find that 90 percent of your pictures go to *inside editorial use* in magazines, periodicals, encyclopedias, textbooks, and trade books. Payment for this type of use spreads across the seven basic fee ranges shown in Table 8-1.

These seven categories reflect the circulations and budgets of the existing market areas, from local newspapers to major magazines and book publishers. If a picture is to be used for a purpose other than inside editorial (for example, as a cover, chapter head, or informational bro-

To apply to publishers and publishing companies for one-time inside editorial use (as of 1981)		
Range No.	**Black-and-White**	**Color**
7	$ 10 to $ 15	$ 35 to $ 50
6	$ 15 to $ 20	$ 50 to $ 75
5	$ 20 to $ 25	$ 75 to $100
4	$ 25 to $ 35	$100 to $125
3	$ 35 to $ 50	$125 to $150
2	$ 50 to $100	$150 to $300
1	$100 to $250	$300 to $500

Table 8-1. *Pricing Guide One.*

chure), you should charge a higher fee, and you can use the above standards to figure what that higher fee should be. (We'll cover how to do this shortly, in Using the Pricing System.)

Which Range for You?

The lower-ranging fees on the chart represent those you will receive from, say, your local newspaper, a nonprofit organization, or a small church magazine. The higher range looks more enticing. I would like to comment on both. I mentioned earlier that you can start your photo marketing in high gear—at the top, so to speak. However, if you are a newcomer to the field of photo marketing, you will find the lower-paying markets a good testing ground. The smaller markets are more likely to tolerate errors as you refine your professionalism. And they offer other pluses: Many of these lower-paying markets are based on special-interest themes that might reflect your own views. Their editors often have small budgets, but big hearts. They are willing to give helpful advice, and to provide you with copies of your published photographs for your files.

Depending on your Track B list and your Market List, you'll probably be dealing primarily with editors in fee ranges 5 to 2.

And why won't you deal with Range 1? Although I've covered this question in Chapter 3, it bears repeating. Range 1 is a closed market. Photo buyers who can pay $100 to $250 (and more) for a black-and-white photograph also enjoy the convenience of having a number of top-flight professional photographers at their disposal, as well as access to the major stock photo agencies. Getting excellent pictures is no problem for them. Nor is the question of cost. The modus operandi of Range 1 markets is to deal with pros they've bought from before, who have established a track record with them. You don't necessarily have to live within the shadow of the World Trade Towers to be included in the stable of photographers of a photo buyer who pays in Range 1, but you do have to have high visibility and a known reliability factor.

If this sounds like a chicken-or-egg situation, it is. It takes an immense investment of time and concentration on the single-minded goal of breaking into Range 1 to create a chance for yourself in this closed market. It can be done, but as I've mentioned before, it requires a freewheeling lifestyle, frenetic work habits, and a willingness to be always on call. Some thrive on it. If your inclinations aren't in this direction, the struggle to break into Range 1 will deprive you of valuable progress you could be making in establishing your own gold mine of markets in the 5-to-2 ranges.

This may sound as if I'm attempting to protect the established professionals. I'm not. They protect themselves by working at their careers ten to fifteen hours a day. Range 1 photo buyers realize this, and when they

award a large commission, they turn to the established service photographers or stock photo agencies who have proven performance records.

Some books say, in effect, "You, too, can start today successfully writing and selling screenplays, television scripts, and songs." I'm aware that some books on marketing photographs similarly imply that it's possible to step right in and sell your photographs to the Range 1 markets. To that I say it's also possible to win a game of chance with 50,000 players. This book—and the pricing system it sets forth—shows you how to avoid such a "sweepstakes marketing" approach, an approach which, from my experience, is nothing short of misleading. Every now and then you do hear about someone new to the field who sold a single picture for $750. My own research shows that most such cases result in small actual return, once out-of-pocket marketing costs, downtime expense, and mental investment are considered. Also the one-picture sale frequently has little bearing on establishing repeat sales possibilities. You can expect a larger return, for less time invested, in selling one of your pictures ten times for $75.

The established pros in the field have a distinct advantage over you in approaching Range 1 markets: their names. (Remember, photo buyers aren't bowled over by a portfolio of excellent pictures. Excellent pictures and talent are everywhere.) But you have an advantage in approaching Range 2-to-5 markets: You can sell pictures of your own choice on your own timetable without changing your lifestyle.

Using the Pricing System: What to Charge

As I indicated earlier, the fee for a particular photograph will vary according to who is using it. This presents the problem, "How do I determine which range to charge a particular market?"

There are three standard answers: (1) Guess. (2) Ask. (3) Research it.

All three are viable alternatives.

Guessing—educated guessing, that is—will become an important tool for you as you progress. You'll be able to "judge a magazine by its cover." Once you know what comparable periodicals and books are paying, you'll find it easier to be on target with your pricing. Figure on using guessing later in the game, after you've racked up some experience.

Asking would be easy if the information were readily given by editors. But photo buyers are sometimes hesitant to reveal such information to unknowns. Some photo buyers, however, provide photographer's guidelines. Write to each photo buyer on your Market List and request a photo guideline sheet. The guidelines (of their picture needs) often include price information. (Be sure to include SASE.) If you approach a photo buyer either by phone or in person, phrase your question this way: "What is your payment range for black-and-white and for color?" Since

photo buyers always work within a given range, you are saying two things to photo buyers: (1) You know something about pricing if you ask for a *range* rather than a set fee. (2) You allow editors to save face and not have to commit themselves (which means you won't be coming back later with, "But you said such and such. . . ."). Editors will usually cooperate when your question is worded in this manner. However, before you embark on your quest for price-range information, review Chapter 7 on dealing with photo buyers by phone, mail, and in person.

The third choice, researching your answer, might be easiest for you. The first direction to turn would be to the marketing directories and reference guides listed in the Bibliography. Remember that fees quoted in a national directory are probably going to be conservative. That is, they will be the lower figure (the minimum) on the pricing guide in Table 8-1.

As an example, let's say in your research you find that the published fee for a black-and-white print for *Golf Today* magazine is $35. You can assume that this magazine will pay in Range 3 ($35 to $50 for a black-and-white, $125 to $150 for a color transparency, inside one-time use).

Many market directories will also give circulation figures, which are invaluable in determining the price ranges of publications that are similar. For example, if *Golf Today* pays in Range 3 and their circulation is 800,000, we can assume that another magazine, *Teen Golf Digest*, with a circulation of 400,000 and with similar advertising accounts, might pay in Range 4. If *National Golf Review* has a circulation of 1,000,000 and stronger advertising support than *Golf Today*, we can figure they probably pay in Range 2 ($50 to $100 per black-and-white or $150 to $300 per color, one-time, inside editorial use). This can give you a base to start from.

Again, the fee ranges in Table 8-1 apply to *inside editorial use*. As I mentioned, if your photograph is used by the publisher for a different purpose, you should receive a higher fee.

Publications, of course, will be local, regional, or national in scope. You should be compensated accordingly. National use carries the most generous compensation, of course, but keep in mind that sometimes a national magazine will be limited to a highly specialized audience and thus yield a lower pay rate. For example, a skydiving magazine would be limited in its impact, even though it might have national circulation. So would a national magazine directed to Baptists or Methodists.

Table 8-2 provides a system for arriving at a fair price to charge for other-than-inside use of your photos, no matter what level of publishing market you're dealing with. Take the price you normally receive for one picture from that market, then multiply it by the factor that represents the purpose the photo will be used for.

For example, if a photo buyer in Range 4 (see Table 8-1) who normally

To apply to publishers and publishing companies when they purchase a photo for *other than* inside editorial use

****Advertising**

National	7.144
Regional	3.155
Limited	2.867
Local	1.621

Annual Reports 1.429

Audiovisual packages

National	1.621
Limited	1.429
Cover	2.859
Advertising	3.155

Brochures

Inside

Limited	1.429
National	2.867

Cover

Limited	1.621
National	2.859

Calendar

Exclusive (limited three-year rights)	2.143
One-time	1.429
World rights	50% additional
Advertising	3.155

Coffee table books (for inside editorial use, see Table 8-1)

Chapter head	1.621
Cover	2.859
Advertising	3.155

Contests (Payment based on contest rules. Allow only limited rights to your winning entry, never all rights.)

****Curriculum**

Chapter head	1.429
Cover	1.621
Advertising	2.143
Montage	negotiable

Decor photography

Sold by an agency

Framed prints	(find out what royalties the competition is paying)
Limited editions	Negotiate

Sold by yourself

Framed prints	(sell to a distributor in volume at one-third his retail fee)
Limited editions	Negotiate, but expect a wide range depending on client, use, and your "name."

****Encyclopedias**

Chapter head	1.621
Cover	2.143
Advertising	3.155

***Table 8-2.** Pricing Guide Two.*

Filmstrips

Educational	1.429
Industry	1.621
Cover	2.859
Advertising	3.155

Gift wrap 2.859

Greeting cards

Exclusive (limited three-year rights)	2.143
One-time	1.429
World rights	50% additional
Advertising	3.155

**Hardcover books

(See also: Paperbacks, Coffee table books, Textbooks, Encyclopedias)

Jacket or cover

National	2.859
Limited	1.621

Chapter head	1.429
World rights	50% additional
Advertising	3.155

**House Magazines

Cover

Limited	1.429
National	2.143

*Magazines

Cover

Limited	1.429
Regional	1.621
National	5.716

Motion pictures

Nonprofit	1.255
Experimental	1.429
Test	1.621
Limited	1.429
Regional	1.621
National	2.143

*Newspapers, news, news services

Cover

Limited	1.429
Regional	1.621
National	2.143

Spectacular exceptions (disasters, etc.): Consult your directories (or the library) to determine competing national news agencies or periodicals and then put the picture up for bids on a limited-rights basis. An agent might be your best bet.

*Nonprofit organization

Regional	1.429
National	2.143
Poster	3.155

Paperback books—editorial (see also Hardcover books)

Cover

National	2.859
Limited	1.621

World rights	50% additional

Place mats

Exclusive (limited three-year rights)	2.143
One-time	1.429
World rights	50% additional
Advertising	3.155

Table 8-2. (cont.)

Playing cards			Puzzles		
Exclusive (limited three-year rights)	2.143		Exclusive (limited three-year rights)	2.143	
One-time	1.429		One-time	1.429	
World rights	50% additional		World rights	50% additional	
Advertising	3.155		Advertising	3.155	

Postcards			Record covers		
Exclusive (limited three-year rights)	2.143		Limited	1.621	
One-time (national)	1.621		National		
One-time (regional)	1.429		Front	2.143	
One-time (local)	1.077		Back	1.621	
Advertising	2.188		Wraparound	4.211	
World rights	50% additional		Advertising	3.155	
			Promotion	1.429	

Posters			*Textbooks (see also Hardcover books)		
Exclusive (limited three-year rights)	2.143		Chapter head	1.429	
One-time	1.429		Cover	2.143	
World rights	50% additional		Advertising	3.155	
Advertising	3.155				

			*Trade publications		
Product packages			Cover		
Limited	1.621		Limited	1.429	
National	5.716		Regional	1.621	
			National	3.155	

Public relations			Video		
Limited	1.429		Commercial		
Local	1.429		Nonprofit	1.621	
Regional	1.621		Limited	2.444	
National	3.155		National	6.152	
			Video disc		
			Educational	1.429	
			Industry	1.621	
			Advertising	3.155	

*For inside editorial use, see Table 8-1.
**Note: A general rule for photographs used in a publisher's advertising campaign: charge 5 percent of the space rate the publisher is paying. Space rate information is available by phoning the newspaper, magazine, etc.

Table 8-2. (cont.)

pays $25 for a black-and-white would like to use one of your photographs for local public-relations use, multiply $25 by the factor 1.429 to come up with a round figure of $35 ($35.725). To figure the fee for the same black-and-white photograph to the same market for use in a *national* advertisement, multiply $25 by the factor 7.144 and you get $175 ($178.6).

For the sake of completeness, Table 8-2 includes uses such as advertising, calendars, record covers, postcards, and video discs; these are all commercial areas that publishers sometimes delve into. (Table 8-2 applies to projects by publishers or publishing companies, not to commercial uses by ad agencies, calendar companies, and the like.) Most often, however, you will use Table 8-2 to figure fees for book or magazine covers, catalog promotions of a periodical or book, chapter heads, informational brochures, and similar editorially connected uses.

Pricing your photographs for cover or other special uses is easy if you follow the pricing guidelines in Table 8-2. The key is to determine the photo buyer's basic budget range. Once you have that, all other prices will fall into line when you use this factor system. Considerations such as inflation or a drop or raise in the photo buyer's fee structure will not be a problem. You simply adjust the price-range number accordingly.

One final word regarding the use of Table 8-2: When you take the appropriate factor, whether you multiply it by the lower or higher figure of a fee range or pick a figure in the middle depends solely on your own experience and/or judgment with regard to that particular market or photo buyer. If your reliability factor has been high with the client and you're confident of the quality of your pictures, aggressively market them. Aim for the highest fee practical (see Negotiating in Chapter 11) that still keeps the door open for future assignments from the same people.

In the end, the buck stops with you. You will have to be the final judge in setting the price. As you gain experience, you will come to know each magazine or publishing house; you will know their photo buyers, and the temper and tone of your relationships with them. All of these factors will help you to fine-tune your pricing.

Within the Price Range, Should You Charge the High End or the Low End?

There's an adage in the business world, "You can always come down in your fee, but you can't go up." For the service photographer this is usually true. As a photo illustrator, it will also be true when you seek assignments. You will want to negotiate for the highest fee (see Chapter 11).

As a newcomer to the field of photo illustration, however, initially you will want to charge the lower figure of the price range. Why? Be-

cause you are an unknown to the photo editor. The editor has little to gain if you charge the maximum fee within the range. He already has a roster of high-priced but familiar photographers with a known reliability factor who would require less time to deal with. But if your pictures are on target and your fee is at the lower end of the range, he can justify the time taken out from his busy day to instruct you in the submission procedures, holding requirements, payment policies, etc., peculiar to his publishing house. Once you have made two or three sales to the photo buyer, test the waters by raising your fee on your next invoice. Since you already know the photo buyer's price range, you know you won't exceed his maximum.

Think in terms of long-range goals. You have done your marketing homework. You know that your PMS is matched with your personalized Market List. By progressing patiently up the pay-range scale, you'll gain experience and eventually become a top-notch contributor to each of the outlets on your Market List.

Second Use of Your Pictures

As a photo illustrator you price your pictures on a one-time-use basis. In effect, you are renting your pictures to the photo buyer. What happens if the photo buyer wants to use your picture a second time? Should he use it free, or at a discount, or at the same fee?

Many publishing houses have set policies on photo reuse. But you can set policies also. For a starting point, you can use the guide in Table 8-3.

Here is an exception to these reuse guidelines: If a publishing house has retained your picture in its central art library and reuses it in a new format, you should expect 75 and not 100 percent. The 25 percent in such

	Percent of original fee
For use in same format as original use (e.g., in a revision, new printing)	75%
For use in an anthology	75%
For use in a new format (a new or different project)	100%
For use as a cover, in advertising, public relations, filmstrip, etc.	See Pricing Guide Two.

Table 8-3. Pricing guide for photo reuse.

a case is understood as a "privilege fee" for holding your pictures in the library; it goes toward the library operating costs and services.

State Your Fee

Always state your fee when you submit pictures to a photo buyer (assuming you've done your homework and can quote a fee you know is within the photo buyer's range). This practice will increase your chances for sales. Why? Photo buyers tell me that one of the main deterrents to purchasing a picture from a submission is that the photographer failed to state a fee in his cover letter.

When I first began submitting photographs, I fell into the hesitancy trap. I hesitated to put down a fee. I believed that by not stating my fee, I would protect myself from aiming too low. I believed that the photo editor would want my picture so much that he would phone me or write and ask for the fee, or better still, tell me what he would pay.

It didn't work out that way. Yes, the photo editor wanted my picture. But he would have to go through the busywork of getting in touch with me (and what if I were out of town?), perhaps negotiate with me, and endure time-consuming back-and-forth for someone he wasn't even familiar with. And he had a deadline to meet. So to avoid those problems, he would use a second-best picture that was available and had a price on it.

The fee you are charging is the most important element in your cover letter (except for spelling the photo buyer's name correctly). If you can't come up with a price you know is within the buyer's range, make an educated guess based on your research. Even a guess too high or too low can result in a sale that you might not have made if you had quoted no fee at all.

Pricing the "Service" Photo

Although this book is written for the photo illustrator, from time to time every stock photographer finds himself involved in a service-photography assignment. Briefly, here are some tips for gauging a fair price for your now-and-then stints as a service photographer.

Two excellent guidebooks exist for the person who sells photography in the following assignment areas: advertising illustration; architectural; general commercial (studio and/or location); photojournalism, photo reporting; public relations; publicity.

The price guides are these:

ASMP—Guide to Professional Business
 Practices in Photography
205 Lexington Ave.
New York, NY 10016

Blue Book of Photography Prices
 by Thomas I. Perrett
Photography Research Institute
Carson Endowment
21237 S. Moneta Ave.
Carson, CA 90745

The ASMP book is a compilation of rate surveys made among the highest-paid photographers in the country. If some of the markets on your Market List are over a quarter-million in circulation, this book could be worth the investment. The ASMP (American Society of Magazine Photographers) is an organization of over two thousand media photographers. (I was a member in the 1960s but dropped my membership when I changed my focus from service photography to photo illustration.)

Service photography, because of the complexities and the high fees often involved, requires extra attention to precision when you negotiate a picture sale or an assignment. The ASMP book will inform you about book-publishing contracts, settlement of disputes, trade definitions, photographer-agency relationships, copyright, stock photo sales, and insurance. It also contains forms (which you can adapt to your own needs) for assignment confirmations, delivery memos, and model releases. Remember, though, that the mission of the ASMP book is to guide the photographer who operates in a city of at least one million population, or who deals with publications of 250,000 circulation or higher. If you employ the ASMP guidelines or forms outside of those parameters, you and your clients might find the experience less than optimum. Keep in mind that it is the *photo buyer* who approves the assignment, initials the proposal, or forwards a statement for reimbursement.

So use the ASMP book wisely. It was conceived and produced for a handful of top pros in the big leagues of Madison Avenue and selected citadels of advertising on the West Coast and in Chicago and Atlanta. A book is always the extended shadow of its author. In this case, the book was written by a committee. Unless you have lucked into a top-paying Range 1 assignment, modify the ASMP guidelines accordingly. (Incidentally, the ASMP underscores that fees mentioned in the book are only guidelines by stating in their introduction, "ASMP DOES NOT SET RATES.")

The ASMP is a group of hardworking photographers who devote their energy and time to setting and maintaining high standards for the industry. As a group they are in a position to exert pressure for the betterment of working policies for service photographers. If you lean toward service photography and would like more information about the ASMP, write to them at 205 Lexington Ave., New York, NY 10016.

The *Blue Book of Photography Prices* has been produced by Thomas Perrett since 1972. Although the *Blue Book* is more costly than the ASMP book, it may be of greater value to you if you are a service photographer and working with accounts that are not prepared to pay the fees suggested by the ASMP.

The *Blue Book* is actually a three-ring notebook, and it's revised every

month to reflect inflation and changes in the industry. Because the book was originally compiled from questionnaires sent to photographers throughout the country, you can be reasonably sure that the suggested prices for architectural, public relations, fashion, and advertising photography are realistic. The book can save you research time as well as dollars by telling you what photographers across the nation actually receive for their service photography.

If you don't wish to invest in either of these pricing guides, you can determine the going rate in your area by a somewhat roundabout route. It's sometimes difficult to get the information from other photographers or the photo buyers themselves. (Unlike photo illustrators who work in their own market and subject areas, and therefore don't compete with other photographers for the same dollar, service photographers very often compete with each other for specific assignments and are not eager to give information out to newcomers.) Do ask other photographers and photo buyers, but do it long-distance—go to a large library and get hold of the Yellow Pages of several cities around the country that are of comparable size to your own. Pick out several photographers and photo buyers and phone them (before 8:00 a.m. and after 5:00 p.m. your time, when possible, for savings) to find out what they consider fair fees. Be sure to establish early in the conversation that you are calling long-distance. The time and money spent in such research will save you hundreds of dollars in either underpricing or accounts lost (assignments missed) because of overpricing.

The Lowest Fee Possible: Nothing

I can't close this chapter without a word about zero-price marketing.

Some publishing houses have no budget for photography. They have budgets for carpenters, secretaries, printers, and the IRS, but they don't budget for you, the photo illustrator.

If you discover some of these nonpaying markets on your Market List, chalk it up to the research and refinement inherent in hammering out a strong Market List, and delete these markets or let them sink to the bottom.

You may wish to let one or two no-pay markets stay in at the bottom, because you feel they'll serve as a showcase for your photography. As a newcomer, you want to build your published-pictures file as quickly as possible. Your credit line beside your pictures will establish your credibility and lead to other sales. Aside from the free-advertising benefit you reap from such publications, you can request copies (tearsheets) of your published picture(s) as "payment." Request a number of these copies, and use them as "stuffers" in your mailings to other prospective photo buyers. (See Chapter 10.) There's also a chance that some no-pay markets may be ground-floor businesses with promise—i.e., markets that

eventually will grow to healthy budgets for photography, and will re-
member and appreciate you when they do (if you keep reminding them
of your existence—it's always up to you to keep the communications
alive).

Once you have attained whatever benefits you sought in allowing
your pictures to be published free, begin working up toward the top of
your Market List, where pricing is healthy and lucrative.

*Joy! to the reader, and also to the photographer—me! Because this picture taught
me how to market my pictures. It was taken fifteen years ago, sold right away,
and has been selling over and over again ever since. Sales from this one picture
have paid for all of my camera and darkroom equipment. Editors use it for
articles on children's games, summer recreation, health, playtime activities,
camping—not to mention articles in textbooks on happiness, sorrow, depres-
sion, and exuberance.*

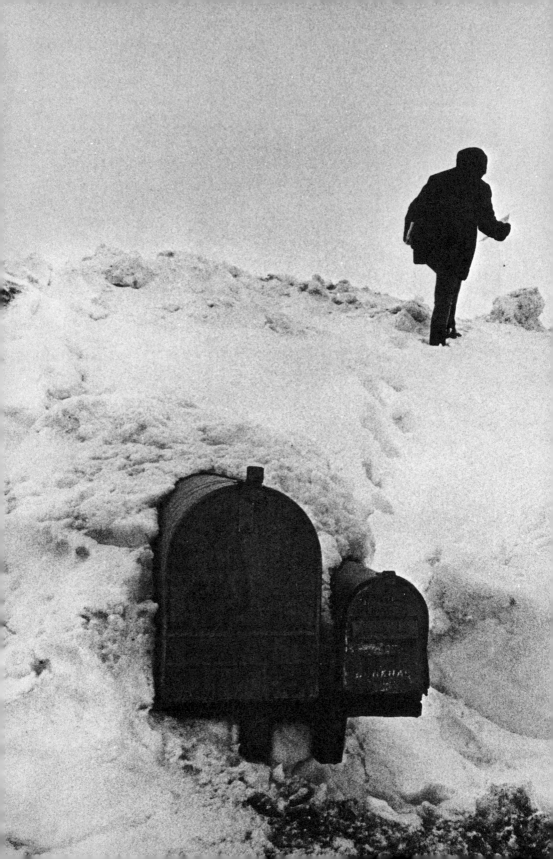

9.
Managing Your Mail-Marketing Operation

Our Postal Service—A Bargain for the Photo Illustrator

As a photo illustrator, you can market your pictures almost entirely by mail. Editors like working this way. It saves them time and it's efficient. For you, marketing by mail is less expensive than costly personal visits. The risk? Minimal. Here at the *Photoletter* I've been engaged in a long campaign to debunk the myth of "photos missing in the mail."

We've all heard horror stories about the U.S. Postal Service, but I've found the vast majority of those "lost picture" stories to be untrue. For example, at my seminars I ask people to describe their experiences with photographs *lost* in the mail. When the facts are laid out, I've yet to discover one case that could be documented. When photos fail to arrive at their destination or return home, it most frequently is the photographer's fault: wrong address, wrong editor, no editor, no zip code, no return address, no identification on prints or slides, poor packaging.

Stock photo agencies and film processors must know something about the U.S. Mail. They have shipped pictures across the nation and the globe for years. Magazines use the postal service successfully, as do Sears Roebuck and Montgomery Ward.

Not that it isn't easy to have a photograph damaged or lost in the mail. Simply ship it out in a flimsy envelope and don't identify it as yours. The odds are you'll never see the picture again.

If there is a risk, it is to *not* send your pictures through the mail. Pictures gathering dust in your files are hazardous to your financial health.

Preparing Your Photos for Market

The first impression a photo buyer has of you comes from the way you package and present your material. Photo buyers assume that the care you've given to your packaging reflects the care you take in your picture-taking and your attentiveness to their needs. They believe they are paying you top dollar for your product. They expect you to deliver a top product.

Sending Black-and-Whites

If your black-and-whites are dog-eared, in need of trimming and spotting, they may miss the final cut. Often excellent pictures never reach final layout boards because they make such a poor first impression that nobody looks beyond it. Your photo illustrations make the rounds of many editors, so check your prints regularly to trim any edge splits or dog-ears. Before submitting black-and-white 8x10s, retouch any flecks. For tips on how to spot your black-and-whites, see Appendix C.

Use plastic sleeves to protect your black-and-whites. These sleeves present a fresh, professional, and cared-for appearance, and hold your prints in a convenient bundle for the editor. They come in 8x10 (or larger) size and are available from the plastic distribution houses listed in the Yellow Pages of metropolitan phone books.

Print Multiple Copies

Successful photo illustrators develop a solid Market List and then supply on-target pictures to photo buyers on that list. To save darkroom time, print several copies of each black-and-white at one session, and distribute them simultaneously to appropriate buyers on your list, or keep them on hand as backups in your files. Use a similar technique for color by shooting several originals of your subject when on the scene. (See Color, Chapter 5.)

Should you send contact sheets as part of your mail marketing system? Only rarely will an editor want to see contact sheets. If you were on assignment, for example, it's conceivable the editor would want to see other selection possibilities. He'll ask you to pre-edit them. Circle with a grease pencil alternative shots. Otherwise, don't display your less-than-perfect pictures by sending contact sheets.

Should you send negatives? If an editor wants your negs, it's probably to make better prints than those you have submitted. Rather than run the risk of damage to your negatives, volunteer to reprint the pictures, or have a custom lab print them. Avoid sending negatives to photo buyers.

Sending Transparencies

To best protect your transparencies, send them in vinyl sleeves. Don't send glass mounts. Editors don't work with them; they're cumbersome,

and they do break. Use slides that have been mounted in plastic or cardboard, or else unmounted. For mounted slides, use the popular vinyl pages that have twelve 2¼-inch or twenty 35mm-size pockets on one page. For unmounted transparencies, the vinyl pages are also useful. Four 4x5s, two 5x7s, or one 8x10 can fit in one page. If you have only a few transparencies to submit, cut the page in half or quarters. Send your selection in a smaller envelope. Single acetate sleeves are another option for protecting unmounted transparencies. They're available at photo supply houses.

When you submit transparencies, you might wish to keep not only a numerical record of your submission but a visual record. Here are two ways:

1. Make a color photocopy (at a library, bank, or print shop).
2. Make a 35mm (black-and-white or color) shot of your slides on your light box. Keep the results on file until your slides are returned.

Some photo buyers don't like mounted transparencies because printers have a tendency to crinkle the transparencies when they remove them from mounts to make color separations. Since editors rarely project your slides, they see little reason to have them mounted. To identify your unmounted slides, fit your information on an adhesive label and place this at the bottom of the protective sleeve or vinyl page pocket where it won't cover the image. If you decide you would like to mount your transparencies at a later date, mounts are available from Kalt Corporation, 2036 Broadway St., Santa Monica, CA 90406.

Inexpensive protective vinyl (or similar plastic) transparency-holder pages are available from:

Plastican Corporation
33 Laurel St.
Butler, NJ 07405

TIE
Box 264
Brownsville, TN 38012

20th Century Plastics
3628 Crenshaw Blvd.
Box 15715
Los Angeles, CA 90016

Unicolor
Photo Systems
Dexter, MI 48130

Identify Your Prints and Transparencies

Identify each of your prints with a rubber stamp on the back that includes: the © copyright notice and your name, address, and telephone number. (Print neatly and lightly so the impression doesn't come through.) Include also your picture identification number (see Chapter 13).

RC papers do not take the standard rubber-stamp ink. Circumvent this by first placing a blank label on the back of your print, then rubber-

stamping the label. Or use spirit-base ink and pen the identification information by hand.

Do not include a date code in your identification system. Editors will recognize the date, and your picture will be "dated" before its time. If slides have a date printed on the side, cover it with a label imprinted with your identification details. If for some reason you need a date, put it in Roman numerals, or use an alphabetical code—for example, A = 1, B = 2, C = 3, etc. The fifth month would be E, and the year '82 would be HB (E/HB).

Captions

Because your pictures will be used as illustrations, not as documentation or news pictures, captions will seldom be necessary. Besides, in most cases the editor is looking for a picture to fit a theme or use he has in mind; he may already have written the caption.

Captions are sometimes necessary for travel pictures or picture sequences. When you need to include captions, type them all on one page, and key them by number to each photograph or slide. Keep a carbon or photocopy for yourself. As a general rule, make your captions brief, and include who, what, where, when, why. The editor will tailor the information to the publication's style.

Before packing up your photographs, give them this checklist test:

☐ **Selection**—Do your photographs fall within the specialized interest area of the editor?

☐ **Style**—Do your photographs follow the illustrative style the editor is partial to?

☐ **Quantity**—Are you sending enough? A minimum of two dozen, a maximum of one hundred. There are exceptions to this, such as the single, truly spectacular shot that you might rush to an editor because of its timeliness or for another reason.

☐ **Quality**—Can your photographs compete in aesthetic and technical quality with photo illustrations the editor has previously used?

☐ **Appearance**—Are your prints and transparencies neat and professionally presented? If your photos don't conform to the suggestions I've given, then hold off submitting. Eagerness is a virtue, but as in any contest, you must match it with preparedness.

Packaging: The Key to Looking like a Pro

Once you have your photos prepared, present them in a professional package. One editor told me that she receives about twenty pounds of

mail every morning. She separates it into two piles: one that she will tackle immediately and a second that she will look at if and when time permits. I asked her how she determined which pile things belonged in, and she answered, "By the way they're packaged."

Your package will be competing with all those other pounds of freelance material when it arrives. The secret of marketing your pictures is to match your PMS with the correct Market List. But if the editor never sees your pictures (because of faulty packaging), they won't get their chance.

Use a packaging system that is trim, sturdy, and stands out. I like to use large white mailers made of stiff cardboard. They give an excellent appearance and have a slotted end-flap, which makes it easy and fast to open and close. Editors can use the same mailer to return unused photographs. (Since you can't be sure the editor will automatically reuse your envelope [or mailing carton as it's called in the industry], have a rubber stamp or label made that reads: "Open Carefully for Reuse," and put it on the flap of the envelope.) The mailers can be recycled several times, since they are made of heavy material and hold up well. (I've tracked down two manufacturers: Calumet Carton, 16920 S. State St., South Holland, IL 60473, and Columbian Safeway Mailer, United States Envelope, Springfield, MA 01101.)

This type of mailer also saves you from having to pack your photographs between two pieces of cardboard, wrap rubber bands around same, and then stuff the result into a manila envelope. When editors have to unwrap this type of submission twenty times a day, you can understand why they welcome a submission in a cardboard envelope, where pictures tucked in plastic sleeves slide in and out easily. Manila-colored envelopes also have the disadvantage that postal workers tend to identify the manila color as fourth-class. This could delay the arrival of your pictures.

Another alternative, especially when you are mailing out large shipments of pictures (50 to 250) is to use the mailing cartons used for 16mm movie films, available at film carton supply houses. Since these cartons are circular or oval in shape, place styrofoam inside and cut a hole 8¼x10½ inches in the center for your prints. Your pictures will be well protected.

As long as we're considering the book-by-its-cover judgment, invest in some personalized, self-apply address labels. Your reliability factor will gain points if your letterhead on the labels is distinctive. Also have return labels printed with your name and address, which you'll include on the inside of your package with return postage for the editor.

How to Send Your Submissions

Unless you subscribe to the UPS service (for a monthly fee, UPS comes

to your house every day for pickup), you will no doubt be sending your package via the U.S. Mail. I have found the mail and UPS equally acceptable. Assuming you will use the U.S. Postal Service, you will find *priority mail* treats your packages with respect, and moves them quickly to their destinations, for the least cost. (Straight fourth-class mail is less costly, but receives rougher handling.) Priority mail is placed in the first-class bin.

If you prefer to insure that a package receives extra care, send it fourth-class, *special handling*. It will cost more than priority mail, but your material will be handled with care. Fourth-class mail, however, does not arrive as quickly as priority mail.

Whether you use priority mail or fourth-class special handling, you might want to consider insuring your package. (The best bargain is the $15 to $50 coverage for under a dollar. Postal insurance rates change, so give your local post office a call for current rates.) Keep in mind that in the event of damage or loss the U.S. Postal Service considers your pictures worth only the cost of replacement film. Your main reasons for getting insurance will be the extra care it guarantees your package and the receipt the delivery person collects from the recipient. The post office will have documentation that your package arrived if you need to trace it. (For under a dollar more, you can also have a return receipt sent directly to you.)

Shipping your photos by registered mail is good insurance, too, of course, but expensive. The lower cost of sending material via fourth-class/special handling or priority mail for regular shipments usually outweighs the speed advantages of registered mail or express mail. I'm aware that many photography books recommend sending your shipment via registered mail. I'm also aware that the authors of those books are not engaged in photo illustration as their principal source of income. Registered mail is expensive.

Be sure to include return postage in your package. Editors not only expect it, they demand it. Some refuse to send photographs back if the return postage is not included. Purchase a small postal scale at a stationery store, and you can easily figure your postage costs at home.

There are two acceptable ways to include return postage (SASE):

1. If you use a manila envelope packaging system, affix the stamps to a manila envelope with your return address, fold, and include in your package.

2. Place loose stamps to cover the return postage in a small (transparent) coin envelope, available at hobby stores. Staple this envelope to your cover letter. This method has the advantage that often the photo buyer will return the stamps to you—unused. You can interpret this as a sign the photo buyer is encouraging you to submit your pictures again in the future.

Writing the Cover Letter

Always include a cover letter in your package. But remember that photo buyers are faced with the task of sifting through hundreds of photo submissions weekly. They don't appreciate lengthy letters that ask questions or detail F-stops, shutter speeds, or other superfluous technicalities. Such data is valid for salon photography, or the art photo magazines, but not in photo-illustration marketing.

If you do feel compelled to ask a specific question (and sometimes it's necessary), write your question out on a separate sheet of paper and enclose SASE for easy reply.

The shorter your cover letter the better. Your personal history as a photographer, or where and when you captured the enclosed scenes, are of little interest to the photo buyer. All you really need in the cover letter is confirmation of the number of photos enclosed, your fee, and the rights you are selling. Let your pictures speak for themselves.

Your cover letter should be addressed to a specific person, whose name you'll find by consulting *Photographer's Market*, or by calling the reception desk of the publishing firm. A typical cover letter might read like the one in Figure 9-1.

This cover letter may not win any literary awards, but it's the kind photo editors welcome. It tells them everything they want to know about your submission.

Photo buyers like to deal with photographers with a high reliability factor—people who can supply them with a steady stream of quality pictures in the photo buyers' specialized interest areas. They don't want to go through the time-consuming process of developing a working relationship with photographers who can supply only a picture or two every now and then. The right cover letter will signal the photo buyer that you are not a once-in-a-while supplier.

To give a professional impression, have your cover letter typeset. If this isn't practical, type it on a carbon-ribbon typewriter, and then have it printed at one of the fast-print services, on 24- or 28-pound business stationery. Include your letterhead and logo for a first-class appearance. Leave the four blanks in your letter to fill in by hand for each submission.

The strategy here is that photo editors will not be offended by receiving a form letter but rather will welcome it as the sign of a knowledgeable working photographer. The message the letter telegraphs is that someone who's gone to the expense of a printed form letter has more than a few photographs to market. If the pictures you submit are on target and you include an easy-to-read, concise form cover letter, you are on your way to establishing yourself as an important resource for the photo editor.

If you have learned of a specific need a photo buyer has (through a

YOUR LETTERHEAD

Dear _____:

Enclosed please find [number] [slides, 8x10 B&W prints] for your consideration. They are available at $_____ (color) and $_____ (B&W)*, for one-time publishing rights, inside editorial use. Additional rights are available. Please include credit line and copyright notice as indicated.

You are welcome to photocopy the enclosed picture(s) for your files for future reference. My name, address, and print no. are on the reverse side of each picture.

I'd appreciate it if you would bring the enclosed pictures to the attention of others at your [publishing house or company office] who may be interested in reviewing them.

You are welcome to hold this selection for two weeks (no holding fee). I have enclosed postage for their return.

Thank you for your attention.

Sincerely,

[Your name]

Figure 9-1. *Sample cover letter to send with submissions to photo editors.*

*It's essential that you state a fee. (See Tables 8-1 and 8-2.)

mailed photographer's memo, announcement in a photo magazine, or listing in a newsletter such as the *Photoletter*), what kind of letter should you send? Again, your letter should be brief. Include many of the details listed in Figure 9-1. However, also include the number or chapter of the book or article for which the photos have been requested. Photo buyers often work on a dozen projects at a time. Knowing which project your pictures are targeted for helps!

Use a form letter if you wish; otherwise, send a neatly typed letter.

Deadlines: A Necessary Evil

Because photography is only one cog in the diverse wheel of a publishing project, photos are necessarily regarded by layout people, production managers, printers, and promotion managers not as individual aesthetic works, but as elements of production value within the whole scope of the publishing venture. Book and magazine editors often have a tendency to treat photography as something that should "support the text" rather than the other way around. Hence they load photo editors with impossible deadlines. If your photographs are due on such and such a date, the photo editor is not kidding. Being on time can earn you valuable points with a photo buyer.

Develop the winning habit of meeting deadlines *in advance*. It will increase your reliability factor, and the number of checks you deposit each month.

Unsolicited Submissions

The word in the street is that photo buyers look upon unsolicited submissions with disdain. This is partly true. If you were an editor of an aviation magazine and I sent you, unsolicited, a couple dozen of my best-quality horse pictures, you'd be righteously perturbed. However, if I sent a group of pictures, unsolicited, that were tailored to your needs, and showed a knowledge of aviation plus some talent with the camera, you'd be delighted, especially if I sent you an SASE for those you couldn't use.

"Most freelancers send me views of birds against the sun or close-ups of flowers, and maybe a kid with a model sailboat. Don't they ever look at our magazine?" an editor of a sailing magazine asked me.

You can understand why some editors have a tendency to lump freelancers and unsolicited pictures into the category of *undesirable*.

With proper marketing, photo buyers will welcome your unsolicited submission. On the other hand, if you haven't figured out the thrust of the magazine or the needs of the publishing house, don't waste your time or postage and earn their ire by submitting random photos to them. Choose a market whose needs you've pinpointed, that you're sure of scoring with.

The Magic Query Letter

If you have advanced to a stage in your photo-marketing operation in which you are prepared to contact multiple markets on your list, here is an introductory query letter system that will prove helpful. This system is designed to hit the right editor with the right photographs. Every time.

When postage was cheap (pre-1975) and photo paper was cheap (pre-1970), photographers used a shotgun method of contacting prospective markets. That is, they sent samples of their photographs almost indiscriminately to any photo editor on any mailing list. Today's economics encourages, instead, the rifle method of reaching editors. That is, narrow down your prospective photo-editor list to a select Market List.

When you are ready to select targets for your query letter, concentrate on the fields of your particular interest, for example: education, medicine, sailing, gardening, botany, automotive, camping. Within your personal interest fields you'll find specialized magazines, specialized publishing houses, specialized readers, specialized advertisers.

The age of the "general audience" magazine disappeared with the weekly *Life, Look,* and *Saturday Evening Post.* Their place was filled by the special-interest magazines, with subject matter ranging from hang-gliding to geoscience to executive health. The diversification continues. Gardeners have their own interests specialized in houseplants, ornamentals, backyard farming, organic gardening, flowers, etc. Boat enthusiasts all have their own special magazines ranging from sailboats to submarines. Horse lovers have their own private reading: magazines on the Arabian, on the quarter horse, and so on. Why venture into fields that have little or no interest to you when you already are a mini-expert in at least a half-dozen fields that could provide you with more than enough markets to choose from?

The key to the magic query method is an initial *query letter* to each prospective editor. What you say in this letter will move the editor to invite you to submit your photographs. (For simplicity I'll use the pronoun *him* throughout, with the reader's understanding that the editor can be him or her!)

The query letter, to be effective, must be brief and simple—yet spur the editor to reply immediately and request your submission for consideration. Here's how to plan your letter, individualized to each market.

You must immediately hit the editor where his heart is: In your first sentence you must include a magic phrase that will grab his attention and rivet him to your letter.

It will take some research on your part, but once you've worked out that magic phrase, not only will your letter be read, but it will be hearkened to and acted upon.

The majority of publications today are designed for specialized audiences. Imagine this as a pyramid. At the base of the pyramid of a special-

interest magazine are the thousands of readers and viewers who are fans of this special area of interest. Next up on the pyramid are the people with an economic interest in this specialized area: the advertisers. Further up are the creative and production people who put the magazine together—the writers, designers, layout artists, printers, photographers, etc. At the top of the pyramid is the publishing management, the people who keep the magazine on track.

At the pinnacle of our pyramid is the concept, the idea or theme upon which the magazine is based.

Now here's the key to that magic phrase. Outside appearances would have you believe that the essence of, say, a magazine called *Super Model Railroading* would be model railroads. It is not.

You're only one-eighth right. (And this is where most suppliers—writers, graphic designers, photographers—lose the trail when they initially contact a prospective editor.) Here's the essence of *Super Model Railroading*: to allow adults the *license* to buy and play with expensive toys.

In the first sentence of your query letter to the editor of this magazine, you would use a magic phrase like this: "I specialize in photographs of people enjoying their hobbies."

Let's take another example. A magazine called *Today's Professional RN* appears to have professional nursing as its theme. Yes, that's the magazine's *stated* theme. But what is its unstated theme—the subject that touches the heart of its readers, and therefore the publication's management? The essence of *Today's Professional RN*: to remind nurses that they deserve the respect and esteem accorded to other community health-care professionals such as physicians, psychologists, dentists, etc.

In the first sentence of your query letter, you would use a magic phrase like this: "I specialize in health-care photography and have in my stock file a large selection of pictures showing nurses playing a key role in our health-care system." The editors of specialized magazines are always looking out for their readers, advertisers, bosses. If the first sentence in your query letter indicates you can help in that mission, the editor will say to himself, "Now here's a person who knows what I need!"

Your job as a query-letter writer becomes one of separating illusion from reality in the publishing world. As you can see, it will take some study on your part. But the study becomes pleasurable if you direct your research to magazines you already enjoy reading. Make a game of distinguishing between a magazine's stated theme and its real theme. You'll be surprised how easily you learn this technique, especially in the magazines on your Market List.

And what is the reaction of an editor who receives a query letter that

shows no preparation on the part of the photographer? He feels insulted. He runs a tight ship. He has deadlines. He tosses the letter into the wastebasket. He's not about to show any consideration to a photographer who has not shown him the courtesy of studying his magazine.

But if you've done your job in your first sentence, and your first paragraph shows you are interested in both the magazine *and* the photo editor, you will have his attention. He will be alerted to your inventory of pictures, but beyond that, a few more ideas will be occurring to him:

1. If you are an informed photographer (in his field) you are a mini-expert and therefore a valuable resource to him, and you could be available for assignments.

2. Although you've said you have certain photographs which you believe to be adaptable to his needs, you might just have many *more* photographs which are adaptable to his needs. For example, perhaps his publishing firm is starting up a sister publication and is on the lookout for additional pictures in an allied area of interest.

The second paragraph of your query letter should confirm the attitude expressed in your first paragraph, namely that you are aware of his photo needs.

And how do you become aware of those needs? By studying the magazines you find in libraries, dentists' offices, friends' homes, business reception rooms, etc. Photo marketing directories such as *Photographer's Market* and those listed in Table 3-1 describe thousands of magazines and list them by special interest areas.

Before you send your query letter to an editor, request his photographers' guidelines. Most magazines provide a sheet of helpful hints to photographers, and if you include $1 with your SASE, they'll send a sample issue of their publication as well.

You are now ready to write the magic query letter. Type it on a handsome letterhead with a clean ribbon. Figure 9-2 shows you a sample of how your query letter should sound.

You'll notice in the magic query letter that there is an abundance of *I*'s. This may seem contrary to your writing style (or training), but those *I*'s are there for a purpose: to give the editor the impression that this new recruit is dynamic, aggressive, and self-centered. (Note: Welcome to the world of business! If being dynamic, aggressive, and self-centered turns you off, you've got to reexamine and adjust your thinking. Timidity, modesty, and humility are nice attributes, but not if you want the world to see your pictures.)

In this letter, there is a good balance with the word *you*. (Most schools of persuasive writing teach that *you* is the "most beautiful word in the language.") Your job as a letter writer is not really to *inform* an editor,

YOUR LETTERHEAD

Dear _____,

 I am a photographer who specializes in* _____
_____ [Note: It's on these lines that you enter
_____ your magic phrase or sentence.]

 May I be of assistance to you? I'd like to send you a selection of my

photographs for your consideration. They are available at $ ** for

one-time rights, inside editorial use.

 I have enclosed an SASE for your convenience. I'd look forward to

working with you.

 Thank you for your attention.

 Yours sincerely,

 [Your name]

Figure 9-2. The magic query letter.

*Or—you could say, ". . . I am a photographer who has a file of pictures that . . . "
**Insert your fee (see Chapter 5).

but to *move* him to action, to make him *want* to see and buy your pictures. The magic query letter will put you leaps ahead of your competition because editors will *act.*

What Are the Heavy Purchasing Months?

Recently I sent out a questionnaire to one hundred photo buyers, asking them which months of the year are their busiest in terms of picture buying. Table 9-1 indicates that the thirty-five editors who responded share one of two prime purchasing periods: midwinter and midsummer. My two decades of experience as a photo illustrator, marketing by mail, confirms that these are heavy purchasing periods for a good proportion of the publishing industry.

Why midsummer and midwinter? At first glance, one might suspect editorial reasons: In midsummer photo editors are buying for the holiday-oriented projects; in midwinter they are buying for the beginning of the next school year.

But editorial considerations don't appear to be the case. My guesstimate would be budgetary reasons. Publishers are working on either a fiscal (July 31) or a calendar (December 31) year, which means cash flow is down in July or December, and up again in August or January.

How does this information help you as a photo illustrator? Moralewise, it might help you to know why those checks aren't coming in during the months of July and December. It can also help you to market more accurately. Your marketing strategy calls for periodic mailings of photo illustrations for consideration. Note in Table 9-1 that you can increase your chances of scoring if you aim at the midwinter and midsummer months.

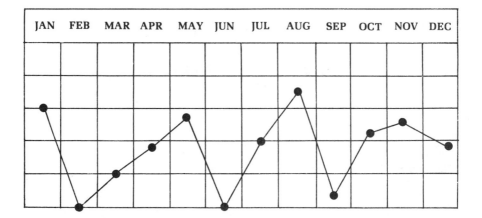

Table 9-1. *Seasonal trends in photo buying.*

But before you decide that you have photo marketing down to a formula, don't forget Table 9-1 represents a sampling of only thirty-five publishing houses. Also, some of the photo buyers, such as Rodale Press and *Highlights for Children*, reported that "All months are equally busy." And what about the peak in the graph in May and the dip in June? I have no concrete explanation, save editors have been known to clear their desks before departing for summer vacation!

If your Market List leans toward textbooks, you'll want to consider this: Many textbook companies work with two different printing dates during any given year—June for the regular September delivery date on textbooks, and December, usually the month of kickoff sales meetings, at which time all new special books and textbooks are presented to the sales staff for the coming year's sales efforts. You can figure that picture selections for books and textbooks are made anywhere from two to four months before the printing date. This average, of course, is relative and subject to variations (both yours and the photo buyer's), so be sure to consider Table 9-1 only as an indication of what happens much of the time in much of the market—to be balanced against your own PMS, your Market List, your experience, and your schedule.

If nothing else, Table 9-1 might help to explain that "slow" payments or "slow" sales do not necessarily reflect a photographer's ability to photograph, or a photo buyer's ability to "pay." To everything there is a season.

Don't forget: When preparing seasonal pictures, check with your individual magazine markets as to their lead time (usually about six months). In other words, be prepared to send springtime pictures in September. Photo buyers usually work that far in advance.

How Long Do Editors Hold Your Pictures?

"The photo editor is holding my pictures an unreasonably long time, don't you think?" a photographer recently asked me. He had sent his pictures six weeks previously.

"Not so," I said. "Especially if the photo editor makes a purchase."

The editor subsequently bought the pictures in question. Everyone was happy.

How long should an editor hold your pictures? Two weeks to two months is a safe answer. Magazine editors, for example, will hold your pictures about two weeks, sometimes four. However, if you've requested in your cover letter that the editor circulate your submission to others at the publishing house who might be interested in reviewing them, and the publishing house is a large one, you may not see your pictures again for six weeks.

If you've directed your pictures to a book or textbook publisher, they could remain at the house for up to eight weeks, since book production

schedules often require more complex dovetailing and coordinating than magazine schedules.

You will not notice how "unreasonably" long photo editors are holding your pictures if you make several duplicates of your black-and-whites and offer them to your Market List simultaneously. If you have made reproduction dupes of your transparencies, offer them simultaneously to several noncompeting markets.

Here are a few variables that can result in photo buyers' holding your pictures for a while:

1. The deadline for the project (textbook, brochure, article, etc.) has been extended, giving the editor more time to make a decision on your pictures.

2. The editor likes your pictures and has set your package aside for further consideration.

3. The editor likes your picture but wants to do a little more shopping, in case he can find something even more on target.

4. The photo buyer has forwarded your pictures to the author (of the textbook, book, etc.) for consideration.

5. The editor's priorities have changed and your picture is now in the #2 (or #6) priority stack.

6. The photo buyer is a downright sloppy housekeeper and your pictures won't surface until spring housecleaning time. (Fortunately, there are very few photo buyers in this category.)

If a photo buyer keeps your pictures longer than four weeks (and you are certain the selection date has passed), drop him a courteous note. You can expect a form-letter reply (letting you know of the disposition of your pictures). Textbook editors hold pictures longer, as mentioned earlier. Usually if a picture lingers at a textbook publisher's, you'll be notified within three months that it is being held for final consideration.

Most editors, however (textbook editors included), when they look over photography (especially general submissions), attempt to review pictures the very same day they arrive, and if none of the pictures are to be considered for publication, the editor will have them shipped back the following day. This makes good sense both for insurance purposes and for office organization. If one or more of your pictures is being considered for publication, the photo editor might hold your complete package until a decision is made.

Again, the best answer to the "unreasonable" length of time a photo editor may hold your pictures is to make several duplicates! Get many, many black-and-white prints and transparencies out working for you, and you'll be so preoccupied with sending them out and reaping the rewards that you won't have time to track down tardy photo buyers.

While your pictures are being held, what insurance coverage does a publishing house have in case of fire or similar calamity? Generally speaking, publishing houses have a blanket insurance policy on your photographs. This blanket policy also includes their office equipment, light fixtures, and other tools of the trade. Your pictures are treated as pieces of paper or acetate, and the insurance covers only the cost of material replacement.

Nevertheless, publishing houses do not like to keep your pictures any longer than they have to, because as long as your pictures are in their possession, they are responsible. Between your place and theirs, the U.S. Postal Service or UPS has that responsibility—if you happen to insure your package. (Note: UPS insures all your packages, free, up to a maximum of $100, but again, will reimburse for loss only to the amount of film or print replacement.)

Using Postcards to Relieve the Agony

If not knowing the disposition of your photos is frustrating to you, take a tip from photo illustrators who include a return postcard with their submissions. The self-stamped card is addressed to the photographer and says in effect that the photo shipment was received by so and so on such and such date.

Another effective contact with a photo buyer would be to affix your letterhead on a memo with the message shown in Figure 9-3. The accompanying postcard reads as shown in Figure 9-4.

A Holding Fee—Should You Charge One?

As mentioned before, some editors must of necessity hold your pictures for several months. This in effect takes your picture out of circulation. If it's a timely picture, such as a photograph of performers who will be in town in two weeks, or a photograph taken at the fair that ends this week, you could lose sales on it. By the time it's returned to you, it could be outdated and lose its effectiveness. To compensate for this the holding fee was born. (Happily, most of your photo illustrations are universal and timeless if you've applied the marketable-picture principles of this book.) Some photographers have been known to charge a holding fee for pictures held beyond two weeks. The holding fee ranges anywhere from $1 to $5 per week for black-and-whites to $5 to $10 per week for color.

To make a potentially lengthy discussion short: Don't charge a holding fee unless you are a service photographer dependent on quick turnover of your images, or you are an established photo illustrator working exclusively with price range 1 (see Table 8-1).

As a newcomer to the field, you'll find, of course, exceptions to my dictum. And you'll have to be the judge when the situation arises. Generally speaking, editors will frown on an unreasonable holding fee and on you, especially if you are a first-time contributor to their firm.

TO:

FROM:

PROJECT:

On _____

I sent _____ [transparencies] [B&W's]
to your office for consideration. Kindly let me know their disposition
on the enclosed return-reply postcard.

Thank you for your interest in my work.

Yours sincerely,

[Your name]

Figure 9-3. Memo to inquire about pictures being held too long.

We have received your (transparencies) (B&W's)

☐ Your pictures were returned to you on _____.

☐ We are still holding your pictures for final selection. You should
hear from us by _____.

☐ _____ of your pictures have been selected. You will receive pay-
ment on _____.

☐ Enclosed are _____ of your pictures. We are still holding _____
pictures for final consideration.

Remarks:

Name Title

Firm

Figure 9-4. Postcard form for editors' reply about late pictures.

Again, the secret to overcoming the possibility of losing sales on your timely pictures: *Make duplicates*, and have several of them out working for you simultaneously. (For information on quality color reproduction duplicates, see Chapter 5.)

When Can You Expect Payment?

Most photo buyers on your Market List will pay on *acceptance* rather than on *publication*. If they don't, drop them to the bottom of your Market List. After all, your PMS matches only certain markets, but you bring to those markets an exclusive know-how that other photographers do not possess. You are an important resource to editors. Be proud of your talents. If some editors don't reward you with payment on acceptance, replace them.

Photo buyers usually send a check to you within two to four weeks after they've made their decision to purchase. However, each publishing house works differently. Some will pay more quickly, others take longer in their purchase-order and bookkeeping procedures. However, if a publishing house has a $30,000-a-month budget and is slow in paying, I'm sure you won't be too irate if the several checks a month addressed to you customarily arrive a little late. There are many publishing houses across the nation with $30,000-a-month photo budgets or close to it, and they're seeking your pictures right now. If a publishing house is late with its payment, spend your energy sending them more pictures rather than composing letters of complaint. If you've built your Market List correctly, you'll find few deadbeats in it.

How Safe Are Your Pictures in the Hands of an Editor?

Contrary to popular opinion, editors do not have machines that split and crack 8x10s, scratch and crinkle transparencies, and sprinkle coffee over both. Your submission will receive professional handling if you are careful to submit only to the professional. If you aren't sure whether a publishing company is new to the field, check a previous edition of *Photographer's Market* or similar directory. If the house was listed three years ago, that's a factor in its favor.

Here at the *Photoletter* I receive occasional complaints from photographers about a photo editor's handling of their pictures. Invariably, mishandling of pictures can be traced to employees of a company new to the publishing business. It's rare that a publishing house with a track record will mishandle your submissions. The reliability factor works both ways. If you find that a publishing house projects a low reliability factor, avoid it.

Lost, Stolen, or Strayed?

Photo illustrations don't offer much temptation to a thief. In order to be

useful, they have to be published rather than hoarded. A stolen photo that's subsequently published increases the thief's chances of being discovered. You'll rarely hear of a "stolen" photo illustration.

Lost pictures more accurately describes a possibility. However, as I mentioned earlier, when a picture is lost, whether in the mail or at an editor's office, the record reveals that it is most often the fault of the photographer.

Here are some common reasons:

1. No identification on the pictures, or identification that is blurred or unclear.
2. Return mailing information missing, incomplete, or unclear.
3. Erroneous address on the shipment to begin with.
4. Failure to include return postage (SASE) when appropriate.

I have talked with many editors who say they have packets of photographs, and single photographs, gathering dust in their offices because the photographers did not include an address on the pictures. Once pictures become separated from the original envelope, the editor has no way of knowing where to return them. Many orphan photographs hang temporarily on photo editors' walls, they're that good!

I myself have lost one shipment in my twenty years of photo illustration. I should say temporarily lost, because after five years the editor's replacement discovered my ten photographs in the back of a filing cabinet. My mistake: sending a shipment to a novice editor.

Loss of your black-and-whites or transparencies is best avoided through prevention. Don't send pictures to photo buyers or publishing houses that have no track record. Prevention is cheap. And it's a good habit to get into in photo marketing.

Your Recourse for Lost Pictures

This is not to say that an honest error can't be committed by a photo buyer. Let's say that some of your pictures are lost, and the photo buyer appears to be at fault. Your best policy is good old-fashioned courtesy. Otherwise, a good working relationship between you and the photo buyer can break down, sometimes irreparably. Don't be quick to point an accusing finger and lose a promising client. Consider the following:

1. Have you double-checked to see if the person you originally sent your picture to is the same person you are dealing with now?
2. Have you waited ample time (four weeks for a magazine, eight weeks for a book publisher) before becoming concerned?
3. Have you asked if your picture is being considered for the final cut?
4. Have you checked with the postal authorities on initial delivery?

If you definitely establish that your picture arrived and is now lost, three options are open to you, depending on who lost your picture, the photo buyer or you.

When I speak of a lost picture, I am referring now to *one* or more transparencies, or a *group* of black-and-whites. Photo editors generally do not expect to engage in negotiations over a *single* black-and-white that they know can be reprinted at much less cost than the cumulative exchanges of correspondence over it between photographer and photo buyer. If a single black-and-white disappears, my suggestion is to accept the loss and tally it in the to-be-expected downtime column.

Transparencies are another story. A transparency is an original. Photo editors are prepared to talk seriously about even a single transparency—if it has been established that they did receive the picture. One excellent way to keep tabs on delivery of your shipments (mentioned earlier) is to insure each package for $50. The post office will provide you with documentation that someone signed for the package.

Another protection is a liability stipulation, which you include in your shipment, to the effect that if the editor loses or otherwise damages your transparency, his company is liable to you for $1500.

Does this latter course seem excessive? Many photo buyers think so, and you get on their blacklist if you try it. There's an old story about Joe Namath demanding a special jersey number, a special footlocker, and white football shoes. The coach just laughed at him. Joe was thirteen at the time. Even Ernest Hemingway at the early stages of his career had to settle for less than optimum contract agreements. So did Van Cliburn, Burt Reynolds, and Ella Fitzgerald.

When you're an unseasoned freelancer, you takes what you gits. Initially, exposure and credit lines are your prime rewards. Only when you have proved to an art director or photo editor that you can deliver the goods, and that he or she needs you, can you call the shots. Until you've proved yourself valuable to a photo buyer or publishing house, you're not in a position to talk liability stipulations.

In this age of malpractice suits, some publishers have become gun-shy because a small but significant number of photographers have aimed at ensnaring companies by pressing suit for loss of transparencies (rarely are black-and-whites involved). Consequently, publishers shy away from dealing with new and untried photographers, or they take precautionary measures with them such as having the photographer sign a waiver that in effect releases the publishing house from any or all liability.

That's why it's important to discern who's doing the talking when you hear ol' pros advise that "you ought to require photo editors to sign liability agreements." When the pro advises you to get a liability release from the publisher, he just might be using one of the tricks of the trade

(any trade) to eliminate competition. They know that photo editors will steer clear of you if you summarily present them with a liability requirement. Or it might be an ego trip for the pro to suggest that you get the release. Only the known and the best can make demands, as Joe Namath eventually learned.

The service photographer and the photo illustrator may have different attitudes toward this liability problem. As a photo illustrator, your interest in photography as an expressive medium differs a lot from that of the photographer who concentrates on photography as a graphic element in advertising, fashion, or public relations. The service photographers' rights to sell their services and to protect their business with holding fees, liability terms and conditions, and so on, should be honored. But their business is not stock business, and their markets are not stock markets, when it comes to dealing with photo illustrations. Yes, of course, if you're dealing with an editor in Range 1 (see Table 8-1), you'll probably arrive at some mutually reasonable liability agreement before too long. If you deal with editors in Range 7 the subject may never come up.

How Much Compensation Should You Expect?

The compensation you should expect from a photo buyer for a lost picture is relative to several factors: (1) the value of the picture to you and to the photo buyer; (2) the anticipated life of the picture itself; and (3) which price range (1 to 7) the photo buyer is in. I have talked with photographers who have received compensation ranging from $100 to $1000 for an original transparency. A good rule of thumb would be to charge three times the fee you were originally asking. If the lost transparency is a dupe, only the cost of replacement would be in order. One final consideration: Each photo buyer can be a continuing source of income for you. How you handle these negotiations will influence how much of that income continues to come your way.

If you are still not convinced that a liberal policy toward a photo buyer's liability is sound, consider this: Two other entities also handle your transparencies, the film processor and the delivery service (U.S. Postal Service, UPS, Federal Express, etc.). None of these organizations will accept liability for your transparencies (or prints) beyond the actual cost of replacement film and paper. You've seen this in small print, but as a reminder, see Figure 9-5.

(These notices are all from reputable film-processing companies.)

Neither the U.S. Postal Service nor UPS will award you more than the replacement cost of the film or prints. If you've insured your package for the intrinsic value of your pictures, in the event of damage or loss the UPS or U.S. Postal Service will want to see a receipt establishing that

LIABILITY: Submitting any film, print, slide, or negative to this firm for processing, printing, or other handling constitutes an AGREEMENT by you that any damage or loss by our company or subsidiary, even though by our negligence or other fault, will only entitle you to replacement with a like amount of unexposed film and processing. Except for such replacement, the acceptance by us of the film, print, slide, or negative is without other warranty or liability.

Customer's film is developed by_____
_____ without warranty or liability of
any kind, except to furnish the customer with replacement film at least equivalent in number of exposures to negatives lost or damaged in processing.

NOTE: Responsibility for damage or loss is limited to cost of film before exposure.

Figure 9-5. *Liability notices.*

value. If you don't have one, they will pay you only what it would cost you to print the pictures again, or have a duplicate made. The insurance would not cover sending you back to France to retake the pictures.

Such harsh terms should be encouragement to you to *prevent* loss of your film or pictures by packaging them well.

If you have arrived at a point in your own photography career where you'd like to test the reaction of your photo buyers to a Terms and Conditions Agreement form, write for a current copy of *Business Practices in Photography* ($15) to the American Society of Magazine Photographers (ASMP), 205 Lexington Ave., New York, NY 10016. It includes the following sample forms (which you can photocopy or modify): Assignment Invoice, Stock Photo Submission Sheet, Stock Pictures Invoice, Model Release, and Terms of Submission and Leasing (which lists the compensation for damage or loss of a transparency at $1,500). For readers who would like to know more about assuring their rights when a transparency or shipment of black-and-whites is lost or damaged, here are three references.

Law and the Writer (see page 99)
Kirk Polking and Leonard S. Meranus,
 editors
Writer's Digest Books
9933 Alliance Rd.
Cincinnati, OH 45242

Photography and the Law (see page 48)
George Chernoff and Herschel B. Sarbin
Amphoto Books
1515 Broadway
New York, NY 10036

Photography: What's the Law? (see page 94)
Robert Cavallo and Stuart Kahan
Crown Publishers, Inc.
One Park Ave.
New York, NY 10016

Remember, the key to successful marketing of your pictures lies in effective communication with the people who approve payment of your pictures—the photo editors.

A Twenty-Four-Point Checklist to Success

Sending out a submission to a photo buyer? Run your package through this quality control:

Packaging

1. ☐ Clean, durable outside envelope.
 ☐ Correct amount of postage.
2. ☐ Professional-looking label.
 ☐ Address is legible and correct.
3. ☐ SASE enclosed.
4. ☐ All photos identified: picture number, plus name and address.
5. ☐ Copyright notice.
6. ☐ No date on your slides or 8x10s (unless you use a code).
7. ☐ Captions, when appropriate.
8. ☐ Transparencies: in vinyl pages.
9. ☐ Cover letter (printed form letter) is brief, on clean, professional stationery.

Cohesiveness

10. ☐ Solicited submission: Pictures are on target as per request of photo buyer.
11. ☐ Unsolicited submission: Pictures follow style and subject of photo editor's publication. They fit the photo editor's graphic and photographic needs.
12. ☐ Pictures are consistent in style.
13. ☐ Pictures are consistent in quality.

Quality

Color

14. ☐ Color balance is appropriate for subject and is suitable for reproduction.
15. ☐ K-25 used for outdoor 35mm.
16. ☐ Dupes are reproduction quality (with proper filtering) or else identified as display dupes.
17. ☐ No glass mounts.

Black-and-White

18. ☐ Good gradation: stark whites; deep, rich blacks; appropriate gradations of grays.
19. ☐ Spotted.
20. ☐ Trimmed: Edges are crisp and straight; no tears, dog ears.

Both Color and Black-and-White

21. ☐ In focus, sharp, good resolution (no camera shake).
22. ☐ Current (not outdated).
23. ☐ Appropriate emphasis and natural (unposed) scenes.
24. ☐ $P = B + P + S + I$

Can your subjects look straight at the camera and still result in an effective photo illustration? Yes—but not always.

10.
If You Don't Sell Yourself— Who Will?

Promoting Your Photography: How to Blow Your Own Horn

The greatest hurdle in the area of self-promotion, it seems, is not *how* to advertise oneself (many clever and creative methods are open to you), but the reticence most of us have to "self-advertising." We're uncomfortable talking about ourselves in glowing terms, afraid of seeming pushy or immodest.

Many a talent has gone undiscovered because he or she failed to act on the salient reality: if we're going to be discovered, it's *our* job to orchestrate it. The number of talented photographers in this country alone must run in the hundreds of thousands. Picture the Bronx telephone directory, and then imagine that all those names are modest, talented photographers and your name is among them. It would seem preposterous to think that the world of its own accord is going to come along and pick you out from all those other fine talents, wouldn't it? Sometimes it's actually immodest to be modest.

Society has ingrained in us the idea that unless we exhibit an acceptable degree of self-effacement, we won't be thought well of. ("He's so conceited!") ("She's stuck on herself!") ("What an ego!")

But the viewing public deserves to see and enjoy your pictures. You deserve to have your talent rewarded with what allows us to survive in today's world: money. You must overcome the conditioning our culture lays on us and accept the fact that if your photographs are going to be seen and enjoyed, you are going to have to blow your own horn.

With good judgment you can accomplish this and come off looking

not like an overbearing egomaniac but like a talented business person who knows how to keep his product in the marketplace.

Here are four tips that should help you maintain your resolve to promote yourself—and to keep on promoting:

1. Many photographers, once they have achieved a name in their local area, lull themselves into supposing that the *world* is aware of their work. Not so. Think big. Don't just toot that horn, *blow* it.

2. If you want your photo illustrations to continue selling, you have to continue selling yourself. Horn-blowing is an ongoing task. Don't be satisfied that photo editors, or potential clients, are going to remember you next week because of your success with them last week or month. Today's successes are past history tomorrow.

3. Once you begin to promote yourself, you will be pleasantly surprised to find that the people you thought would be highly critical of your promotional efforts will actually be the first to compliment you.

4. Because part of your motivation as a photographer is to share your insights, your vision of the world, with others, you will find that the rewards of promoting yourself (and therefore your photography) will far outweigh the personal discomfort you sometimes feel when writing and distributing press releases about yourself or enclosing tearsheets of your triumphs with business correspondence. Without such promotion, you leave yourself at the mercy of chance. Sure, a few photographers are going to make it by sheer luck alone. Someone always wins the Irish Sweepstakes or the $200,000 jackpot at Atlantic City. But the majority of photographers who become successful have managed it by means of effective self-promotion.

Look like a Pro Even If You Don't Feel like One Yet

This applies to everything from your stationery to your flyers. The adage at work in this business is *Appearance communicates quality of performance.*

Your new contacts in the photo-marketing field, since they rarely meet you in person at first, will rely heavily on the appearance you project via your communication materials. Your photography speaks for itself. Your promotional material speaks for you. It tells photo buyers how serious you are about your work—whether you're a good bet to be producing the same fine photography next month, or next year, at an address they can reach you at (your reliability factor). Photo buyers assume that your performance and dependability will match the quality of your presentation.

As publisher of the *Photoletter* I have the opportunity to see numerous creative methods of self-promotion. I've included some examples in the following sections. They'll give you an idea of the possibilities open

to you: producing brochures of photo samplings, making catalogs, enhancing your stationery with examples of your work, designing a distinctive logo. Limitations of space preclude my showing many more fine examples.

Your Personal Trademark

Your photography itself becomes your trademark once you get established. But before you reach that point, a trademark may very well be an important element contributing to your success. A distinctive logo or design can help your correspondence start looking familiar to editors—and your name to start being remembered.

When you design your symbol, or logo, be aware of a common error: the temptation to use the obvious—a camera, a tripod, a piece of 35mm film, etc. You may of course want to choose from things photographic, but try for a combination or adaptation that's all your own. Make it simple, and easy to remember. Recruit that graphics student, or friend who's good at designing, drawing, or critiquing your work. Let them help in the decision, based on the pointers mentioned above. Flip through the Yellow Pages or a business directory to see how others have tackled the question of logo. Don't be too "cute" in your design—the novelty will soon wear off, or even be offensive to clients. Don't be obscure, either.

If your photographs are highly specialized in one area, be specific with your trademark. If you are a nature photographer, you can choose a design that reflects your photography—a silhouette of a fern or a close-up of a toad. Children's photographer? Choose a classic shot of yours that lends itself to a simplified sketch or drawing. As your photo-marketing enterprise grows, you'll be building equity, exposure, mileage, in your trademark. Decide your specialty early and produce a trademark that will cause editors to say, "Aha—he's a transportation photographer," or "She's a tennis photographer." However, don't worry if you don't have a strong specialty yet. You can work gradually toward becoming strong in one or two defined areas on your PMS list, and then alter your trademark from a more general design to one tied into your specialty.

Your personal trademark doesn't necessarily have to include a design (logo) or photograph. It can also consist of the name you give to your photo illustration business, with or without an identifying design. The name can be your own name or the product of your imagination. Choosing your trademark is like naming a child. The result is here to stay. Do it carefully.

It's not necessary to formally register your trademark, but if you wish to explore the process to insure that no one will copy your design, you can write: Trademarks, Superintendent of Documents, U.S. Govern-

ment Printing Office, Washington, DC 20402, and enclose $1 (price subject to increase).

Your Letterhead

Your letterhead is often your first contact with a photo buyer. Put special care into designing it. For your lettering, try the distinctive press-on letters available in stationery and art stores rather than the routine typefaces available at the printers. If you have a general mood running through your pictures, match it with a typeface that has the same feel to it. And consider incorporating a carefully chosen sample of your photographs themselves in the design. Barter with a graphics student to conjure up some ideas for you to choose from. Outside help is usually more objective.

Envelopes

Make your envelope a calling card. How to decide which photograph you should use on your outside envelope? Use one that (1) commands attention and (2) reminds photo buyers and the public of your specialties. If your specialty is agriculture and an extensive portion of your Market List includes publications in the area of farming, a strong agriculture photograph will serve well. Keep in mind the purpose of your envelope promotion. You want your name to become synonymous with agriculture photography. When photo buyers in the farm-publications industry ask themselves, "Who has good agriculture pictures?" you want your name to come up.

And what if you have two or three specialties? Print two or three different envelopes targeted to the different segments of your Market List.

Business Cards

A distinctive business card will keep your name circulating. They're inexpensive, and any printer can produce them. But don't fall into the trap of acquiring a couple thousand business cards that are cheap-looking and indistinguishable from your competition. Make your next business card something people will remember: a photograph (see Figure 10-1).

Build a Mailing List

The core of your operation is your Market List—the list of your photo buyers—past, present, and future. Your promotional mailing list should start with your publication Market List. Now begin to extend it to camera columnists, local galleries, photography schools, camera clubs, camera stores, radio and TV stations, and newspapers that will receive the press releases you'll periodically circulate.

The question naturally arises: Should these names and addresses be on several different lists or one major list? Generally speaking, it's better

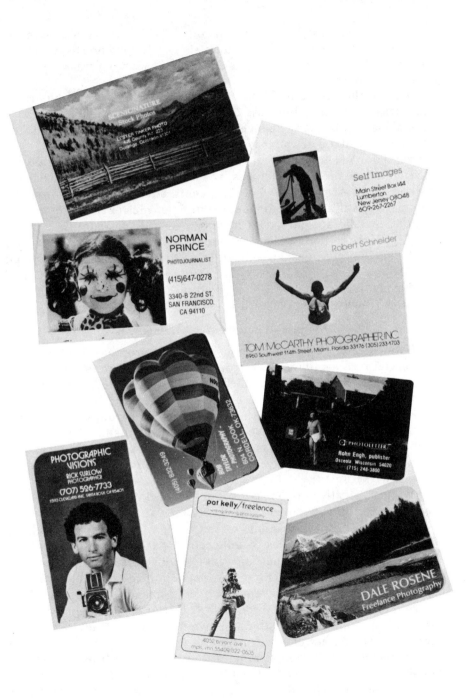

Figure 10-1. *Photographers' business cards.*

to maintain one master list. You can code by color or symbol all those that are markets, those that are columnists, etc. Having one list will help you avoid duplication in mailings and time-consuming tracking when an address changes.

Compare the problem if you had a friend's name on your current Christmas card list, a business firm list, a potential client list, and a general mailing list. Any change in address would have to be made (or possibly missed) on all the lists.

Keep your list faithfully up to date. Print "address correction requested" on all of your envelopes. The cost from the Postal Service for the correction is currently twenty-five cents, but it's worth it. Whenever you make a mailing, code the mailing on your master list with a color, symbol, or date so that you'll have a means to measure how many mailing pieces certain markets or columnists, etc., are receiving. If your list is on computer, design your program to anticipate categories that may be useful in the future, such as number of sales per individual market and type of sales (book, curriculum, magazine, etc.). Clean your list often (i.e., weed out changed or no longer useful addresses).

Mailers—They Pay for Themselves

Probably the most cost-effective means of self-promotion is the use of mailers (also called flyers, inserts, or stuffers). These promotional pieces are similar to brochures (described later in this chapter) and serve the same purpose, but they are less elaborate, thus less costly, and you can make them yourself if you wish. They consist of a grouping of some of your pictures, in whatever size you wish to make them.

In my own business, I use mailers as my principal form of advertising. I send them out regularly every three to six months to the photo buyers on my Market List.

My most effective mailers consist of eight prints reduced together to 3x9. Each group conveniently fits in a No. 10 (business) envelope.

Rather than print the mailers myself, I send them out to a studio in Minneapolis which handles volume printing accounts. They shoot my eight pictures on an 8x10 neg and mass-produce the results.

I order 250 and mail 100 out to a portion of my Market List. They usually cost from fifty to seventy-five cents apiece, but they invariably pay for themselves because a good percentage of the photo buyers either see a picture on the mailer that they want to order or they're triggered into requesting other photos from me.

The remaining 150 mailers remain at my desk to stuff into my regular business correspondence with potential as well as current photo buyers. You can add other inserts to bring attention to your photography: press releases, tearsheets of news about you, change-of-address notices, announcements, and press kits.

Other types of mailers are 3x5 or Rolodex-size cards (2¼x4 in various

colors) with promotional reminders on them. Rolodex cards are available through Graphcote, 91 Ingraham St., Brooklyn, NY 11237.

Brochures

Design and produce a professional-looking four-page brochure—that is, one large (8½x9½) sheet folded once. It'll be a showcase for you, and it will pull in sales and assignments. Use as guides the brochures or pamphlets found in airline or travel offices. Such a brochure usually pays for itself, whether you invest $100 or $1000. My advice, if you have the cash, courage, and marketable pictures available, is to bend your budget and produce a full-color brochure aimed at a specific market that has both the need for your PMS and a pay rate that will make it worthwhile. How many photographs should you include? Look at other brochures to see which appeal to you most. When you find one, adapt the design, using pictures you think will appeal to your Market List.

How many brochures should you print and where? Take your mock-up to several four-color printers for quotes on one, three, and five thousand copies. The quantity depends on the size of your market. I've always found it's better to print more than you think necessary. It's cheaper per unit, plus you discover new uses for your brochures once you have them.

Such brochures need very little copy. Put your photographs into the space. About the only words you'll need are your name, address, and phone number.

Catalogs

Have a catalog printed displaying a selection of your photos based on your PMS. Assign numbers to each picture. Three-hole punch the left side of each page. Send it to current and prospective editors (Figure 10-2).

The cost for this 8½x11 black-and-white, eight-page catalog is currently "$600 for 3,000 copies," says Robert Maust of Harrisonburg, Virginia. "That amount was paid off in sales directly related to the catalog in only a few months."

Here's how to put together such a catalog: Place sixteen verticals or fifteen horizontals on one page. Using 8x10s, make a huge paste-up of each half of the page. The printer shoots it in halftone, reduces it, shoots the other half, tapes the upper and lower halves together, and prints.

Another type of catalog useful in promoting current pictures to prospective photo buyers is one displaying a group of actual prints (8x10s). Punch holes down the left side of the prints, and bind them in a plastic binder with covers front and back. I assemble seventy-five double-weight pictures of a particular category and include an invoice form.

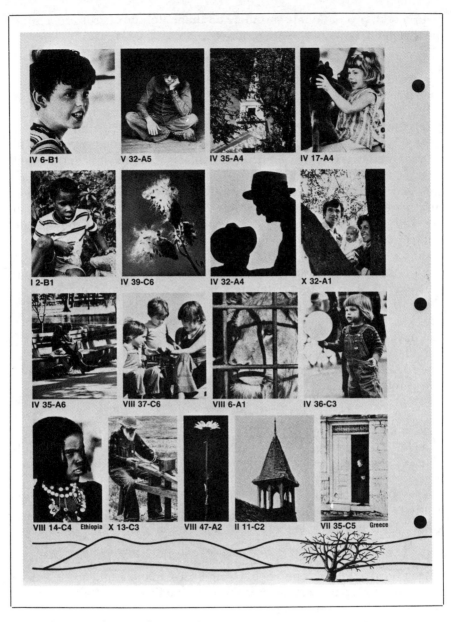

Figure 10-2. *A photographer's catalog.*

Editors order from the invoice form, which is coded to the catalog pictures. When the print edges of the catalog become worn, I send the catalog back to the bindery and they trim the book a few millimeters.

I also assemble smaller catalogs of pictures from recent trips. I print three or four pictures to a page and include a picture identification number for each.

Photographers have asked me if printing (lithographing) their catalogs would be just as effective. In my own experience, there are three reasons why a "print-your-own" catalog is more advantageous.

1. You have complete flexibility as to how many editions you wish to produce.

2. You have complete control over the quality of the pictures.

3. Printers require a minimum run whose cost might be prohibitive to you. Also, with printing (by litho) you are at the mercy of the printer's technical capabilities and experience.

The Phone

Telephone marketing is an effective way to sell yourself. Each phone call is actually a self-promotional opportunity. Be sure to prepare for it with a "give list." If you call a prospective photo buyer with nothing to give, your intended promoton may end up as demotion. (For more on dealing with photo buyers by phone, see Chapter 7.)

Your local telephone company will have promotional aids available to you, ranging from WATS-line information (wide-area telecommunication system) to literature on how to overcome "phonephobia." Practice your promotional calls on a tape recorder. If your voice sounds too high, too low, or unenthusiastic, keep trying until you get it right. Then practice with a few trial calls. You'll know by the response if the phone is for you.

Credit Lines and Tearsheets—Part of the Sale

Credit lines and tearsheets of your published photo illustrations are significant self-promotional tools for you.

How do you get them? Request them when you are notified your picture has been purchased. Even better, in your original cover letter to an editor, you can include a courteous statement that the terms of sale include use of your credit line and provision of a tearsheet upon publication.

Major markets ordinarily print credit lines as a matter of course; they expect you to purchase the publication and get your own tearsheets, however. Textbook editors also will expect you to make your own photocopies of your published pics. Photo editors of regional, local, or specialized limited-circulation publications, however, work with smaller

budgets, and will usually supplement the dollars with a credit-line guarantee and will forward tearsheets to you. Some of your markets will have the provision of tearsheets built into their standard operating procedure. They automatically send them to all contributors of a given issue to confirm for their own records that the photographer (or writer) has been correctly credited and paid.

You can use tearsheets for self-promotion in a variety of ways. Make photocopies of them to tuck into your business correspondence, to show prospective clients how other publishers are using your photographs, and to remind past photo buyers of your existence. Dave Strickler of Newville, Pennsylvania, regularly includes such samplings in his correspondence with editors and art directors. Inexpensive and immediate, such promotions often pay for themselves through orders for the actual photos pictured in the photocopy.

You can also use groups of tearsheets (originals or photocopies) to send to a prospective photo buyer to illustrate the depth you have available on a given subject.

When you gather a good number of tearsheets, file and cross-reference them to use as tools to locate subject matter you've previously photographed.

Credit lines are obviously good advertising for you, *and* they can be instruments for additional sales. Art directors and photo editors are always on the lookout for promising new photographers. When your credit line appears (next to your photo illustration or in the credits section of a publication), it's available for all to see and make note of. If you're doing your self-promotion job correctly, your credit line will be popping up often, and art directors will become familiar with your name.

In some cases, photo buyers will want to reuse a published photo that catches their eye, and they will seek out the photographer to make arrangements. Without a credit line, this would be a complex detective task the photo editor doesn't have time for.

To help insure a correct credit line for your photographs, use the identification system described in Chapter 13.

What if a photo buyer doesn't give you a credit line? Beyond an approach of courteous insistence, your hands are tied. The use of credit lines, in the majority of cases, is left up to the editor or art director of the publishing project. You're fightin' city hall when you vent righteous indignation at the lack of a credit line. But have faith. As in city hall, administration changes occur in the publishing world, and the next art director you deal with at a particular publishing house may have the "right" attitude toward including credit lines. An examination of magazine and book layouts over the last decade will show that the trend is decidedly moving toward the use of credits.

Meanwhile, it is up to you to politely but firmly continue to press for the use of your credit line next to your published photograph.

Show Yourself Off

Your promotional tools are working for you to make sales of your pictures. Now you want to begin getting some promotional exposure for *you* as a photographer.

Trade Shows

Publishing trade shows, book fairs, and magazine workshops always attract publishers and photo buyers. Invest in trade shows with either an exhibit booth or a ticket to the event to personally meet publishers and photo buyers—potential markets and/or new members for your promotional mailing list.

To learn which trade shows would be most productive for you, ask buyers on your Market List which ones they personally attend. Since these people are your target markets, you can be sure the events they deem worthwhile will pay off for you in opportunities to become aware of new, similar market areas.

Carry your business cards and several packets of your photographs with you, each packet representing a separate area of your PMS. I went to my first trade fair with a general portfolio of pictures. Photo buyers weren't interested in seeing my pretty pictures. The next year, I built three packets, each with twenty-five 8x10 black-and-whites and two vinyl pages of color (forty 35mm), enclosed in a plastic folder. Each aimed at a specific market: education, gardening, teens. I talked only with photo buyers in each of those three specific interest areas and showed only the photographs they were interested in seeing. My visit more than paid for itself in the subsequent sale of pictures.

Speaking Engagements

Here's a simple way to promote yourself, and it doesn't cost you anything. If you communicate effectively with your camera, you may have the potential to communicate effectively as a speaker. Take to the platform!

In the trusty Yellow Pages, you'll find a listing of community and photographic organizations, clubs, and associations. Most have a regular need for interesting program speakers. Let the program chairpersons of several groups know that you are available. In most cases they'll be happy to book you.

How do you get started? What should you talk about? As a photo illustrator you have a wealth of subject material available to you—and since 90 percent of your listeners fancy themselves photographers, too, you'll have a receptive audience.

Build your talk around a how-to subject, for example, "How to Take

Pictures of Your Family," "How to Take Indoor Natural-Light Pictures," "How to Make a Photo Illustration."

For some ideas on titles for your speech or speeches (there's nothing wrong with having one basic speech for quite a while), order a catalog (free) from Kodak entitled "Your Programs from Kodak." These are basically movie and slide programs, but their titles alone are enough to stir your imagination for your own speech. (Write to: Audio-Visual Library Distribution, Eastman Kodak, Rochester, NY 14650.) Give your speech title this test: "Am I speaking about something that applies directly to my audience?"

Your listeners don't want a lecture. If they did, they'd register at the local adult education center. Tailor your speech to be entertaining. Include anecdotes, personal experiences of your own or photographer-friends, humor. Use audiovisual aids such as charts, slides, or blackboards. You'll get audience response (feedback), and this will aid you in refining your speech. Eventually, program chairpersons will seek you out.

Payment? At first, charge nothing, except perhaps a fee to cover your out-of-pocket expenses such as baby-sitting, gas, and the meal (if part of the meeting). At this stage, the speaking experience and exposure are more valuable to you. As you progress, start charging by the hour—for example, $25 per hour. Increase the fee as demand for your services increases. As your track record grows, so will your fee.

And how does all this relate to self-promotion? You'll discover some surprising spin-offs from your public appearances. Local publishers will hear of your talents. Assignments will be directed your way. You'll learn of places, people, and happenings that you'll want to photograph. Photo buyers will contact you. Your name as a photo illustrator will be catapulted ahead of equally talented but less visible photographers.

Another spin-off: If you find that you enjoy speaking, the field is wide open to you. Eventually, you may want to promote your own seminars.

For good advice and direction on speaking engagements, there's a newsletter that could be helpful to your speaking career: *Sharing Ideas*, Dotty Walters, Royal CBS Publishing, 600 W. Foothill Blvd., Glendora, CA 91740. If you branch out into seminars, a valuable book for reference is *Photography Seminars* by Robert McQuilkin, published by Lightbooks.

Radio and TV Interviews

Make yourself available to community radio talk show hosts. They are usually interested in interviewing people engaged in out-of-the-ordinary pursuits, and you qualify. Photography is an ever-popular subject, as listeners are always eager to learn how they can improve their picture-taking. Add some local or farther-afield radio-show hosts to your promotional mailing list. Some radio hosts will phone across the nation for an on-the-air phone interview if they feel their listeners

would be interested in what you have to say.

A good source to locate radio stations and the addresses of hosts of talk shows is *Contacts,* Larimi Communication Associates, 151 E. Fiftieth St., New York, NY 10022. The same organization can give you the names and addresses of TV show hosts. Television interviews are possible if you can present your story in a five-to-nine-minute segment. Since photography can easily hold viewer attention, your chances are better than average for making a TV appearance, particularly in a nearby city.

Contact the producer of a local talk show (by letter, phone, in person— or all three). You could offer to serve as the "resident critic" for photography submitted by viewers. Build your format around a how-to theme. Tailor your critiques so that the average snapshooter will understand and be able to improve the family's scrapbook photographs.

All this, again, is in the interest of exposure and self-promotion.

Press Releases

If you've been making speeches, giving talks, making appearances at vo-tech graphics or design classes, or giving interviews on radio or TV, someone's going to be mentioning you in your community news media. But whether you've been engaged in these activities or not, you can write your *own* press releases: They are an excellent form of promotion for your photo illustration business. Newspapers and magazines are open to accepting news about you and your photography; so are the specialized newsletters and trade magazines that reach photo buyers and publishers. *You* must contact *them* and send them your press release. You'll find that about one-third of the media channels you contact will print your release.

At the average advertising rate of $50 per inch, when your press release is used you receive a sizable amount of advertising space—free. What's more, your release is read as editorial, human-interest material by the reader, rather than advertising.

When can you send a news release about your photography or yourself? Depending on whether the item would be of interest on a local, regional, or national level and whether your target is a trade publication or a general-interest one, your press release can center on a recent trip; your photo exhibit at the local library; an award you received; your move to a farm, garret, former carriage barn; your donation of photo illustrations to a nonprofit publication or auction; your publication of a photo in a national magazine or book; a recent speech or interview.

Press releases follow a basic format: double-spaced on a half page or one page. Write your release as if the editor (or radio commentator) were writing it. Remember: It is not an ad. This is not the place to speak in glowing terms about yourself or your photography. A good handbook on this subject is *Public Relations Basics for Community Organizations* by

Sol H. Marshall (Creative Book Company, Box 2244, Hollywood, CA 90028). See also *The Successful Promoter* by Ted Schwarz (Contemporary Books, 180 N. Michigan Ave., Chicago, IL 60601).

You don't need to include a cover letter, but do enclose a photograph (5x7 is acceptable) when appropriate and practical. (Don't expect its return.)

Your best teachers for learning your way around press releases are news items you discover in the press. If you find yourself saying "That could be me!" rewrite the item to reflect your own information and send it to similar media channels.

Occasionally you will learn that a trade magazine in one of your fields of interest will be devoting an issue or an article to a certain subject. If you or your photographs can comment on that subject matter, volunteer to contribute (for free) to the issue. The resulting exposure of your name and your photos, both in the publication itself and the subsequent press release you write about it, will more than compensate for your effort and expense.

Once a press release is used, capitalize on it by making copies and sending the news item along in all your business correspondence and/or in a mailing to your market and promotional list.

Promotional News Features

Local, regional, or trade publications often welcome articles or short features (250 to 500 words) on somebody who's doing something interesting—you. You don't have to wait until a magazine or newspaper contacts you. Write your own material.

Photographer Bill Owens of Livermore, California, gets more mileage out of free advertising by turning a news feature about himself into a productive promotion mailer.

Advertising

Straight advertising is of course a direct method of self-promotion, but here you'll have to experiment—and it's usually expensive. Ordinarily, ads are not the most cost-effective route for a photo illustrator, unless you have strong depth in an unusual specialty with a known targeted market.

The following publications can be useful advertising vehicles— depending on what you're planting—as some photo buyers cull photo contacts from them. (Most of the ads are run by stock photo agencies and a few photo illustrators who have extensive coverage of specific, select subjects.)

American Society of Picture
 Professionals Newsletter
Box 5283 Grand Central Station
New York, NY 10017

The ASMP Book
American Society of Magazine Photographers
205 Lexington Ave.
New York, NY 10016

The Creative Directory of the Sun Belt
Ampersand, Inc.
1103 South Shepherd Dr.
Houston, TX 77019

The Educational Marketer Yellow Pages
Knowledge Industry Publications
2 Corporate Park Dr.
White Plains, NY 10604

Folio Magazine
125 Elm St., Box 697
New Canaan, CT 06840

Madison Avenue Handbook
Peter Glenn Publications
17 E. 48th St.
New York, NY 10017

Magazine Industry Market Place
R.R. Bowker Company
1180 Avenue of the Americas
New York, NY 10036

Publishers Weekly
R. R. Bowker Company
1180 Avenue of the Americas
New York, NY 10036

Small Press Review
Dustbooks
Box 100
Paradise, CA 95969

Although you may not wish to invest in a costly display ad in any of the above, you could test for response with a classified ad. A typical example, which appeared in *Folio* magazine listed under "Photography, Stock," reads like this: "Emphasis on the Southwest. 150,000 images. Color and B&W. Write for free catalog [name, address, and phone]."

In deciding where to place an ad, one helpful route is to ask the publishers on your Market List which trade publications they read. You can assume that other publishers with similar editorial thrust read the same publications, and there is where you'll want your ad experiments to start. Among the questions you should ask yourself when you're thinking of buying an ad: Who are the readers of the magazine? Do they buy photography? Will your ad get effective placement in the magazine?

Whenever you advertise, key your ad with a code number (for example, add *Dept. 12* to your street address). You'll be able to tally the replies to check how well an ad pulls for you.

To measure the response rate to your ad, divide the number of queries you receive by the circulation of the magazine. Expect a response of between 0.1 and 1 percent. Compare the response from each ad with those from the rest of the ads in your advertising program to weed out ads that are ineffective or reaching the wrong audience.

One good year-round advertising tool is a handy calendar of a size you can include in correspondence.

Or you can engineer this kind of arrangement: When I was starting out in business I cooperated with a Midwest printing firm in a wall-calendar project. In return for the use of twelve of my photos they "paid" me with a prominent credit line and 500 calendars, which I distributed as promotional pieces.

The optimum ad is reaching the point where a manufacturer or sup-

plier or photography magazine wants to highlight (promote) you and your photography. Nikon, for example, featured different photographers and their work in a series of full-color, full-page ads that appeared in national photography magazines.

Again, you don't *wait* for things like this to land in your lap. You do something interesting and then let the industry and the media know about it. You keep alert for openings, and *you* go to *them*.

Reassess Your Promotional Effectiveness

Periodically monitor the effectiveness of your promotional efforts. Chart the percentage of your releases that are used; document the response to them and any ads you place by including a code; match numbers of mailings to specific markets with numbers of sales; analyze feedback from your photo buyers. Continue to test new ideas. Drop those that show no promise, and produce more of those that have been effective.

Postscript

The central message of this chapter has been to blow your own horn—let people know who you are; get your name known, your work seen. The more exposure, the more sales.

"What about portfolios, exhibits, contests?" you may ask. They seem to be good sales tools, exposure opportunities. For the photo illustrator these elements, thought of almost synonymously with photography, either don't help at all or do very little to increase sales. Let's examine them.

Portfolios

A portfolio is an excellent tool for a *service* photographer because of the types of markets the service photographer works for. A portfolio exhibits the breadth of a photographer's talent and experience to a potential client who may wish to contract for his *services*. Legwork and personal visits are part of establishing credibility when one is selling *oneself*.

For the *stock* photographer—the photo illustrator—a portfolio and personal visits are not necessary. You work primarily by mail, and your kind of photo buyers are not interested in looking at portfolios—they want to see pictures geared to their current layout needs. Your pictures, if they're on target, sell themselves.

A stock photo buyer really isn't interested in your versatility. In fact, he wishes you weren't so versatile. He'd prefer you concentrate more thoroughly on one subject—his favorite, the subject of his magazine or books. It stands to reason that a photographer who mails apple-orchard pictures in response to a photo request from an agriculture magazine

editor is going to make a lot more points with that editor than a photographer who takes up time showing him a portfolio of underwater, aerial, and architectural photography.

The stock photographer's portfolio, in effect, is each sampling of pictures he sends to an editor for consideration. But the pictures must be on the subject of domestic animals if you're sending them to the editor of a veterinary magazine, on the outdoors if you're sending to a camping magazine.

Exhibitions

Exhibitions are monumental time-consumers and have limited influence on sales, but they don't hurt, and they're good PR, especially when you attain national prominence. You can range from volunteering to set up an exhibit in your local library, bank, insurance office, or church to approaching a city gallery or art museum. For the latter, a theme exhibit, rather than a general across-the-board show, will get more response from a gallery director. An exhibit built around a specific theme affords the viewing public insight into aspects of society with which they have little familiarity, or into some Weltanschauung of your own, which they may find entertaining or informative. Once you have pinpointed your PMS, your thematic material should build rapidly. Later on, these same photo illustrations can lend themselves to books—another advantage for you as you build your career with marketing precision.

Exhibits can run from thirty to fifty mounted prints, ranging in size from 8x10 to 16x20 or larger. Usually an exhibit shows for two to four weeks. Capitalize on the exhibit through news releases and posters, plus radio, TV, and speaking appearances.

Salons

Salons, usually sponsored by local and national photography organizations such as camera clubs, offer you little promotional value. Salons are a cross between exhibits and contests. They are extremely—I would say unrealistically—formalized. Salons, in fact, perpetuate many of the myths that photo illustrators must unlearn in order to understand what is a marketable picture and what is not. Salon photographs are usually the standard excellent pictures, exquisite clichés. In fact, unless an entry conforms to this pattern, including the utmost technical perfection, the judges usually look on the entry with disdain. Salons remind me of outdated laws that no one ever questions. In a day when photo illustrations are meaningful tools of communication among strata of society that are drifting further and further apart, salons are an anachronism.

Contests

Contests are somewhat different from salons in that they can offer national publicity plus cash awards to the winners. Contest sponsors

tend to judge pictures on their photo-illustrative merit rather than out-moded classical-composition rules that limit a photographer's creativity and expressiveness. If you win a prestigious photo contest, let the photo buyers on your Market List know about it through a press release or photocopy of the news announcement. However, enter photo contests with caution. Read the rules carefully. Many times it's the sponsor of the contest who is the *real* winner. Rule #6 or #7 will sometimes state, "All photos that receive cash awards become the property of the sponsor, including original negatives and transparencies, and picture rights." The film or camera manufacturer who sponsors such a contest requires the photographer to give up *all* rights to the picture. In other words, you transfer your copyright over to the sponsor—who can then use your picture whatever way he wishes, ad infinitum.

Keep in mind that if your picture is good enough to win a national contest, it's good enough to earn you several thousand dollars in the marketplace in its lifetime. (You can even pass the rights to a picture on to your heirs, by the way.)

Here at the *Photoletter,* we have been engaged in a five-year war with the nationally known firms that sponsor such photo contests. To date, about half of them have rescinded their "ownership" policy regarding the winning pictures.

If you come across any contests that require you to give up the rights to your photo, I suggest you remind them that you, the photographer, own your own creation, and offer the following line: "Copyright privileges remain with the photographer as per Section 203(a)(3) of the Copyright Act of 1976, Public Law 94-553 (90 Stat. 2541) Title 17 USA Copyrights."

Decor Photography

Producing artful Track A prints for use in commercial buildings or residences can result in excellent showcases for your talents. As you'll read in Chapter 12, decor photography (or "photo decor," or "decor art" as it's sometimes called) will take special administrative (as well as photographic) talent on your part. One solution is to become associated with an existing decor photography business that has already solved the administrative problems. Place your Track A pictures with them, much as you would with a stock agency, and receive a percentage. Beware of *new* outfits, though—they often tie up your pictures for lengthy periods while they learn the ropes themselves.

Greeting Cards, Calendars, and Posters

Greeting card, calendar, and poster companies offer you other showcase opportunities but have drawbacks of their own (see Appendix A).

From time to time you may decide it's worth your while to barter a supply of cards, calendars, or posters in return for certain rights. De-

pending on where you stand on the ladder, such an arrangement may be of self-promotional value to you.

Some Final Self-Promotion Suggestions

1. Have several current photographs of yourself on file for promotional use. Often, photographers have to make a quick Polaroid of themselves to meet a deadline. Have a press kit handy that includes a couple of black-and-white prints of you plus a biography of you and your accomplishments.

2. Don't do it all yourself. Get help. Promotion is always more effective if you can get someone else to write it for you, or at least read it and suggest corrections.

3. You can't measure promotion such as news releases, interviews, and exhibitions as effectively as you can direct advertising. If your business grows, you can assume your promotional efforts are on the right track and are having an effect.

4. Be helpful. If a writer requests information or an interviewer wants answers, cooperate. *Any* kind of publicity is good. As Huey Long once said, "Say what you want about me, just spell my name correctly."

5. Share the news with others. If an article about you appears in a magazine or newspaper, share it with the photo buyers on your Market List. They'll be interested not so much in you, but in the confirmation that they chose rightly in adding you to their available-photographers list.

6. Here today—gone tomorrow. Promotion—like "fitness"—is short-lived. Your smashing success today will be past history tomorrow. Photo buyers forget. Oh, do they forget! Keep reminders flowing their way every three to four months.

7. Don't expect overnight results. Expect to move mountains, yes, but only stone by stone. Promotion works slowly. But it works.

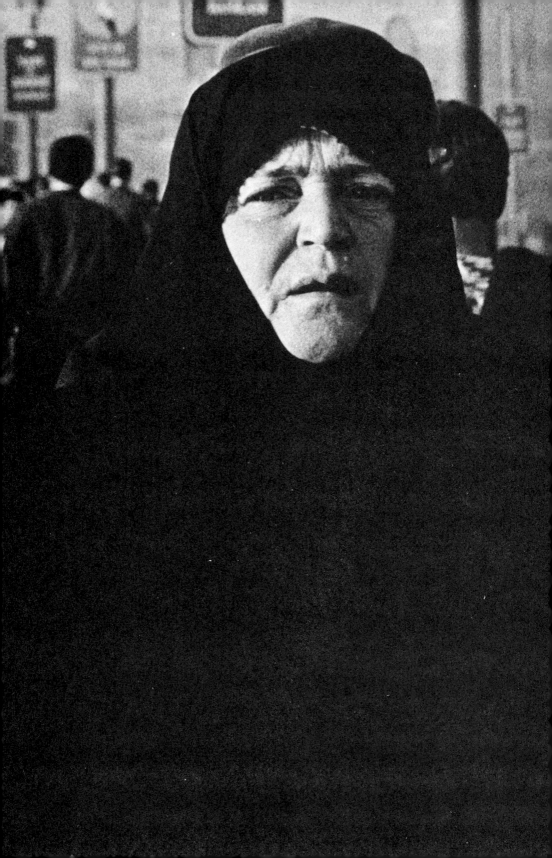

11.
Assignments

An Extra
Dimension
for the
Photo Illustrator

Buzz Soard of Denver was making a family vacation trip to New Zealand and queried editors on his Market List before he left. The result was a four-page article on New Zealand's flora and fauna for *Adventure Travel*.

Gene Spencer of Virginia queried his Market List before he left for the Northwest and learned one photo buyer needed a picture of the Olympia brewery in Washington. "I did several other assignments, too," Gene said, "but that one picture nearly paid for all my gas!"

Assignments can be fun, lucrative, and fascinating, and you can generate them yourself, as well as experience those happy times when the phone rings unexpectedly. One of the biggest rewards, even for those workaday situations ("We need a shot of the National Balloon Race winners") is the satisfaction, and yes, glow, that come from the professional recognition of your competence implicit in any assignment.

As a photo illustrator you can nail plenty of assignments—again, many of them by mail. Once you have sold several pictures to a photo buyer, you become a valuable resource for that buyer. The situation can arise where the editor needs a particular picture in a particular part of the country. He consults his index of available photographers (in much the same way as you consult your Market List) and finds that you live near the area. He contacts you and offers you the assignment.

It also works the other way. You are planning a trip and you inform several of the photo buyers on your Market List of your itinerary, as Buzz and Gene did. One might respond with a two-day assignment,

another might tell you that he needs one picture dependent on the weather ("I need clouds in the sky . . ."), and a third might imply he needs three different pictures if you'd like to take them on speculation. Assignments come in all varieties and will be limited only by the focus of the markets on your personal Market List.

Are assignments in your future? It all depends on your own personal interest in being mobile in your photo-marketing operation. Some photo illustrators thrive on travel, others like to work from their homes. If you opt for assignments, you'll find it rewarding to apply the principles in this chapter.

Negotiating Your Fee

How much should you charge when you get an assignment?

I could give a quick answer to this question by referring you to ASMP's guide, *Professional Business Practices in Photography* (American Society of Magazine Photographers, 205 Lexington Ave., New York, NY 10016), but this guide doesn't have all the answers since it reflects top-dollar fees commanded from top-drawer markets by top pros—and pertains primarily to the world of service photography, where fees range from $200 to $1,200 per day. The going rate is $250 a day, plus expenses.

As in any business, until you have an impressive track record and your name is known, it's unrealistic to expect top dollar. But perhaps the most basic point to keep in mind is this: Many of the markets you deal with as a photo illustrator are publishing markets that consistently pay you respectable fees for your photos, but they can't match New York day rates. Your fees will depend entirely on your own mix of markets. Some of the photo buyers on your Market List may indeed have healthy budgets for photography assignments, but feel them out—don't price yourself beyond what they can bear.

Essentially you are left on your own to judge the particular market and your track record with it, and to negotiate accordingly. Effective negotiations will make the difference between making or missing an assignment.

Now that I've delivered a caution to not overprice yourself, I want to emphasize on the other hand not to *undervalue* your services. Many creative people tend to put too low a price tag on their talents. A good formula to follow is to take whatever you decide to quote to the photo buyer as your day rate—and quote half again as much. You will be surprised how many will accept your higher fee.

In other words, say you have a chance at a plum assignment from an oil company's regional trade magazine. Taking into consideration that you have already sold two pictures to this magazine and this is your first assignment opportunity, you arrive at a $300-a-day rate for such a mar-

ket. Instead, quote $450. You're probably worth it—and the photo buyer probably agrees—but you won't know until you start negotiating. In a situation like this, think big. With assignment work, while you have to walk a fine line and not charge beyond the range for the particular market, if you quote too low a figure you not only lose the photo buyer's dollars, but his esteem.

Also, in a situation like this (with the higher-paying trade magazines), you probably will be invited to the photo buyer's office rather than negotiate by phone or mail. Being there in person is an advantage in this case, because you can watch the photo buyer's expression and body language when you quote your fee. He'll let you know if you're on target or not.

If your figure is high for his budget, you'll get some resistance. However, remember that he invited *you* to the office. Thus you know he thinks that

1. You are an established photographer.
2. You bring specialized knowledge and talent to the assignment.
3. You have access to a certain profession and/or geographical area in relation to the assignment.

Keep in mind that there are a dozen other photographers he *could have* invited to his office. It may seem like a disadvantage to have all that competition, but it's actually a plus in this case. By inviting *you,* he has established in his own mind that he has chosen the *right* person. If you quote a low fee—it might lower his estimation of you.

Remember, the photo buyer must report to his superiors. A high fee tends to justify his choice of photographer.

How you state your fee should go like this:

When the photo buyer inquires as to your rate, state your prepared answer confidently, and then—remain quiet. Don't say another word. This is a well-established principle of negotiating. The person who speaks next is at a disadvantage in the bargaining process.

Let the buyer do the talking. When he speaks, it'll probably be to commit himself to your fee or to indicate his budget. He'll probably indirectly answer some questions that are important to you:

1. How badly is the picture needed?
2. What is the competition charging?
3. How easily can he get the picture from some other source?

If you discern that the photo buyer is genuinely resistant to your fee, determine the basis for his resistance, and it will aid you in figuring the direction you should take in the negotiations.

Here are some guidelines:

1. He'll probably come back to you quoting a lower figure (you've tossed the ball to him—now he's tossing it back . . .). Don't immediately accept it. Why? He is probably feeling you out with a figure lower than what he actually could pay. He'll make some concessions if you press him.

2. Don't concede anything if you can help it, or at least don't be the first to concede ("OK, I'll complete the assignment in two days instead of three . . . "). If you concede first, the picture buyer has the upper hand.

3. If you have to concede something (the editor tells you he can't cover the cost of developing your film, for example), then ask him for a concession, too ("I must have double mileage for this trip. There are a lot of dirt roads out there in West Texas!").

4. If you must match concessions with the picture buyer, remind him that these concessions are valid only if you and he are able to reach a final overall agreement on a contract or a fee for the assignment.

5. Decide beforehand what you want: a minimum and a maximum. (Make sure these figures are realistic.) Keep score as you negotiate.

6. If you come out smelling like roses, don't feel guilty about it. Remember: You don't always win in such negotiations. Enjoy the glow while it lasts. Next time you may not come out so well.

7. What if the photo buyer says, "This is the fee we can pay—you can take it or leave it!"? You can either say "thanks but no thanks" or explore with him the possibility of retracing your steps to either narrow or broaden the scope of the assignment. Offer more or fewer pictures, discuss travel expenses, change the length of the assignment. These are areas where you can concede wisely. Don't agree, however, to give up your negatives or to grant the buyer ownership (all rights) to your pictures. (Even in these areas, though, it isn't a case of "never"—you may get in situations where the fee for all rights is sky high, or where you are anxious to get that particular assignment at all costs. (See the discussion of work-for-hire in Chapter 15.)

Negotiating can be a challenge, and even fun. Practice makes perfect. Try out variations of your routine with your spouse or a friend playing the part of photo buyer. If you will be doing your negotiating by phone, then do your practicing on extension phones or in a couple of phone booths. You'll find that just "running through your script" is a tremendous catalyst to new thoughts, new ways to phrase your points.

In the long run, a photo buyer will appreciate your efforts to get the best fee for your pictures. Even if you come away with $300 a day instead of your $450, remember that's the fee you originally were willing to settle for.

Expenses

The quote you make for your day rate to a photo buyer does not include your expenses. These are over and above the day rate you receive, and depend on a number of variables.

When negotiations reach the point where you address expenses, your reliability factor will be strengthened if you hand the photo buyer a copy of your Expenses form.

Have typeset and printed a personalized business form that lists expenses involved on assignment work. I had my own form printed on 4½x9½ paper in three different colors—white, blue, and pink—then collated and gum-sealed into a pad. I use carbon paper above the blue and pink, and I send the first two copies to my client and keep the third for my records. The pad paid for itself on my first assignment.

In a corner of the pad, in small print, is this message: "This sale or assignment is in accord with the code of practices as set forth by ASMP."

Although you may not be an ASMP member, or even if your client cannot afford ASMP rates, your expenses are a fixed cost and you should expect reimbursement accordingly.

Your expense form should read as the one in Figure 11-1.

Extra Mileage from Assignments

Your assignments will take you to locations you might not ordinarily visit. Carry along an extra camera (or two—one for black-and-white and one for color), and shoot some photo illustrations for other photo buyers on your Market List.

This will not be as easy as it sounds. Full concentration on your assignment is essential to producing quality results, which is also the way you maintain a strong reliability factor with your client. Anything less than 100 percent attention to your assignment will give you mediocre, or at least ordinary, results. When you shoot "side" pictures while on assignment, then, plan to shoot them on your time and at your expense.

Many assignments call for only specific pictures. This will allow you to add the outtakes to your stock file. Some photographers arrive early on the scene or stay later on an assignment. As long as the client has paid the transportation expense, you can capitalize on the (sometimes exotic) locale and shoot for your stock file. Some photographers shoot to add to their collection of pictures on special themes. Simon Nathan of New York, for example, snaps pictures of clothes hanging on clotheslines all over the world. "One day I'll have an exhibit—or publish them in book form," says Simon.

Do you own the pictures you take on assignment? It depends on what type of contract, if any, you have signed, or what rights agreement you and your client have arranged (see Chapter 15).

EXPENSES

FROM: Your Name, Address, Logo, etc.

TO:
DATE:
SUBJECT:

TRAVEL
Taxi . $_____
Auto (_____¢ per mile) $_____
*Plane, train, bus . $_____
*Car rental. $_____
Tips. $_____
*Meals _____ *Lodging_____ $_____
PHOTOGRAPHIC
Processing
*Color: _____ Rolls @ $_____. $_____
*B&W:_____ Rolls @ $_____. $_____
*Rental of special equipment. $_____
Other:

$_____
PROPS . $_____
(Construction of or rentals)
MODEL FEES . $_____
(Hiring or non-professional releases)
LOCATION CHARGES. $_____
MAILING, UPS CHARGES, TRUCKING $_____
INCIDENTALS
Long distance phone calls. $_____
Messenger, porter, assistant, guard. $_____
Liability insurance . $_____

SPECIAL SERVICES
Casting . $_____
Hair and makeup . $_____
Home economist. $_____
Costumes, clothing. $_____
Location search. $_____
OTHER . $_____
TOTAL EXPENSES: $_____

*Receipts attached

Figure 11-1. *A sample expense form.*

The Stringer

Another assignment channel is open to the photographer who is on tap for picture-taking services for a trade magazine, news service, or industry account. The photographer in this situation is usually called a "stringer." You are, in effect, a part-time freelancer who sometimes works on a retainer basis—that is, for a regular monthly fee. In most cases, however, you work on a per-assignment basis. You get paid only when you produce.

Being a stringer falls primarily into the area of service photography, but stringer opportunities are also there for the photo illustrator. By working out a flexible contract with a trade publication, you can arrange, for example, to supply them on a regular basis with single pictures relating to their subject theme.

For example, if one of your PMS areas is breed dogs, and you travel often to dog shows, you would be a valuable resource to editors of dog magazines, with audiences ranging from breed associations to veterinarians. (We're talking about good working shots of dogs in action or breed portraits—remember, if you emphasize cute puppy pictures, that's crossing over into Track A, pictures that you'll want to place in a photo agency; see Chapter 12.) If you travel often, you could tie in your mobility with other photo buyers on your Market List (recreational pictures for outdoor magazines, horse shows for horse magazines, equipment in use for heavy-equipment magazines).

Your contract need not be any more formal than a letter of agreement stating that you will supply them with X pictures a month (week, or year) for X dollars. The fee will not be monumental, but if you have several contracts, the sum will more than cover your expenses to those dog shows.

Competing magazines, of course, would not appreciate your supplying the same photographs simultaneously across the market. So by researching the specific needs of the photo buyers on your Market List, you can guard against inappropriate multiple submissions, yet set up an operation to receive checks with regularity.

Self-Assignments—Where Do You Start?

If assignments aren't coming your way yet, give them to yourself. Such self-assignments will reward you with new insights into lighting, working with models, using the $P = B + P + S + I$ formula (see Chapter 2), and using varied lens lengths for effect, as well as pulling elements together to make a cohesive and interesting feature.

You can start right away, and at the same time give yourself a course on producing the picture story, if you're not afraid to copy. Through the ages, creative people have learned from each other by imitating each other. As the Bible says, "There's nothing new under the sun!" A simple,

effective technique based on this principle is *the switch*. Here's how it works:

Let's say you're reading one of the magazines on your Market List and you come across a one-page, three-photo picture story about a young Eastern boy who is spending his summer in the West, earning money for college by working as a wrangler at a horse ranch in Wyoming. The copy block contains about 300 words. The pictures are a close-up of the young man and two middle-view shots, one a vertical, the other a horizontal.

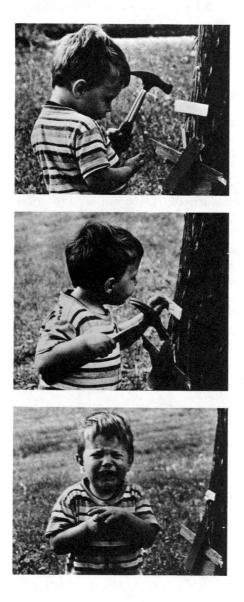

THE PHOTO ESSAY. *Want to make your picture stories come alive? Learn from the pros. A moviemaker in Africa taught me this trick and you can apply it to your photo stories. "Every story has a beginning, middle, and end," he said. "Whenever I get spectacular footage, say, of a successful rescue in a river, or one of my African crew fending off an attack by an animal, I consider that the climax footage. I then go back and film footage that will lead up to my climax footage. This subsequent footage I then use as my beginning and middle shots." In the case of the little boy at left, I shot the third picture on Saturday, and on Sunday I shot the first two.*

You will use this story as a blueprint. It shows you what the requirements are for a similar picture story. Not the same story, but one that's similar. In your case, you know of a young Dutch girl down the block who is in the U.S. for a year as a high school exchange student. In order to improve her English, and to earn spending money, she is working as a babysitter for your neighbors.

The city-boy-turned-cowboy story pictured the boy with a ten-gallon hat. You will picture the Dutch girl in a native Dutch hat. The blueprint story showed the boy helping in the early morning roundup of the horses. You will show the Dutch girl with neighborhood children explaining how wooden shoes are made. The blueprint story showed the boy at breakfast with companions, downing heaps of flapjacks. You will picture the Dutch girl cheering with friends at a high school football game.

The original article is also a blueprint for the writing. You will tailor your writing to match the content and style of your blueprint. Insert quotes and anecdotes in much the same proportion as your model. If you have no writing skills, find a friend who does and team together. Or simply amass the details (who, what, where, when, how), and submit them to the editor with your pictures. The editor will find his own writer.

Where to market your picture story? Start with the local metropolitan Sunday paper. They're always interested in seeing this slice-of-life kind of story. Also send it off to non-competing magazines on your Market List that accept brief photo stories.

Expand certain aspects of your story to fit other markets. The wooden shoe, emphasized correctly, would appeal to trade magazines in the shoe industry. Periodicals in the educational field would like to see emphasis on the Dutch girl's learning experience in this country.

Submit at least a half-dozen pictures to give the editor a choice for his layout. Again, tailor your story line to your original blueprint, and you will earn not only the price of this book, but possibly the price you paid for the camera that took the pictures.

The key is to locate your blueprint example in the magazines on your Market List. This way you know you're on target with subject matter and treatment that are coordinated with your PMS.

Such self-assignments may not prove immediately marketable as picture packages, but certain of the photographs may turn out to be individually marketable singles.

Speculation

On self-assignments, you're working on speculation. Is this a "no-no" in photo illustration? Not if you've used some savvy and done some homework to identify your PMS and become familiar with the kind of pictures needed by your individual Market List.

This way, if your picture doesn't sell the first time around, it's a valuable addition to your files and stands a good chance of earning its keep over the long haul.

You can also take pictures on speculation in response to a specific photo request by an editor, and this, too, is not a no-no. In fact, it is especially helpful to the newcomer to the field. When you speculate by following the guidelines of a photo editor you are, in effect, receiving free instruction in what makes a good, marketable photo illustration. The editor's specifics will tell you what to include and what not to include.

There are times, however, when you shouldn't speculate: A timely picture will quickly lose its marketability. A highly specific picture will probably not be marketable to many targets. Going after a picture that entails a good deal of expense (in time, travel, special arrangements) is questionable. (The Pope's visit to Iowa might attract so much freelance and staff-photographer competition that it wouldn't be cost-effective for you to get involved.) Finally, a picture that is outside your PMS might reflect your lack of expertise, and that would limit its marketability.

Take a Free Vacation

One type of self-assignment you can give yourself with assurance, over and over again, is the travel assignment—but with a switch: If you're planning a vacation or a business trip, plan to profit on your trip through your photography. (Because your travel can be a business expense when it involves getting pictures to add to your stock photo files, your travel expenses can be a tax write-off—another way your trip pays for itself. Chapter 16 gives more details on the tax benefits of making a business out of your photography interest.) However, rather than aiming your camera at standard tourist attractions (Track A pictures, with limited marketability), concentrate on pictures where the supply is short and demand is great.

Who buys travel pictures? Travel editors, of course, but they are *so* deluged with travel pictures (exquisite clichés) from freelancers, government agencies, stock photo agencies, PR people, and authors of travel stories, that this market takes time to break into. At first, you represent more *work* for the travel editor as someone new that he has to deal with, communicate with, explain his picture needs to—all of which he wants to avoid since he already has established picture sources that supply his needs. Instead of aiming at travel editors at first, direct your marketing efforts toward the publicity offices of airline, bus, train, ship, and hotel organizations; city, state, and national tourist offices; PR agencies; filmstrip companies; ad agencies (who represent the country or state); plus encyclopedia and other reference-book publishers who are

continually updating their publications. Also, it's helpful in some cases to contact photo agencies. (See Figures 11-2, 11-3, and 12-1.)

Standard travel pictures are difficult to market because of the competition. Do not submit spectacular (in your estimation) pictures of standard tourist sites. The publicity officer or editor has already rejected hundreds of them. You can, however, include pictures of *new* travel attractions, or *changes* in existing attractions.

What does the travel photo buyer really need? Current pictures in their locales of these areas of interest: agriculture, mining, transportation, contemporary architecture, communications, recreation, education, industry, labor, sports, and special events.

Your travel pictures, then, are not really *travel* pictures at all—but pictures of factories, airports, new sports facilities, freeways, festivals, open-pit mines, housing, and skylines.

To know what to take and where to find the subject matter, write to the Department of Economic Development and/or Department of Tourism (or Consulate/Embassy, if foreign) of the area you will be visiting. They will supply you with several pounds of literature—all of which needs updating. Travel agencies can supply similar literature. Consult the encyclopedias at your library, and other reference books, maps, filmstrips, and pamphlets that feature your area of interest. Make photocopies of pertinent leads, pictures, and details (these will aid you in your query letter).

The agencies you will be working with are actually *promotion* agencies. They want to put their client's best foot forward. In these changing times, the profile of a city, tourist attraction, national park, or monument changes rapidly. *Updated* quality pictures are always of interest to travel picture buyers. (Note: Remind the photo buyer that your picture is an update.)

Stock agencies (see Chapter 12) are interested in seeing specific quality travel pictures. If they like your selection, they'll probably ask to see more from other areas of the country or the world that you could take or may have in your files. If your pictures are large-format (120-size, 4x5, 8x10), you'll probably have a better chance of scoring at an agency than if they are 35mm. However, some agencies will enlarge your 35mm to 4x5 for you.

But scoring depends on factors other than size. One of the most important is *content*. If they are pictures of a relatively untraveled area of the world or of places currently in the news, they will probably interest an agency more than if they were taken in, say, New York or Paris.

Here's another buyer for your kind of travel pictures: book publishers. New books on the area you just photographed will be coming out shortly. Why not have your pictures appear in them? The departments and offices mentioned above are often aware of books in progress. They

will steer you in the right direction (since their job is PR) if you mention in your letter to them that you would welcome information on forthcoming publications about their area. Photo agencies, too, are aware of new books in progress because photo researchers are knocking on their doors, looking for a picture from such and such a place. While you're checking at the photo agencies, tell them you have fresh, updated pictures of the place(s) you've visited. Frequently, photo agencies miss a sale because their locale pictures are outdated.

What about postcards? Postcard companies (see Appendix A) are rarely good markets for your travel pictures. They pay low fees, your picture is bucking hundreds or thousands of others for selection, and the companies usually want all rights. The competition is stiff in the postcard/gift area and the fees are generally low. Unless you have a special reason for marketing in these areas, avoid them.

Making the Contact

When possible, contact picture buyers *before* you go on your trip rather than after you return. Photo buyers, editors, and agencies can inform you of their current needs, plus suggest side trips to collect pictures (on speculation or assignment) to supplement or update their files. Independent photographers do sometimes shoot first and ask questions later (the *shotgun* method). But most veterans inquire first, with a letter like the one shown in Figure 11-2, and then shoot (the *rifle* method). Here are your letter-writing guidelines:

1. This is a form letter you will send out to a number of promotion directors or editors, so type an original on your professional letterhead, which includes your address and phone, and then photocopy or instant-print it. Leave a blank in the salutation to fill in the name, with space above for each different address. (You can write to "Editor," "Photo Editor," or "Art Director," but if you can find out the name of the individual, this of course is preferred.) The form-letter format is an asset in this case because it tells the picture buyer two reliability factors about you: that you deal with many photo buyers who are interested in your pictures—and he gets the impression that if he acts quickly, he can be first to review them; and that you do business in *volume*, so you must be competent and familiar with the marketing process—someone he could develop as a consistent source of pictures. Photo buyers usually aren't interested in dealing with one-shot photographers.

2. In your first paragraph, let the editor know *when* you're going, for *how long,* what your *itinerary* is (only the routes that will relate to his area of interest), and how you'll be traveling (car, plane, bus).

3. Never ask if he'd like to *see* your pictures of *standard* tourist attractions—national monuments, parks, etc. (You should know that he

YOUR LETTERHEAD

Dear _____:

On August 15 through August 20, 19____, I will be traveling in the state of Minnesota. My itinerary will include Duluth, the Iron Range, Charles Lindbergh's home, a visit to Control Data in Minneapolis, and stopping points in between.

May I help you update your files with pictures from these areas? I shoot B&W and color, in both 35mm and 2¼-inch format.

If you have specialized photo needs along this itinerary, I would be interested in learning about them. Perhaps we could work out an assignment which is mutually beneficial. I would submit my pictures to you, of course, on a satisfaction-guaranteed basis.

My pictures, including the several thousand I have in stock, are available on a one-time basis for publication at your usual rates.

Thank you for your attention and I look forward to hearing from you.

Yours sincerely,

John Doe

Figure 11-2. A typical assignment query letter.

already has these covered.) Instead, ask him if he would like his files of these pictures *updated*. Your recognizing his need to constantly update his files puts you in a professional light.

4. Explain whether you will shoot in black-and-white, color, or both. And tell him the size of your camera(s).

5. Suggest that if he has some upcoming photo needs, you can save him time and expense by shooting them for him—if it's not too much out of the way for you. Assure him that you are not locking him into any definite contractual arrangement. (It's easy to say no to those.) Let him know your pictures will be taken with no obligation or precommitment on his part. Mention in the next paragraph your stock file of several thousand. The editor will interpret this to mean there will be no loss to you if he does not accept your pictures—that you are an established photographer with a high reliability factor and plenty of available markets. Let him know you are renting these pictures, not selling them. Try to find out the going rate for his publication or publishing house before you contact him, but if you can't, tell him your pictures are available for publication at his usual rates.

Figure 11-2 is a typical assignment query letter—you'll notice it's brief. No photo editor wants a history of you or your photography. If your photos fit his needs, he'll buy. If they don't, he won't.

Let's say you didn't contact anyone before your trip, though, and you've just returned from Poland with many fine pictures. What do you do now? Contact all promotion bureaus, offices, and agencies which represent Poland. These will include government agencies as well as private Polish and American agencies such as airlines, ship lines, and hotel chains. Your list might also include American ad and PR agencies which handle these accounts. Design a form letter which informs these agencies of your pictures of Poland. Do not send actual pictures or a Poland portfolio until an agency expresses interest to you. Visit the agency in person, if possible, with a portfolio of pictures tailored specifically to the agency's interest. Use the tips in Chapter 7 on how to contact photo buyers by phone, by mail, and in person. It's on these visits that you might receive referrals for your pictures ("No, we can't use them—but I know Joe Jones is preparing a book on Northern Poland").

Here's how you would develop your "after-the-trip" contact letter (see Figure 11-3 for a sample):

1. See #1 of instructions for writing a letter of inquiry.

2. In your first paragraph, let the editor or director know who you are, where you're from (your letterhead will help), and when you were in his state or area. If your pictures are fresh updates, he is going to be in-

YOUR LETTERHEAD

Dear _____:

My name is_____ , and
I recently updated my stock photo files of several thousand transparen-
cies and B&W prints when I traveled through [state/country] in
[month]. My files now include substantial coverage of these points of
interest:*

I would be happy to send you a selection of B&W prints and
transparencies for your consideration. They are available at
$_____ on a one-time rights basis. Request to review these pic-
tures does not obligate you to any purchase.

Which pictures would you like to receive for consideration?

Yours sincerely,

[Your name]

*P.S. I also have strong coverage in my stock file of these areas:

Figure 11-3. Sample shotgun (after-the-trip) query letter.

terested. Mention specific areas that you have photographed.

3. Ask if you may send a selection of color and/or black-and-whites for his consideration. (Don't send photos with this first letter.) If you know what he pays, mention this fee in your letter. This will save both of you an extra exchange of negotiating correspondence. If you don't know his fee range, apply some of the pricing tactics outlined in Chapter 8.

4. Being an unknown photographer puts you at a disadvantage. Editors sometimes ignore introductory letters such as this. They prefer to stay with their own cadre of familiar and reliable photographers—rather than go through the extra work of establishing contact with a new photographer. It's a good idea, therefore, to insert a line in your letter to this effect: "Requesting review of these pictures does not obligate you to any purchase."

5. Ask outright which pictures (of those you've listed) he would like to review.

6. The copywriters of the world tell us that the section of your letter that gets read first (if your letter gets read at all) is the *postscript.* You can attract the editor's attention by listing some of the places you have previously (or recently) photographed in his city, state, country, etc. Since these names will be familiar to him, this will help personalize your letter to him.

If the director or editor does ask to see your pictures, you should enclose a cover letter when you submit them for consideration. Again, a form letter is useful both to you (for your own records) and the editor. Your pictures, of course, will sell themselves, but as consumers, we all know that we are not likely to buy a new product (in this case, you are the new product) if service and support are not available. In other words, if the editor suspects you are a fly-by-night, that you have no reliability factor, that your business address or telephone might change next week, he is not likely to give your submission much attention. Photo buyers recognize the professional touch in submissions accompanied by a form cover letter. Again, it must be brief. Editors are faced with the task of sifting through hundreds of photo submissions weekly. They don't appreciate lengthy letters which ask questions or relate irrelevant details about the enclosed submission. If you do feel compelled to ask a specific question (and sometimes it *is* necessary), write it out on a separate sheet of paper and enclose an SASE for easy reply.

If your form letter is neatly typed (never handwrite queries to editors), the editor will greatly appreciate your conciseness. Better yet, have it printed by one of the fast-print services (ask for 70-pound stationery stock), leaving blanks to fill in specific details for each different situation. The editor will then recognize you as not a one-shot photographer, but as someone with a good supply of pictures and, therefore, as an

important resource for handling future stock photo needs and assignments. (The thinking here is that no one would go to the expense of a printed form letter if he had only a few photographs to market.

A typical form letter to accompany your submissions could be the standard cover letter in Chapter 9 (Figure 9-1). (If your submission is solicited you can lead the letter off with the line: "Thank you for your request to see my coverage of _____.") Be sure to mention in this letter that "captions are included."

Ordinarily, photo illustrations (unless they are meant for technical or scientific use) do not require identifying captions. But travel and location pictures generally do. In your captions identify the location and what's going on in the picture. For a sample, see the illustrations of Poland in the following sections.

To reiterate, your prime travel markets will be reference books, PR agencies, Bureaus of Tourism, publicity offices of airline, bus, train, and ship companies, hotel organizations, and other offices whose mission is to promote travel and economic development in the state or country they represent. These offices actively seek new and updated views of their areas of interest. Your secondary markets can be stock photo agencies, travel-oriented magazines, calendar and greeting card companies. The addresses of hundreds of such markets are easily available in reference guides such as *Photographer's Market,* 9933 Alliance Rd., Cincinnati, OH 45242; *Internal Publications Directory,* National Research Bureau, 424 North Third St., Burlington, IA 52601; and *Magazine Industry Marketplace* (MMP), R.R. Bowker, Inc., 1180 Avenue of the Americas, New York, NY 10036. These reference guides are available at most libraries. A newsletter with markets for travel writers and photographers is Bob Milne's *Travelwriter Marketletter,* Rm 1745A, The Plaza Hotel, New York, NY 10019. An annual seminar for travel (tourism) photography is Lisl Dennis's Santa Fe Photography Workshop, held at Santa Fe around Labor Day (one week), Box 2847, Santa Fe, NM 87501.

A Sampling of "Hot Sellers"

Each of your prime travel markets (e.g., mining, transportation, education) will present varied opportunities for photo illustrations. The following pictures of rural Poland are a good indication of the style and type of pictures sought by encyclopedias, textbook publishers, airlines, ship and rail lines, heavy-equipment trade magazines, agricultural periodicals, and Bureaus of Tourism. Instead of aiming your camera at tourist attractions, produce pictures such as these for repeat sales.

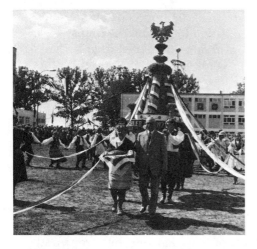

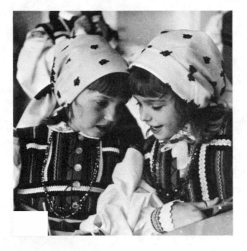

12.
Stock Photo Agencies and Decor Photography

Outlets for Track A

Stock photo agencies can offer opportunities or headaches. This chapter will help you avoid the "stock agency blues" and capitalize on the dollars available to the photographer with the right kind of stock photographs at the right agency.

If you choose wisely, you can approach agencies as an investment— one that should pay off in time.

You will gain most by selling your prime Track B pictures yourself, to your hot Market List. Let agencies handle your Track A pictures—those excellent standard photos that are so difficult to market on your own, because of excessive competition and the fact that the buyers who look for those types of shots are the ones who usually turn to agencies or their own list of favorite pros, not to a lesser-known freelancer.

I myself have pictures at three agencies: in New York, Chicago, and Colorado. My first contact with a stock photo agency was in 1958, when I had just returned from a trip through Africa. In New York, a friend introduced me to Anita Beer (who later merged her stock photography agency with Photo Researchers, Inc., New York City). In those days agencies were not plentiful, and they attempted to be all things to all people. Emphasis was on black-and-white. Today the emphasis has moved to color, computerization, and specialization. Although some large, prestigious agencies still hold out as general agencies, new ones have seen what happened in the magazine industry to general magazines and have taken the hint to specialize.

Most of the better-known stock photo agencies ("picture-rental libraries") are located in New York. The photo buyers who use stock agencies range from book and magazine publishers to ad agencies and PR firms.

These photo buyers have one thing in common: They can pay the high fee stock agencies demand.

Prepare to Share Your Profit

Stock agencies do demand high fees. They can afford to, because they offer the photo buyer something he can't get anywhere else—a huge selection at his fingertips. It's this fact, so attractive to photo buyers, that is your disadvantage. If your picture of a windmill or frog or seagull is being considered for purchase among dozens and dozens of others in the same agency—never mind competing agencies—your chance of scoring is minimal.

Even against this reality, however, the chances of that kind of Track A picture selling are greater at an agency than if you tried to market it yourself. Does big money await you when you go with an agency? It depends on how well you choose your agencies and how often you supply them with your targeted photos. Agencies will tally their sales for you on a monthly, quarterly, or half-year basis and send you a check. And although this check is for only 40 to 50 percent (sometimes 60 percent) of the agency's sales (the agency receives the remainder), it's always welcome. (From $40 to $150 is the present range of your share of an average transparency sale.) Most photographers, whether they are service or stock photographers, count on agency sales only as a supplement to the rest of their photography business.

Newcomers to photo marketing (and some not so new) sometimes think they can relax once their pictures are with an agency—they believe that now they can concentrate on the fun of shooting and printing and check-cashing, and let the agency handle the administrative hassles of marketing.

Agencies: A Plus with Limitations

It just doesn't work that way. In fact, it's a bit like gambling. You can increase your chances of making regular sales through agencies if, as at the baccarat table, you study the game.

Agencies offer the pluses of good prices and lots of contacts, but they have limitations that affect the sales of your pictures. One is that monumental competition faced by any one picture. Another is that no agency is going to market your pictures as aggressively as you do. The agency has something to gain from selling, yes, but it spreads its efforts over many photographers.

Another limitation, which you can turn to a plus once you're aware of it, is that different agencies become known among photo buyers as good suppliers in some categories of pictures but not others. Like art galleries, agencies tend to be strong in certain types of pictures. Sometimes, however, an agency will accept photos in categories outside its known spe-

cialties. If you place your pictures in the *wrong* agency, they'll not move (sell) for you.

When a photo buyer at a magazine or book publishing house needs a picture, he assigns the job of obtaining that picture to a photo research-er, a person (often a freelancer) who is adept at finding pictures quickly, for a fee. The researcher makes a beeline for an agency that he knows is strong in the category on the "needs sheet."

If a book publisher, for example, is preparing a coffee-table book on songbirds, the researcher will know which agency to visit, and it might not be an agency you or I have ever heard of. And it might not even be in New York.

Photo researchers know that agencies, like magazine and book pub-lishers, have moved toward specialization. By going to an agency that he knows is strong in songbirds, the researcher knows he'll have, not a handful of pictures to choose from, but several hundred. Often the picture requirements will demand more than simply a "blackbird"— they'll specify the background: the type (Brewer's or red-winged), the time of the year (courtship? nesting? plumage changes?), the action in-volved (in flight, perching, or a certain close-up position)—and the wide selection will be particularly necessary.

Researchers feel that they're doing their client justice in choosing an agency they know will have a wide selection. If your pictures of birds or alligators are in a different agency, they may never be seen.

The first order of business in regard to agencies, then, is to research the field and pick the right ones for your mix of categories. You can have your picture in several agencies at once, chosen on the basis of geo-graphical distribution (an agency in Denver, one in Chicago, one in New York), and on the basis of picture-category specialization (scenics at one, African wildlife at another, horses at another).

How to Find the Right Agency

If your photography is good, just about *any* agency will accept it, whether or not they're looked to by photo buyers as strong in your particular categories. That's where the danger lies. How, then, can you find the right agency or agencies for you?

It takes time, but here's one approach. Part of your task on the second weekend of your Get Started Action Plan (see Chapter 4) is to separate your pictures into Track A categories on the one hand and your PMS on the other. Take both your Track A and PMS lists and narrow them down to the areas where you have the largest number of pictures.

Let's invent an example. Let's say that in Track A (the excellent stan-dards) you isolate three areas in which you are very strong: squirrels, covered bridges, and underwater pictures. In your Track B PMS you isolate five strong areas: skiing, gardening, camping, aviation, and agri-

culture. Taking your Track A pictures first, rather than place all three Track A categories with one general agency, do some research and find which agencies in the country are strongest in each of your three categories.

You might find that your covered-bridge pictures land in a prestigious general agency in New York that happens to have a strong covered-bridge library. You will supply that agency with a continuing fresh stock of covered bridges, and they will move your pictures aggressively. Your underwater pictures might land in a small agency in Colorado that is noted for its underwater collection. Again, your pictures should move, since photo researchers will know to look to this agency for underwater shots.

Your covered-bridge pictures fall into Track A; you would probably have difficulty marketing them on your own. But how about your Track B pictures, like your camping or agriculture shots? Should you ever place them in an agency, too—or will you be competing against yourself, since you will be aggressively marketing your Track B pictures to your own Market List?

Your answer will depend on your Track B pictures themselves, their particular categories, and your Market List. If your own marketing efforts are fruitful, you will do best to continue to market your B categories yourself. If certain of your Track B pictures move slowly for you, you might find it advantageous to put them in an agency. (If you do, place your slower-moving Track B categories in different agencies with the same forethought you gave to your Track A categories.)

Researching the Agencies

Tracking down the strengths of individual agencies will take some research on your part. The magazines and books that are already using pictures similiar to yours will be your best aid. As an example, let's take your Track A squirrel pictures.

Being a squirrel photographer, you naturally gravitate to pictures of squirrels. If you see one in a newspaper, encyclopedia, or textbook, it attracts your eye. Make a note of the credit line (if there is one) on each squirrel photograph. It will be credited with a photographer's or agency's name in about a third of the cases. (Picture credits are sometimes grouped together in the back or front of a magazine or book.) If after six months of this kind of research the same agency name keeps popping up, your detective work is paying off. (Sometimes, depending on your Track A category, two or three agency names will appear. This is a plus—it means you can be choosy about whom you eventually contact, basing your decision on how long each agency has been in business, their location, whether they have a WATS line, etc.) Locate the photo agency address in a directory such as *Photographer's Market*.

You can also check agencies out by contacting the Picture Agency Council of America (PACA). Send $1 plus SASE for a list showing their membership's specialties. (This list will prove helpful in locating agencies and the categories of pictures they carry, but you'll learn more about where photo buyers go for what through your own research.) The address is 60 E. Forty-second St., Suite 2130, New York, NY 10165.

How to Contact a Stock Photo Agency

Agencies, like photo buyers, expect a high reliability factor from you. If you are certain you have discovered an agency that is strong in one or more of your categories, contact the agency with a forceful letter.

Your first paragraph should make the agency director aware that you have been doing some professional research, and that you aren't a fly-by-night who just happened to stumble onto his agency's address.

Let the agency know the size and format of the collection you are offering, and whether it's black-and-white or color (a surprising number of agencies require black-and-white in addition to color). If you place special emphasis on a certain category, or you live in or photograph in a unique environment, state this also.

Impress upon the agency that your group of pictures is not static, that you continually add fresh images. (Some photographers hope to dump an outdated collection on an agency.)

Tell the director you are considering placing this particular collection in a stock house. Give the impression you are shopping, *not* that you are expecting or wishing to place your pictures with him.

A typical letter that you can tailor to your own style is shown in Figure 12-1.

If your research is accurate and your letter professional in tone and appearance, the photo agency will welcome your contribution to their library.

More important, your pictures will be at an agency known for a specialty—that happens to be *your* specialty.

In some cases you can make a personal visit to an agency instead of writing a letter. A few agencies in the large cities designate one day of the week when photographers can come in to display their photos for consideration.

One photographer I know walked into a New York agency with ten notebooks of vinyl pages (about four thousand slides). The director said, "I can't look at that many slides. Weed them down to one book and come back tomorrow." The photographer went back to his hotel room and spent until 3:00 a.m. narrowing the selection down to one book representing his best. He returned the next day and the director said, "This is nice stuff. Do you have any more of these 'people having fun in winter sports'? We get a lot of calls for outdoor recreation."

YOUR LETTERHEAD

Dear _____,

I have noticed your placement of [category] pictures with many national accounts and want to compliment you on your success.

My collection of [same category] photographs is [600] strong [400 color, 35mm, and 200 B&W] and I am adding fresh images [weekly; monthly; regularly]. I am presently seeking a photo agency that will aggressively market my [category] pictures.

May I send you a sampling for your consideration? How many?

Yours sincerely,

[Your name]

Figure 12-1. Sample contact category letter to a stock photo agency.

The photographer went back to his hotel, went through the selection process again, and rushed back to the director with a book of outdoor-recreation pictures. The photographer has since sold outdoor-recreation scenes through the agency and continues to update his file there. Learn from this example. Categorize your pictures before you step into an agency. The director will want to see the best you have—on the subjects that interest him.

Once an agency says "OK, we'll carry your pictures," how many should you leave for their files? If it is a highly specialized agency, a minimum of forty black-and-white prints or slides (two vinyl sheets) is acceptable. A general agency would expect ten to fifteen of your vinyl pages and/or two hundred to three hundred black-and-whites. They would expect you to update this selection with twenty to forty new photos at a time, every six months to a year.

The agency will specify how your pictures should be identified and

captioned. For example, on slides, most agencies want their agency name at the top, the caption information at the bottom. Your identification code, name, address, and telephone number should appear on the sides. They'll want to know which pictures have a model release (MR) or a model release possible (MRP).

The agency will send you their standard contract form in which they'll stipulate, among other things, that they will take 50 (sometimes 40, sometimes 60) percent of the revenue from picture sales. Expect them to require you to keep your pictures on file with them for a minimum of five years. (If after a period of time you want your pictures returned, an agency may take up to three years to get them back to you.)

The PhotoDataBank and Compu/Pix/Rental

Nothing is more important to an editor than to have the picture he needs in hand, in front of him, ready to go.

As the demand for photography in publishing grows, the need outraces the supply, and immediate access becomes increasingly difficult for a photo buyer.

That's why a market letter like my *Photoletter* has been successful. Editors with highly specialized needs cannot always find their pictures readily, since stock photo agencies hold in inventory only pictures with the potential to sell over and over. Where does an editor go for that picture of Albuquerque after a winter snowfall taken within the last two years? Or a picture of a carbonized piece of grain, or a scene of the plains in Iowa as the Mormons might have seen them in their trek across the country in 1847?

The *Photoletter* broadcasts such needs to our subscribers, and invariably some photographer can supply the picture. We also offer a free stock photo service to our subscribers and editors, called the PhotoData Bank. Our subscribers list up to one hundred subject areas (e.g., snails, windmills, Memphis) on 3x5 file cards with their name and address. When an editor wants to locate pictures of collies, for example, we make a photocopy of all the 3x5 cards that designate collies and send them to the editor so he can contact the photographers directly.

An organization in California called Compu/Pix/Rental (C/P/R) has come up with one better—a computerized list of over two thousand picture categories and the photographers who have them. A photographer submits a sampling of pictures (which are returned), and if the photographer is accepted, he pays a fee to enter a category (with cross-references) on the C/P/R computer. If an editor needs a picture of an eagle, the computer in microseconds flashes on the screen the names, addresses, and phone numbers of photographers who can supply eagle pictures. The photographer deals directly with the photo buyer, and if a sale is made, pays 10 percent to C/P/R. Their address is C/P/R, Associated

Photographers International, 21822 Sherman Way, Suite PL 209, Canoga Pk., CA 91303.

The Timely Stock Agencies

A few picture agencies deal in current photojournalism and sell for the service photographer who supplies fresh, news-oriented pictures. The agencies, again, are based in New York, and they send individuals or teams to trouble spots or disaster areas, much as a local or regional TV camera crew covers news of immediate interest. Most of these agencies, with channels or sometimes headquarters in Europe, sell single photographs and provide feature assignments around the globe for their top-ranking photographers. If you happen to photograph a subject, situation, or celebrity that you think has timely national impact, phone one of the following agencies and feel them out:

Gamma-Liaison, 150 E. Fifty-eighth St., New York, NY 10022, (212) 888-7272.
Black Star, 450 Park Ave. S., New York, NY 10016, (212) 679-3288.
Sygma Photo News, 225 W. Fifty-seventh St., New York, NY 10019, (212) 765-1820.

Payment for your picture or picture story is based on several factors: (1) exclusivity (Has the rest of the world seen it yet?); (2) impact (Would a viewer find your picture(s) of interest?); (3) your name (If your name is Pete Turner, add 200% to the bill.); (4) timeliness (Is it of immediate interest?). The following agencies will accept the kind of pictures and picture stories mentioned above, but will also accept non-deadline, human-interest pictures and stories:

Associated Press (AP), 50 Rockefeller Plaza, New York, NY 10020, (212) 262-4000.
United Press International (UPI), 220 E. Forty-second St., New York, NY 10017, (212) 682-0400.

Possible Problems in Dealing with Stock Agencies

In dealing with a stock photo agency, remember: You are the creator, you are in control, and you own your picture.

Contracts

Read any stock agency contract *carefully*. Most photo-agency contracts ask you to sign with them "exclusively." Some stipulate that if you market any picture on your own, 50 percent of those revenues become theirs. Some agencies ask that you shoot stock pictures on a regular basis and send the results to them. If you fail to do so, they assess a "maintenance charge" to your account.

Contracts should be treated as agreements to be modified by both parties. Draw a line through any section in the contract that you disapprove of, and initial it. If your pictures aren't returned to you shortly thereafter, you'll know that the agency values the opportunity to market

your pictures more than having agreement from you on the point or points you deleted from the contract. (Be prepared for possible negotiation and sharing of concessions with the agency.)

Conflicts

Some photo agencies may express wariness of a possible sale conflict— say, two competing greeting card companies buying the same picture—if the agency, plus you, plus one or two other agencies in the country are marketing your pictures. Explain to the agency that you have placed your pictures *by category* with agencies who are strong in these differing categories—and have not placed the same picture (or a duplicate) in competing agencies, and you don't intend to.

Could a problem still arise on a major account where significant dollars are involved? In such a case, the art director would thoroughly research the pictures with you for releases, history of the picture, previous uses of it, etc., before it is used, and any inadvertent duplication or possible sale conflict would come to the fore at that time.

Delays

You'll be more likely to run across a problem in this area: By far the highest percentage of complaints that come into my *Photoletter* office are about the slowness of stock agencies to move pictures. ("I know they could sell my stuff, but they don't try. They don't actively keep my pictures moving for sales. They're selling other photographers' work, but not mine!")

I've followed up on every complaint and have found in all cases the grief could have been avoided. The problem usually lies in the *eagerness* of both parties.

The eagerness of stock photo agencies to supplement their stock of pictures by accepting categories of photos outside their known strength areas can be likened to the well-run garage that keeps its well-paid mechanics busy. They accept any job, any make vehicle, foreign or domestic. They pride themselves on their versatility. The fact is, no one is *that* versatile. Someone usually loses: the customer. With a little research, the auto owner could have found the *right* garage for his car and his pocketbook.

By the same token, the eagerness of photographers to have their photos accepted into a prestigious stock photo agency for the name, rather than on the basis of research showing the agency as strong in their specific categories, gives rise to the "They don't aggressively move my material!" complaints.

If your pictures of Alaskan wildlife, for example, were placed in the ABC Agency—a well-known, prestigious agency—a photo researcher seeking wildlife pictures would bypass that agency if it were not known for a strong wildlife selection, and instead head for the little-known

XYZ Agency, strong on wildlife. Do your research, and choose your agencies with care.

There are other complaints and problems. I often hear them in this form: "Are they honest? I'm not receiving checks for *all* the pictures of mine the agency is selling."

If it is any consolation, I have never heard of a documented case in which it turned out that a stock photo agency purposely attempted to carry out the above. I know it happens, but I believe it rarely happens on purpose. Stock agencies trade on their own reliability factor, just as you do.

As a freelancer, you place yourself at the mercy of the basic honesty of all the contacts you make in the world of business. That's one of the disadvantages of being a freelancer, and probably a good reason why there aren't too many of us. Before you place your pictures with a stock photo agency, find out as much as you can about the agency and then take a leap of faith.

Do You Need a Personal Rep?

What stock photo agencies do for photographers on a collective basis, representatives do on an individualized basis. A rep earns a living by securing the best price for your single pictures and the best fee for your photographing services. There's an old saying in the business, "You'll know if you qualify for a rep because the rep will come to you—just when your photography has finally arrived and you don't need him anymore."

Can a rep be of benefit to you? Yes, especially by freeing you from the confinements of administering your sales. You'll have more time to take pictures. But reps can be expensive too. Depending on the services they

Figure 12-2. *Ways to identify transparencies left at stock photo agencies.*

provide to you, they take from 20 to 50 percent of the fee. Most reps are in New York, where so many commercial photo buyers are.

Unless you live in a city of over a million population and your name is well established in the industry, you and a rep would not find each other mutually beneficial. For further information on reps, contact the Society of Photographers' and Artists' Representatives (SPAR), Box 845/FDR Station, New York, NY 10022, (212) 832-3123.

Start Your Own Mini-Agency

If a stock agency or a rep is not for you, but you want the photo-agency system for marketing your pictures (i.e., you want someone other than yourself to handle the selling), and you want a more aggressive approach to the sale of your photographs than you get with a regular agency, then establish a mini-stock photo agency of your own to handle your pictures.

The Individual Agency

Find a person (friend, neighbor, spouse, relative) who has spare time, an aptitude for elementary business procedures, and a desire to make some money. An interest in photography is helpful, but not necessary. More important, the person should have the temperament for recordkeeping and the ability to work solo.

Your job will be to supply the finished pictures. (You absorb all costs for film and processing.) Your cohort's job will be to search out markets, send out the photos, keep the records, and process the mail. From the gross sales each month, subtract the expenses off the top, and split the net fifty-fifty. (There won't be many expenses: postage, phone, mailing envelopes, stationery, invoices, and miscellaneous office supplies such as rubber bands and paper clips.)

Before you start up your mini-agency, decide on a name and design a letterhead and invoice form. Open a business checking account. Work up a letter of agreement with your colleague that in effect will say:

1. You will split the proceeds fifty-fifty after business expenses, and all pictures, transparencies, and the *name* of the agency will revert to you, the photographer, in case of termination of your business arrangement. Also, the back of your prints will show *your* personal copyright—not the agency's.

2. Bookkeeping records will be kept by your colleague, who will pay you from the business checkbook. Major purchases will be mutually agreed upon and the cost divided between the two of you. (Should you incorporate at this point? Probably not, but it depends on many variables that only you can answer. See the list of business information books in the Bibliography.)

3. Other photographers' work may also be collected by your colleague to market. Reason? IRS rules state that if other photographers' work is also represented, then your colleague is not an employee of yours (which requires employment records), but rather an independent contractor, which requires no government paperwork on your part. Your colleague fills out his own tax forms.

Personalized photography business forms are available from the New England Business Service, N. Main St., Groton, MA 01450. They may have photography forms adaptable to your mini-stock agency.

The success of your mini-agency will depend on the efficiency of your retrieval system—designed for the convenience of both the office help and the walk-ins (i.e., photo researchers looking for pictures). Pictures should be categorized and filed with attention to physical ease of retrieval. Chapter 13 will give you help on this.

A trend for the future of mini-agencies might very well be microfiche, the convenient information storage method used by libraries, banks, and some publishing houses. Documents are photographed and then reduced to a miniature size and placed on film for easy recall.

Bud Kimball, of Steilacoom, Washington has made a unique use of the microfiche. He specializes in scenics and panoramic views of the west. He isolates categories, such as his collection of Mount Saint Helens views (see Illustration 12-1), and puts 89 shots on a 4x6 microfiche card. The first two frames are used for identification. He sells the microfiches to photo libraries who hold them on file, and if they want a print (black-and-white or color) they order it from Bud.

"Customers have a choice of many views," says Bud, "just like at a stock photo agency."

Illustration 12-1. *A full-size copy of Bud Kimball's microfiche. Eighty-two views are on one fiche. Two of the squares are used for identification information. Kimball sells his fiches to libraries and other information sources that rely on such research materials.*

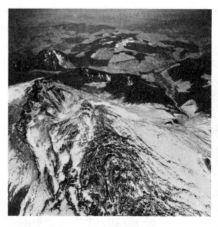

Illustration 12-2. *An enlargement of one of the views of Mount St. Helens from the microfiche.*

The equipment to make microfiches is not cheap: $18,000 is the cost of apparatus to shoot the microfiche. Bud has his processed by Sid Bugelholl (13854 Kinbrook St., Sylmar, CA 91342).

For business reasons, as a mini-stock agency, you may want to explore joining the following three organizations. (Membership can add credibility on your business stationery, and all three provide newsletters with information from the picture-buying point of view that can be valuable to your operation.)

SPAR (see p. 217)
PACA (see p. 211)
American Society of Picture Professionals, Inc., 5283 Grand Central Station, New York, NY 10017.

Once your mini-agency is set up and rolling, if you've chosen a good, aggressive colleague, you'll find you'll be able to concentrate more on picture-taking and less on administration.

The Co-Op Agency

Some photographers prefer to band together and form a cooperative agency: Nonphotographer members handle the administration; photographers handle the picture-taking. They share office-sitting chores, and they are compensated on a total-hours-contributed basis.

I have watched the demise of many such agencies—and the failure can always be traced to a concept problem: They attempted to be a general agency servicing local accounts. This seems logical enough, but a local account figures if it's going to pay national prices, it ought to get its pictures from a national source—and it does. It bypasses the local agency.

The solution for a small regional agency might very well be to specialize. For example, a small agency in Nebraska might specialize in submarines, an agency in Vermont might specialize in things Mexican, and an agency in Florida might specialize in pro-football celebrities. In today's world, where distance has been annihilated by telecommunications, express mail, and computers, there's little reason for a Montana agency to specialize in the obvious: cowboys. It's more important to be a mini-expert on one subject. You'll then gather the pictures from all over the country, and the world, if need be. Here is a list of popular request categories, any one of which could be the specialty of a co-op mini-agency: celebrities, movie stills, historical, natural history, fine art, industrial, agricultural, food, sports, glamour, scientific, geographic, and still lifes.

The local accounts might continue to ignore you—but not when they need your specialty. You'll find them standing in line with the rest of your national accounts.

Decor Photography:
Another Outlet for Your Standards

As a photo illustrator, you will find that many of your Track A pictures lend themselves to a photo-marketing cousin of stock agencies: decor photography (or *photo decor,* or *decor art,* or *wall decor,* as it's sometimes called)—photographs that decorate the walls of homes, public places, and commercial buildings.

There are two basic ways to sell photography for decoration: (1) *single sales* (yourself as the sales person), and (2) *multiple sales* (an agent as the salesperson). In either case, you, or the person you appoint to select your prints for marketing, should have a feel for the art tastes of the everyday consumer. You are headed for disaster if you choose to market prints that appeal only to your sophisticated friends. You'll ring up good decor sales if you can match the kind of photos found on greeting card racks.

Single Sales

Art shows, craft shows, and photo exhibits of all kinds are typical outlets for single sales of your decor photography. Aggressively contact home designers, architects, remodelers, and interior decorators. They are in constant need of fresh decorating ideas. Your pictures can add a "local" touch. Gift shops and boutiques can be regular outlets.

Art fairs provide an opening into the decor photography market. Offer your pictures at a modest fee. (Most visitors come to an art fair expecting to spend no more than a total of $25. Let this be your guide.) You'll find you can make important contacts at art fairs that will lead to future sales. Pass out your business card vigorously. For a listing of national and local art fairs, write Gadney's Festival Publications, Dept. PL, Box 10180, Glendale, CA 91209.

Photo galleries offer important exposure and sales opportunities for your decor photography. The Garlic Press has produced *Photography Galleries and Selected Museums: A Survey and International Directory* (533 Rialto, Venice, CA 90291).

The single-print-sales system that requires person-to-person contact can be time-consuming, cutting into your profits. However, if you enjoy the excitement and camaraderie of art fairs and public art exhibits, it can be rewarding. Probably the most lucrative market for single sales is architects and interior designers—who are in a position to sell your pictures for you.

Multiple Sales

If you want to spend your time shooting rather than selling, use the multiple-sales method. Again, your pictures must be a reflection of the common denominator, but even more so—because your aim is to sell

your pictures in volume to masses of people. If Montgomery Ward can do it, if Vincent Price can do it . . . why don't *you* try it?

Ken Townend of Burlington, Ontario, tried it, and he's doing it. In the last four years he's averaged around ten thousand sales—about $70,000 clear profit. "It's just a Ma-and-Pa operation," Ken says. "I wouldn't want this business to grow any larger. It's very rewarding. I take the kind of pictures I prefer and they are seen in thousands of homes yearly. I'm paid very well in the process."

He says the secret is to find a *good* agent. Where? In the Yellow Pages. "Sixty of them are listed in the Chicago telephone book alone! [Note: See Giftware Wholesalers and Manufacturers.] These are the fellows who also sell Dresden china to the department stores."

Ken was originally an advertising executive and now applies his marketing knowlege to his photography. He finds that sepia-toned pictures on RC paper sell the best. He has written a book revealing more of his secrets. It's called *How To Produce and Mass Market Your Creative Photography*. Write to: Lightbooks, Dept. PL, Box 1268, Twain Harte, CA 95383.

Another entrepreneur in the field of decor photography is William R. Eastman III. Rather than selling in great volume through an agent, he leans toward low-volume sales directly to stores and other outlets. Whereas Ken Townend's finished product sells for $9.95, William Eastman's sells for $75. The latter's forte is the *limited edition*, which enhances the value of a print once the entire edition (usually two hundred to five hundred) has been marketed and the original destroyed. This encourages patrons to buy for investment reasons. Eastman tells all in his excellent book, *How to Produce and Market Your Own Limited Edition Photographs*, available from ARC Pen, 2101 Stover St., Ft. Collins, CO 80521.

What Makes a Marketable Decor Photograph?

One that makes your viewers wish they were there. Choose a view or subject you would enjoy looking at 365 days a year. If *you* don't like the view or subject, chances are your customers won't either. Keep in mind that most buyers of decor photography enjoy pictures of *pleasant subjects* because they find in such pictures an escape from the hassle and routine of everyday living. That's why for this market it's important to take your scenics without people in them. Your viewers would like to imagine *themselves* strolling through the meadow or along the beach. Recognizable people in your picture are an intrusion on their own quietude and privacy. In addition, people included in decor-photography pictures can date the pictures with their clothes, hairstyles, etc. Here are some excellent standards that sell over and over again for decor-photography purposes:

Nature close-ups. Zooming in on the details of the natural world at the correct F-stop always produces a sure seller. They rarely become outdated: dandelion seeds, frost patterns, lichen designs, the eye of a peacock feather, the quills of a porcupine, a crystal-studded geode.

Decor-photography buyers tend to buy *easily recognizable subjects.* An antique windmill would consistently sell better than an antique wind generator (the kind with propeller blades). A still life of a daisy would sell better than a still life of potentilla. Keep your photography salable by keeping your subject matter simple. (Feature only one thing at a time, or one playing off another, rather than a group of things.)

Animals. Both wild animals and pets are perennially popular. Choose handsome and healthy subjects. Keep the background simple to enhance, rather than overpower, your subject.

Dramatic landscapes. Shoot landscapes in all seasons, and especially approaching storms, complete with lightning and rolling thunderclouds. The effects of ice storms are always popular, as are New England pathways in the fall, and rural snow scenes.

Len Nemeth of Northfield, Ohio, sells landscapes to hospitals. "They use them for the ceilings of intensive-care rooms," says Len. "I find the scenics that work best are those that have a splash of *light* somewhere off in the distance. If a path or road in the scene leads to the horizon, it must lead to a light area rather than a dark area. This seems to have a positive psychological effect on patients who have little to do all day but to look at my scenic above them on the ceiling. The light area seems to represent hope."

Bill Ellzey of Telluride, Colorado, also sells decor photography for use in waiting rooms, hallways, and patients' rooms. "Local scenes offer more than decoration," Bill says. "Administrators know the cheering effect decor photography can have on both patients and their relatives, not to mention the staff." Bill also sells to insurance companies, professional offices, and government offices.

Nostalgia. This is a winner—if you can find the right rustic pioneer's cabin or antique front-porch swing; historical sites with patriotic significance such as Paul Revere's home or Francis Scott Key's Fort McHenry; still lifes containing memorabilia such as Civil War weapons or whaling ship artifacts. Again, choose the easily recognized subject.

Abstracts. Your pictures can range from bold urban shadow patterns to the delicate network of filaments in a spider's web. Abstracts lend themselves well to waiting rooms, attorneys' offices, and professional buildings, as well as homes.

Sports. Capitalize on the nation's avid interest in sports personalities and the games they play. Close-ups sell best. Scenes of sporting events such as football, soccer, tennis, and skating lend themselves to game rooms and family playrooms.

Portraits. Model releases are necessary. Close-ups sell best. Exotic, interesting, quizzical, yet pleasant (Mona Lisa) faces sell to legal suites and corporation offices.

Erotic. Eroticism finds a market in private clubs. Subject matter can range from newsstand pornography to esoteric nude studies.

Industrial. Sell your best industrial scenes to engineers' offices. It goes without saying your pictures should be well composed, visually exciting but easy to look at, and of high technical quality. Sell to industry itself. Capture the strength of industry (a la Ayn Rand), its contributions to society: visually appealing abstract patterns, laborers in meaningful work, factories at sunset after a fresh rainfall. Deemphasize the negative aspects of industry.

What to Charge

Prices depend on whether you sell in volume or individually. In either case, after markup, the buying public will pay about $35 for an 11x14 and $25 for an 8x10. Before you decide on your own price, see what the local department stores are getting for similar decor photography.

Limited editions are another question. You can demand a higher fee. And, of course, if you keep a couple prints for the grandchildren, they just might become heirs to a *very* valuable print. How do you limit the edition? As with other printmaking (silk screen, etching, lithography), you destroy the original after making 100 to 500 prints. In decor photography, you destroy the negative.

What to charge for limited editions? Keep in mind the professional artist who once said, "If you are going to price your watercolor at $15, you'll find a $15 buyer. If you price it at $75, you'll find a $75 buyer. And if you price it at $850—you'll find an $850 buyer. Just takes time." The going rate for a 16x20 (color) photograph is between $75 and $150.

Black-and-white or color? Surprisingly, black-and-white prints sell well as decor photography if they are sepia tones. But color probably has the edge over black-and-white. Shoot in transparencies rather than negatives—for three reasons:

1. You can project them effectively when you are demonstrating your subjects to a potential client.

2. Processing-lab technology can handle transparencies cheaper than negs and prints.

3. As a photo illustrator, you'll also want to market your color through regular publishing channels, and they require transparencies.

Size. If you sell your prints on a single-sales basis, you'll find the larger 16x20 print (and higher fee) will result in more year-end profit than smaller (11x14 or 8x10) prints (and lower fee). On the other hand, if you go to *multiple sales* and smaller prints, and aim for the volume market in high-traffic areas such as arts-and-crafts fairs or shopping

malls, you will be equally successful.

Production. The resin-coated papers make black-and-white production on your own very easy. Color production is usually best accomplished by a lab. Shop around. In New York, for example, an 11x14 costs $24 and a 16x20 costs $45 to print. Quality is superb, and the delivery is one-day. However, the decor photographer couldn't survive at those rates.

Here's a processing firm which has taken an interest in serving the decor photographer: Dale Color Inc., Bldg. G, Box 2460, Bloomington, IL 61701, (309) 663-7325. They presently charge about one-quarter of New York prices—but you have to order a minimum of three. Write them for details, and they'll send you a free pamphlet called *Sell Prints for Profit*.

How to Make Your Decor Photography More Salable

Frames. Framing or matting your print definitely enhances its appearance and salability. Some prints can be improved by using textured or silk-finish print surfaces. Dry mounting materials, glass, and hinge mattes are available everywhere. Dale Color (mentioned above) offers protective "shrink wrap" (a thin, close-fitting clear plastic covering). The following company offers inexpensive imported frames (write for a catalog): Picture Frames by Caroline Kingcade, 1313 Atlantic St., North Kansas City, MO 64116, (417)474-5230. And finally, try making frames on your own. How-to series are often featured in photo and hobby and craft magazines. Consult your library's *Reader's Guide* for back issues. Or if all else fails, team up with a frame shop and split the profits.

Promotion. This is the key to your selling success. If you've sold a series of prints to one bank in town, let the other banks know about your decor photography. Work for ways and places to exhibit your pictures often. Sign your prints or mattes for added promotion and referrals. Offer your services as a guest speaker or local TV talk-show guest. Produce brochures, flyers, or catalogs of your work. (For more hints on self-promotion, see Chapter 10.)

More information on decor photography. Kodak has produced *Decorating With Photographic Art* (P3-120) and *Photo Decor: An Idea Book* (P3-200), Eastman Kodak, Dept. PSI, 343 State St., Rochester, NY 14650. Associated Photographers International (API) has produced three reports on decor photography in its newsletter, *APIdea* (issues #57, #59, and #92), 21822 Sherman Way, Box 14, Canoga Park, CA 91303.

Decor photography and stock photo agencies both offer opportunities as outlets for your Track A pictures. The main message of this chapter has been to emphasize that success with these two secondary marketing channels takes research and time on your part. If you're willing to give what it takes, you can realize rewards.

13.

Keeping Records: Knowing Where Everything Is

The Lazy Man's Way to Extra Sales—Knowing What Is Selling

I'm lazy at heart. I like to put the lawn rake back when I'm done with it. Because I've learned it's a lot *more* work next time to search and possibly not even find it when I really need it.

This lazy kind of thinking got me into a very good habit after a while. By having (or finding) a place for everything here at the farm, I got into the habit of putting *everything* away.

I take the same approach to filing away slides, negs, and black-and-white prints. If something's worth having, I figure, it's worth knowing where it is when you need it.

I was happily spurred along in this principle when I inherited several hundred used file folders from a businessman who was retiring. By using a separate folder for each separate stock illustration, I could note right on the folder whenever a picture sold. I put a matching contact print on each folder, thus giving myself an immediate visual reminder of what's selling.

After a few years, my recordkeeping system was teaching *me* what pictures sold best, and therefore, which pictures I should take more of. By continually supplying my Market List's buyers with the kind of pictures they needed, I survived as a photo illustrator.

File It! How to Avoid Excessive Recordkeeping

Here at our barn office, we recently bought a computer. We use it primarily for our newsletter records and mailing systems. I don't think it

will ever replace the good old-fashioned filing system of slipping 8½x11 sheets in a filing cabinet or putting information on a cross-referenced 3x5 file card.

The Library of Congress has used the 3x5 file-card system for scores of years and has no plans to change in the foreseeable future. For the present I plan to continue to file things in the same fashion.

One advantage of my antiquated file system is it gives me a day off every year in April to do my spring cleaning. I eliminate from the front end of many files the material that dates furthest back and is no longer needed. This thins out the files. I save only essential papers or correspondence and eliminate the rest of the file. I also eliminate categories that are outdated or no longer relevant, and thus free some folders for new use. For a list of the files I consider essential, see Figure 13-1.

I don't believe in excessive recordkeeping, and my spring cleaning day helps keep things to manageable proportions.

Another method I use to minimize recordkeeping is to direct new projects to a mini-file, rather than into the central files. I find that mini-projects are usually completed in about a year. Researching for and purchasing our computer was a mini-project; so was remodeling our office in the barn. Others revolve around collecting material for future photo stories or photo essays.

Here's a simple technique for a mini-file. The essential ingredients: Two dozen file folders numbered 1 to 24. A temporary portable "open" file cabinet (like a box), usually made of pressed cardboard or metal and available at stationery stores. Two 8x10 cards—one numbered from 1 to 24 and the other lettered from A to Z.

Each entry is given a numerical designation, filed numerically, and entered on the numbered card. The category is also entered by title and subject on the alphabetical card, with its numbered designation under the appropriate letter. The alphabetical listing also allows you to cross-reference the subject of the project or category. Since the file is small and portable you can carry it between home and office, or store it in a regular file drawer. I often have as many as six or seven projects going at one time, with information building in twelve to fifteen others, and the mini-file system aids me in being a lazy shopkeeper. I never have to work at finding anything.

Knowing How to Put Your Finger on It: Cataloging Your Black-and-Whites and Transparencies

Efficiency is essential if you market your pictures by mail. Establish a workable identification system—and stick to it.

Black-and-White

Here is the heart of your black-and-white cataloging system: negative

Your files will grow, both in size and diversity, as your operation grows. Listed below in order of importance are a dozen basic files.

FILE:

— Transparencies

— Black-and-white prints

— Contact sheets

— Negatives (black-and-white) (color)

— Market list (file by publishing house rather than an individual file for each editor—some publishing houses have as many as thirty editors)

— Cross-reference list (your photos, both color and black-and-white, are cross-referenced on 3x5 file cards)

— General correspondence and business files

— Tearsheets (file by frequently-asked-for categories, according to your PMS)

— Story/article (file story ideas, finished stories, and those in progress)

— Accounts receivable/payable

— Reminders (file by month for future reference)

— Sample copies of market list magazines

Figure 13-1. *What files will you need in your photo-marketing operation?*

sleeves, contact prints of each roll, an identification system, a 3x5-card cross-reference system (or computerized, if you wish, on today's available home-computer programs), and a contact sheet file. Your system can begin inexpensively with these essentials. You can add on as your stock of pictures increases.

One of the best ways I've seen to identify your black-and-whites is the letter/number system. Here's how to set it up: For your identification on each print, use a letter of the alphabet to signify which category of your PMS the print is in. For example: A = Camping, B = Rural/Agriculture, C = Aviation, D = Portraits, E = Automotive, F = Construction, G = Underwater Photography. Follow the letter with a number to signify the number of rolls you've taken in that category. Example: You are on your fifteenth roll of black-and-white underwater photography and you are printing frame number 24. The number of your print would be G-15-24. (The number on the contact sheet would be G-15.) Table 13-1 will give you some more examples.

Of course, there are times you do not devote a complete roll of black-and-white film to one subject. In this case you can cut the film and make two or more contact sheets (each with a different identification number), or you can let the subsequent subject matter remain on your underwater-photography roll and cross-reference it by 3x5 card. No big problem.

In any case, identify your negs. If you already have a large collection

Letters	Categories	No. of Rolls Taken	Frame No.	Neg. No.
A	(Education)	708	12	A-708-12
B	(Rural/ Agriculture)	556	6	B-556-6
C	(Aviation)	28	36	C-28-36
D	(Portraits)	28	30	D-28-30
E	(Automotive)	138	6	E-138-6
F	(Construction)	250	15	F-250-15
G	(Underwater Photography)	15	24	G-15-24

Note: File numerically by first number, then alphabetically. Thus, G-15-24 goes before C-28-36, which is followed by D-28-30, then E-138-6, F-250-15, B-556-6, A-708-12.

Table 13-1. *Code for filing your black-and-whites.*

of black-and-whites taken over several years, you can still use this system. Arbitrarily assign a neg number to all your negatives.

I have seen some photographers use a month/year system to identify prints. However, this doesn't work out well for the photo illustrator. Here's why. For one thing, since the first number in this system should denote the number of rolls you have taken to date, after a few years of taking many rolls of film, your left-hand number will get quite lengthy. (Somewhat like how unwieldy the number on your checks in your checkbook can get.) For example, 3675-24. If you added a date in front of this, say, April '82, your number would read 4-82-3675-24. As a photo illustrator, you might make a dozen prints of the same picture for multiple-submission purposes. That's a lot of numbers to be writing on invoices and the backs of prints, not to mention negs and neg sleeves. If you need to know when a picture was taken, write it on the back (or front) of the contact sheet.

The biggest hazard with the "date" system is that you reveal the age of your pictures. Labeling a picture "4-72" will dampen its reception by a photo buyer. (Like day-old bread at the bakery, somehow it's not fresh.) Out of a selection of equally excellent pictures, a photo buyer tends to purchase the most recent. He is not fully up on equipment or style changes, and he feels he's safest in buying the more recent picture. If you are compelled to include a date, put it in Roman numerals or use the letter system explained on page 144.

For ease in writing your ID numbers on your negs and contact sheets, shoot blank the first two frames of your roll (numbers 1 and 2). Cut off frame number 1, and write your number and any other identification on frame number 2 in india ink. When it's dry, make a contact print. (Since black-and-white rolls are actually thirty-seven frames long, if you didn't snip off the first frame, you'd have to snip off the thirty-seventh frame and have it float loose in your negative sleeve.) The last picture on a roll is usually an important one—and your thirty-seventh frame will now fit exactly (in multiples of six) in your neg sleeve. Store your negs in flat or fold-up (accordion-style) sleeves. I found that trying to save film by writing my identification number in tiny letters on some unused portion of the film was counterproductive. In the long run, it cost me more in time spent deciphering my numbers. Also, I found that by allowing myself a full frame for identification purposes, I had more room for identification of the subject matter—for example, "Gaines Farm," "Aug '81," and so on.

Your ID number should also be written on the back of each print, with a china marker or *very* soft pencil and very light pressure. In a corner near the edge of the print (but not too near, to leave space for trimming the edges later), gently press your rubber stamp or label with © 19__, your name, plus your copyright notice, address, and phone number. Do

Letters	Film Type	Transparency No.
A	35mm (1-500)	A-493 (35mm) A-1008 (4x5)
B		B-623 B-624 (120) B-628
C		C-735 C-860 (120) C-1210 (4x5)
D	120 (501-1000)	D-493 　　　(35mm)
E		E-488
F	4x5 (1001-1500)	
G		

Note: File numerically, then alphabetically. Thus, E-488, A-493, B-623, B-624, B-628, C-735, C-860, A-1008, C-1210. You know immediately that the first two in the list are 35mm, the next five are 120's, and the last two are 4x5s.

Table 13-2. Code for filing transparencies.

not enter the year on your © notice.

After you've made and coded a black-and-white print, you're ready to file it. Here's where your photocopy of your contact sheet comes in handy. Cut out the photocopy contact print of the picture you just printed, paste it under the file tab on a manila file folder, and mark the tab with the print number. This will readily identify the print inside the folder, plus serve as a visual guide when the folder becomes empty because the print is out making the rounds.

Note that the manila-file-folder system works better than storing pictures in, say, 8x10 Kodak boxes. Used manila folders are often available (cheap) from companies switching over to computers. So are used dental and X-ray cabinets for black-and-whites, negatives, or slides. Or if you want to go first class, Display Fixture Company offers a prebuilt slide cabinet (1579 Larkin Williams Rd., Fenton, MO 63026; ask for the Multiplex Cabinet).

When you file your stock photo file folders, file them not alphabetically, but in numerical order, using the first number in your identification code. For example, A-708-12 would be filed somewhere *after* our earlier example of G-15-24 (as in Table 13-1). Z-8-36 would be filed *in front of* A-708-12. Again, if you want to date your prints, use Roman

numerals or the letter code shown in Table 13-2.

A word about printing: It's a good idea to print your black-and-whites on double-weight (or RC) paper—they last longer, plus they just plain look and feel better to a photo buyer. Print four or five at a time. Store the extras in your manila file folders. When a picture is sold, indicate it on the file folder. This will be your best sales barometer. For example, if sales are brisk on a certain picture—and it is a timeless picture—this system will visually suggest to you that you ought to make ten or fifteen more prints of it when you're next in the darkroom.

Keep a running record of your submissions to your Market List. A simple "in/out" ledger is all you'll need.

Transparencies

Here's the best system I've come across to date: Use the alphabet/ number system. File your transparencies in plastic three-ring sleeve pages and a three-ring hanging-style notebook. This type of three-ring binder—usually free when you buy a couple dozen vinyl (plastic) pages—hangs upside down in a letter-size filing cabinet. Since they hang free, the vinyl pages do not buckle and curl as they do when in an upright notebook. Figure out basic categories that reflect your picture-taking interests: camping, rural, classroom, snow skiing, fishing. Decide on your categories when you evaluate your PMS, in the beginning, and prepare several three-ring books. When you expand your supply of pictures, your numbering system will grow along with you. (Three-ring hanging notebooks are available at stationery stores. See Chapter 9 for addresses for plastic pages.)

Hand-letter the code numbers (neatly!) on your slides on either vertical side, near the top. To give a professional appearance, use a system such as Numbatabs (available from Saunders Photo/Graphic Inc., Box 111, Rochester, NY 14601). These stick-on tabs sometimes cause problems in projectors, but photo illustrators rarely allow their slides to be projected. The slides should always remain in plastic sleeves.

To be able to locate specific pictures, cross-reference your picture subjects on your 3x5 file card system.

Rubber-stamp the right-hand or left-hand vertical side of your slide (as you look at it, right side up) with the copyright notice © 19__(your name).* Include your address, and if possible, your phone number. The

*The revised Copyright Law (see Chapter 15) allows (in fact encourages) you to personally affix the © notice to your pictures. Again, do not enter the last two digits of the year so as not to date your photo and diminish its sale potential. The art director or photo editor can enter the current year next to the published picture when (if) he puts your © notice and credit line in the layout for printing. I say "if" because this isn't put in automatically. You should always request the © and credit line in your cover letter to a photo buyer, both for your use of the tearsheets later for self-promotion and possible copyright registration, and for documentation of the picture as your property.

top and bottom of the slide should be left clear in case your slide ends up in a stock photo agency. They'll want that space for their identification system and description.

If your mounts have a date imprinted on them, place a label with your identification information over the top of the date. Self-apply labels are available in one-quarter-inch size: Rubber-stamp a whole page of them at a time, with your name and address, etc. If you need to date your mounts, use the coded system in Table 13-2.

As you begin to increase the number of slides in a particular category, you'll find you're developing a substantial portfolio of pictures on a single subject—for example, agriculture—so that when an editor calls for farm scenes, you'll be able to quickly and efficiently sort out specific pictures to send off for consideration.

A Cross-Referencing System for Retrieving Your Pictures

An editor calls and wants a certain item—a lake in Utah or a picture of a bulldog, for example. Can you locate it readily? If not, it might mean a missed sale.

However, if you are able to consult a 3x5-card cross-referencing system that will pinpoint these subjects quickly for you, the sale could be yours.

Here's How to Do It

Black-and-white. After you develop each roll of film, make a contact sheet on 8½x11 paper. Always place your ID number (as shown in Table 13-1) on the upper left, so that when you're looking for a particular picture, you can flip through the upper left corners of the contact sheets rapidly (a Graphics box usually holds forty to fifty contact sheets). Next, make a photocopy of your original contact sheet. File the original by number in a contact-sheet carton.

On the back of the photocopy, jot down several subject titles that could be used to refer to the subject matter of the pictures on that contact sheet. When making these subject references, keep in mind that photo buyers are usually seeking out prominent aspects in each of your images—nothing obscure. Then set the photocopy in a special file or shelf. When you've amassed a few dozen photocopies of contact sheets in this way, set an evening aside to enter the lists of subjects and their ID numbers in your cross-reference 3x5-card system. (Keep the photocopy sheets; don't toss them away.)

I found that by paying our babysitter a dollar extra an hour to tackle the cross-referencing chore, I could get the job done efficiently. By selecting the right babysitters, I found few errors or omissions. If your family situation doesn't include a babysitter, you'll find time passes

quickly on this tedious job if you plug in to your favorite stereo program.

Color. Cross-reference your color basically by the same system. The identification numbers on your transparencies will have a letter designating the category and only one number (e.g., 5 for the fifth horse picture in your files; 52 for the fifty-second). Thus on your cross-reference 3x5 cards you'll recognize which are referring to color and which to black-and-white.

Since your color will consist of different formats (35mm, 120, 4x5), allow a space on each card between the lists of numbers referring to the different sizes of transparencies, and give each size a characteristic number. For example, under the category of A (we used camping), start your 35mms at number 1; start numbering your 120s at number 501; and your 4x5s at 1001. This will also give you a quick reference—if an editor refers to one of your transparencies over the phone by ID number, you'll know the size.

If your transparency collection in any category or size grows beyond 500, you can revert to the beginning again and assign a small letter a to the next series of 500.

Again, use the hanging file folder system and vinyl pages to store your transparencies. File them in the notebook pages by letter, and then within the pages by number.

Protecting Your Files

Humidity is the greatest enemy of your transparencies (and sometimes of your prints). For $10 you can buy a humidistat (from the hardware store) to locate near your storage area; it should read between 55 and 58. If the reading is lower, you'll need a humidifier; if it's higher, a dehumidifier. Moisture settles to the lower part of a room. Depending on the area of the country you live in, store your negatives and transparencies accordingly.

Damage from fire, smoke, or water can put you out of business. Locate your negs and transparencies near an exit with easy access. If your budget permits, invest in fireproof cabinets. If you live in a flood-prone area, store your film as high as possible. Excessive temperatures will damage your transparencies and negatives. Store them where the range of temperature is 60 to 80 degrees.

Everything Has Its Place

We've all seen cartoons picturing busy editors, their desks piled high with terribly important papers. The caption usually quotes the editor in some defense of his "filing" system.

Photo illustrators can't afford the luxury of an editor's haphazard filing system. As your stock photo library grows, so will your need to be able to locate everything, from pictures to contact sheets, negs to notes.

Keep in control. If everything has its place, nothing should get lost. If you use an item, put it back when you're finished. The editor's desk got that way because he didn't follow these two principles:

1. Make a place for it.
2. Put it back when you're finished.

Is the editor lazy? To the contrary. It's a lot more work to shuffle through that heap on his desk to locate something.

Time lost can mean lost sales for the photo illustrator. Take the lazy man's approach—know where everything is.

"Include minorities when possible" is a request you'll often get from publishers of books and magazines. Such pictures will be highly marketable. The young people in this picture were playing a game of touch football and were discussing their next play. By moving in close, the football is eliminated and it appears they are in discussion.

Is grain objectionable in a photo illustration? Photo editors are more artist than engineer. If the picture fits their need, they tend to excuse what a photography purist might call technical imperfection such as the grain in this picture.

14.
Working Smart

The Success Habit: Following Through

"There's no big secret about how to succeed as a photo marketer. You simply take good pictures. They'll sell themselves."

Wrong.

For every picture that sells by itself, there are about 100,000 waiting in files, unsold, because the photographer believed the above. Good pictures are only half of what you need. The other half is working *smart*.

Photo marketing is a business. And the principles that help business people to make a success of their efforts will also help you.

Knowledge is useless unless it is applied. That's the first thing novices learn when they venture into the business world. Photographers who succeed do so not because of their knowledge of photography or photo marketing, but because they apply what they know.

Action. Sounds simple. But wisdom in business is not a one-time move, it's a continuing movement, a momentum, a follow-through, until it becomes habit. If you take the principles in this chapter and make them habits of your photo-marketing lifestyle and work style, you are on the road to success.

Setting Goals

Where is your ship headed? Are you on a fishing expedition, heading out in the bay and hoping to get a bite? Or do you have a definite destination, a well-researched spot where "they're bitin' "?

The SBA (Small Business Administration) tells us that most new-comers venture into a new business as if they were going fishing, with a

lot of anticipation and enthusiasm and most of the emphasis on externals instead of on precisely where they want to go and how to get results.

Your chances of getting your pictures published and recognition for your photographic talent will be excellent if you form the winning habit of setting goals for yourself *before* each move you take in your business development.

Are you captain of your ship? If you're not, then you're letting others steer your ship for you. You have no way of knowing where you're going or how you will get there.

But if each day you plan to reach a point by the end of that day and a further point at the end of the week, and another by the end of the month, your ship will travel the most efficient way between where you are today and where you want to be.

The reward in this way of operating is that you don't cut into your free time, or playtime, in the process of accomplishing your goal. You replace wasted time and lost motion with productive energy directed toward your destination.

Getting Organized

Have you ever tried to enter a sailing race without checking for torn sails, sizing up your competition, charting the course, figuring what currents and river traffic you'll have to buck, knowing when and where to tack, being prepared to adjust to the vagaries of the weather, sandbars, or reefs? An organized and efficiency-conscious person will be on the dock, enjoying wine and cheese, while the person who thinks he can enter the race without setting goals and making plans will still be out in the elements attempting to get to shore, paying the price for his lack of preparation.

"But I'm a creative person. I'm not organized," you might say. "I believe in the spontaneous approach."

People who visit me here at the farm are surprised to see how organized I am. They expect disorganized bliss. They find instead self-discipline, and a smooth-running operation.

Some talented musicians, artists, writers, and photographers feel it's unfashionable, uncomfortable, even un-American to be organized. But creative people, the ones who accomplish with consistency, *are* organized. They can't afford not to be. Time is too important to them. Anyone who values his time and expects to accomplish anything of note *is* organized. A disorganized person will sometimes attain momentary fame and brandish his disorganization as a badge of distinction. But the ones who sustain and expand their success have learned to quietly get organized.

Lou Jacobs, Jr., the photographer and author, once told me, "The only

time I'm unorganized is when I'm on vacation." Like Lou, save your spontaneity for your Sunday shots and days off. As you build your photo-marketing business, set your goals, follow through, and be prepared when opportunity beckons. These are the secrets of creative success.

Time Your Goals

Set short-term and long-term goals. Make them realistic.

For a short-term goal, aim to be sending out a certain number of pictures by a certain month. Aim to cut your processing, film, and paper costs by a certain percentage within the same month (by shopping for the best price and streamlining your buying procedures—order by mail or phone rather than in person, and order in quantity).

For a long-term goal, aim within two years to be selling three times the number of pictures you are currently selling.

Goals need not be rigid and inflexible. They can be changed— upwards or downwards—depending on many variables. Write them down, though. Spoken goals don't have the same impact.

Write down a few "dream" goals, also. They're free.

I'd advise you not to share your written goals with anyone, save your spouse or cherished friend. Few people will share your enthusiasm. Friends, colleagues, and relatives are often experts at giving advice, though their experience and personal life situation may not justify it. Keep your goals to yourself, and share them by accomplishing them.

Is It Easy? A Survival Secret

Probably the most frequent question put to me is "How can I become successful at publishing my pictures?" The answer is simple, though it's not the answer most photographers expect. And that may be one reason the answer is so elusive to so many.

We might expect the answer to be "Be born with *talent*" or "Work hard!" Having talent and working hard can help, of course. But we all know photographers with a lot of talent who are going nowhere. We also know a lot of "hard workers" who are headed for the same place. To get to the point: If your desire to become a published photographer is so strong that your personal constitution will allow you to "put up with and do without," then success is just around the corner.

Whenever I follow up photographers who in the past expressed dreams and aspirations of publishing their pictures, I find that the ones who have met with success are the ones who have persisted and endured.

First of all, they have "put up with" the unglamorous chores inherent in this business. As they faced each day, they didn't avoid the tedious tasks. They had *true grit*. They knew that if they avoided an irksome job,

it wouldn't go away, but would grow into a larger problem the next day, and by the end of the month, it would be an insurmountable barrier.

And what are these unpleasantries? As a photo illustrator, you face them daily: retyping a poorly composed letter to a prospective photo buyer; spotting a black-and-white print; making a phone call that will straighten out a disagreement; cross-referencing your pictures; filing your contact sheets; packaging photos and licking stamps.

If you are new to the field of photo illustration, you'll nevertheless recognize those drudgery jobs in a different form at your household. Every uncleaned paintbrush, or tool unreturned to its shelf, that unbalanced checkbook, and every unanswered letter in that pile of important letters—all are examples of things we don't like to do, things that pile up until it becomes a habit to *not* get them done. That habit then becomes our style, or *us*. Wishing away drudgery jobs never works. We cannot become a success at anything until we face the fact that a goal or a purpose must be worth *more* than the inconvenience of tackling the chores most people just don't like to do.

In my experience, I find that photo illustrators who throw in the towel do so not for lack of talent, but because they are victims of their own failure to recognize this essential point: *Put up with the drudgery.*

The second dictum is, Do without the creature comforts. Hopefully, this will be necessary only in the initial stages of your career. How long you will do without depends on the goals you have set for yourself. Some goals are short-range and easily attainable. Other goals are long-range, worthwhile, and rewarding to the soul, but not immediately rewarding to the pocketbook.

In order to get established as a photo illustrator, one must frequently do without the conveniences Madison Avenue continually reminds us we must possess: air conditioning, color TV, latest model car, a new wardrobe. In order to meet film or postage costs, or the purchase of a new enlarger, we must often change lifestyle or supermarket habits to economize. We must do without.

If you begin today to economize, and tackle each "drudgery chore" as it comes along, you'll be surprised to find that you'll get into a habit of successfully meeting challenges. What was once an annoying task will become a joyous one for you, because you'll welcome and recognize it as another milepost on your journey to your goal as a successful photo illustrator. If you persist and develop the inner constitution to "put up with and do without," you will begin your success where others failed.

"Victory belongs to the most persevering."—Napoleon

Think Small

In a few pages, I'll be asking you to think big, once you get your photo-marketing operation rolling. But Rome wasn't built in a day. Aim high in

your photography aspirations, but initially aim low in your sales targets. Make your first mistakes where large audiences and your later market editors won't see them.

I'm not proposing mediocrity, simply advising you not to fall into the "glory" trap: You'll run up against the wall built by experienced competitors, only to become discouraged and take that lucrative job offer in vacuum cleaner sales. The result: You'll become another name in the Directory of Also-Rans. *Work smart = think small* in the early stages. Give yourself production and fee goals that are immediately reachable, and then move along in steps on your way to thinking big.

Don't Misdirect Your Work

Working smart includes not working—on projects or in directions that offer little promise. If you gauge in advance what to avoid, you can save yourself money and time. As a photo illustrator breaking into the markets, assess beforehand the degree of difficulty you will face when approaching a particular magazine or publishing company. Is the market crowded? (For example, *Ski* magazine, in New York, states in *Photographer's Market:* "Presently overstocked with photos.") Is it a closed market such as *Time, People, National Geographic?* Or is it wide open? (Open markets include local magazine supplements for Sunday newspapers; denominational publishers, listed in *Photographer's Market* under Book Publishers, that publish dozens of magazines and periodicals; association and organization magazines like the *Rotarian* or *Kiwanis* magazine.)

What is the supply/demand ratio involved for each type of market? Some photographers do not learn the answer until they have uselessly spent a fortune trying to market pictures to a virtually closed market. Read the cues: "No use for this type of photography." "We're overstocked on those." "Bring more detail into your pictures if you want to sell to us." "We have a photographer who does those and don't need any more."

When you fill in your yearly assessment of your best markets, you'll know which ones to shut out. With each sale, you'll gravitate closer to your ideal markets.

The typically closed markets (see Appendix A) are the calendar, greeting card, poster, and placemat areas. The market is glutted with fine photographs and fine photographers. Why try to drive through a stone wall for occasional sales, when lucrative avenues await you? Magazine and book publishers with $10,000-, $20,000-, and $30,000-a-month budgets for photography await the photo illustrator who has discovered his own PMS and has zeroed in on a specific Market List.

Your research and your own personal experience will determine which markets are closed to you. If the situation doesn't look promising

in light of your current degree of expertise or depth in a certain photographic area, don't knock fruitlessly at a door that isn't ready to open to you yet. First put your energies and your dollars into tapping the lesser-known markets. You'll save money, gain experience, build your picture files, sell photos—and that's working smart.

Draw up a weekly report that tallies work activity scores, such as how many shipments were sent out, how many pictures were sold, and so on. Analyze these on a continuing basis to see if your sales are growing and what categories and which shipments have been most successful. Continue to revise your Market List priorities from these figures.

Your PMS—The Heart of Working Smart

At the heart of how smooth your business will run is a solid understanding of your personal marketing strengths (PMS), well coordinated with a sound Market List.

To photograph and attempt sales outside of your PMS or Market List is akin to being adrift out there on the bay on that fishing trip—yet many photographers are slow to switch over to the habit of concentrating on marketable photo illustrations.

Decide early in your photo-illustration career what portion of your photography is your hobby and what portion is business. Learn the difference between pictures that are marketable as photo illustrations and pictures that feed your soul but are monumentally difficult or even costly to market. Concentrating on producing marketable pictures can add up to sizable savings for you, as well as sizable earnings—and that's *working smart.*

Learn how to specialize. Don't be a photographic jack-of-all-trades. Instead of spreading yourself thin, get to know your strong areas even better. Provide your photo buyers with expertise that matches their readers' interest. You'll be in control of a well-managed photo-illustration business if you concentrate on your areas of personal marketing strength.

You Manage the Business—Not the Other Way Around

Being one step ahead of the competition, whether in a footrace or a pass pattern in football, makes all the difference between winning and losing. In business, it works the same way. If you get behind, you lose control, and get behinder and behinder. The business begins to manage you. You can be out front, even if it's by inches, if you adopt the winning habit of daily keeping your ship on course.

In photo illustration, this applies especially to the routine you establish to get your shipments out to photo buyers. Establish a written plan (this will help to crystallize your thinking), and follow through.

If you are not a self-starter, here's a technique many people have used effectively: Hire a part-time assistant to come to your office certain days of the week to send out shipments of pictures. To keep your helper productive, you must always have new work ready to send out.

A Self-Evaluation Guide

How do you tell if you're making any progress? By measuring it. Too often, photographers and other creative people find one year running into the next without ever analyzing their efforts to see if they're really moving or just running in place. A well-received exhibit or a TV interview might create an illusion of success, but if the bottom line shows zero at the end of the year, it's time to assess your efforts.

Your measuring system doesn't have to be elaborate, but to be effective it should encompass at least a three-year span, so that you have a meaningful basis of comparison. (Quarterly or monthly assessments—based on your photo submissions "in/out" ledger—will be helpful until you reach the three-year mark.)

There are four areas you will want to keep a running tally on: pictures sent out; pictures bought; money received; and film, paper, and processing costs. Chart these monthly, as shown in Table 14-1, and at the end of three years you will see your progress. ("Pictures bought" in one month may include many pictures actually sent out during previous months.)

How to Measure Your Sales Strengths

You'll know your sales strength areas if you track your sales for a year.
Start any month of the year.

1. Assign a code number to each of your sales areas.
2. Make a sales slip (use carbon paper, photocopy, or mimeograph) that includes a blank space for:

Sales Slip
Date:
Amount:
Code Number:

3. Each time you receive a check for the sale of one of your pictures, record the above information. If one check is for two or three different sales areas (code numbers), make two or three sales slips.
4. File your sales slips in a drawer until the end of the month.
5. At the end of the month enter the information from the sales slips on to a chart (ledger) similar to the example in Table 14-2.
6. Make a total of the previous months and the current month for a year-to-date total.

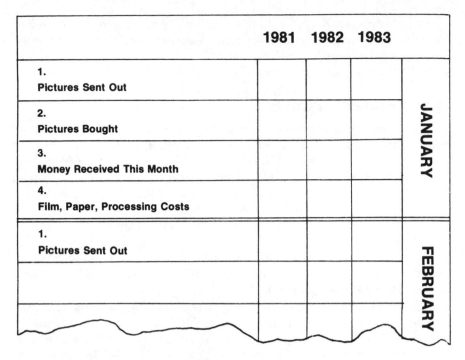

	1981	1982	1983	
1. Pictures Sent Out				**JANUARY**
2. Pictures Bought				
3. Money Received This Month				
4. Film, Paper, Processing Costs				
1. Pictures Sent Out				**FEBRUARY**

Table 14-1. *Your success scorecard.*

Your sales totals are your best marketing teacher. Which code area(s) shows the highest income?

By monitoring these statistics, you will be able to accurately document in which areas you should concentrate your sales efforts.

Pictures Just Aren't Selling?

Working smart includes reevaluating your working procedures now and again, too. Start with your packaging presentation. Here's a trick you can use to assure that you're maintaining top quality. Ask the person closest to you to be your quality-control engineer. Every so often, when you prepare a package for a photo buyer, don't let it out of the house until your spouse or special friend has given it the quality-control go-ahead. Let this person critique it, acting out the role of photo buyer. Painful as it might be, you'll form the habit of giving every detail of your presentation your best.

The Five Reasons for Rejection

If you're not getting the sales you feel you ought to be getting, give the following points some serious thought. Often, success can be a process of elimination. By avoiding failure, you succeed. Get back to the basics,

MONTH: _____	CODE NO.	TOTAL SALES PREVIOUS MONTH	TOTAL SALES THIS MONTH	TOTAL SALES YEAR TO DATE	TOTALS FOR 12 MONTHS BEGINNING: _____ ENDING:___
PRIMARY MARKETS — **MAGAZINES** — SPECIAL INTEREST	100				
TRADE	101				
BUSINESS	102				
DENOMINATIONAL	103				
ASSOCIATIONS, ORGANIZATIONS	104				
LOCAL MAGAZINES	105				
STATE & REGIONAL MAGAZINES	106				
NEWS SERVICES	107				
OTHER	108				
BOOKS — TEXTBOOKS	200				
CHURCH RELATED BOOKS	201				
ENCYCLOPEDIA	202				
CONSUMER TRADE	203				
OTHER	204				
SECONDARY MARKETS — **STOCK PHOTO AGENCIES** — AGENCY A	300				
AGENCY B	301				
AGENCY C	302				
AGENCY D	303				
OTHER	304				
MAJOR NEWSSTAND MAGAZINES	400				
DECOR PHOTOGRAPHY — MARKET A	500				
MARKET B	501				
MARKET C	502				
MARKET D	503				
OTHER	504				
THIRD CHOICE MARKETS — **PAPER PRODUCTS** — CALENDARS	600				
GREETING CARDS	601				
POSTERS	602				
POST CARDS	603				
OTHER	604				
COMMERCIAL ACCOUNTS — ADVERTISING AGENCIES	700				
PUBLIC RELATIONS FIRMS	701				
RECORD COMPANIES	702				
AUDIO/VISUAL HOUSES	703				
GRAPHIC DESIGN STUDIOS	704				
OTHER	705				
ART PHOTO SALES — MUSEUMS	800				
PRIVATE INDIVIDUALS	801				
OTHER	802				
OTHER — GOVERNMENT AGENCIES	900				
NEWSPAPERS	901				

Table 14-2. *A ledger to assess your sales strengths.*

and turn your marketing sales spiraling upward.

There are four basic reasons for photographs being rejected. If you are guilty of any of them, you should reassess your marketing methods.

1. Poor presentation. Is your outside envelope clean, presentable durable, and crisp-looking? Are you using a professional label or imprinted logo? Did you include SASE with your submission (if you are a new contributor to the publication)? Are your transparencies packaged in vinyl sleeves? Are they clearly identified? Have you checked for the current address and photo buyer's name? Is your cover letter a professional-looking printed form letter (which saves your time and the editor's) rather than a rambling handwritten letter?

It may seem unfair that the outside appearance of your package is so important. But photo editors are busy people and have found through experience that amateurish packaging usually reflects the contents. Often they relegate a sloppy package to the "return" bin—without opening it.

2. Off-target and unrelated submissions. Does the material you've submitted stick to the point of the editor's request? Do your pictures hit the mark? Or has the editor asked for pictures of waterfalls, and you've submitted pictures of brooks and streams "just in case" the editor might want to see them?

Also, are your pictures *cohesive* in *style?* Do the pictures themselves have a consistent, professional-looking appearance? That is, do they all look like they came from the same photographer? A good way to test the cohesiveness of your pictures, and their professionalism, is to gather pictures from magazines and periodicals on your Market List, lay about twenty of them on the living room floor, and then place your pictures beside them (or if you deal in slides, project them on a screen with the tearsheets taped to a nearby wall). Do your pictures fit in? If so, you are on target. If not, retake the same pictures, incorporating into your new pictures what you have learned from this exercise.

3. Poor quality. Take a look at your pictures again. Is your color vibrant and appropriate for the mood and scene? Have you properly filtered your indoor shots where fluorescents are involved? If you've used flash or lights, have you avoided "hot spots"?

How sharp are your color and black-and-white? Published pictures must go through several generations before they reach the printed page. Your pictures must be appropriately in focus, with good film resolution (sharpness), with no grain (again, unless appropriate), and with no camera shake, as these faults will be magnified in your published picture.

Are your prints technically good? Have you achieved the best possible gradation in your black-and-white prints: a stark white (with some

details), several gradations of grays, all the way down to a deep, rich black (also with some details)? If you've used burning/dodging techniques, they shouldn't be apparent to the photo editor. Have you spotted your prints (see Appendix C), especially the 35mms?

Are your pictures dog-eared, with rough edges, cracks, folds, tears—or scratches?

All of the above are quick evidence to a photo editor of poor craftsmanship and low reliability factor.

4. Outdated pictures. Outdated pictures can be another enemy to your sales. Photo editors expect a fresh batch of new pictures from you on each shipment. Some pictures are long-lived, timeless: fifty years from now, your heirs could continue to benefit by their sales. The majority of pictures, however, are short-lived because they reflect the *now*. In a matter of years (usually between five and ten), you will want to extract these pictures from your files because they are dated by clothing and hair styles, equipment, machinery, furnishings, and so on.

Some stock photographers have attempted to circumvent this problem by eliminating anything from their pictures that would date them. This (generally speaking) means excluding people. However, the one most essential element in a successful photo illustration *is* people. Exclude them and sales diminish.

Putting your dated pictures out to pasture is not an enjoyable prospect. Be as objective as possible in your weeding-out process. If you find it difficult to eliminate pictures, ask a friend to look through a group and to try to guess what year the pictures were taken. Your friend's objective assessment will be very similar to a photo editor's.

We all have a tendency to rationalize our pictures' usefulness and stretch their life span beyond marketing reality. It's no fun sending them to the incinerator. At the risk of sounding like dial-a-mortician, I'm asking you to *be realistic*. Photo editors are. Outdated pictures will "outdate" you, and possibly eliminate you from the photo editor's roster.

5. Poor composition. Assess the *composition* of your pictures. Do they adhere to the $P = B + P + S + I$ formula? (See Chapter 2.) Do you zero in on your subject matter with the appropriate emphasis for each situation? When you work with people in your pictures, do you orchestrate the scene so that the results are natural and unposed? In other words, are you producing marketable photo illustrations?

If this section on why pictures fail to get published is discouraging to you, it shouldn't be. Remember that the photographers who are successful at photo marketing are not those who occasionally produce a brilliant photograph, but those who periodically assess and evaluate their

progress. If they find deficiencies, they take the next step: they do something about it.

Please be cautioned that some photographers take my suggestions for avoiding failure to extremes. These folks are *perfectionists*. "Do it right or not at all." "There's always enough time to do it over—but never enough time to do it right in the first place." These admonitions are certainly well-founded, and many successful photographers can trace their success to adherence to such good rules. The paradox is that many unsuccessful photographers can trace their failures to them, also. Why? The procrastinator, under the guise of perfectionism, accomplishes nothing for fear of not doing it flawlessly.

Procrastinators spin wheels reading and studying about cameras and equipment and how to take pictures—and keep telling themselves they don't know enough to start, that their pictures aren't good enough yet to send to an editor.

If you find yourself justifying procrastination, ask yourself to redefine *quality*. You can pride yourself on quality presentations without crippling yourself by equating quality with perfection.

A Potpourri of Additional Aids in Working Smart

Remember the Law of 125

When you get upset with a photo buyer, remember the Law of 125. Each person you deal with influences 125 other friends, neighbors, relatives, or business colleagues. It works this way: If you produce a good product for a person, that person will probably tell five people (5) who may each tell five people (25) who may tell five people (125).

$$1 \times 5 = 5 \times 5 = 25 \times 5 = 125.$$

If you turn away a prospective customer with an angry remark or letter or poor attitude, you may be turning away 125 prospects.

Insurance

Are you insurance-poor? That is, are you putting a disproportionate amount of your dollars into insurance instead of film and photo supplies? Don't allow yourself to be talked into equipment insurance plans that will put you in a bind. Talk around with other photographers. If you hear of many instances of stolen equipment, then a solid equipment or business protection plan might be in order for you. Reexamine your policy from time to time. Some of your equipment may have depreciated to the point where it isn't cost-effective to continue to insure it. On the other side of the coin, the incidence of theft may have increased in your neighborhood. Protect yourself accordingly.

Buying insurance is like gambling. You play the odds. However, some careful research on your part can establish how much insurance is "enough" for you. Shop around. If you're quoted disproportionately different rates, read the fine print and investigate the company through *Consumer Reports* or your local Better Business Bureau.

The best insurance is the daily habit of prevention. *That's* affordable.

1. Know the high-risk areas for thievery.
2. Don't tempt thieves with flashy camera bags or unlocked car doors.
3. Invest in a burglar-alarm system.
4. Inscribe your name on your equipment. Your local police department will help you on this.
5. Ask for references from the people you employ.
6. Keep receipts and serial numbers of all your equipment.

Toll-free Numbers

The telephone is rapidly becoming an important resource for the photo illustrator. The numbers listed here are toll-free, and the people on the other end of the line stand ready to serve you in some aspect of your photo operation. This is only a sampling of the toll-free numbers available to you. For a number not on this list, call the toll-free information operator at 800-555-1212 and ask if the company has a toll-free number. You'll save on your phone bill, and get your answers from the experts, quick. The major photography magazines often list toll-free numbers in the ads for camera equipment and film processing. A toll-free directory is available from *Toll-Free Digest,* Box 800, Claverack, NY 12513.

800-221-0448	**Apple Label.** They produce a variety of labels useful in your work.
800-328-8006	**Century Camera** (Minneapolis). Cameras and photo equipment at a savings plus special finance terms. Call them with your inquiries. Ask to be placed on their mailing list. Highly recommended.
800-348-2220	**Fox Professional Color Labs** (nationwide). Call them for a catalog or for information on how you can get your color processing done via their mail system.
800-238-5355	**Federal Express.** Will deliver your pictures overnight anywhere in the U.S.A.
800-223-9808	**Midtown Foto** (21 W. Forty-seventh St., New York, NY 10036). Call or write for a free copy of their catalog. Need a camera at a savings? Call them for details.
800-225-1618	**Polaroid.** Are you using the Polaroid process in any part of your photography operation? Here's the hotline to call if you come across problems and need them answered by a Polaroid technician.

800-221-2222 **QWIP.** Want to transmit photos by phone? The industry is moving toward transmitting pictures via telecommunication methods. Although the results are still primitive and few editors have the receiving terminals, keep your eye on this industry.

800-638-4480 **Ritz Camera** (11710 Baltimore Ave., Beltsville, MD 20705). Huge inventory of camera equipment at savings. They offer a full-year limited warranty. For information about sales on cameras, call them. Friendly service. Catalog available.

800-527-5172 **T.I.E.** (Brownsville, TN). They manufacture plastic sleeves for transparencies.

800-628-1063 **U.S. Envelope Co.** (Dallas). They manufacture and sell business envelopes at rock-bottom prices.

800-331-1212 **Avis Rent-a-Car.**

800-228-9650 **Budget Rent-a-Car.**

800-654-3131 **Hertz Rent-a-Car.**

800-433-7300 **American Airlines.**

800-323-7323 **Eastern Airlines.**

800-621-7107 **Pan American Airlines.**

800-621-6640 **TWA Airlines.**

Helpful Government Agencies with Toll-Free Numbers:

Some of your assignments or Market List magazines might call for direct dealing with some aspect of the government. This list is a small sampling of those offices that have toll-free numbers. You can find many more.

800-638-6700 **Basic Education Grants.** Student information on loans and grants.

800-362-8025 **Consumer Hotline.** These folks will listen to your product complaints.

800-638-2666 **Product Safety Office.** If it's falling apart, they'd like to know.

800-323-1608 **USTS Travel Information.** Hotline for travel and tourist information.

800-424-7962 **U.S. Postal Service.**

Federal Tax Information. Provides answers to your questions, plus assistance on your federal tax questions. Number varies by state.

Grants, Loans, Scholarships, Fellowships, and Aids

Assistance is available to photographers on local, regional, and national levels. The funds come from state and federal agencies, plus private corporations and foundations. The monies are awarded usually for specialized photographic projects. If your grant, fellowship, etc., idea is accepted, the grant can provide a boost for your supply of stock photos in one of your PMS areas.

To apply, photographers propose a photographic project, and if selected, receive a stipend ranging from $500 to $1,000 a month for a period of several months.

You can learn more about how to write proposals for and receive such funds through these books:

The Art of Winning Foundation Grants
by Howard Hillman and Karin Abarbanel
Vanguard Press
424 Madison Ave.
New York, NY 10017

Gadney's Guide to Contests, Festivals, &
 Grants
Festival Publications
Box 10180
Glendale, CA 91209

Documentary Photography Grants
by Bill Owens
Working Press
Box 687
Livermore, CA 94550

Foundation Grants to Individuals
The Foundation Center
888 Seventh Ave.
New York, NY 10016

Getting a Grant
by Robert Lefferts
Prentice-Hall
Englewood Cliffs, NJ 07632

Grants and Aid to Individuals in the Arts
Washington International Arts Letter
Box 9005
Washington, DC 20003

Grants in Photography—How to Get
 Them
by Lida Moser
Amphoto Books
1515 Broadway
New York, NY 10036

Grants Register
St. Martin's Press
175 Fifth Ave.
New York, NY 10010

National Endowment for the Arts
Washington, DC 20506

The ultimate in working smart, of course, is doing work that you don't consider work at all. If you've defined your PMS well and tailored your Market List to markets which offer you the best potential, you'll find that you'll automatically be working smart.

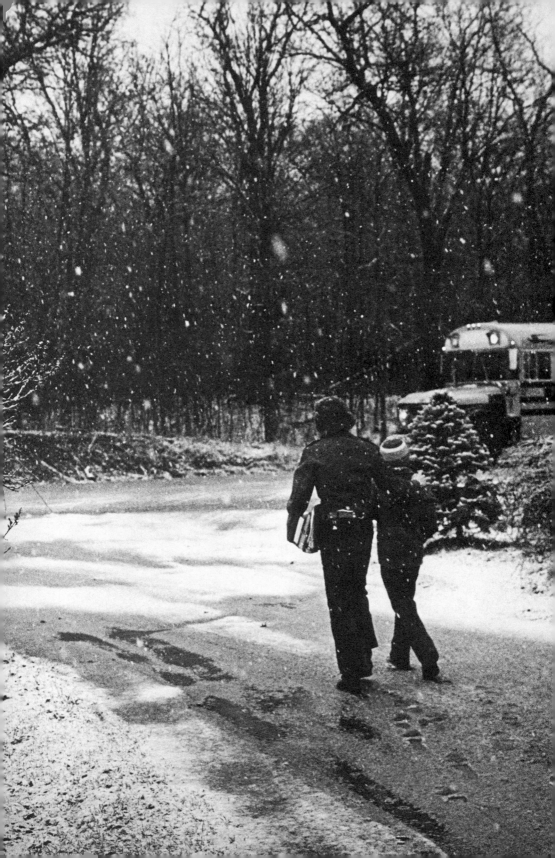

15.
Rights
and
Regulations

Copyright

Who owns your picture? You do! The Copyright Law now speaks loud and clear.

In 1976 the U.S. Congress revised our ancient Copyright Law (the first major revision in sixty-nine years), and the revised version has been in effect since 1978. The new law makes it possible to claim copyright for each of your photos by simply affixing the © 19__ Your Name to each print or transparency. Now you have, by law, the ability to "lease," to resell, every photo in whatever way you specify, and have your work protected by the Copyright Office in case of infringement.

You can also choose to formally register your picture with the Copyright Office for a fee (currently $10). You then receive a registration certificate, which in effect makes your claim to the picture airtight in the event you ever have to haul an infringer (one who used or reused your picture without authorization) into court. If you don't register your picture, it is still protected by copyright, as your property. You still have legal claim to it. However, formal registration eliminates any risk and insures that you'll receive full financial recompense in the event of infringement.

Copyright Infringement

Let me say at the outset that copyright infringement in the area of photo illustration is rare (as opposed to service photography, where infringement does crop up now and then). In twenty years as a photo illustrator I have experienced only one instance of possible infringement. And in that case an art director, new on the job, made an honest mistake.

If you wish to be super-safe, you can register your extra-special marketable pictures. When you do, you'll receive the benefit of the Copy-

right Office's computerized facilities, documentation, and recording and search assistance. Plus you'll have copies of your work filed with the Library of Congress. But generally, in photo illustration work you won't find it necessary to register every picture. The © symbol affixed to the back of your picture (or the front if you wish), or next to your credit line in a layout, offers a warning to would-be infringers. The right to affix the © symbol is yours; it costs you nothing. The law recognizes that you own your picture once you have it on film. The new law is, in effect, a photographer's law, rather than a publisher's law as it was prior to 1978.

Remember: a copyright only protects your picture, not the idea your picture expresses (Section 102[b]). If someone improves your idea with his picture, that's not copyright infringement; that's free enterprise. For example, if your photograph shows a kitten hanging precariously by its tiny claws from a clothesline, it's not copyright infringement for another photographer to photograph his own kitten (or mouse or hamster) in the same situation.

Group Registration

Another option, and to the photographer quite an advantage, is that under the new revision, you can "group-register" photographs that have been published in periodicals if you wish. Whether you're registering five pictures or fifty, whether they're from one magazine or newspaper, or many, a single fee (currently $10) is charged—a bargain from the Copyright Office. You can select any number of pictures published within any twelve-month period in a periodical but you need one copy of the entire issue in which the photo appeared for each photo you choose. If your copyright notice is not included with your credit line, you then cannot group-register your picture. However, the picture will still come under the publisher's "blanket copyright," included in the masthead, which protects all editorial matter and photographs (excepting advertising) within the publication.*

How to Contact the Copyright Office

For more details on specific points in this chapter, phone the Copyright Public Information Office (202) 287-8700 between 8:00 a.m. and 4:00 p.m. (their time), or write: Register of Copyrights, Library of Congress, Washington DC 20559. If you feel you need legal advice, contact an attorney. For a free copy of the Copyright Act of 1976, Public Law 94-553, write to the Register of Copyrights.

The Copyright Law is lengthy (twenty-two pages) and covers all as-

*Service photographers take note. Since noneditorial photographs (ads) are not protected by the blanket copyright of a magazine, insist that your copyright (or the ad agency's, if you worked "for hire") be included with your picture.

pects of creative endeavor, from motion pictures to book publishing. We'll be addressing here only the portions of the law that relate to photo illustration. If you are also a writer, I suggest you get hold of some of the fine articles written on Copyright Law listed later in this chapter.

Interpreting the Law

Writing and commenting on "the law"—any law—is like discussing philosophy or religion. A point of law might be stated one way—but it's open to different interpretations. Only time and court tests solidify the interpretation. Even then, there are exceptions to the rule. As each photo illustrator's Market List and PMS are different, so is his need to interpret the Copyright Law. I have made every effort to insure the accuracy of the information contained in this chapter, checking it with copyright officials and attorneys, but I cannot guarantee the absence of error or hold myself liable for the use or misuse of this information.

To sum up points of the law covered so far:

—You own your picture (unless you have signed a "work for hire" agreement, discussed later in this chapter).
—You can register your pictures for added protection.
—You can group-register photos for a reasonable fee.

Be Wary of Dates

All of your pictures published prior to *January 1, 1978,* which appeared in copyrighted publications, are copyrighted jointly by you and the publisher. The Copyright Office does not recognize you as the *sole* owner of the copyright on such a pre-1978 picture unless you can show proof that you leased the picture on a one-time basis or that the publisher reassigned all copyright privileges back to you. It is doubtful that this situation will cause you any problems, unless the picture concerned is one with great market potential (such as a person who recently catapulted to fame . . .). Nevertheless, all pre-1978 pictures are not in public domain; if they're your creation, you do have copyright protection on them—but limited to the arrangements you originally made with the publisher. (Pictures taken before 1978 but not published until after 1978 will enjoy the benefits of the new Copyright Law.)

Now for the bad news. It *is* possible for you to lose the right to your pictures and for them to fall into public domain. Here's how it can happen: If you fail to include the rubber-stamped (or handwritten) copyright notice (© 19__Your Name) on your print (front or back), and if it is then published in an *uncopyrighted publication* (e.g., a literary magazine or a low-budget regional publication), and if you do nothing about correcting the error in a period of five years from the date your

picture was published, then the Copyright Office will refuse to register your picture. It is then implied that your copyright has expired and that your picture belongs to "the people." It is in the public domain. Anyone who happens to get hold of one of your prints or original transparencies can use it.

This, of course, is an extreme example—but how would you correct the situation? If it's an important picture, you should register it immediately with the Copyright Office. Send two copies of the original (8x10s if black-and-white, dupes of a transparency) along with your registration fee. Ask for form VA.

The revised Copyright Law offers the machinery to protect your ownership of your pictures, but ultimately the burden of protecting your rights is on you. The rationale behind the "public domain" concept goes like this: A created work deserves to be enjoyed by the people. Credit and reward should go to the creator, but if he, by choice or circumstance, is not in a position to reap the potential benefits, then the public at large can lay claim to the creation. In which case anyone can capitalize on your picture if he sees potential in it that you may have missed.

The Copyright Office can offer you no protection if you have relinquished your rights through neglect, ignorance, or your own wishes. If two people claim the right to the same picture, the one who shows legal ownership (published copyright notice and/or registration) is the person who will be recognized by the law as the owner. (It's possible, for instance, for two people, or a group of photographers, to be in the same place, at the same time, getting the same picture. The one who completes copyright notice or registration first receives the certificate of registration. Do not rely on your ownership of the original negative as your claim to copyright. An infringer who has produced a copy of your picture might testify that his original negative was lost or destroyed. The courts would probably recognize the photographer who holds the copyright certificate, not the negative.)

Again, I am citing an extreme case involving a distinctive picture that would have great significance or commercial value for one reason or another.

I suggest in Chapter 13 that you leave the year blank when you order the rubber stamp for your copyright notice (© 19 ___ Your Name), so as not to "date" your pictures and lose potential sales. The Copyright Law is not clear as yet as to the stringency of adherence to date requirements. The Copyright Office is interested in the date the picture is (was) published, not the date you took the picture or printed it in your darkroom. Therefore, the layout person or art director can insert the date of publication in small print adjacent to your picture in the layout and satisfy this requirement.

However, some art directors don't include the © notice and date next to

your picture. What, then, if there's an infringement question? The answer to this still has to emerge over time and experience with actual situations, as they arise. In the meantime, the © notice with the year blank is accepted by the Copyright Office (since you can register an *unpublished* photo that has no publication date yet), and the advantage of not "dating" your pictures far outweighs the remote possibility of complications from an infringement.

Laying Claim to Your Picture

The Copyright Law doesn't specify what else you should have on your picture for identification other than © 19 __ Your Name. (Always copyright under your name, not the name of your business. Otherwise, if you sell your business, with it would go the copyright to all your pictures.) For your own ID purposes, however, always include your address and phone number. I also advise ordering a stamp with the memo shown in Figure 15-1. (Use two stamps—the other for your address and phone.)

(Your slides will require an abbreviated form of the stamps shown in Figure 15-1 because of the border-size limitation, but be sure to include all the information on your accompanying invoice.)

There are sound reasons for going to the trouble of such a memo stamp:

1. "Leased" implies that this picture is not work-for-hire.* (In work-

Stamp 1

> © 19___ Your Name
> This picture is leased for
> one-time inside editorial
> use only. Please include ©
> credit.

Stamp 2

> Your Name
> Name of Business (optional)
> Your Address
> Your Phone Number

Figure 15-1. Stamps to protect your prints.

*If the purchase order or agreement—or even the check—you receive from your client requires you to sign anything that implies that you are offering more than one-time publishing rights, or states a work-for-hire arrangement, don't sign it. Cross out and initial that portion of the purchase order or agreement, stamp your rubber stamp on the margin, send it off with the picture (also stamped), and let them carry the ball from there.

for-hire, the copyright may not belong to you.) "Leased" also means that you have not entered into any separate sales arrangement with your client, and that you want any transparency returned to you, and, when practical, you'd like any black-and-white print returned to you.

2. "One-time" assures that you are not assigning any rights other than rights to one-time use. If you wish, include this sentence in your invoice: "Additional rights available."

3. "Inside editorial rights" simply lets them know that if they decide to use your picture on a cover, they must pay you extra. (See Table 8-2 for how to increase your fee when a picture is used for a cover, advertising, etc.) It will also protect you in the future if an art director happens to use your picture without authorization for commercial (trade) purposes or advertising. If a suit were to arise relating to trade and advertising use because of the people pictured in the photograph, you could show proof that the picture was leased only for editorial purposes (which usually require no model release).

4. Include © credit. Shows proof, in case of infringement, that you asked the publisher to name you as copyright owner.

Some Drawbacks of the New Law

> INFRINGER (Section 501[a]): Someone who violates any of the exclusive rights of a copyright owner.

The revised law, although it benefits the photo illustrator, must be seen realistically as also potentially benefiting an infringer—a person who innocently (or knowingly) pirates your pictures. To illustrate how an infringer might have more muscle than you do when it comes down to the bottom line, consider this: The cost for registering a picture in actuality is about $24, if you consider the cost of the initial correspondence, the printing of your two 8x10s (deposits), postage and handling, clerical work at your end, and the $10 registration fee. If you were to discover an infringement, five more exchanges of letters with your attorney and the infringer would amount to about $50. The attorney's pretrial consultation fee would be $35 to $90, and a day in court would cost you $250 to $1,000. And here's the curve ball. Section 504(c) (2) and Section 405(b) provide that, when an infringer is not aware that and does not have reason to believe that his acts constitute an infringement, the court is allowed to reduce the minimum statutory damages to $100. (Even if you had your picture registered!) The upshot of all this is, you could lose money in the deal. If you won the case you might be lucky and the court might award you reasonable attorney's fees as part of the costs. But as we all are aware, sometimes it's nonproductive to sue.

Your greatest protection, then, is to place the copyright notice on *each* of your pictures. (Remember, the notice costs you nothing.) An "innocent infringer" would rarely pirate your picture if identification were on it, and most assuredly not if you had it stamped with a copyright notice. It carries clout. Like the average citizen who never removes the mattress label (Do Not Remove Under Penalty of Law), the infringer is likely to shy away from anything that looks like a federal offense.

In the rare instance where you might discover an infringer within three months after you have published an unregistered picture, if you choose to press charges, you can run and get your picture registered at the Copyright Office and haul the infringer into any court having jurisdiction in a civil action. If it's past the three-month deadline, you can still register your picture, but damages you would receive if you won the case would be limited.

The process of registration is simple for authors who register an entire book for $10. For photo illustrators, who produce thousands of pictures, the administration and expense of registering each one might be likened to separately registering each paragraph in a novel or textbook. As photo illustrators, then, we continue to be left to the mercy and basic honesty inherent in most people. God save us from "innocent infringers!"

Under the new law (Section 113[c], 107, the "fair use" doctrine), libraries, schools, and noncommercial broadcasters (such as public television) can use your pictures without requesting your permission, provided their use is limited to educational and noncommercial activities and does not diminish the future marketing potential of your picture.

This latter ruling will need further interpretation because of the paradox involved when a picture receives wide exposure. Consider the broadcasting of pro football—the profession is still not sure whether broadcasting enhances or decreases gate sales. Hence the blackout provision. This provision of "fair use" by the nonprofit sector, which has yet to be fully tested in court, could prove to be a great disadvantage to the photo illustrator.

Let's hope we can make enough clamor that appropriate provisions and adjustments will be made in the law for the photo illustrator. As one sage put it, "A new law is like a new baby; it's created, but that's only the beginning. Then we watch to see which way it will grow."

Q & A Forum on Copyright

In the following Q & A Forum, I'll give detailed answers to some significant questions as they apply to you, the photo illustrator, first citing the source in the Copyright Law of 1978.

Can the © be placed on the back of Section 401(c)
my picture, or must it appear on the and
front? House Report
 ML-182

Your copyright notice can be rubber-stamped, printed on a label, or handwritten on the back or on the front of your prints. In the case of a transparency, it can be placed on the border (back or front).

Who owns my picture?
 Sections 201(a)
 (b)(c) and
 203(a)(3)

You do, from the moment you snap the shutter ("fix the image in a tangible form"). Before 1978, it was assumed the person who used your picture (publisher, ad agency, client, etc.) owned the copyright. The new law assumes you own all rights to your pictures unless you have signed those rights away. Except in a case where you have entered into some kind of transfer-of-rights agreement with a client or publisher, such as a work-for-hire agreement, no one else can exercise any ownership rights to your picture. Even if you do sell "all" rights to your picture, you retain title to it, and in thirty-five years, full copyright privilege reverts back to you, if you request it.

How long do I own the copyright on Sections 302(a)
my photograph? and
 405(1)(2)(3)

The new Copyright Law says your picture "subsists from its creation" (when you snap the shutter), and you own copyright to it for as long as you live, plus fifty years. That is, if you *register* your copyright. (The old law, by the way, allowed you only fifty-six years to own your picture.) If you don't register your copyright, your photograph could, under certain circumstances, fall into public domain. You might wish to register pictures that hold special importance for you. The current fee is $10. Ask for Form VA. If you wish to register nonphotographic work such as writing, ask for Form TX.

How can my picture fall into the Section
public domain? 405(1)(2)(3)

The new law has not actually been put to the test on this one yet, and we hope it never is. But theoretically, if you were to publish your picture without a copyright notice, or your name was misspelled on your notice, your picture could become public domain. If you didn't register a claim to correct the error with the Copyright Office (i.e., register your picture) within *five* years after the picture was published without the notice, or

with the error, then the picture's copyright would be invalidated. The Copyright Office would not register your picture after that time and copyright invalidation would be implied, which in effect would mean your picture would be in public domain—that is, anyone could use it and not be required to pay you for it.

What is group registration and how do I do it?
Section 408(c)(2)

This provision of the new law says you can register any number of pictures from any twelve-month period for one price. Whether you're registering five pictures or fifty, and whether they're from one magazine or newspaper or many, the fee is currently only $10. (Group registration for your pictures appearing in books, however, is not possible. They must be registered separately.)

How to do it: For each photo you choose, obtain one copy of the entire periodical in which it appeared. Under the current rulings of the Copyright Office, it is mandatory that a bona fide copyright notice (© 19___ Your Name) appear adjacent to your published picture for it to be group-registered*—another reason to encourage photo buyers to include your © and credit line next to your picture in their layouts.

To group-register, fill out Forms VA and GR/CP (available from the Copyright Office, Library of Congress, Washington DC 20559), and send them along with your $10 fee (in check or money order payable to the Register of Copyrights) and copies of the periodicals or newspapers in which your published pictures appeared.

For *unpublished* pictures: Submit several contact-size pictures on one 8x10 sheet or submit photocopies of unpublished transparencies or black-and-white prints (not photocopies) of the pictures you wish to register. Since unpublished works must be in the form of a collection, call this collection of pictures "Collection of Photographs by (Your Name)." Fill this title in where it asks for it in space #1 on Form VA. The new law is undergoing interpretation in this area. Submit as many pictures on one application as you care to. The Copyright Office will react to your request on an individual basis until a regulation on group registering has been solidified.

If I ask a publisher to include my © notice alongside my picture when he publishes it, but the © is omitted, does this invalidate my copyright protection?
Sections 401(a)(c), 405(a)(2)(3), 407(a)(2), and 408(a)

*This requirement of the law (Section 408(c)(2)) is especially disadvantageous to photographers, since few art directors seem willing to include © notices alongside photographs in their layouts.

No. Your copyright protection exists if you can show proof that your picture was (1) rubber-stamped, printed, or handwritten with the copyright notice on the front or back before it was published, or (2) published in a copyrighted publication. Since *all* of the pictures (except advertisements) in a publication are covered by the blanket copyright notice in the masthead, copyright protection for you is implied.

Can I place the © notice on my slides and photographs and be protected in court even if I didn't register my picture with the Copyright Office?	**Sections 401(a)(c), 405(a)(2)(3), 407(a)(2), and 408(a)**

Yes, the © notice that you put on is "official," and it is *free*. If a picture is not registered (with the Copyright Office), it does not mean it is not copyrighted. Use this analogy: your automobile—you *own* title (copyright) to it, even if you choose not to register it. Once you drive it (publish your picture), you're vulnerable to accidents (infringement). If you were to go to court, it would be a lot easier for your attorney to represent you (and to win your case), if your automobile (picture) was registered with the Department of Motor Vehicles (Copyright Office).

If I do not register my pictures but I publish them anyway with the © notice, can I be ordered to send them in to the Copyright Office?	**Sections 407(a)(d)(1)(2)(3) and 704 Title 44 (2901)**

Yes. Under the new system the photographer will not be forced to register his pictures, but he can still be ordered to submit two copies of a *published* work in which a © notice appears, to the Library of Congress (the parent office of the Copyright Office). If after being ordered to send them, the photographer does not do so *within three months,* he can be fined up to $250 (for each picture) for the first offense, plus the retail cost of acquiring the picture(s), plus: If the photographer fails to or refuses to comply with the demand by the Copyright Office, an additional fine of $2,500 can be imposed.* All deposited pictures become the property of the Library of Congress (but you retain the copyright!).

What does "work for hire" mean?	**Section 101(1)(2)**

If you are employed by a company and take a picture for that company

*Random published photographs, under this system, are arbitrarily requested for deposit by researchers at the Copyright Office.

as an employee, generally speaking, that's work for hire. The company owns the picture. You have probably, somewhere along the line, signed a work-for-hire agreement with your employer. (If you haven't, the new law assumes *you* have total ownership of your pictures.) If you are a freelancer and a picture is specifically ordered or commissioned by a company, and you have signed an agreement saying so, you are "working for hire." However, if a magazine gives you an assignment and pays for the film and expenses, this is not working for hire unless you *sign* a document saying so. If you receive such an assignment, avoid signing a work-for-hire statement. Instead, agree to allow exclusive three-year rights to the client (or two-year rights). If the client insists on "all rights," increase your fee.

Are the pictures I submit to a photo editor who's listed in Photographer's Market or similar reference works considered "work for hire"?	Sections 101(1)(2) and 201(b)

No, unless you have signed a work-for-hire statement.

What if a publisher wants to reprint my picture a second time as a reprint of the original article, or wants to use my picture to advertise his publication, or wants to use my picture a second time in an anthology? Does the publisher have the right?	Section 201(c)

As a photo illustrator, you should assign only *one-time publishing rights* to a publisher. In fact, unless it's stipulated in writing, the law now assumes that you have assigned (or "leased") your picture to him for one-time use. A publisher is privileged to use your picture in a revision of a book or a reprint of the magazine article it originally appeared in or in collective works—but in no other case may the publisher presume to use your pictures without your consent and/or compensation to you. If a publisher would like your picture for additional use, refer to the pricing guide for photo reuse in Table 8-3.

What penalties does infringement (unauthorized use of a photo illustration) call for?	Sections 412(1)(2), 205(d), 411, and 504(c)(1)(2)

If your picture is registered, you receive the full benefits of the Copyright Law. The owner of a registered copyrighted picture on which infringement has been proved may receive, in addition to damages he has suffered (court costs, attorney fees, etc.), the amount in cash of the profits received by the infringer. The copyright owner has the burden of proving the infringement, but could receive as much as $50,000 if he wins. But if the infringer proves that he infringed "innocently," the award to the copyright owner could be as low as $100—or even zero. If the copyright owner asks only for statutory damages, and he wins the case, the award could be between $250 and $10,000. If you do not register your picture and your picture is used without permission, even though you still own the copyright on your picture, the court fight might not be worth the trouble and expense. Your legal remedies are limited.

What is the statute of limitations for infringement?	**Section 507(a)(b)**

If you don't discover an infringement within three years, you have no recourse for damages.

Can I take a picture of a photograph or an object that is copyrighted?	**Sections 113(c) and 107**

Yes, under the "fair use" doctrine, a photograph or other copyrighted work can be copied or photographed for purposes such as criticism, comment, news reporting, teaching, or research. Generally speaking, if you don't intend to make a profit from the copyrighted item, the law is on your side. For example, your use of a copyrighted picture in a slide program for a nonprofit lecture series or camera club demonstration does not require permission from or payment to the photographer or owner of the copyright. However, if the picture were to be used by you for self-promotion or advertising purposes, or if the picture of the copyrighted object were to be given such wide distribution and dissemination as to reduce the effective market value of the original copyrighted photograph or article, you would probably be guilty of infringement. As a photo illustrator, since your pictures are used basically to educate and to inform the public, taking a photograph of a copyrighted object or picture probably would not be infringement. Of course, you must keep in mind that your interpretation might be different from the court's, and consider each case in its own context.

Should I register all my best pictures?	**Sections 411(b)(2) and 412(1)(2)**

That's like asking, "What kind of boat should I buy?" It depends on whether you'll use it on a lake or an ocean, how large your family is, and your pocketbook. Even if your picture is not registered with the Copyright Office and you discover infringement within *three months* of publication, you can still register your picture. If you discover the infringement after three months, you can register, but legal remedies would be limited. If you discover the infringement after three years, you have no recourse (statute of limitations).

The cost of registering your copyright(s) might be considered a disadvantage. Most photo illustrators own at least 5,000 excellent pictures. $10 x 5,000 = $50,000. Remember, registering your pictures is optional. Registered pictures receive better protection under the law. You can, of course, save costs by group-registering your published pictures.

How long can I wait to register a published picture?

Sections 104(a), 412(2) and 408(a)

Any length of time. Registered pictures receive broader legal remedies than unregistered pictures. But copyright protection is yours whether your picture is registered or not. If there is an infringement you have *three months* to register your picture from the date it was first infringed. If for some reason your pictures were published in such a way that your copyright notice was erroneous or omitted, or your name was misspelled (for example, on the masthead of a magazine where copyright notices are usually listed), you have five years to make correction and five years to register the picture(s).

If my picture is included in a magazine or book that is copyrighted, does that mean the publication owns the copyright to my picture?

Section 201(c)

No, *you* own the copyright, unless you've made and *signed* some special arrangement with the publisher. If you've leased your picture on a one-time-rights basis, then it is assumed that the publisher has only "leased" your picture for temporary use.

If I don't have my picture registered and it is included in a copyrighted publication without my copyright notice on it, am I protected by the blanket copyright of all the (editorial) material in the publication?

Section 201(c)

You are protected by the Copyright Law whether you publish in a copyrighted publication or an uncopyrighted publication. You receive additional protection in a copyrighted publication; in an uncopyrighted publication, the burden of proof would be on you. The current trend for most publications is *not* to include a separate copyright notice in the layout alongside each published photograph. The publisher is more likely to include your copyright notice in a list of credits somewhere in the magazine or book. The Copyright Office does not presently recognize this as a separate notice. Because the copyright law requires a *separate* notice for proper copyright identification of your picture (for example, if you choose to group-register your pictures), this currently presents a dilemma for the photographer. "Separate notice" is an unreasonable requirement on the part of the Copyright Office, given the nature of photography publication.

Are pictures used in advertising **Section 404(a)**
also copyrighted by the publisher in
a copyrighted publication?

No. The publisher can claim copyright only on that material over which he has editorial authority. Therefore, if your picture is used for advertising purposes, it should be published with the copyright notice visible. Request that the advertising agency include your © notice, or at least theirs.

What is the copyright status of all **Section**
the pictures I published before the **408(c)(3)(c)**
new law came into effect on
January 1, 1978?

Under the old law, unless you *registered* those pictures, your pictures would have copyright protection limited to the transfer arrangements you made with the publisher when you published your pictures. (If you rented your picture on a one-time-rights basis, your copyright protection would not be in jeopardy.) The Copyright Office might question such ownership, in which case you might be requested by the Copyright Office to submit proof, such as a waiver, or "transfer of rights," from a publishing house. It could prove to be an enormous administrative hassle for you to group-register, say, all the pictures you published between August 1972 and August 1973. You would be better off registering your *best* pictures from that era by submitting original 8x10 deposits (a deposit = a print in the lingo of the Copyright Office), rather than group-registering them.

Work for Hire

Although the Q & A Forum touches on "work for hire," you should know

more about this subject, especially if you will be accepting an occasional service assignment that could fall into a work-for-hire situation.

Before 1978, the courts generally assumed that if a freelancer did a specific photographic job for a person or company, the photographer did not own the resulting pictures; the company or client owned them. The new Copyright Law reverses this, and the courts assume the *photographer* owns the pictures, not the client. This alone clearly indicates the growing awareness of the resale value of photo illustrations.

The law now says that, unless both parties have a written agreement between them stating the assignment is "work for hire," no claims to ownership of the resulting pictures can be made by the client.

A client *could* assume ownership of your pictures under these circumstances:

1. If your client is actually your employer, and you have made no provision to transfer copyright ownership of your pictures over to yourself while under his employ. (Note: It is possible to have the copyright of your pictures transferred back to you after an agreed-upon time.)

2. If you have signed a purchase order, assignment sheet, or similar form that states (sometimes in an ambiguous or roundabout way) that you are working for hire—even though the words "work for hire" are not actually used. The statement might read, "All photographs covered in this contract become the sole property of the client."

3. If you have endorsed a check which has printed on it a statement that says by endorsing the check you relinquish all claims to ownership of your pictures. "Endorsement below constitutes release of ownership of all rights to manuscripts, photographs, illustrations, or drawings covered by this payment." Your recourse here would depend on various circumstances. You might cross out the offending lines and endorse the check. You might send the check back and ask the client to issue a new check minus the offending phrase. Each situation is different. If possible, consult with other photographers who have completed assignments for the same company and compare notes on how arrangements with the client have been worked out.

In some cases, the client may be testing you. Handle with care. With diplomacy, you could get full copyright ownership and remain in the client's good graces.

Which Rights
Do You Sell?

The title of this book is *Sell & Re-Sell Your Photos*. It should be: *Sell & Re-Sell the Rights to Your Photos*.

You don't want to sell all rights, as in a work-for-hire situation. You want to "rent" your photos, selling only certain types of rights. There are different sizes, shapes, and extents of rights—but primarily you want to base your sales on *one-time-use* rights. Any other rights of use should require separate negotiation and additional payment.

Read the Fine Print

The different designations of rights commonly accepted in the industry are:

One-time rights. The client or publication has permission to use the picture only once. You "lease" the picture for that one use.

First rights. The same as one-time rights, except that the client or publication pays a little more for the opportunity to be the first to publish your pictures.

Exclusive rights. The client or publication has exclusive rights to your photograph for a *specified amount of time,* such as one or two years. After that time, the rights return to you.

Reserved rights. A client or publication may wish to pay you extra for being the only purchaser to have the privilege of using your picture in a particular manner—such as on a poster or as a bookmark—in which case you would reserve that use specifically for them.

All rights. This is the outright transfer to a client or publication of all rights of reproduction and use of your photograph. (The *title* to the photograph, however, according to the revised Copyright Law, remains with you since you are the creator. After thirty-five years, if you wish the rights to the photo to return to you, or to your heirs, you or your heirs have the right to reclaim them.)

As a photo illustrator, you should avoid assigning "all rights" to a client or publication if the picture has marketing potential as a stock photograph. If the picture, however, is timely, it may be wiser to accept the substantial payment that "all rights" commands and relinquish your rights to the picture. Examples of pictures that might soon become outdated, and therefore unsalable, are photos of sports events, festivals, and fairs.

Your standard cover letter (Figure 9-1) can serve as an "invoice" to your photo editor. In some cases, however, you will come to an agreement with an editor regarding certain other rights and/or arrangements that are not covered by your standard letter. Spell out these terms in a separate letter to the editor confirming the understandings. Also send an invoice with your shipment which reiterates all of the pertinent details of the transaction, such as rights being offered, number of pictures and their ID numbers, size, color or black-and-white, date, and so on. In-

voices are available at stationery stores. Professional-looking invoices are available from mail-stationers (write for a free catalog) such as New England Business Service, N. Main St., Groton, MA 01450; Grayarc, Box 227, New Hartford, CT 06057; and The Drawing Board, Box 220505, Dallas, TX 75222.

Forms to Protect Your Rights

Up to this point we've been discussing the rights of photo usage that you sell. What about *your* rights with regard to damage, loss, or pictures being held for lengthy periods of time? Your photo-marketing endeavor necessitates submitting valuable photographic materials to persons with whom you've never had personal contact. Is this taking a risk?

Is it a risk to travel down a road at 55 mph and face the oncoming traffic? Any one of those cars could cross over into your lane. What makes you continually take this risk?

You take it due to the plain fact that the benefits of driving your car outweigh the risks involved.

You are likewise going to have to place a lot of *faith* in the honesty of the photo buyers you're dealing with. You're going to have to continually risk damage or loss to reap the benefits of getting wide exposure for your pictures.

There are contract forms available—also called "Terms and Conditions" agreements—that a photographer can issue to a photo buyer to specify terms of compensation in the event of damage or loss of photos while in the hands of the photo buyer or his company. But newcomers (or sometimes anyone—veteran or neophyte) have little chance of getting a photo buyer to sign a "Terms and Conditions" agreement. The disadvantages to the buyer outweigh the potential benefits. In fact, he might turn the tables and ask you to sign an indemnification statement that will free him of any liability as a consequence of using your pictures.

Keep in mind that others you depend on to handle your prints and transparencies—the U.S. Postal Service, United Parcel Service, your film processor—refuse to reimburse you more than actual film cost, in the event of damage or loss. Also, the IRS, in assessing the depreciation of your slide inventory, sets value not at intrinsic value, but only at actual film cost.

My advice: Lay out your terms and conditions to a photo buyer in a friendly, easy-to-understand cover letter as shown in Figure 9-1. Once you attain stature in your photo-illustration operation, if you wish—or in special instances—you can then test the waters by submitting a formal "Terms and Conditions" statement. This kind of statement, however, might tend to intimidate, turn off, or actually anger a publisher, unless presented by a "name" photographer.

Even a "name" photographer will think twice about using these agreements, however. For example, there is a provision that calls for reimbursement of $1,500 for each transparency lost or damaged. This fee has indeed been collected on occasion, but subsequent communication between photo buyer and photographer is usually not quite the same, if it exists at all. If you find yourself in a similar situation, you will probably want to weigh your loss against your relationship with the photo buyer, and determine whether you wish to press such a payment from a good client for the result of unusual accident or an honest mistake.

If you wish to research these forms further, particularly as an aid in dealings with clients or companies you're not familiar with or whose track record is questionable, the following books listed in the Bibliography offer sound examples: *ASMP Professional Business Practices in Photography* (includes tear-out sample forms); *Selling Photographs: Rates and Rights; Selling Your Photography: The Complete Marketing, Business and Legal Guide; Volunteer Lawyers for the Arts Model Forms.*

Legal Help

If you run into a situation where you need legal help in dealings with a photo buyer, a publisher, or the IRS, the following organizations offer assistance. To consult with just *any* attorney on a legal problem concerning the arts and publication is like offering him a blank check to finance his education in the matter. Different attorneys are well versed in some areas, less informed in others. Before you contact an attorney, make a call to one of the organizations below. The VLA (Volunteer Lawyers for the Arts), for example, number more than 350 volunteer attorneys across the nation who handle a variety of arts-related situations. In some cases, the consultations are free.

Bay Area Lawyers for the Arts
25 Taylor St.
San Francisco, CA 94102
(415) 775-7200

Volunteer Lawyers for the Arts
36 W. Forty-fourth St., Suite 1110
New York, NY 10036
(212) 575-1150

Lawyers for the Creative Arts
111 N. Wabash Ave.
Chicago, IL 60602
(312) 263-6989

Model Releases

There is perhaps no area of photography more fraught with controversy and misconception among equally competent experts than the issue of

when model releases are required. A recent issue of a photography magazine states, "So, at present, we are all forced by this ambiguity in the law to obtain model release forms from virtually everyone we photograph if publication is intended. It is much better to be safe than sorry, so obtain a release beforehand, regardless of the hardship, and save yourself a lot of aggravation."

The above was written by a respected columnist in a national magazine for amateur photographers. It is misleading and does a disservice to photography and impressionable newcomers to the field.

Where do great photographs come from? From great photographers who were once amateurs. What if Alfred Eisenstadt, Margaret Bourke-White, Eugene Smith, Henri-Cartier Bresson, or Irving Penn had been exposed to such misinformation as youngsters? Would it have inhibited their photography?

What about the promising photographers of today who will be photographing (for publication) topics such as poverty, agriculture, the environment, industry, our social and political institutions?

Will they be influenced by what appears to be an authoritative dictum from a nationally respected industry magazine? This is only one of many admonitions from equally credible platforms that advise carrying a model release pad in your back pocket wherever you go.

Photographers are confused, and as a result, often hesitate to take or use a picture because model releases will be too difficult to obtain. This seriously limits the photographer, and in the end it limits you and me—the public.

Freedom of the Press

In the last decade, we as photographers have let increasing distance slip between us and a basic right conferred by our Constitution. The First Amendment affords us the right, not shared by closed societies of the world, to freedom of the press—to know what's going on about us. The First Amendment recognizes the dangers of restricting the ability of the press to report in good faith on matters of public concern. We need to be ever on guard, not only against constricting laws, but the more subtle, binding practices that the government can impose on photographers.

To wit: In recent years the court has approved searches of newsrooms (Zurcher v. Stanford Daily) and of the minds of reporters (Herbert v. Lando). It has narrowed the public-figure concept in libel cases (Hutchinson v. Proxmire; Wolston v. Reader's Digest) and sanctioned closings of courtrooms to the press and the public (Gannett v. DePasquale).

As we all know, model releases are required when pictures are used for commercial purposes such as advertising and endorsement. By also requiring a model release for editorial photographs, a publication or an

institution opens itself to tyranny. Who's to say what restrictions would be placed on a photographer if we didn't have the First Amendment on our side?

Camera columnists who perpetuate the model-release myth become unwitting partners in a disturbing trend that would put a muzzle—or a lens cap—on every media person, including you.

How, then, has this myth about model releases evolved? Much of the confusion arises because the information in how-to photography books is slanted to the service photographer who definitely requires model releases for his commercial work. Little is written for the photo illustrator, whose target markets are magazines and books, where editorial content slated to *inform* or *educate* does not require releases.

Two surprising further perpetrators of the model-release myth emerge: photography magazines and prestigious film and camera companies.

Photography magazines are essentially trade magazines. In the interest of being super-safe, a growing number of corporate attorneys for trade magazines have made it a practice to advise a blanket model-release requirement for all pictures published in the magazine, whether commercial *or* editorial. This protects the magazine from the possibility of nuisance suits, of persons writing and saying "You used a picture of me and it put me in a bad light and I want compensation."

Timid corporate attorneys, who would advise driving to work in a tank to be safe, should not be in a position to dictate the editorial content of the magazines that influence up-and-coming photographers. The blanket model-release decree is an easy way out for corporate attorneys. But in making their own jobs easier, they diminish your freedom. If you've noticed how photography magazines have moved steadily toward abstract, soft-focus, and artificial-looking people pictures, you will understand the influences that have been at work.

Don't be intimidated by the cage-rattling of corporate attorneys—usually not photographers themselves—who are paid to protect the profit picture, not your picture.

As for film and camera companies, it is astonishing to learn of their direct role in engendering and continuing the model-release myth. They accomplish this through the annual photography contests that they sponsor.

The contests attract thousands upon thousands of student photographers. Because the contests are sponsored by big names in the industry, photographers are eager to win the trophies and ribbons offered, not to mention the cash. Some of the contests have been annual traditions for decades. Photography instructors receive special literature to explain to their students the rules, one of which never fails to state: "Model releases must be available for recognizable people in any entry."

Thus photography instructors as well as students believe that, indeed, model releases are always necessary. After all, it came from The Source.

Why *are* the model releases required by the sponsors? Take a look at one of the other standard rules: "Winning entries become the property of the sponsor." These large companies have discovered an effective way to acquire excellent photography—cheap. The real winners in these contests are the sponsors, who find many uses for the winning entries: magazine ads, promotional brochures, flyers, billboards, TV ads, and so on. Because the winning entries are used for commercial purposes, model releases must be on file for all recognizable people in them.

So you see, your picture is no longer yours if you win. It's theirs. And since they will use the picture to promote *their* products, it is now a *commercial* photograph—which requires a model release.

Again, the distinction hasn't been made for newcomers that model releases aren't necessary in the normal course of taking pictures in the public interest. Such contests should state the difference, the reasons for the releases for contest entries, and they should also award royalties to the winning entries (for more on contests, see Chapter 10).

I may appear to be laboring this point on the myth of model releases, but the implications are far-reaching. Photography has advanced to the point where it is one of the most important communicative tools. Yet fewer "people pictures" are being taken in public because of the apprehension instilled in photographers by misinformed camera columnists and a protectionist industry.

You Will Rarely Need a Model Release

The Constitution is brief and open to interpretation when, in the First Amendment, it affords us freedom of the press. Freedoms are sometimes abused, and court cases over the years have attempted to interpret and clarify our freedom to photograph. New York State courts have tried many cases over the years. As a consequence, many of the other forty-nine states tend to look toward New York statutes and precedents for guidance. The current spirit of the interpretation of the First Amendment is that we, the public, relinquish our right to be informed if we succumb to a requirement of blanket model releases for everything photographed. If a picture is used to *inform* or to *educate,* a model release is not required.

What are other books saying about model-release requirements?

It has long been established that photographs reproduced in the editorial portions of a magazine, book, or newspaper do not require model releases for recognizable people. Under the First Amendment of the U.S. Constitution, photographs may be used without releases if they are related to the subject they illustrate, or

if the captions are related to the pictures properly, and if they are of public interest. These provisions are for nonadvertising and noncommercial purposes.

—from *Selling Photographs: Rates and Rights,* page 174, by Lou Jacobs, Jr., Amphoto Books.

Can you include bystanders in the photographs of the parade when the article is published? Yes, you can, and you don't need a release. This is because the parade is newsworthy. When someone joins in a public event, he or she gives up some of the right of privacy.

—from *Selling Your Photography: The Complete Marketing, Business and Legal Guide,* page 194, by Arie Kopelman and Tad Crawford, St. Martin's Press.

Generally speaking, news pictures that report current happenings or illustrate other items of public interest need not have the model's permission to be used. Sometimes the fine line between what is newsworthy and what is not may be difficult to draw.

—from an article by Richard H. Logan III in *Law and the Writer,* page 111, edited by Kirk Polking and Leonárd S. Meranus, Writer's Digest Books.

If the pictures are sold for editorial use such as in a nonfiction book or in a magazine in connection with an article or item that is newsworthy or of general interest, it is unlikely that he would be liable if the pictures were misused, even though no releases had been obtained.

—from *Photography and the Law,* page 35, George Chernoff and Hershel B. Sarbin, Amphoto Books.

Use of photographs in the news, educational, current illustrative areas, generally does not require a release.

—from *Photography: What's the Law?,* page 44, by Robert M. Cavallo and Stuart Kahan, Crown Publishers.

Most of your publishing markets are well aware of the fact that they seldom need to require model releases. In my own case, I started out getting model releases without fail whenever I shot, hampering my photography in the process. Once I learned that publishers for the most part take their First Amendment rights seriously and do not require model releases (with the exception of specific instances, which I'll discuss in a moment), I stopped getting written releases and haven't gotten any for

eighteen years. (One of the advantages of being a photo illustrator and not a service photographer.) My model-release file gathers dust in a far corner of my office and my deposit slips continue to travel to the bank with regularity.

In the course of my photo-marketing career, I've come across publishers now and then (or photo buyers new to the job) who were unaware of their First Amendment rights or were unwittingly surrendering them. If they persist in requiring model releases when they're not necessary, I drop them from my Market List.

By and large, publishers know and protect their rights. As I've noted, some publishers depend heavily on independent photo illustrators. A blanket model-release policy would only serve to cut them off from a major proportion of their valued picture sources. They know that stopping for model releases is a disruption or intrusion contrary to the very nature of photo illustration—capturing the spontaneity and unaffected essence of the human scene.

Model Releases—When Must You Get Them?

Your photo illustrations are used to inform and to educate. That's why your photo buyers will rarely require a model release. Just when are you likely to need one?

Some gray areas have developed over the years, and these instances are the exceptions to the rule. Pictures that might shock what's defined as the normal sensibilities of ordinary people may be categorized as outside the "inform or educate" interpretation. Some other sensitive areas include mental illness, crime, family or personal strife, chemical dependency, mental retardation, medicine, religion, and sex education. Each case has to be interpreted in its own context. For example, a court case involving sex education might be treated differently in Mississippi than it would in California. Take local and regional taboos into consideration when you are photographing.

A model release might be required by the publisher of an industry-sponsored magazine because of implied endorsement. If a picture of you, for example, were to appear on the cover of *Mainliner* magazine, it might imply that you, indeed, agree that the skies of United are friendly.

As mentioned earlier, model releases are usually required in service photography. If a picture of you or your son or daughter is published in a commercial way and a trade benefit is implied, you or your son or daughter should have the right to give permission for such use, on the one hand, and you should receive compensation for such use, on the other.

As for stock photo agencies—they sell pictures for both editorial and commercial use, and while they frequently do not require model releases when your pictures are submitted, they will want to know if

releases are available. Being in a position to say to an agency, "MRA"—model release available—will make your pictures more salable.

Oral Releases

Written model releases are required in New York State, but oral releases are valid in most other states. This means you can verbally ask permission for "release" from the person you photograph. This is for the purpose of avoiding later misunderstanding, even though the way your picture is used might not even require a model release. You can say, for example, "Is it OK if I include this picture in my photography files for possible use in magazines or books?"

However, if you are also a service photographer and there's a chance the picture may be used for commercial purposes, it's advisable to make your verbal request more encompassing: "If I send you a copy of this picture as payment, would you allow me to include this picture in my files for possible use in advertising and promotion?"

When you read about lawsuits involving the misuse of photographs by photographers, it's usually a service photographer who has used a photograph of a person in a manner different from what the model expected. If you are a *service photographer, don't* rely on a verbal model release. Get a signed release. Spell out exactly how the picture will be used. If the person is under eighteen years of age, obtain a release from his or her parent or guardian.

How do you learn if oral model releases are acceptable in your state? Most every county in the USA has a law library at the county court house. Consult the current volumes of state statutes for the laws on invasion of privacy. Ask the law librarian or the county attorney to assist you. For details on cases involving invasion of privacy, consult the volumes entitled "case index" or the equivalent. You'll be pleasantly surprised to learn that few cases are recorded.

If you are unable to visit the law library in person, try phoning them. If you are not familiar with terms or descriptions, let the librarian know this. An expert will be more helpful if you let him or her control the conversation. They're usually flattered and will be willing to help and to refer you to additional sources of information.

Many photographers shoot the people pictures that they plan to send to an agency, or that might be used from their own files for commercial purposes, within a close geographical area. They can then easily go back later and obtain a written model release, when necessary. Another route is to work with one or several neighboring families and get a blanket model release for the entire family, then trade family portraits over the years in return for the privilege of photographing family members from time to time for your stock files.

Figure 15-2 shows an example of an acceptable model release. Figure 15-3 shows a release for parents and guardians to sign for models under eighteen years old (under twenty-one in some states). These two releases have been designed to fit onto a 3x5 pad.

The Right of Privacy

The rights safeguarded by our Constitution include the right of privacy—our individual right to decide whether we want our peace interrupted. Occasionally a photographer violates normal courtesies, laws, and decency with his picture-taking. Such instances are of course exceptions—and are all answerable within the law.

However, we have seen instances where leaders of political groups, individuals engaged in medical quackery, or religious cults will commit their misdeeds against society and then attempt to take refuge in our right-of-privacy laws. Usually, prominent public figures must surrender such privacy and open themselves to public scrutiny. Such is the price of glory.

But what about the nonpublic figure, the person who is just going about his normal business?

Invasion of privacy is not so much a question of whether you should take a picture or not, but whether the publisher should publish it or not. And in what context.

While our Constitution allows us freedom of the press, it also allows us freedom from intrusion on our privacy. Herein lies a conflict, and the courts are left to make the decision whether invasion of privacy was committed by a photographer in any individual instance.

Instances usually considered invasion of privacy would be where you:

1. Trespass on a person's property and photograph him or members of his family without valid reason. (In connection with a newsworthy event would be a valid reason.)

2. Embarrass someone publicly by disclosing private facts about them through your published photographs.

3. Publish a person's picture (without permission) in a manner that implies something that is not true.

4. Use the person's picture or name (without permission) for commercial purposes.

There have been very few cases in U.S. court history involving a photographer with invasion of privacy. Except for number one above, invasion of privacy usually deals with how a picture is *used,* not the actual taking of the picture. When in doubt, rely on the Golden Rule.

RELEASE

In consideration for value received,* I hereby authorize
_____ ("the photographer") and or parties designated
by the photographer (including clients, purchasers, agencies, and
periodicals or other printed matter and their editors) to use my photo-
graph in conjunction with my name (or fictitious name) for sale to or
reproduction in any medium the photographer or his designees see fit
for purposes of advertising, display, audiovisual, exhibition, or
editorial use.
 I affirm that I am more than 18 (21) years of age.

Signature: _____

 Date: _____

Figure 15-2. *Model release.*

RELEASE

I, _____, parent of _____ a minor,
 guardian
in consideration for value received,* assign to _____
its customers and representatives, the exclusive right to copy and
reproduce for the purpose of illustration, advertising, and publication
in any manner whatsoever any photograph of said minor in its posses-
sion.

 Signed _____

 Address _____

Witness _____

 Date _____

Figure 15-3. *Guardian's consent (for model release).*

*Value received translates in everyday terms to compensation. The compensation the
model receives might be a dollar, a copy of the publication the picture appears in, etc.

A Turning Point

Privacy is important to all of us. It was an important factor in moving to our farm here in western Wisconsin, insulated by acres of rolling hills.

In my early days as a photographer, my views on privacy used to get in the way of my photographing. For example, once as a young tourist in France, I photographed two people, a man and his wife, who were so inebriated they had fallen to the ground; one was trying to help the other up. I got two pictures before bystanders started kicking me and tossing rocks at me. I had entered into that picture-taking encounter believing that I was recording insights into the problems of alcoholism in France. I exited with remorse, believing that I had invaded the privacy of two individuals and insulted their compatriots. For several years, I avoided "invading the privacy of people's lives" and took few pictures in public.

Then one day it occurred to me that the moment of life I had captured on film that day in Paris was significant. I realized that the potential impact of that mini-drama on those who might view the picture outweighed the "invasion of privacy" I had committed, not to mention the guilt I had imposed on myself.

From that day forward my interpretation of *privacy* was different. Photo illustration has become a powerful communicator for all of us. If privacy is a gift we all cherish, so is the gift of *insight* photography affords us. Our lives are richer each time we move closer to understanding ourselves, our fellow creatures, and this planet we live on.

As a photo illustrator you will affect the lives of others. Closed societies are aware of this and severely limit the rights of photographers and the press. In our free society, we photographers have the responsibility of not abusing our freedom of the press. We owe it to our profession to respect the rights of our models. Your mission as photo illustrator is to inform and educate, not to libel and slander. You can reassure your models with courtesy and the explanation that your photograph(s) will "be in the public interest." By making it clear how the photo will be used, and sticking by your statement, you build your reliability factor with the people you photograph (and the reliability factor of photographers in general).

The definition of *rights* expands and shrinks with changes in government, society, and culture. We are fortunate to live in a society that guarantees both freedom of expression and the right to privacy. Photography, at times, walks a fine line between those two rights.

Page 282: Available light is the friend of the photo illustrator who finds that flash would destroy the atmosphere or intrude on the intimacy of a situation.

Page 283: Cute animal shots are usually Track A pictures, but when people are involved with the animals in a meaningful way, the picture becomes something more than a "cute animal" picture.

16.
Your Stock Photo Business: A Mini Tax Shelter

The Great Rebate

As you read this book, if you've discovered you've missed out on a lot of selling opportunities, then I'm accomplishing my purpose. This chapter shows you another significant and far-reaching opportunity: If you work at a salaried job, you have an annual tax rebate coming to you—when you begin calling your stock photography work a "business." Your rebate can amount to as much as $1,000 a year, depending on your salaried income, the number of dependents you claim, your photography business deductions, and a few other considerations such as investment credits.

"Is that legal?" you ask. "Would I need an attorney, or at least a CPA?"

Yes, no, and no.

"Well, then, why aren't more people doing it?"

They never ask.

When I bought a new enlarger, I asked my tax man if I could get a tax investment credit to reduce my income taxes, just like a former president I'd been reading about in *Newsweek*. He said yes.

"Well, why didn't you tell me this before?"

His answer: "You never asked."

What I'm going to say will enable you to buy a new camera every year, new lenses, new darkroom equipment. Listen carefully.

The System to Beat the System

I call it the "Tax Rebate System." It is legal, logical, and lovely. It is based on the fact that in our free-enterprise system, the government tries to help small businesses get off the ground. Many a flourishing business

existing today started as a transfigured hobby—and made it, thanks to the initial tax shelters offered by the IRS.

If you follow a few simple IRS-approved guidelines, a tax rebate will come to you, you'll get your stock photography business off the ground, and the IRS will give you no heat. In fact, the IRS will be on your side—after all, your business will one day be in a position to pay taxes, too. Up to now you may have called your photography a hobby, but Uncle Sam will pay you as much as $1,000 a year or more to call it a business.

Declaring your photography as a business is easy. You simply say, "My photography is now a business"—and that's it. Then at income tax time, in addition to the regular 1040 tax form, you also fill out a form called "Schedule C" (Profit or Loss From a Business or Profession).

To give airtight officiality to your business status, I suggest that you do three additional things:

1. Give a name, or title, to your business, and open a separate business checking account in this name.

2. Have some business stationery printed.

3. Ask the IRS for a tax identification number. It costs you nothing. It remains your number for as long as your business is in operation.

Naturally, the IRS does not act kindly toward the person who fabricates a "business operation" and then enjoys the benefits. These three actions show clear-cut intent for IRS purposes, if any question arises later.

Bear in mind that we are not discussing tax evasion. That's against the law. We *are* talking about making legitimate, legal, justified tax deductions—that's your right. And it's called "tax avoiding."*

If you are still in doubt, here's an inexpensive way to check out what I'm saying. Call the toll-free IRS number for your local area. Tax information specialists are on hand to answer questions and send you literature. Most IRS operators are knowledgeable and cooperative, but if you find one who isn't, excuse yourself, hang up, and try again. You'll usually reach a different operator, since several work the phone lines at any one time. In fact, it's sometimes a good idea to ask the same questions of two or three operators to check the consistency of the answers you get.

You can also ask your tax consultant about these guidelines, but be conscious of a need to check the thoroughness of the response. Your questions might require some research on his part—that is, extra work.

*To AVOID is LEGAL but to EVADE is ILLEGAL.
U.S. Supreme Court
(*Gregory* v. *Helvering,* 293 U.S. 465)

My own experience has been that many tax consultants concern themselves only with the routine elements of standard business situations—not the individualized self-employment questions that may take extra research and study.

By establishing your business status with the IRS, in their language you are establishing intent to make a profit. In your first five years of operation, you should be able to show a profit for any two years out of five. (In other words, you could go as long as three years before you need to show a profit.) The second five-year period, the third, and so on, are treated in the same manner by the IRS. However, the law does not say that the profit must be large (or likewise that a loss from your business must be small); a $1 profit is a bona fide profit, not a loss. You can make sure you show a profit for two out of those five years by not deducting some of your expenses—thus increasing your profit.

The record proves that the IRS does not come down hard on people who don't show a profit, so long as they show reasonable intent of making their business prosper. If you conduct your business in a businesslike manner—with evidence of consistent submission of your photographs, self-promotion activity, reasonable recordkeeping, use of a business letterhead, and so on—there's little likelihood that you'll be challenged by the IRS.*

A Government Incentive to Start Up Your Business

Even though you might not make a "profit" the first couple years (on paper), you may have more money available to you, in terms of actual cash flow, than if you never attempted to start up your photo-illustration business. Here's how it works: Say you're making $20,000 a year at your regular job. Your weekly paycheck should be $384.62. But after taxes and other deductions (about 27.5 percent), you could take home as little as $279.12—or $105.50 less than your gross salary. Since your employer has taken taxes out of your wages in advance (withholding tax), you in effect have placed on deposit with the IRS a sum of money (about $15 a day), which, if not owed to the IRS, is returnable to you. (Maybe this is why they originally called it a "tax *return*"!)

Aside from your salaried job, as you are now also a small business person just starting up a new business, you are going to have a lot of related expenses. When you figure out your 1040 Form, you will, in

*The IRS could claim that your business is actually a hobby, in which case you can claim deductions only to the amount of actual gross income from your "hobby." The burden of proof, however, lies with the IRS, not you. You qualify as a bona fide business, if you claim business status and conduct your business with regularity, though as a sideline. If the IRS challenges your "intent" before a five-year period has elapsed, within sixty days after receiving an IRS notice to disallow your business deductions, you can file Form 5213, Election to Postpone Determination, until the end of the five-year period. This form can also be filed within three years after filing your first return as a business.

addition, fill out a Schedule C (Profit or Loss) form for your photo-illustration enterprise.

Let's say that after your first year, when you have deducted the legal tax deductions listed later in this chapter (film, chemicals, car expense, stationery, travel, home office expenses, etc.), you find you show a "loss" of $4,000.* On your 1040 Form you will deduct this from your regular salary of $20,000, which means your actual net for the year has been $16,000. Since taxes were taken out on $20,000 and not $16,000, you have a rebate coming back to you from the government. (Or if you are self-employed and haven't taken advantage of all of these deductions, it will mean a lower taxable income.) The size and make of the camera you can now buy will depend on your tax bracket, exemptions, etc. You could receive back from the U.S. Treasury Department anywhere from $10 to $1,000. Nice going.

Your Photo-Marketing Business Deductions

Now that you have your own business, you can, in addition to the personal deductions you normally take, allow yourself dozens of other deductions. Your film and processing expenses, magazine subscriptions, business-related seminars, office supplies, even the cost of this book, are natural business deductions. As an independent photographer, you are always on the lookout for stock photographs—whether you take them across town, or across the country. This means your next vacation (don't use that word anymore) will actually be a business trip. You will bring back dozens of pictures of interesting mining operations in Colorado, or agricultural observations in Wisconsin, to add to your stock photography collection. You will talk an editor into giving you an assignment in one of the villages or cities along your travel route. The deductions don't occur just on your three-week summer trip, but throughout the year. Your car now becomes your "business transportation." In fact, when you buy your next car, you claim an investment credit on it because you use it for your business. Your spouse carries your equipment when you are taking pictures on a trip, so her (his) expenses are deductible. You will keep a daily log of your travel plus gas, meals, and lodging receipts for IRS verification.**

*Remember, this is an "academic loss" in that you probably would have had similar photo, car, film, travel, heat, light expenses (deductions) whether you called yourself a "business" or not. Your wife's (or husband's) expenses are now also deductible if you can show your spouse's presence on a trip (or at a dinner, seminar, etc.) had a bona fide business purpose (e.g., assisting you in some manner). By establishing yourself as a business, you can now legally deduct these as business expenses from your total income, thus reducing your taxes. When large corporations or a person in the 50 percent-or-above tax bracket talks about taking a "paper loss," this is what they're referring to.

**Generally speaking, the IRS won't question expenses for meals and lodging if they're within the limits the government allows its own traveling employees. Current rates per

It continues. Since you are a photographer, everyone is a potential customer. Whenever you entertain, at home or elsewhere, keep records of your guests and define a business relationship or a potential business relationship (as a buyer of your photos; possible model; possible client). Then you can deduct those expenses too. Be sure, though, that you *can* show a relationship between your guests and your work to the IRS.

Let's look at your new business expenses in some detail.

Home Use

The room(s) in your home where you conduct your photo-marketing business must be used specifically for your photo-marketing operations. The IRS won't approve the room as a deduction if it's also used for a sewing room, or a part-time recreation room, or if it's part of your living room. If you also have a darkroom, consider that room also as tax deductible. Measure the square footage of your home (don't include the garage unless it's heated), then measure the square footage of your working space. Divide the latter by the former and you'll determine what portion of your home is used for "profit-making activity." For example, if your working area is a 14x11 room (used exclusively for your photo-marketing business), and the total square footage of your home is 1,232 square feet, you are using one-eighth of your home. "Business Use of Your Home" is the title of IRS Publication 587 (revised November 1980). It is a clear explanation of what you can and cannot deduct. Write to the IRS for a free copy.

Formerly, you were unable to use the expenditures in the following list as tax deductions. But now that you are engaged in a profit-making activity, you may deduct one-eighth (or 50 percent or 100 percent— whatever your particular setup may be) of the following expenses. Make these deductions when you're computing your taxable income (which includes the income from your full-time employment):

Home repairs	Heat	Refuse collection
Real estate insurance	Fuel	Painting
Carpentry	Depreciation	Decorating
Plumbing	Rent	Lighting
Masonry	Water	Fire losses
Electrical work	Air conditioning	Sprinkler system
Roofing	Maintenance	Burglar alarm system

Auto Use

The deductions don't end with your home expenses. Your car will be

day: $46 (Rev. Ruling 74-433).

Receipts: No receipt is required for expenditures less than $25. (Ed. note: IRS rulings change from time to time. Call your local IRS toll-free number to validate figures in this chapter.) A receipt is required for an expenditure of $25 or more. A receipt is required for hotel or motel, *regardless* of amount. A receipt is required for transportation only where such receipts are readily available.

used to travel on assignments, research stock photo possibilities, deliver packages to the post office. If you have two cars, designate one your business car, and use it for that purpose. Note the mileage at the beginning of the year and on December 31. No matter how many cars you have, keep a perfect record of their use (keep a diary in the glove compartment), and record trips and expenditures related to transportation for your business and professional activities.

You can also deduct a percentage of the maintenance and repair of your car equivalent to the percentage of time it is used for business. See the list of deductible expenses below:

Insurance	Waxing	Tolls
Registration	Accessories	Parking
Gas and oil	CB radio	Repairs
Lubrication	Tires	Depreciation
Car washes	Snow tires	License

Travel Expenses

In order to get your photo illustrations, you may have to travel far and wide—in which case these expenditures are legal tax deductions*:

Bus	Airplane	Motel
Train	Taxi	Meals
Boat	Hotel	Passport fee

Entertainment

You'll have all the usual business expenses, including taking clients out to lunch.

Lunches	Theater	Tickets to miscellaneous
Dinner	Nightclubs	events

Advertising

Getting yourself known is deductible.

Design work	Leaflets	Newspapers
Graphics work	Brochures	Telephone (Yellow Pages)
Copywriting	Booklets	Radio
Typesetting	Catalogs	TV
Mailers	Business cards	Matchbooks
Flyers	Magazines	Calendars

Photo-Related*

Those expensive chemicals are now deductible.

Camera(s)	Processing	Darkroom equipment
Lenses	Lights	Paper
Accessories of all kinds	Model fees	Chemicals
Film	Props	
Printing	Costumes	

*Depreciate major purchases.

Printing

It's an important expenditure for you, and it's deductible.

(see Advertising)	Books	Announcements
Business stationery	Ads	Tearsheets
Mailers	Catalogs	Office forms

Business Education and Self-Improvement

If it's going to help you make a profit in your business the IRS says it's deductible.

Subscriptions (business-related)	Dues to professional organizations	Cassettes
Club memberships	Seminars	Directories
	Books and references	Courses

Office Supplies*

The "little" expenditures in this area can add up. Be sure you keep track of them.

Typewriters	Paper clips, erasers	Diaries
File cabinets	Blotters, pads	Postage stamp envelopes
Staples, pencils, pens, ink	Mailing envelopes	International Reply Coupons
Paper	Rubber bands	
File folders	Return labels	Bookkeeping supplies
Typewriter ribbon	Loose-leaf notebooks	Calendars

Other

A sure-fire test for any business deduction is to ask yourself: If I weren't in business, would I have this expense?

Accounting fees	Business-related tools (Ex-acto knives, etc.)	Professional fees
Self-publishing expenses		Interest
Legal fees	Postage	Bad debts
Babysitting (if connected with your business)	Telephone calls	Commissions
	Telegrams	Consultants
	Contract labor fees	

Keep records of your expenses. (Two excellent personal tax record books are the *Dome Notebook* and the J.K. Lasser *Tax Diary*.) Gather these together at tax time, and list them on Schedule C. These legally deductible expenses are bound to reduce your income from your regular occupation, as listed on your 1040 Form. The result will be a rebate for you, or if you are self-employed, it will lessen your taxable income.

Additional Tax Avoidances

Besides all these deductions, your business may get an additional credit directly on your taxes in the form of Investment Credit (Form 3468, Publication #572) on any major depreciable purchases that will last three years or more, such as a camera, lens, enlarger, etc. The item can

*Depreciate major purchases.

be new or used, and the tax credit (your saving) might be as much as 10 percent of the purchase price deducted from your taxes. It works like this: If the item has an expected life span of three or four years, you deduct one-third of the cost times 10 percent. If the life span is five to six years, you deduct two-thirds of the cost times 10 percent. If you expect its life to be seven years or more you deduct 10 percent of the cost.

Other tax "avoidances" you will want to consider (depending on your circumstances) are Capital Gains (Schedule D), Income Averaging (Schedule G) exemptions, Credit for Child Care Expenses (Form 2441), Residential Energy Tax Credit (home insulation—Form 5695), Moving Expense Adjustment (Form 3903), and the tax-sheltered retirement plans such as IRA and Keogh.

Also, two other provisions might result in the return of money to you:

1. *Earned Income Credit.* This credit is available to persons with income less than $10,000 who have a dependent child. Information on how to apply for this is usually at the top of page 2 of your 1040 Form. A rebate could be due you if your deductions reduce your income below $10,000. (Note: Treasury Department rulings and allowances go up and down with the times. This income figure could change.)

2. On the *state* level, about half the states offer *Homestead Tax Credit* (in Wisconsin, for example, use Schedule H, Homestead Claim). This is a rebate on your property tax if you are in a low-income bracket. If you rent, you also receive a proportionate refund.

As noted earlier, in order to be recognized as a bona fide "pro" in the eyes of the IRS, you have to, in good faith, be operating your business with regularity. The IRS will provide you (free) with some excellent booklets on operating professionally: #583 and #552 deal with record-keeping; #587 is on using your home for your business; #552 deals with business expenses and losses; and #334 deals with small business taxes. Ask for their *Mr. Businessman's Kit* for men or women thinking about starting up a business.

Here's some recommended reading: *How To Cut Your Taxes in Half by Incorporating Your Job or Business* and *Pay No Income Taxes Without Going to Jail* (both available from Tax Information Center, Rt. 1, New Concord, OH 43762); *The Home Office Guide,* ARC Books; *Free Business Planning Guide,* The Federal Reserve Bank of Boston, Boston, MA 02106; the Small Business Administration offers a library of how-to books, and many are free (contact Superintendent of Documents, Government Printing Office, Washington, DC 20402); *The Tax Reliever* (Drum Books, 2163 Ford Parkway, St. Paul, MN 55116); *Justice Times* (Box 187, Murrieta, CA 92362); *Tax Angles* (901 N. Washington St., Alexandria, VA 22314).

Note: The information in this chapter can be helpful to you in getting your photo-marketing business off the ground, because it will allow you to reinvest money into your business by keeping more of the dollars you earn.

I assume you will take this information and apply it in an honest manner. To make sure you don't put yourself in a position to get heat from the IRS, always plan your deduction activities with the IRS in mind. In other words, cover your bases *before* you go on that trip, or plan that business entertainment, or make that photo-related purchase. Ask yourself, "Can I satisfy IRS substantiation requirements? Does this proposed tax deduction meet current IRS guidelines?" When in doubt, give the IRS toll-free number a call.

If you use this simple procedure, you'll encounter few problems with the IRS when they come to call (the percentages are actually heavily against your photo-marketing enterprise's ever being audited) because you have followed the rules of the IRS game. You beat the system with your own system.

How do you illustrate a cold, wintry, snowy day? Without the cat, would this picture be as effective?

Appendix A
Third-Choice Markets

Paper Product Companies

For want of a better name, I've grouped calendars, greeting cards, posters, postcards, and the like under the heading *Paper Products*. This segment of the marketplace produces millions of products, but pays very little. And why not? There are millions of standard excellent pictures available to them from thousands of photographers—all scrambling to sell their silhouettes of a seagull against the setting sun. As you learned in Chapter 2, you can't expect dependable sales from standard excellent shots because of the overwhelming competition.

Moreover, the *large* calendar and greeting card houses do not welcome freelance submissions. Their photographic needs are filled by either staff people or their freelance regulars who are proficient with 4x5- and 8x10-format cameras.

The middle-size and smaller calendar and card markets do rely on freelance submissions, but they also rely on your vanity to fill their photographic needs cheaply. Not only are their rates low, but they attempt to acquire three- to five-year exclusive rights and sometimes all rights (see Chapter 15 to define the difference) to your photograph. They may even ask you to transfer copyright of your picture over to them. Such terms, which take a photo out of circulation, are contrary to your working methods and diminish the resale and income potential of your photographs. Remember this when you're thinking of dealing with a calendar or greeting card house: The stock photo agencies rarely deal with them. When they do, they negotiate for a high fee, and a two- or three-year limit for *one-time* picture use, and they allow North American rights only. (Otherwise, a greeting card or calendar company will resell your picture overseas for added profit—to them, not to you.)

Stock photo agencies know they can get better mileage and better return elsewhere for their pictures, so why shouldn't you? Most new-

Employ the 360 degrees available to you when you select a subject for photo illustration. A straight-on view would have had less impact.

comers to photo marketing start out with the paper products field and then graduate to the more lucrative and dependable markets outlined in Chapters 1 and 3. Why waste your time and talent in the paper products field when markets with lucrative photography budgets are waiting for your talent and know-how at this moment?

The one redeeming feature of greeting cards and calendars is that they can offer a showcase for newcomers to the field. If you feel this exposure would be advantageous to you, then deal with the well-established companies. Check an early edition of *Photographer's Market* against a current edition, to see if a firm is still listed and the address is the same.

Here are the paper products markets:

Postcards. You can sell and resell your travel pictures more often at higher fees elsewhere, so why bother with the low-paying picture postcard companies? If you nevertheless want to pursue this field, look on the back of current postcards in gift shops and stationery stores in the state or country you're visiting to find addresses of the companies that produce the cards. Also consult the Yellow Pages of the local telephone directory (under Printers, Publishers, Postcards) for companies and addresses. The same goes for souvenir color transparencies—the kind you buy in a gift shop at the airport. Send the companies color photocopies of your work, with a request for their photographer's guidelines.

Calendars. Calendar markets prefer large-format and rarely 35mm. They buy exclusive rights. They use staff or established service photographers who shoot in 4x5 or 8x10. Sometimes they will use freelancers, especially the smaller companies.

Calendar companies usually accept the standard scenic clichés; however, some houses have become innovative in their photographic tastes. Every now and then a calendar company will produce a line of calendars featuring abstracts or art photography. However, the experienced (and financially successful) calendar houses have learned to stick with the standards that appeal to the general public.

Greeting cards. Trends change more quickly here; visit a stationery store to see what's selling now. They buy exclusive rights (see Chapter 15); the pay is low and competition is high.

Posters. These are usually produced by calendar and greeting card houses; however, some are produced by independents. Nevertheless, the constraints mentioned previously hold true for the poster markets. They rely on freelancers, but they also usually require exclusive rights.

Puzzles, placemats, gift wraps. Again, you can sell your pictures at higher rates to other markets. Unless you are doing a favor for an in-law, stay clear of these markets. Your time and talent are worth more than they can offer.

If you wish to try your luck at calendar, greeting card, poster, and

placemat sales, you'll find the following of some help: the market reference guides listed in Table 3-1 and in the Bibliography. You can also write to the National Association of Greeting Card Publishers and Gift Wrappings, 600 Pennsylvania Ave., Washington, DC 20003, and ask for the *Artists and Writers Market List*. This brochure lists several dozen possible markets.

Contact markets for calendars, greeting cards, and posters by using the mail techniques outlined in Chapter 9. Table 8-2 tells you how much to charge for sales to these markets.

Commercial Accounts

Commercial markets are concentrated in metropolitan areas. They attract service photographers. Many books and most how-to courses are devoted to some phase of commercial photography.

Commercial markets prefer to deal with photographers in person. They can afford to. The pay is high. So is the competition. It is *possible* to sell stock pictures to commercial accounts; it's also possible to win the Irish Sweepstakes. Commercial accounts do use stock photography, and they'll pay a good price if *you* want to pay the price—huge investments in time, prints, transparencies, shoe leather, travel fees, postage and UPS costs, phone bills, and mental frustration—for *each* sale.

You might make sales of your stock photography to commercial outlets, if you can answer yes to the following five questions:

1. Do you live conveniently close to the commercial account so that you can make periodic (at least monthly) visits to keep yourself and your work in the photo buyer's mind? (Commercial accounts "buy the photographer" as well as his photographs.) Commercial accounts rarely deal by mail with photographers. They figure the stakes are too high to risk dealing long distance.

2. Are you prepared to provide *rush* service to your clients?

3. Are you willing to shoot to a client's specifications, not your own? Commercial accounts have rigid photographic requirements: "I want a red background, a 1961 Dodge convertible, two blond males."

4. Can you provide model releases for all recognizable people in your pictures?

5. Are you willing to relinquish ownership of your pictures? Ordinarily if you are dealing with commercial accounts, you would be doing so on a service photography basis. (See the discussion of work-for-hire in Chapter 15.)

Some commercial markets do use stock photography regularly, but they usually obtain their stock pictures from a stock photo agency

they're familiar with, where they know they can get (1) speedy service, (2) immense volume to choose from, (3) a variety of styles to choose from, (4) the work of established service photographers, (5) the going rates, and (6) an established and easy line of communication.

The only advantage you have as an independent photo illustrator breaking into the commercial markets is that you can charge a lower fee. But that isn't even an advantage at ad agencies or PR firms, where the fee they earn from their client is a percentage of the fees the agency pays for the components of the account, including the photography. They could actually lose money if they bought your picture at a low fee.

The commercial accounts listed here usually do not deal by mail. They prefer dealing in person with service photographers. Some even have policies against dealing long distance, unless it's with a top-ranking pro (or his rep) who has provided years of service to the com-mercial account.

Over the years, I have met many photographers who have attempted to market their stock pictures to commercial accounts, only to learn, after years of fruitless toil and wasted money and energy, that better and more steadily lucrative markets were waiting for them in the primary markets outlined in Chapter 3.

If breaking into the commercial accounts is a challenge you just can't turn down, here are your commercial account targets:

Ad agencies. Ad agencies rely heavily on photography for their vis-uals. The smaller the agency, the more apt they are to take time to look at you and your photography. The reality: Ad pictures are usually created and shot to order by an established service photographer. If ad agencies want stock photos, they historically go to a stock agency or to the es-tablished local pros first. Since ad agencies want to deal in person with their photographers, contact the agencies closest to you (see the Yellow Pages).

Graphic design studios. The smaller studios do buy from freelancers. The pay is good, and if you love knocking on doors, wearing out shoe leather, and showing off a portfolio, these folks will entice you with the carrot on a string. They may like you, but you'll find that they still like dealing with a large stock agency better.

Record covers. If you know the industry backwards and forwards, you might score here with stock photography. But it's rare. They prefer dealing with local service photographers or massive stock agencies. If you deal with record companies, it is more likely to be as a service photographer supplying photography for promotional and advertising use, rather than the record covers themselves.

AV: Filmstrips, motion pictures, video discs. These audiovisual mar-kets rarely buy stock photography off the street. They turn to stock

photo agencies, or have a staff photographer shoot it. The prospective AV photographer must be prepared to adapt to rapid change. Time spent cultivating this market is usually fruitless because the AV field lends itself best to the service photographer who routinely visits clients.

Business and industry. Since businesses of any size (and these are the only ones who have volume photo needs) have staff photographers and on-tap independent service photographers, your pictures won't carry much weight with them, even if your pictures are outstanding. When these people need a stock picture, they go to a stock agency. Business and industry are not worth developing as a market for your photo illustrations; selling stock photography to business and industry is usually a one-time thing.

Fashion. Don't confuse fashion with *glamour*, which sells well to the publishing industry. The fashion industry sometimes has use for stock shots for backgrounds, but they consistently go to stock agencies for the selections. Unless you live in New York, your chances of scoring are about zero. Fashion photography is service photography, and unless you can answer yes to the five questions posed earlier, fashion photography will be lost motion for you.

Product photography. Forget it. They don't buy stock pictures—it's all "to order."

(See Table 8-2 for prices to charge for audiovisual, record cover, and other commercial market sales.)

Other Third-Choice Markets

The following are included in third-choice markets because they rate an A in "Exposure Value," C-minus in pay and resale potential.

Newspapers. Sunday newspaper feature supplements sometimes buy stock photography (see Chapter 1). Daily and weekly papers (a good starting place for the beginner) will occasionally buy a single photograph. The pay is low, but the exposure is helpful. It's like free advertising. Contact the editor of your nearest metropolitan newspaper for guidelines and payment information for picture stories, photo essays, and single picture sales. Your human-interest pictures and local scenics will sell newspapers.

Government agencies. Although the government is this country's largest publisher, it is also its smallest, since each unit deals on its own local specialized level. Government photo buyers come with a variety of titles: art director, editor, promotion manager, etc. They buy pictures for their publications in a variety of fields: agriculture, transportation, commerce, health, education, and so on.

They publish pamphlets, manuals, books, posters—the works. Finding the buyers is like entering a maze. It's said that it takes seven phone calls

(don't give up) to locate the federal employee you're looking for. I know photographers who have persisted and found a market in the government for their photo illustrations, but they live in cities where there is a large federal center, such as Kansas City or Atlanta. Caution: Government publications are often not copyrighted, which means your pictures could become public domain if a valid copyright notice is not included with your picture.

Art photography. A definition of art photography, of course, is elusive. Generally speaking, when photographers refer to it, they have in mind the photographs seen in magazines such as *American Photographer, Camera Arts,* and *Print,* and in salons and exhibitions.

Art (or artful) photography is salable. Collectors will purchase it in much the same way as paintings, and for the same reason: the investment value is ultimately dependent on the renown of the painter or photographer.

Except for a few specialized, low-paying magazines, art photography is not marketable in the publishing world. Photo buyers hang them on their office walls, but rarely buy them for publication in their books or magazines.

Do single art pictures bring in money? Witness a Ben Shahn or a George Silk going for $1,000, a Eugene Smith for $500. Once you become famous, your pictures will sell for prices like these and higher. So don't give up your Sunday photography. In the meantime, keep shooting those marketable pictures I discuss in Chapter 2. Your family and your accountant will thank you.

Appendix B
Choosing Your Equipment

Big Camera or Little Camera?

Camera columnists usually advise their readers that *versatility* is the key to pro photography. The photographer is counseled to be prepared with both the experience and the equipment to handle whatever the occasion may demand, from 35mm natural light situations to 4x5 industrial photography setups. *Basic equipment* is defined by them as including not only wide-angle and telephoto lenses with filters, but several different sizes of cameras (each with back-up bodies).

These recommendations are valid if you are a service photographer. But the photo illustrator doesn't need to invest in so extensive an arsenal. You will probably be able to get started with one 35mm single-lens reflex camera. Photo illustration requires no studio, no lights, no multiple array of cameras, and rarely any special-effects lenses.

The type and style of camera equipment you'll need will be determined by your PMS and your Market List. For example, if your photographic strengths are in the areas of people pictures, indoor situations, and natural light, you'll have little use for a 4x5 camera and artificial light. If you own such equipment, you might consider selling it and buying back-up equipment for your 35mm system.

On the other hand, if your strong areas center around wildlife pictures, for example, a larger format may be appropriate, and you might want to trade off your 35mm equipment for 120-size. In the 120 format, you'll want to be aware that Hasselblad-type cameras with "through-the-lens viewing" are noisy when you trip the shutter, and they can be distracting in situations where you do not want to be obtrusive. The twin-lens type of camera, such as the Rolleiflex or the Mamiya, is generally much quieter.

The 120 and the 4x5 format are the sizes of choice if or when you take

Track A pictures (scenics and "standard excellent pictures"). You can successfully use 35mm for these areas, though, and quality 4x5 reproduction dupes can be made from your 35mm.

Though your equipment for making photo illustrations needn't be elaborate or extensive, you will want it to be complete for your needs, that is, capable of producing the kind of photos you want to deliver to your particular spectrum of markets. A good 35mm, or 120-size camera, with normal, wide-angle, and telephoto lenses, is basic. If your financial situation won't allow the auxiliary lenses, rent or borrow them to test their suitability to your PMS and Market List. These and other lenses will quickly pay for themselves if you've planned your marketing strategy wisely.

You don't need to choose the expensive models. The question often comes up, "But won't I get excessive grain using a low-priced camera or lenses?"

If you've done any reading in how-to photography books and magazines, you've encountered admonitions against grain. The question of grain, however, is one that technicians enjoy debating—photo buyers have a different viewpoint and aren't so concerned about it. Graininess may be a concern when talking about salon prints. Photo illustrations, however, are judged on their illustrative, not their technical, quality.

Ed Wallowitch, a pioneer in the field of photo illustration, once was asked why he shot with a Pentax instead of a Nikon. "Because I can own *two* of them and have a back-up, for the price of one Nikon," was Ed's reply.

Before buying any equipment, compare prices. An easy way to do this is to check mail-order catalogs, such as Unity's, Sears's, Ward's, Penney's, or Sibley's. Check the ads in the photography magazines. Check also the sale ads or the classified ads in a Sunday newspaper for used equipment. Comparing prices can save you dollars. And by comparing the features of each camera or lens, you can decide for yourself what you need, rather than let a camera department salesperson influence your purchase.

What other equipment is essential for the photo illustrator?

Your Accessories

Lens shade. Buy one for each of your lenses. The screw-on or stretch-rubber kind works better than the snap kind.

Lens cap. Caps are necessary to protect your lenses when they aren't being used. Dust, oil, or scratches on your lens will affect picture quality.

Meter. If your camera doesn't have a reliable light meter built in, use a hand-held one, preferably the "spot meter" type. Rarely will you want to use the incident and reflective types of light meter, which require getting

right up to your focus of interest. This breaks the mood or atmosphere of the situation you're photographing.

Carrying case. Make it yourself. Buy four slabs of one- to two-inch thick foam rubber. Glue or rubber-cement one slab in the top and one in the bottom section of a small suitcase. (Find a good durable suitcase at a secondhand store. A well-worn suitcase works best. It doesn't announce that you're a photographer, and your bag in the luggage rack doesn't look like a camera case to airport thieves.) Use the other two pieces of foam rubber to nest your equipment in. Using a marker, outline on these pieces the shape of each piece of equipment, plus a few slots for film cartons. Cut the shapes out to the size of each piece of equipment. Glue these two cut pieces of foam rubber onto the first two pieces, in the top and bottom of the suitcase. Your equipment will fit snugly in these slots, and the two pieces in the top section of your suitcase will hold the equipment in firmly.

Tripod. Since your photo-equipment needs as a photo illustrator will be minimal, invest in a sturdy tripod—the kind with several knobs for tilting and raising it. It will prove handy for scenes with inadequate lighting, and especially for slow color film, such as K-25.

Extra body. To preclude any disaster while photographing a special situation or an assignment, purchase an extra body that can also be used for color film if you're shooting in black-and-white. If your primary camera body needs repair or preventive maintenance, you'll still be in operation with the back-up body.

Belt. An ammunition carrier, that is, a canvas belt with pockets in it, the kind available in surplus stores (or the commercial "vest" available in photo stores), is a good accessory to have for carrying lenses to keep them handy for quick changes. Such a carrying vest or belt can also be made on a sewing machine using denim or heavy-duty sailcloth.

Appendix C
Spotting Your Black-and-Whites

You can easily eliminate the tiny spots on your prints with a #0 water-color brush and a product such as Marshall's Neutral Black, or Spotone's #3. Sometimes a #1 pencil will do a good job, if your print is a J or similar matte surface.

If you've never spotted a print before, use a few of your reject prints to practice on. The idea is to dab in tiny dots, don't "paint." After a few tries, you'll soon become an expert.

Since photo illustrators often print several of the same picture to distribute to several editors, the question often comes up: How well should I spot each print?

After looking at the same print for several minutes as you're spotting it, dozens of flecks become apparent—and you might find yourself spending an undue amount of time spotting. When you first pick up a print to examine it, scan it for a few seconds and note in your mind the most obvious flecks that need your attention. The photo editor scans your pictures just as quickly. Also, 90 percent of your pictures will be used in the layout in a much reduced size—thus reducing (or eliminating) the problem.

Appendix D
The
Darkroom

Developing and Printing: Do It Yourself or Farm It Out?

Should you set up your own darkroom or send your negatives off to a film lab to make up your prints? Again, your PMS and your Market List will be the best guides for your particular situation. If most of your photo illustrations will be color transparencies, a darkroom may be of little use to you, since color processing is complex, risky, and expensive to set up on your own. You'll fare better sending your color out.

Photo buyers rarely use color prints. Only about 10 percent of your Market List will accept color prints, and then only if they are 8x10 and technically perfect. And most of these markets will be in the lower-paying ranges. On the other hand, 90 percent of the photography budget at many publishing houses goes for black-and-white prints. If your Market List includes many photo buyers who use primarily black-and-white, you may want to consider your own darkroom. Even with black-and-white, however, it's possible to farm out your developing and printing and still come out ahead.

Here are some elements to think about in making your decision. Your personal darkroom time is valued at X dollars. (For the sake of illustration, use the minimum-wage figure.) Add to that darkroom equipment and operating costs (paper, chemicals, etc.). Include interest and depreciation. Set these costs against what developing and printing charges would be at a processing lab in the nearest city (you can do all your communication with the lab by mail). If you have tailored your Market List wisely and score frequently with your submissions to photo buyers, it could turn out that farming out your developing and printing could actually cost you less than investing the time and dollars into having your own darkroom.

You may wish to have a darkroom, though, for the enjoyment, flexibility, immediacy, and complete control it gives you.

Darkroom Equipment

If you do plan to set up a darkroom, the following list will insure that your system will be complete:

To Develop Film

Magnifying glass*	Chemical bottles*	Film dryer
Developing tank(s)*	Graduate*	Negative filing system
Developing reel(s)*	Funnel and filter*	B&W darkroom data guide
Developer*	Thermometer*	Sponge
Stop bath*	Timer*	Changing bag
Fixer*	Film washer*	Water filter system
Hypo clearing agent*	Film squeegee*	Water temperature controls
Photo flo*	Film clips*	

To Print

Enlarger*	Print tongs*	Paper safe
Enlarging lens*	Trays*	Darkroom apron
Negative carriers*	Chemicals*	Toners
Lensboard*	Chemical bottles*	Print flattening solution
Enlarging bulb*	Developer*	Photo chamois
Safelight and bulb*	Enlarging meter	Gloves
Safelight filter*	Contact printer	Dry mounting tissue
Enlarging easel*	Focus lens	Mounting board
Polycontrast filter kit*	Projection print scale	Print washer
Canned air*	Negative brush*	Print dryer
Photographic paper*	Paper cutter	Ferrotype plate and polish

Combine the Options

If you can't afford to build and equip a darkroom just now, all is not lost. Search for a neighbor or contact a friend who may have a darkroom you could rent or trade time for with family portraits, etc. High school, local community college, or vocational school students who enjoy darkroom work might serve as apprentices to you in trade for your marketing of their pictures. Caution: Photo buyers expect professional quality from you. Train your apprentice(s) to meet your print quality standards.

In my case, I started out by borrowing the lab of a nearby college, trading my photographic services in return. Once I learned the mechanics of darkroom work and paired this knowledge with my PMS, I set up a small darkroom of my own in one of our closets.

Today I have a large darkroom in the office area of my barn, where I produce a master copy of each print. I send my black-and-white master prints to a lab in Minneapolis to have twenty duplicate file copies, plus an 8x10 negative, made of each master.

If a darkroom is in your future, make your decision as to size and content, based on a thorough examination of your PMS and your Market List.

*The necessities.

Appendix E
Tips
for
Nonwriters

Photo buyers sometimes pay more for your pictures when they are accompanied by a text or story. As a photo illustrator, you will sometimes be called upon to supply words with your pictures. Don't freeze. Here are a few tips.

Instead of attacking that blank sheet of paper in your typewriter as though you were preparing a technically perfect, erudite report, consider it a letter you are writing to a friend. As in a letter, keep the tone, the mood, friendly. You can even go as far as to type in a fictitious salutation at the top of your "letter." Some writing textbooks suggest that you write "like you talk." One caution about that technique: Too often, trite phrases and overworked clichés will creep into your text. They might sound clever when you say them, but they look god-awful when you read them.

Don't attempt to be "cute" in your writing. If something you've written strikes you as extremely nifty, or clever: *Danger!* Strike it out. It might sound that way to you, your grandmother, or your son, but not to your readers. Keep it simple.

That's easy to say, but not easy to do. Keep to your subject, and *only* that subject. Don't try to tell the history of the world. If a secondary thought or idea comes along, write it down, yes, but on a separate sheet of paper, and develop that idea—later.

Try to entertain, not to educate. Your readers come to you *not* to be educated, but to be entertained. Don't attempt to inflict a message on your readers. To paraphrase an old Hollywood homily: If your readers want a message, they'll go to Western Union.

In cases where a caption or a copy block of a hundred or so words is needed, the editor might ask you just to supply the raw details. The editor will tailor them to his needs. If you decide to move into more extensive picture stories and articles, there are two ways you can go:

You can explore teaming up with a writer friend or acquaintance, which often works fruitfully for both partners, but takes cooperation and attention to logistics, such as who does what, how the proceeds will be divided, etc., or you can handle both copy and photos yourself.

If you decide to be the producer of the whole package, the best course of action is to start right in with on-the-job self-training. I hesitate to recommend that you take a writing course through your local adult-education system. Most of these courses (I used to teach one) are aimed at "creative writing." They're for a broad audience of writers and are too generalized in their content for your specific needs.

Writing is too vast a subject to treat in a weekend writing course or in a few pages of this book. Let your personal Market List be your guide. Do your editors like to see short features, news reports, extended captions, full-length features, or short copy blocks? Master the writing of these in whatever happens to be the preferred style of your editor(s). Give yourself assignments to produce articles similar to those in the magazines on your Market List.

There are many writing books available that cover these different formats. Here are some books that will help you teach yourself to write for your particular markets.

Beginning Writer's Answer Book. Polking, Chimsky, and Adkins, eds. Writer's Digest Books.
The Elements of Style. William Strunk, Jr., and E. B. White. Macmillan.
How to Write, Speak and Think More Effectively. Rudolf Flesch. Harper & Row.
Make Every Word Count. Gary Provost. Writer's Digest Books.
A Treasury of Tips for Writers. Marvin Weisbord, ed. Writer's Digest Books.

In the Bibliography I've listed additional books, seminars, and newsletters for part-time writers.

Bibliography

Note: All of the books listed are in my personal library and each has its own strength and degree of usefulness. Ask your librarian or bookstore for a copy and examine each for its application to your own photo-marketing operation.

Selling Your Pictures

The Focalguide to Selling Your Photographs. Ed Busiak. Focal Press. A general how-to guide for the beginner in both stock and service photography.

Freelance Photographer's Handbook. T.J. Marino and Donald Sheff. Bobbs-Merrill. A basic guide to freelancing. Aimed at the service photographer, but offers tips useful to the photo illustrator.

Freelance Photography: Advice From The Pros. Curtis Casewit. Collier Books. Conversations with service photographers in the field reveal some helpful advice for stock photographers as well.

How You Can Make $25,000 a Year with Your Camera: No Matter Where You Live. Larry Cribb. Writer's Digest Books. Service photography at its most accessible.

Outdoor Photography: How to Shoot It, How to Sell It. Robert McQuilkin. Lightbooks. A specialized area treated in an easy-to-read style by a pro who knows this select field.

Photographer's Market. Robert D. Lutz, ed. Writer's Digest Books. A favorite desk-top reference for locating names, addresses, and categories for your Market List.

Photography Market Place (2nd edition). Fred McDarrah. R.R. Bowker. Source guide for your Market List.

Selling Photographs: Rates and Rights. Lou Jacobs, Jr. Amphoto Books. The author is both a writer and a working photographer. Clear and concise.

Selling Your Photography: The Complete Marketing, Business and Legal Guide. Arie Kopelman and Tad Crawford. St. Martin's Press. The marketing section is aimed more toward the New York service photographer than the non-New York photo illustrator, but the legal and business pointers are useful.

Sell Your Photographs: The Complete Marketing Strategy for the Freelancer. Natalie Canavor. Madrona Publishers. Good hints for the photographer who

lives in a large metropolitan area, especially New York, and expects to make personal contact with editors and commercial accounts.

Stock Photo and Assignment Source Book. Fred W. McDarrah. R.R. Bowker. Lists the names of photographers who are available for assignments, plus their specialties. Even if you don't get yourself listed, you'll find this book a useful lead to sources who use a lot of photography.

Stock Photography: How to Shoot It, How to Sell It. Ellis Herwig. Amphoto Books.

Where and How to Sell Your Photographs. Arvel Ahlers. Amphoto Books. An old favorite, first published in 1952. Some of the marketing methods suggested are not in use today.

Writer's and Photographer's Guide. C. Richard Ogden. Clarence House Publishers. Another source guide for your Market List.

You Can Sell Your Photos. Henry Scanlon. Harper & Row. Based on the premise that you can place your pictures with a stock photo agency and make big money.

The Business Side

ASMP Professional Business Practices in Photography. American Society of Magazine Photographers, 205 Lexington Ave., New York, NY.

Blue Book of Photography Prices. Thomas Perrett. Photography Research Institute, Carson Endowment, Carson, CA.

Boardroom's Business Secrets, by Boardroom Experts and Editors. Boardroom Reports Publishing.

The Complete Handbook for Freelance Writers. Kay Cassill. Writer's Digest Books.

Do It Yourself Marketing Research. George Edward Breen. McGraw-Hill.

The Entrepreneurial Woman. Sandra Winston. Newsweek Books.

Getting Your Act Together: Goal Setting for Fun, Health, and Profit. George Morrisey. John Wiley & Sons.

Handbook for Manufacturing Entrepreneurs. Robert S. Morrison. Western Reserve Press.

How to Advertise: A Handbook for Small Business. Sandra Linville Dean. Enterprise Publishing.

How to Begin and Operate a Successful Commercial Photography Business. Bill Montaigne. Halls of Ivy Press.

How to Do Your Own Accounting for a Small Business. Roger R. Milliron. Enterprise Publishing.

How to Organize a Small Business. Clifford M. Baumback, Kenneth Lawyer, and Pearce C. Kelley. Prentice-Hall.

How to Start a Professional Photography Business. Ted Schwarz. Contemporary Books.

How to Start and Manage Your Own Business. Gardiner G. Greene. McGraw-Hill.

How to Start Your Own Business . . . and Succeed. Arthur H. Kuriloff and John M. Hemphill, Jr. McGraw-Hill.

How to Win the Battle Against Inflation with a Small Business. Murray Miller, M.D., and Franz Serdahely. Enterprise Publishing.

How You Can Make $20,000 a Year Writing (No Matter Where You Live). Nancy Edmonds Hanson. Writer's Digest Books.

Penny-Pinching Postal Pointers for Everyone. Edmund J. Gross. Halls of Ivy Press.

Pocket Pal: A Graphic Arts Production Handbook. International Paper Co.
Professional's Guide to Publicity. Richard Weiner. Weiner Publishing.
Successful Business. Arthur Liebers. Key Publishing.
The Successful Promoter. Ted Schwarz. Contemporary Books.
The Writer's Resource Guide. William Brohaugh, ed. Writer's Digest Books. A
 great aid to streamlining your research efforts.

Legal Questions and the Photographer

Fear of Filing. Volunteer Lawyers for the Arts.
How to Pay Less Tax. Consumer Guide Publishing.
Legal Guide for the Visual Artist. Tad Crawford. Hawthorn Books.
Photography and the Law. George Chernoff and Hershel B. Sarbin. Amphoto
 Books.
*Photography: What's the Law? How the Photographer and the User of Photo-
 graphs Can Protect Themselves*. Roger M. Cavallo and Stuart Kahan. Crown
 Publishers.
*Strategies for the Harassed Bill Payer: The Bill Collector—and How to Cope
 with Him*. George Belden. Grosset & Dunlap.
Tax Loophole Digest, ULC Research, Box 526, Montreal Rd., Clarkston, GA
 30021.
The Tax Reliever 1980: A Guide for Artists, Designers, and Photographers.
 Richard Helleloid. Drum Books.
U.S. Master Tax Guide. Commerce Clearing House, Inc..
The Visual Artist's Guide to the New Copyright Law. Tad Crawford. Graphic
 Artists Guild.
What Everyone Needs to Know About Law. U.S. News & World Report Money
 Management Library, U.S. News & World Report Books.
Your Income Tax. J.K. Lasser. Simon & Schuster.

Newsletters

For Photographers

APIdea, 21822 Sherman Way, Canoga Park, CA 91303. How-to tips for the ser-
 vice photographer, with a monthly column on marketing.
Photoflash, Box 7946, Colorado Springs, CO 80933. How-to tips for the glamour
 photographer.
Photographically Speaking, 1071 Wisconsin Ave., N.W., Washington, DC 20007.
 Tips and news about the Uniphoto stock photo agency.
Photography Today, Route 2, Box 197, West Highway 46, Templeton, CA 93465.
 About the business side.
The Photoletter, Pine Lake Farm, Osceola, WI 54020. Pairs picture buyers with
 photographers; lists current photo needs of specific editors and photogra-
 phers.
Phototraveler, Box 8801, Toledo, OH 43623. Aimed at the travel photographer.
Simon Says, 316 W. Seventy-ninth St., New York, NY 10024. Reports on equip-
 ment and the camera industry.
SMP Photo Market Newsletter, 1500 Cardinal Dr., Little Falls, NJ 07424. Tips and
 news of students of the School of Modern Photography.
Take Stock, 182 Quadrangle, 2800 Routh, Dallas, TX 75201. News and tips from
 Images Unlimited, a stock agency.
TSA, Tom Stack Newsletter, 3350 Cortina Dr., Colorado Springs, CO 80918.
 News and tips from this stock photo agency.

Wide Angles, 2512 "Que" St. N.W. (rear), Washington, DC 20007. News for amateur photographers, both in this country and abroad.

For Photojournalists and Writers with a Camera

Angles and Lines, National School Press Association, 720 Washington Ave., Suite 205, Minneapolis, MN 55414. For journalists at high school and college newspapers.

Author's Newsletter, P.O. Box 32008, Phoenix, AZ 85064.

Contacts, Larimi Communication Associates, 151 E. Fiftieth St., New York, NY 10022. Pairs editors with PR people.

Copyright Management, 85 Irving St., Arlington, MA 02174. Copyright updates and case histories.

Freelancer's Newsletter, Circle Publications, Inc., 307 Westlake Dr., Austin, TX 78746. Pairs editors with freelance writers.

Freelance West, Box 601, Edmonds, WA 98020. Leads and tips for the freelancer; regional.

Outdoors Unlimited, Suite 208, 4141 W. Bradley Rd., Milwaukee, WI 53209. Newsletter for the Outdoor Writers Association.

Photographer's Market Newsletter, 9933 Alliance Rd., Cincinnati, OH 45242. Market leads for photo sales. Tips. Monthly.

Ragan Report, 407 S. Dearborn St., Chicago, IL 60605. For public relations people and copywriters.

Towers Club Newsletter, Box 2038, Vancouver, WA 98661. For independent writers who self-publish; tips and how-to information.

The TravelWriter MarketLetter, Room 1745, The Plaza Hotel, New York, NY 10019. For writers who also sell their travel pictures.

Writer Report, Woodbury Communications, 4219 Las Cruces Way, Sacramento, CA 95825.

Writer's Digest, 9933 Alliance Rd., Cincinnati, OH 45242. For writers; with a monthly column on photography.

Special Reports

These publications and others relating to photo-marketing are available from the *Photoletter.* For prices and additional titles, write to me at the *Photoletter,* Station 5, Osceola, WI 54020.

"Fine-Tuning Your Photo-Marketing Techniques." For the veteran photo illustrator. An advanced how-to manual.

"Pre-Travel Planning Kit." List three countries, provinces, or states you plan on visiting, and you'll receive a computerized printout of possible market contacts with names and sample cover letters.

Seminars and Workshops

A seminar will more than pay for itself if you shop wisely. Most of the seminars listed here offer information directly related to running your own photo-marketing business and helpful insights into publishing and graphics. I've included a few of the many Track A-oriented seminars available for readers who wish to pursue the secondary and third-choice markets.

The Bill Thomas Nature Photography Workshop, Deer Trails, Rt. 4, Box 387, Nashville, IN 47448. How to take and sell outdoor pictures.

Business Guide, Professional Workshop for the Visual Artist. The Graphic Art-

ists Guild, Room 405, 30 E. 20th St., New York, NY 10003. How to keep more of what you earn.

Communicating with Pictures. The Douglis Visual Workshop, 212 S. Chester Rd., Swarthmore, PA 19081. How the photo buyer—and the photographer—can effectively use photographs for greatest visual impact.

Designing with Photography: A Hands-On Workshop. Dynamic Graphics Educational Foundation, Inc., 6707 N. Sheridan Rd., Peoria, IL 61614. How to use photographic images effectively.

Elaine Sorel Workshop. Elaine Sorel, 640 West End Ave., New York, NY 10017. Teaches artists how to be good businesspersons.

Fundamentals of Modern Marketing. American Management Associations, The American Management Associations Building, 135 W. 50th St., New York, NY 10020. How to take color photos as a service photographer working with ad agencies.

Inflation Survival Courses. Target Publications, Box 2000, San Ramon, CA 94583. How to manage your business creatively.

Motivating the Reader and Selling the Graphic Arts Buyer. Dynamic Graphics Inc., Box 416, Peoria, IL 61614. How to deal with photo buyers.

Mountain Photography Seminar, Box 399, Invermere, British Columbia, Canada, V0A 1K0, (Backpacking and camping while "camera hunting.")

Owens Valley Photography Workshops, Box 225, Agoura, CA 91301. How to take better Track A pictures.

Photocommunications Workshop. Rochester Institute of Technology, One Lomb Memorial Dr., Rochester, NY 14623. How to be a photojournalist.

Rohn Engh's Photo-Marketing Workshops, Pine Lake Farm, Star Prairie, WI 54026. Held throughout the year in locales from California to New York and Florida. The workshops range from one to three days and cover the elements in this book plus Q and A feedback and personal critiques on students' pictures.

Successfully Self-Publish Your Book Seminar. Copy Concepts, Inc., 5644 La Jolla Blvd., La Jolla, CA 92037. How to publish your photo book.

Summer Weekend of Photography. SWMCCC, 620 DeLand Rd., Flushing, MI 48433. How to take the Track A picture.

Telephone Skills for Business. Business and Professional Research Institute, 353 Nassau Street, Princeton, NJ 08540. How to market via the phone.

Wilderness Photography Seminars, conducted by Robert McQuilkin, 1028 North Cherry, Station 3, Wheaton, IL 60187. How to live in the wild and take photos and picture stories that sell.

Writer's Digest Saturday Seminars, Writer's Digest Seminars, 9933 Alliance Rd., Cincinnati, OH 45242. How to write and photograph for your markets, and how to sell to them.

Additional Workshop Sources

National Press Photographers Association, Box 1146, Durham, NC 27702.

Professional Photographers of America, 1090 Executive Way, Des Plaines, IL 60018.

Photographic Society of America Regional Conventions, 2005 Walnut St., Philadelphia, PA 19041.

Local camera stores often sponsor half-day workshops. Consult the Yellow Pages.

Photography magazines (for the pro and amateur) often list current seminars and workshops.

Universities, colleges, and technical schools conduct seminars and workshops. Consult your telephone directory.

INDEX

Other Writer's Digest Books